THE UNIVERSITY OF
WINCHESTER

Martial Rose Library
Tel: **01962 827306**

ᒍᒪᒪ
2 7 OCT 2015
AUB915

D1610663

To be returned on or before the day marked above, subject to recall.

THE
LITERATE
EYE

Victorian Art Writing and Modernist Aesthetics

Rachel Teukolsky

OXFORD
UNIVERSITY PRESS

OXFORD
UNIVERSITY PRESS

Oxford University Press is a department of the University of Oxford.
It furthers the University's objective of excellence in research, scholarship,
and education by publishing worldwide.

Oxford New York
Auckland Cape Town Dar es Salaam Hong Kong Karachi
Kuala Lumpur Madrid Melbourne Mexico City Nairobi
New Delhi Shanghai Taipei Toronto

With offices in
Argentina Austria Brazil Chile Czech Republic France Greece
Guatemala Hungary Italy Japan Poland Portugal Singapore
South Korea Switzerland Thailand Turkey Ukraine Vietnam

Oxford is a registered trade mark of Oxford University Press
in the UK and certain other countries.

Published in the United States of America by
Oxford University Press
198 Madison Avenue, New York, NY 10016

© Oxford University Press 2009

First issued as an Oxford University Press paperback, 2013.

Library of Congress Cataloging-in-Publication Data
Teukolsky, Rachel, 1975–
The Literate eye : Victorian art writing and modernist aesthetics /
Rachel Teukolsky.
p. cm.
ISBN 978-0-19-538137-5 (hardcover); 978-0-19-973923-3 (paperback)
1. Art criticism—Great Britain—History—19th century.
2. Aesthetics, Modern—19th century. I. Title.
N7485.G7T48 2009
701'.1709034—dc22 2008047730

9 8 7 6 5 4 3 2 1

Printed in the United States of America
on acid-free paper

For my parents,
Roselyn and Saul

ACKNOWLEDGMENTS

This book began as a dissertation at UC Berkeley under the direction of Catherine Gallagher, where it was also read by Sharon Marcus and Martin Jay. I thank them for their shaping influence and their majestic scholarly examples. Cathy was, and still is, the center of a lively Victorian studies group at Berkeley, creating a wonderful and formative community of young scholars. The Berkeley English department, the Mellon Foundation, and the Mabelle McLeod Lewis Foundation provided financial support that allowed me to devote long research hours to the dissertation.

Colleagues at Penn State helped me to navigate the confusions of junior faculty life, especially the world of academic book publishing. For their kind mentorship and friendship, I thank Robert Caserio, Mark Morrison, Bob Lougy, Nick Joukovsky, Hester Blum, Jonathan Eburne, Lisa Sternlieb, Janet Lyon, and Chris Castiglia. Eric Hayot donated generous time to this project, even helping to design the cover. Penn State supported my research with a semester leave from teaching. I also send cheers to the Penn State Nineteenth-Century Reading Group for a few good years of wine and Victoriana.

I am grateful to Jay Clayton, Carolyn Dever, and Mark Wollaeger at Vanderbilt University for their acute professional advice, and look forward to joining their welcoming community. Talia Schaffer and Peter Logan both provided immeasurable support and warm friendship at a crucial juncture in this book's history. Jonah Siegel has been both mentor and friend for an amazingly long time. I can't list here all of the debts I owe him, but only thank him for his ongoing friendship and zest for things both academic and beyond.

Through a series of unexpected twists and turns on the road to publication, this book was reviewed by a number of anonymous readers. I thank them for their close, passionate readings and useful comments. The finishing touches on the book were applied during a fellowship at the Beinecke Rare Books & Manuscripts Library at Yale University. Emily Hines provided invaluable research assistance in checking the book's numerous sources. At Oxford University Press, I am indebted to Shannon McLachlan and Brendan O'Neill for their amiable facilitation of the publishing process. Vanderbilt University helped to make this book into a beautiful object by supporting costs for image reproduction and book production.

Chapters 2 and 3 contain material that has been revised from previously published essays. I thank the University of Virginia Press for permission to reproduce material from "This Sublime Museum: Looking at Art at the Great Exhibition," in *Victorian Prism: Refractions of the Crystal Palace*, edited by James Buzard, Joseph Childers, and Eileen Gillooly (Charlottesville, 2007): 84–100. For permission to reproduce material from "The Politics of Formalist Art Criticism: Pater's 'School of Giorgione,'" in *Walter Pater: Transparencies of Desire,* edited by Laurel Brake, Lesley Higgins, and Carolyn Williams (2002): 151–69, I thank ELT Press, Greensboro, N.C.

Various friends and family supported me through graduate school and faculty life. In Berkeley, the graduate student household at 1830 Allston Way—especially Eran Karmon, Sarah Baird, Temina Madon, and John Renner—helped me to enjoy my off hours. Susan Zieger accompanied me on an exciting (research) trip across the United Kingdom and Ireland. In State College, Lyn Elliot, filmmaker extraordinaire, allowed me to move into her house for a blessed year. Jo Park and James Ker helped to brighten the commute to Philadephia. Scott Herring has shared with me the hectic yet often amusing journey of junior faculty life. My sister, Lauren, inspires me with her verbal fireworks and legal work on behalf of the disenfranchised. Alex Gross has been a dear companion through many adventures. This book is dedicated to my parents, Roselyn and Saul, for their unwavering love and support over all these years.

CONTENTS

THE
LITERATE
EYE

Introduction
Victorian Aesthetics

It is...the beholder who lends to the beautiful thing its myriad meanings, and makes it marvellous for us, and sets it in some new relation to the age, so that it becomes a vital portion of our lives, and symbol of what we pray for, or perhaps of what, having prayed for, we fear that we may receive.

—Oscar Wilde, "The Critic as Artist" (1890)

Victorian and Modern

In Victorian Britain, critics and essayists turned with a new enthusiasm toward the subject of the visual arts. Art writing became tremendously popular as art spectatorship came to define taste and culture for a growing middle-class audience. This textual fascination in art accompanied other Victorian interests—in the body, in science, in vision, as well as in history, politics, and global conquest. Victorian writers responded to art with a myriad of textual forms: they published treatises on aesthetics, reviews of exhibitions at museums and galleries, volumes of art history, and lectures to amateur societies. John Ruskin conveys the Victorian passion for aesthetic spectatorship when he writes, famously, in *Modern Painters III* (1856), "The greatest thing a human soul ever does in this world is to see something, and tell what it saw in a plain way ...To see clearly is poetry, prophecy and religion, all in one."[1] Nineteenth-century British writers helped to invent an idea new in the nineteenth century, that art spectatorship could provide one of the most intense and meaningful forms of human experience. The "literate eye" of my title refers both to the Victorian investment in aesthetic education and to the more personal subjectivity that was felt to be affirmed by art's sublime experience.

In this book, I analyze British art writing to present a newly complex vision of Victorian aesthetics. I locate aesthetic history not only in the visual arts but also in the prismatic assemblage of texts, spaces, institutions, and practices that shaped Victorian critical discourse more broadly. Using the methods of cultural history, I argue that Victorian writers contributed to the emergence of modern Anglo-American aesthetics, especially in the moves toward formalism and abstraction that would come to dominate twentieth-century canons of art and value. Though

aesthetic modernism has most typically been portrayed as a radical break from staid Victorian conventions, I show how some of the most canonical high-art philosophies of modernism had their roots in the cultural and literary histories of Victorian Britain.

Scholars now routinely link the arts of the nineteenth and twentieth centuries, but my argument will still likely seem a challenging one, beginning with the subject of aesthetics itself. The disciplinary study of aesthetics has been shaped around an elite canon of German philosophers and French avant-garde artists.[2] Focused on a relatively small number of texts, traditional scholarship has defined aesthetic discourse as the abstract philosophy of art and beauty unbounded by constraints of time or context. Newer work in aesthetics, however, has moved to historicize aesthetic values as philosophical concepts with a specific and shifting history.[3] The editors of the recent collection *Aesthetic Subjects* observe that "the aesthetic, for all its putative associations with the timeless and the universal, is in fact the surest and most particular sign of the onset of modernity."[4] These scholars find that the desire for an autonomous and disinterested mode of art judgment emerged, not coincidentally, at the same time that Europe moved toward an incipient industrial—and secular—culture. The essays in their ensuing collection suggest that aesthetic history might be located in an array of places and texts beyond the traditional philosophical field.

Victorian Britain has not usually been seen as a significant source for aesthetic histories of the West by those who are not scholars of Victorianism, in part, perhaps, owing to antiquated stereotypes still attached to the period. The old master-narrative of Western aesthetic history, while now increasingly outdated, is worth rehearsing if only to note its relative silence on Victorian art. The rise of the aesthetic has typically been narrated as a leap from German Enlightenment philosophy to the Continental avant-gardes of the late nineteenth century. In the traditional account, Kant's resonant call for artworks to display a "purposiveness without a purpose" in his foundational *Critique of Judgment* (1790) was recapitulated in the European avant-garde mantra of "art for art's sake," which demanded that art separate itself from tyrannical mainstream values and expectations.[5] Late nineteenth-century avant-garde groups harnessed a neo-Kantian formalism to arrive at experimental visual styles that challenged legibility and illusionism, particularly French post-impressionism and cubism. The aesthetic was seen to emerge in its purest form from the artistic and technological advancements of the early twentieth century, when modernity culminated in modernism. In both literature and art, the most cutting-edge aesthetic philosophies embraced qualities of resistance, autonomy, avant-gardism, formalism, and purity. One major endpoint of this narrative trajectory was the abstract expressionist school of American painting in the 1950s, where images offered non-representational swathes of color that refused to outline any clear narrative, figures, or illusionistic

space. These "pure" canvases, it was argued, fulfilled the demands of an art freed from cozy, self-affirming, bourgeois morality.[6] The final blankness of abstract painting signified an arrival at the ultimate meaning of the aesthetic as a hallowed, separate space, a sanctified art-world unsullied by the mundane or avaricious concerns of business, politics, or moral conformity.[7]

If this narrative simplifies the complex history of aesthetic modernism, it also gains momentum from a similarly reductive account of Victorianism. Modern scholars of the nineteenth century have little patience for the stereotypes that cast Victorian artworks as merely the complacent reflection of middle-class values—especially since the typecasting was largely effected by British modernists, who tended to frame the traits of their ancestors as everything they wanted to reject.[8] The Vorticist manifesto *BLAST* (1914) proclaimed, with typical extremity, "BLAST years 1837 to 1900...bourgeois Victorian vistas...BLAST their weeping whiskers—hirsute rhetoric of eunuch and stylist—SENTIMENTAL HYGIENICS."[9] For many modernist writers, the Victorian arts were flawed by qualities of realism, high sincerity, sentimentality, and a restrictive morality.[10] While contemporary scholars are usually quick to dispatch simplistic clichés about Victorian art styles, these older perceptions might go toward explaining the absence of Victorianism from broader, traditional studies of Western aesthetic history.

The modernist reception of Victorian aesthetics was perhaps encapsulated by treatments of John Ruskin, the influential critic whose thirty-nine volumes of collected works dwell extensively on the visual arts. Ruskin was taken to be representative of the sins of Victorian critics, known for their indignant passions, their preference for visual realism and "truth to nature," their promiscuous combinations of aesthetics and politics, and their moral judgments of art reflecting truisms of public opinion. Ruskin himself helped to establish the contrast between Victorian and modernist values with his infamous 1877 assault on J. A. M. Whistler's abstract-looking Nocturnes. "[I] never expected to hear a coxcomb ask two hundred guineas for flinging a pot of paint in the public's face," he declared.[11] Whistler responded by suing Ruskin for libel, resulting in a sensational court case in the following year. This event would seem to solidify the distinctions between a provincial British art criticism and a more progressive American-French avant-garde. The spectacle of the court case has worked to obscure Ruskin's own more rebellious tendencies in the early part of his career, as well as the complexity of his writings across forty years and many different subjects. The old-fashioned, modernist vision of Victorian aesthetics is summed up by the two-part title of Henry Ladd's 1932 study, *The Victorian Morality of Art: An Analysis of Ruskin's Aesthetic.*[12]

Contemporary scholarship has been more subtle in its accounts of the relationships between the Victorian and the Modern. For revisionist art historians, some late-Victorian artists embraced modernity with formal or painterly experiments.[13] David Peters Corbett argues that Whistler and D. G. Rossetti, among others, used

painting techniques to produce "an art that would reflect upon and diagnose the character and values of modern experience for its audience."[14] Literature scholars, too, have discerned proto-modernist values in Victorian authors, in studies such as those by Jerome McGann and Jessica Feldman. For the most part, however, these studies use modernist approaches to locate modernist values—that is to say, they use deep close readings of canonical texts to locate moments of formalism, self-consciousness, or neo-Kantian philosophy.[15] Rather than analyzing the formal qualities of high literary or visual artworks, *The Literate Eye* looks instead at the cultural history of aesthetic judgments, focusing on the diverse body of Victorian writings devoted to interpretation in the visual arts. I argue that the formalist aesthetic has an important Victorian cultural and textual history, separate from an art-historical account of line, color, or facture, or from a literary account of chapter, stanza, or style. By moving away from the visual arts to focus on the texts that surrounded them, my discussion shifts from production to consumption—or rather, to the mediating field of representation between the two, as critics stepped in to interpret the visual art world for a new and eager audience.

My chapters collectively outline a continuity between the aesthetic values of the Victorians and the Moderns—values that were not monolithic in either period. Already in the early Victorian decades, writers debated the merits of autonomous judgments of art versus more collective or popular judgments. These debates persisted into the twentieth century, even while the images under discussion changed radically. In the first volume of *Modern Painters* (1843), Ruskin argues for both accurate picturing, influenced by scientific developments of the 1830s, and for a more personal, subjective vision associated with the Romantic artist. The tension between an objective, impersonal sight and a subjective, poetic vision—later to become one of the central cruxes of modernism—first emerged from contradictory strains in Victorian cultural history.

While this book follows the current scholarly trend in linking nineteenth- and twentieth-century culture, it does so with a sense of skepticism regarding the extent to which the relationship between the two fields can truly be remade. The divide between "Victorian" and "Modernist" is not simply semantic; both terms encompass more than mere historical fields of study. "Victorian" has a contemporary cultural afterlife signifying antiquity, repression, and a strict adherence to norms; it is the faded, dowdy background against which modernism sets itself to "make it new."[16] Though modernism has ostensibly ended, it also remains continuously present—and attractive—to us by signifying the kind of bold formal experimentation that appeals to some scholars' nonconformist sensibilities. These underlying structural ideologies ensure that, no matter what Victorianist scholars argue to the contrary, the survey-course shorthand separating the two fields will remain deeply entrenched. And, indeed, there are significant differences that emerge in art values over time, in any period. The challenge this book takes up is to analyze those shifts,

while revising our dominant expectations into a more nuanced, and perhaps more generous, picture. This is also to say that a seemingly narrow dispute between two scholarly fields is in fact a window into larger ideological questions about aesthetic value—those of the Victorians as well as those of our own.

Victorian Formalism

The Literate Eye does not provide a general survey of all the kinds of Victorian art writing. Instead, each chapter focuses on a different controversy in the visual art world that inspired writers to make arguments for the autonomy of art judgment from broader cultural standards—an autonomy usually figured as the promotion of visual, formal qualities over narrative, figurative, or imitative expectations. I argue that some Victorian art writing adopted a disinterested stance, embracing what Amanda Anderson has called "the cultivation of detachment" as a key mode of Victorian intellectual approach.[17] Matthew Arnold famously demanded in "The Function of Criticism at the Present Time" (1865) that commentators take a more measured, detached view of their political subjects, advocating for the "disinterested love of a free play of the mind on all subjects, for its own sake."[18] The desire for a knowledge pursued "for its own sake" well pre-dated the Victorians, and can be traced back to the Enlightenment removal of objects from functionality within political or religious systems, as thinkers sought explanatory mechanisms within a more secular and individualist tradition. This intellectual ideal can be seen to underlie phenomena as diverse as the emergence of the modern professions, the elaboration of aesthetic ideology, and the framing of Victorian liberalism.[19] It gained perhaps its greatest nineteenth-century influence with the rise of scientific disciplines. T. W. Heyck has written of how the sciences modeled a profoundly authoritative, detached professionalism that all other disciplines would attempt to emulate.[20] It is no coincidence that knowledge gathered "for its own sake" finds a linguistic echo in the label of the rebellious Victorian art movement, "art for art's sake." (This English phrase adds a small but distinct twist to the French phrase it translates, "*l'art pour l'art*"). Though historians have traditionally discerned a split in the nineteenth century between the two cultures of science and art, in fact art writers were powerfully influenced by the rise of science as the preeminent discourse of professional authority and disinterested vision.[21]

In particular, Victorian essays on art often produced a confusing overlap between artistic and biological forms in their attempts to account for new scientific models across the century. Discoveries in optics, neurology, botany, zoology, even the chemistry of color, were all negotiated by art writers in proposing theories of aesthetic value. The visual arts became an especial medium for meditations on the unstable relation between the outside world of objects

and the inside world of human perception. The ubiquity of scientific reference in these essays highlights a tension between subjective and objective ideals in the visual arts, a tension that recurs in each chapter. Even Walter Pater, the most famous subjective critic, writing in the "Conclusion" to *The Renaissance,* sets his discussion of subjectivity within the bounds of "our physical life," amidst the "perpetual motion" of "the passage of the blood" and "the waste and repairing of the lenses of the eye."[22] Pater was writing after Darwin, whose theories permeated every late-Victorian cultural discourse, including aesthetics. But it is no coincidence that art writers with a greater distance from Darwin, like John Ruskin and Roger Fry, were trained as natural historians before turning to art writing. Although these authors are usually seen as positing theories diametrically opposed to each other, both take the observational sciences as the basis for their aesthetic arguments.

The Victorian fascination with visual form, while partaking of disinterested and detached modes of judgment, was not in itself a model of disinterestedness. In fact, all of the authors discussed here had some kind of agenda in promoting their aesthetic principles. New mid-century art professionals, for example, espoused a detached view of classical form as a way to cement their emergent professional expertise. While recent criticism has often insisted that claims for autonomous aesthetics have a definite politics, either heroically good or hegemonically bad, my analysis suggests that aesthetic values cannot be simplified into distinct moral categories.[23] Many of our contemporary alignments between aesthetics and politics matched up differently for the Victorians. The formalist aesthetic, portrayed by some recent scholarship as a despotic modernist ideology supporting the interests of cultural elites, is seen here to be embraced by socialist activists, sexual dissidents, and even by anti-imperial Indian and Japanese writers who claimed it as the basis for their own cultural nationalist movements. What emerges is the sheer plasticity of aesthetic ideologies, their capability to be adapted to the interests of many different groups and politics.

Visual formalism, at the most basic level, might be described as an aesthetic judgment or style emphasizing elements of shape, color, line, facture, or composition, as opposed to qualities of narrative, morality, politics, or social distinction.[24] In art historical accounts, a formalist style first emerged—especially in the paintings of Cézanne—as the stretching or flattening of the canvas's realist fabric, challenging and eventually destroying the illusion of three-dimensional space that had defined canons of Western art since the Renaissance.[25] This visual experimentation, often considered part of a broader modernist "crisis of representation," was aligned with a neo-Kantian philosophy in which art's only function was to exist in and of itself, expressing immanently the rules by which it was to be judged. The Kantian phrase "the autonomy of art" captures the way that modern art's value was meant to emerge apart from established conventions

and social codes, asserting, in Pierre Bourdieu's terms, "the irreducibility of pic-
torial work to any kind of discourse."[26] In the twentieth century the autonomy
of art came to be embodied by an abstract or "nonobjective" art, though some
art historians have challenged this formalist emphasis for privileging cubism and
abstract art over other movements like dada and surrealism.[27] The literary arts of
modernism never moved to such a radical effacement of mimesis, partly because
of their own linguistic medium. Formalism in literature speaks more to experi-
mental language games and a self-consciousness about artmaking. Yet modern-
ist authors were highly influenced by the example of experimental visual arts
and often used them to symbolize their own literary endeavors—perhaps most
famously in Virginia Woolf's *To the Lighthouse* (1927), when Lily Briscoe's post-
impressionist painting mirrors the shape of the novel itself.

Spiraling out from the somewhat simplistic contrast between content and
form or between realism and abstraction, scholars have discerned all the com-
plex history of art's complicity with, or rebellion against, the dominant values of
Western culture. In other words, the innovative styles of modernist art came to
be associated with broader kinds of cultural rebellion, as captured in the political
roots of the term "avant-garde."[28] In the case of the Victorians, modern scholar-
ship has pursued questions of aesthetic form and ideology most predominantly
not in the study of the visual arts but in the exhaustive theorizing of the real-
ist novel.[29] For the Victorians themselves, however, aesthetic debates about art's
responsibilities to mainstream values were rehearsed around a range of genres,
including, and especially, the visual arts. The terms of my study span the worlds
of both literature and art history, presenting formalism as a Victorian argument
with both visual and verbal dimensions, sometimes in contradictory relation to
each other. Walter Pater advocated for visual formalism using a deliberate, finely
worked prose, but John Ruskin outlined his austere vision of natural form in
the early volumes of *Modern Painters* using an expansive linguistic style that often
clashed with his more stern, unyielding claims about nature.

While proposing that literary and visual formalism have a shared history, this
analysis will ultimately suggest that the idea of an autonomous aesthetic does not
deal equally with words and images. The canons of aesthetic philosophy would
already seem to confirm this conclusion. In the *Critique of Judgment,* Kant's exam-
ples of a formalist aesthetic are all visual, ranging from flowers to architectural
ornaments. Richard Rorty writes that he suspects Kant's "purely aesthetic value"
is more "plausible" for visual arts than for literature.[30] Philosopher John Dewey
attacked traditional aesthetic theory for its unspoken privileging of the visual
arts and its bias toward spectatorship.[31] In the emergence of modern aesthetics,
the visual arts gained an aura of purity that language could not equally achieve.
Ruskin, for example, describes a fantasy of pure visual aesthetics in a passage
from *Modern Painters I* (1843) praising the colors of J. M. W. Turner's paintings.

Turner, writes Ruskin, "went to the cataract for its iris, to the conflagration for its flames, asked of the sea its intensest azure, of the sky its clearest gold."[32] Turner's paintings distill and heighten the sublime effects of nature into an extreme sensory experience, offering the fantasy of a nonlinguistic, unmediated, purely corporeal encounter with color. Art here creates an idyll allowing for an escape from the impurities of modernity—one can almost hear Manchester's furnaces roaring in the background. It is ironic, of course, that the aesthetic idea, with its bias toward the visual, was itself constructed by the language of critics and philosophers. Ruskin's idyll of colors gains its intensity from the poetic connotations of waterfall, fire, sea, and sky. As this book will show, even while modernist aesthetic theory moved toward abstraction and anti-figuration as the most sublime and unmediated styles of art—styles that defined themselves against narrative or linguistic meanings—that theory was scripted by the written words of powerful, taste-making critics and connoisseurs.

The Rise of Art Writing

The scene of art spectatorship was depicted frequently in a range of nineteenth-century artworks, both visual and verbal, attesting to the great significance many Victorians attached to art response. In the visual arts, paintings depicted families gathered in the museum, marveling at touching images on display, while cartoons satirized aesthetes in galleries dropping pretentious remarks on the latest visual fashions (figure I.1).

These scenes also appeared prominently in Victorian novels, as authors revealed important truths about a character by showing her or his attitude toward a visual artwork. Though Jane Eyre is born into humble circumstances, her true nobility in Charlotte Brontë's novel is revealed by her ability to draw; her pictures are the most arresting symbols in the book, and Rochester's appreciation of them a sure sign that the two lovers share an elevated emotional sensibility. Victorian poetry, too, embraced the trope of the visual arts, featuring artists as speakers in dramatic monologues (in Robert Browning's "painter poems") or creating ekphrastic sonnets on the subject of famous paintings. The ubiquity of art spectatorship in Victorian fiction and poetry highlights its importance as a linguistic act, demonstrating that art writing itself—the act of putting images into words—functioned as a definitive sign of class and character. The language of art worked to establish crucial sensibilities of self and society for the Victorians.[33]

The history of art writing stretches all the way back to antiquity, but the Victorian textual interest in the visual arts had its most direct antecedents in the exclusive British art milieu of the previous century. Most eighteenth-century

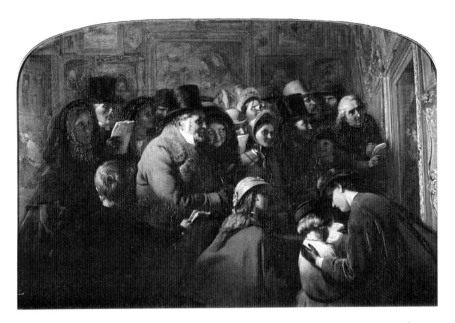

FIGURE I.1 George Bernard O'Neill (1828–1917), *Public Opinion*. Oil on canvas, c. 1863. Credit: © Leeds Museums and Galleries (City Art Gallery) U.K. / The Bridgeman Art Library.

artworks were closeted away in the private galleries of aristocratic collectors, open only to genteel visitors who could procure invitations and afford the exorbitant touring fees.[34] Art writing was largely penned by and for this privileged class, usually taking the form of aesthetic treatises seeking to situate art appreciation within a universalized, philosophical framework. Joshua Reynolds' *Discourses on Art* (1769–90) canonized the "Grand Style" in painting, eschewing particular details of time and place for a more generalized idea of "beauty or truth, which is formed on the uniform, eternal and immutable laws of nature."[35] These laws were best discovered through the study of past art, especially antique statues and old master Italian paintings. The Grand Style accorded with a hierarchy of genres crowned by history paintings, featuring vast scenes of sweeping historical or mythical significance. Reynolds himself wrote the *Discourses* while serving as president of the Royal Academy, chartered in 1768 to promote "the prestige of the nation in its most abstract embodiment."[36] The conservatism of the monarchical institution was reflected in Reynolds' tradition-laden theory, by which painting could only be valued for its invocation of a received body of myths, stories, or styles. Eighteenth-century art theory (and reality) thus favored an elite group of tasteful gentlemen—what Kant in Prussia named the *sensus communis*—whose best selves were mirrored back to them in history paintings as heroic, public personas engaged in major projects of nation-building.[37]

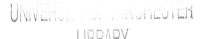

The eighteenth-century public discourse of art was fractured both by the reality of the art market, which favored smaller genre pictures and portraits over grand history paintings, and by the growing emphasis on private values and personal judgment associated with the practice of "virtuous" capitalism in the later eighteenth century.[38] In a related development, the aesthetic treatise was gradually replaced by art criticism in periodicals as the dominant genre of British art writing. Art historian Andrew Hemingway suggests that the shift away from aesthetic treatises coincided with the emergence of a new kind of imagined audience, as the ideal type of the country gentleman with an estate collection was replaced by a more urban, bourgeois reader of art criticism.[39] Yet periodical criticism did not necessarily embrace a bourgeois, nascently liberal perspective in opposition to the more genteel aesthetic treatise. Most of the reviews and articles of the early nineteenth century invoked the treatises of the earlier age, and many of them espoused a conservative politics in the art world. Periodical art criticism usually reflected the politics of the journal where it appeared, and debates about art were rehearsed from within these broader political viewpoints.

While art criticism began to appear with increasing regularity in periodicals of the early nineteenth century, the art-viewing opportunities for most people were generally scarce. Romantic visual culture was sharply divided between the high-art realm of the Academy and private estates, and the mass-culture realm of new visual entertainments like the panorama, diorama, and cyclorama.[40] In London, Rudolph Ackermann sold paintings, prints, and books to the fashionable elite at his Repository of the Arts shop, which also hosted weekly salon-style *conversazioni* during the London season (figure I.2).[41] The essayist William Hazlitt captured the elite aesthetic milieu when he declared that "Taste is . . . the impression made on the most cultivated and sensible minds."[42] Hazlitt's writings helped to originate the alluring figure of the Romantic artist, a genius who worked apart from (and in opposition to) the demands of a clamorous public. Like many of the writers who helped to create this mythic figure, Hazlitt held progressive political views while at the same time scripting the emergence of an exquisite aesthetic sensibility that trumped mere common taste.[43]

Romantic art institutions generally favored members of society's upper echelons; both the Royal Academy and the British Institution, founded as a rival display space in 1805, charged an entrance fee at their exhibitions. The British Museum demanded that would-be visitors enter their name and social standing into a book in order to apply for tickets for admission, which then took months to arrive.[44] A sign of change came with the opening of the National Gallery in 1824, when the State purchased the art collection bequeathed by John Julius Angerstein, a Russian-born shipping insurance magnate of Jewish descent. Art was finally

FIGURE I. 2 Augustus Pugin and Thomas Rowlandson, *Ackermann's Repository of the Arts, 101 Strand*. Hand-colored aquatint. *Repository of the Arts*, vol. 1 (January 1809): 52. Reproduced with the permission of Rare Books and Manuscripts, Special Collections, the Pennsylvania State University Libraries.

available to be viewed freely by the British public. When the gallery moved to much larger quarters at Trafalgar Square in 1838—a result of the reform-minded politics of the 1830s—attendance jumped from numbers of below one hundred thousand visitors per year to between four hundred thousand and eight hundred thousand per year, and included members of all British classes.[45] It is no coincidence that John Eagles pinpoints the 1840s as the moment when "there began to be a great talking about the Fine Arts."[46]

"For the first time in England," writes one historian, speaking of the 1840s, "it was possible to make a living by writing about art."[47] No longer simply an aristocratic entertainment to be covered alongside other gossipy or newsworthy items, visual art was beginning to occupy its own privileged place among the discourses of periodical criticism aimed at the middle class.[48] By 1830, the greatest audience was reached not by books but by articles published in magazines and newspapers.[49] Already by 1839, an article on "The Influence of Periodical Literature on the State of the Fine Arts" could suggest that the power of the art press was "generally admitted to be one of the most striking characteristics of our times," supplying a "gradual but irresistible force in producing and modifying our feelings and opinions."[50] The *Art Journal*, founded in 1839, began with a circulation of 700; ten years later, according to the editor, the number was up to 15,000, and by 1851 an impressive circulation of 25,000 had been achieved.[51] The rising power of the art press within the art world mirrored the broader phenomena of Victorian periodical expansion and influence.[52]

Art writing thus emerged as part of the broader democratization of culture in the nineteenth century, a shift rooted in the radical economic and industrial developments that transformed British social life. Raymond Williams argues in *Culture and Society* that Britain's fraught history as a cauldron for the industrial world led to a new, special pressure on categories like "culture," "art" and "artist"—a force that only intensified into the later nineteenth century.[53] The spectacular emergence of capitalism and empire in Britain produced a cultural power most evident in acts of consumption, ranging from museum spectatorship, to art patronage, to the writing of art criticism. Though the government was sluggish to patronize native artists, the British were some of the leading Western art consumers, especially as the influx of industrial cash created a new class of purchasers eager to build up cultural capital.[54] Henry James, describing "The Picture Season in London" for American readers in 1877, captures a sense of the luxurious offerings on view during the fashionable season. Noting the fleet of sandwich-board men advertising exhibitions of the various arts of "modern Germany, medieval Florence, and ancient Athens," James marvels,

You are not among the greatest artistic producers of the world, but you are among the greatest consumers. The supply is for the most part foreign, but the demand is extremely domestic.... [I]f art is a fashion in England, at least it is a great fashion...; what handsome things they [the English] have collected about them; in the absence of production, on what a scale the consumption has always gone on! A great multiplicity of exhibitions is, I take it, a growth of our own day—a result of that democratization of all tastes and fashions which marks our glorious period. But the English have always bought pictures in quantities, and they certainly have often had the artistic intelligence to buy good ones. In England it has not been the sovereigns who have purchased, or the generals who have 'lifted,' and London accordingly boasts of no national collection equal to the gallery at Dresden or at the Louvre. But English gentlemen have bought—with English bank notes—profusely, unremittingly, splendidly.... These exhibitions give a great impression of the standing art-wealth of Great Britain, and of the fact that, whether or no the English people have painted, the rest of the world has painted for them.[55]

James's jealous admiration of magnificent English art collections is tinged with an ironic note at the unabashed display of wealth. His remarks capture the contradictory mixture of elite fashion and democratization that characterized the late-Victorian cultural scene. He also aptly observes Britain's consumerist relation to the rest of the world, especially in the nation's collection of old master artworks (and sometimes forgeries) purchased from European aristocrats forced to sell on

the international market. The substantial art patronage of a growing British mer-
chant class accompanied other phenomena of cultural capital amassment, such as
Grand Tours in Italy and France, the rise of the guidebook, handbook, and tour
book, and the increasingly urgent sense that modern British citizens needed to be
literate in the visual arts. The cultural forces of British industry ultimately led to
the creation of the quintessential aesthetic spectators, a nation of beholders and a
multitude of critics, both amateur and professional.

The critical essay thus developed as a preeminent genre for shaping the taste
of middle-class readers. Matthew Arnold makes a famous claim for critics in "The
Function of Criticism at the Present Time" (1864), shifting cultural clout away
from the creative makers to the critical writers as the ones most empowered to
bring about political change. Oscar Wilde's "The Critic as Artist" (1890) takes
Arnold's reorientation to an extreme, arguing that the highest criticism is indeed
"the record of one's own soul." Wilde looks all the way back to Ruskin's *Mod-
ern Painters* (1843–60) as a foundational example of his aesthetic model—ask-
ing, with a typical Wildean desire to outrage, "Who cares whether Mr. Ruskin's
views on Turner are sound or not? What does it matter? That mighty and majestic
prose of his, so fervid and so fiery-coloured in its noble eloquence . . . is at least
as great a work of art as any of those wonderful sunsets that bleach or rot on
their corrupted canvases in England's Gallery."[56] Though Arnold and Wilde see
criticism accomplishing very different ends, both presume that the genre itself
speaks profoundly to the conditions of their own Victorian modernity. English
national self-identification with a critical eye—a "nation of critics," as one writer
opined—coincided with other nationalist rhetorics, combining a lucid, rational,
and imperial kind of looking with a more subjective, Romantic, and deeply felt
response to art.[57]

By assimilating art writing into a history of Victorian criticism, this book
presents an expansive and diverse body of prose devoted to the visual arts. More
than simply "word painting," as Victorians described the artful phrasings of John
Ruskin and Walter Pater, art writing functioned as part of a broader literary phe-
nomenon that stretched back to the eighteenth century, in which popularizers
and reviewers disseminated increasingly specialized bodies of knowledge for a
lay audience in a common language.[58] Art specialists produced texts for middle-
class audiences in a variety of new professional roles—as bureaucrats in museums
and galleries, as newly appointed professors of fine arts at Oxford and Cam-
bridge, as art dealers or late-century connoisseurs, and, not least importantly, as
professional art critics in Victorian periodicals.[59]

There is perhaps something incongruous in the idea that lesser-known or
anonymous Victorian art writers might have contributed to vaunted twentieth-
century philosophies of aesthetics. Yet art criticism is divided from aesthetic
discourse by means of a deeply ingrained ideology. For much of the twentieth

century, "aesthetics" has described the sublime, atemporal encounter of a phi-
osophical critic with a pedestaled artwork, producing a literature theorizing
abstract principles for the consumption of intellectuals and art elites. Art criti-
cism, by contrast, has connoted the monthly magazine or weekly newspaper,
bourgeois readership, middlebrow culture, event-driven commentary, and,
eventually, stale news. In the publication history of famous Victorian art writers,
the iconic essays of Ruskin, Pater, Morris, and Wilde have been readily available
in volumes of collected works—obscuring the extent to which these writers
were responding to contemporary controversies and debates. In fact, all of these
writers published essays on art in Victorian periodicals. Literary canonization
itself—with its promise of an enduring worth exceeding the text's moment of
production—creates an amnesiac envelope around the aesthetic essay, making it
seem to speak more timelessly than it did in its original context. Although many
Victorian art writers contributed to the rise of the aesthetic idea as a private, sub-
jective, autonomous, and quasi-religious response to visual form, *The Literate Eye*
will show how these values actually arose from very public, contingent debates at
specific moments in Victorian cultural history.

Cultures of Word and Image

The Victorian experience of art was shaped by a flurry of accompanying captions,
poems, guidebooks, and other linguistic signs, producing a wholesale entwining of
writing and seeing. Jonah Siegel has written, in his book on the nineteenth-century
culture of art, that the Victorian museum-going experience was "scripted," over-
laid with textual expectations and directions, in a way that the modern museum
experience is not.[60] The act of looking at art was not a disembodied Gaze of
power but a scripted, linguistic, culturally conditioned experience. In this book,
I argue that the scripts of art writing were not merely incidental to spectatorship,
but in fact worked to construct the Victorian art experience. The value of visual
arts was (and is) determined not merely by intrinsic aesthetic qualities, but by a
host of extrinsic factors, the most significant of which was the language used to
characterize the arts—a language that, in the nineteenth century, often had little
to do with the actual image itself, and was at times unrecognizable in connection
with the art it was meant to describe.

The idea that our visual judgments might be dependent on linguistic con-
structions defies a long-standing tradition pitting the visual and verbal media
against each other, seeing them as locked in a bitter rivalry for the title of great-
est expressiveness. Finding the "sister arts" to be reducible to some elemental,
essential qualities is an idea as old as 1435, when Alberti, in *De Pictura*, coined
the notion of a *paragone* as the comparison between art forms. Gotthold Ephraim

Lessing famously contrasted the two media in his 1766 treatise *Laocoön,* praising poetry for its ability to move through time, while disparaging painting for its static, spatial fixity. Yet, as W. J. T. Mitchell has shown, the two media are not quite as distinct as some theorists have presented them; painting and poetry both share spatial and temporal qualities. Indeed, the distinctions drawn between the media are often most revealing of the author's own prejudices—as when Lessing disdains paintings by giving them qualities associated with women, and the French.[61] For the Marxist sociologist Pierre Bourdieu, there was a special alliance between word and image in nineteenth-century France that helped to transform the visual art object into a sublime commodity:

> As long as painting is measured by surface units and duration of production, by the quantity and price of the materials used (gold or ultramarine), the artist-painter is not radically different from a house painter. That is why, among all the inventions which accompany the field of production, one of the most significant is probably the elaboration of an artistic language. This involves first establishing a way of naming painters, of speaking about them and about the nature of their work as well as the mode of remuneration for their work, through which is established an autonomous definition of properly artistic value irreducible to the strictly economic value and also a way of speaking about painting itself, of pictorial techniques, using appropriate words ... which enable one to speak of pictorial art.[62]

Bourdieu's thought experiment contrasting art painting with house painting highlights the way that art gains an almost miraculous aura exceeding its own material existence. For Bourdieu, it is the invention of an "artistic language" that has most significantly imbued this magical quality. Ironically enough, the artistic language of the nineteenth century proposes an "autonomous definition of properly artistic value," even while that autonomy is created by something outside of the work itself—the writing, not the art.

The fusion of writing and seeing in the nineteenth century occurred not merely in texts targeted to educated elites. Art spectatorship was a matter of national pride and political urgency for all classes; hence the widely read comic magazine *Punch* relentlessly parodied the art world, while the popular *Penny Magazine* ran weekly articles teaching art history to working-class readers. From 1843 to 1845, the *Penny Magazine* ran a series of essays by Anna Jameson, likely the first professional art historian, later reprinted as *Memoirs of the Early Italian Painters* (1845).[63] Each essay focused on the biography and standard works of a single Renaissance painter and was accompanied by engraved illustrations of the major artworks (figure I.3).

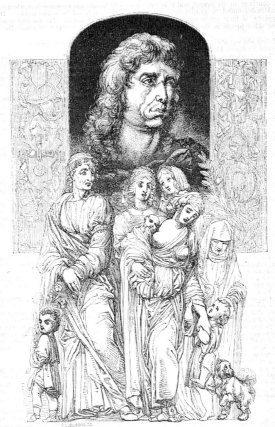

[Andrea Mantegna, with a Group from his Triumphs of Julius Cæsar.]

ESSAYS ON THE LIVES OF REMARKABLE PAINTERS.—No. XVII.

ANDREA MANTEGNA : b. 1430, d. 1506.

For a while we must leave beautiful Florence and her painters, who were striving after perfection by imitating what they saw in nature—the common appearances of the objects, animate and inanimate, around them—and turn to another part of Italy, where there arose a man of genius who pursued a wholly different course ; at least he started from a different point ; and who exercised for a time a great influence on all the painters of Italy, including those of Florence. This was Andrea Mantegna, particularly interesting to English readers, as his most celebrated work, the Triumph of Julius Cæsar, is now preserved in the palace of Hampton Court, and has formed part of the royal collection ever since the days of Charles I.

Andrea Mantegna was the son of very poor and obscure parents, and born near Padua in 1430.* All we learn of his early childhood amounts to this,—that he was employed in keeping sheep, and being conducted to the city, entered, we know not by what chance, the school of Francesco Squarcione.

About the middle of this century, from which time we date the revival of letters in Europe, the study of the Greek language and a taste for the works of the classical authors had become more and more diffused

* The date of Mantegna's birth and death were long subjects of uncertainty and controversy. According to some authors he was born in 1451, and died in 1517 ; but the best and latest authorities are now agreed upon the dates as given in the text.

No. 742.

FIGURE I.3 Anna Jameson, "Essays on the Lives of Remarkable Painters—No. XVII. Andrea Mantegna," *The Penny Magazine*, October 21, 1843. The Pennsylvania State University Library.

With their straightforward tone and minimal jargon, these essays embodied the idea prevalent in the 1830s and '40s that a knowledge of art history could be useful to common people. This ideology was consonant with the writings that filled the reports to Parliament in the 1830s on the state of the fine arts in Britain, and which led to the relocation of the National Gallery to more democratic quarters at Trafalgar Square. For Jameson, the dissemination of fine arts knowledge to an ignorant public was entirely compatible with the rise of a democratic print culture, as she notes in an 1843 essay on Mantegna:

> In these days, when we cannot walk through the streets even of a third-rate town without passing shops filled with engravings and prints; when not our books only, but the newspapers that lie on our tables, are illustrated; when the *Penny Magazine* can place a little print after Mantegna at once before the eyes of fifty thousand readers; when every beautiful work of art as it appears is multiplied and diffused by hundreds and thousands of copies; when the talk is rife of wondrous inventions by which such copies shall reproduce themselves to infinitude, without change or deterioration, we find it difficult to throw our imagination back to a time when such things were not...What printing did for literature, engraving on wood and copper has done for painting.[64]

Jameson celebrates the mass reproduction of visual images, in both prints and photographs, as a kind of democratic victory for aesthetics. Even "third-rate towns" are strewn with pictures. Her comments point to the double valence of the visual literacy espoused by the *Penny Magazine*, aiming to tutor the audience in both the canon of art history and in an ability to interpret visual reproductions as "beautiful."

Jameson alludes to a major development that revolutionized the production of images during her lifetime. Victorian art writing flourished in the midst of significant historical changes in visual culture more generally. Scholars of nineteenth-century Britain have described a "pictorial turn," in which new media technologies produced a deluge of etchings, photographs, lithographs, and other heretofore unknown visual reproductions.[65] "The second half of the nineteenth century lives in a sort of frenzy of the visible," Jean-Louis Comolli writes of this phenomenon.[66] Yet as W. J. T. Mitchell warns, "to live in any culture whatsoever is to live in a visual culture"; the portrayal of Western modernity as "more visual" than other times or cultures is "a received idea which never fails to stir the ire of those who study non-Western and nonmodern visual cultures."[67] More specifically, then, Victorian visual culture was the product of capitalism as it was practiced in Britain following the Industrial Revolution. In an attempt to market new goods and services, print culture was enlisted to create images and spectacles that

would entice viewers to buy. Rapid developments in new technologies of visual reproduction and display were propelled by the demands of bourgeois commodity culture. Entrepreneurs used new discoveries about materials and construction to create ever more impressive (and lucrative) visual spectacles, ranging in scale from handheld stereoscopes to city-sized world exhibitions.

These shifts in Victorian visual culture had a direct impact on the formulations of art writing. The flood of reproducible images enabled by new media technologies—photographs, illustrations, advertisements, cartoons, signs, or prints—had to be distinguished from the fine arts like paintings, sculpture, and certain kinds of architecture. High Art was posited as a relief from vulgar mass-culture visuality. Machine production extended beyond printed images to the manufacture of design objects more generally. Wedgwood's mass-produced china plates of the late eighteenth century ushered in the "birth of consumer society," a process that gathered steam quite literally into the nineteenth century.[68] At the Great Exhibition of 1851, organizers tried to unite the worlds of arts and manufactures— an increasingly daunting project, given the cultural pressures separating the two kinds of object production. New visual cultures necessitated that viewers discriminate in the visual field and hierarchize certain kinds of visual experiences.[69] Art writing can thus be seen as both a product of and reaction against the new kinds of visual culture invented in the nineteenth century. If prints reproduced in *The Illustrated London News* could be viewed at any newsstand, a painting could only be seen by making a special trip to an imposing, temple-like building—an exquisite temporal experience whose aura art writing helped to construct. Likewise, if advertisements used images as instruments for the sale of goods, then one value in art writing was to emphasize high art as a limpidly disinterested version of "the beautiful." Despite the Victorian reputation for moral didacticism in art judgments, market forces encouraged an opposite kind of aesthetic perception, separate from any apparent goal or lesson. The tension between these different kinds of art interpretations is a recurring theme in this book.

Methods and Trajectory

In its methods, *The Literate Eye* actually combines two types of analytical approach. Some of the chapters offer in-depth readings of familiar figures, while others provide more cultural-studies surveys of noncanonical authors. My choices in all of these chapters are inevitably inadequate, as it would be impossible to include in a single book all of the important texts and histories of nineteenth-century art writing.[70] Yet my dual method, moving between canonical and noncanonical authors, and between text and context, might also serve as an implicitly revisionist model for the working of intellectual history. Traditional approaches shine a

spotlight on canonical figures as the most representative thinkers of their time. By contrast, my method suggests that intellectual movements gain currency through a variegated ferment of opinions, penned by both famous minds and lesser-known contributors, all of whom influence and are influenced by broader cultural developments. The book thus presents a more expansive account of intellectual trends, even while acknowledging that certain well-known figures did have a disproportionally greater impact on their moment.

The Literate Eye cannot, then, be strictly categorized as cultural or intellectual history, but is some amalgamation of both. The juxtaposition here of high art, middlebrow culture, and popular culture serves as a challenge to recent arguments in the academy about the political valences attending elite versus popular arts. Ian Hunter has influentially framed the terms of the debate as a clash between "the aesthetic" versus "cultural studies," where aesthetic ideology—understood as high-art, bourgeois codes of value—compares unfavorably with cultural-studies objects or practices, which connote everyday life, authenticity, and "the people."[71] *The Literate Eye* is necessarily positioned between these two kinds of thinking, since it examines an historical era when the distinctions between high art and popular culture were less easy to draw, and when the fine arts were considered important subjects for all classes of British society. Even while I analyze canonical essays on aesthetics, I adopt the cultural studies notion that aesthetic value is constructed by cultural factors rather than inhering in an artwork. My analysis is consonant with the assessment of John Frow: "No object, no text, no cultural practice has an intrinsic or necessary meaning or value or function; and . . . meaning, value and function are always the effect of specific (and changing, changeable) social relations and mechanisms of signification."[72]

While *The Literate Eye* focuses on the Victorian art world and its critics, this book is ultimately not a work of art history, a fact that will likely frustrate certain readers. The book deliberately focuses on linguistic constructions of art, often to the exclusion of visual analysis. An underlying thread of argument inheres in this perhaps obtuse approach, namely, that certain cruxes in Victorian aesthetic history cannot be solved by art-historical means. For instance, as I explore in chapters 1 and 2, John Ruskin promotes the paintings of both Turner and the Pre-Raphaelites, even though these works feature almost opposite visual styles. In my argument, Ruskin's reasons emerge not from a visual truth discernible within the artworks themselves, but from his own unique intellectual and ideological allegiances. His contradictory preferences can better be explained by analyzing his writings within the contexts of the 1840s and 1850s, rather than by seeking some kernel of similarity between the paintings. Instead of presenting my own visual analyses, then, most often I supply the interpretive moves of Victorians themselves. My aim is to historicize aesthetic judgments rather than to revise current art-historical evaluations.

The strongly teleological shape of this book, moving as it does from early Victorianism to a concluding chapter in 1910, might give the impression that the Victorian debates I examine produced a momentum hurtling toward a definitive modernist endpoint, culminating in the naissance of a glittering and highly canonical aesthetic theory. My goal, however, is not to reveal that most Victorians were actually modernists in disguise. This book at its heart seeks to illuminate the prismatic complexity of Victorian aesthetics, of which Roger Fry's formalist theory ultimately seems an apt and famous extension. While each chapter alludes to certain intellectual or cultural trends in modernism, I do not mean to suggest that Victorian writers are valuable only insofar as they produced or influenced later modernist artists or styles. "Modernism" in all its fully fledged aesthetic miscellany is less my focus than the Victorian cultural history that initiated certain formalist values, judgments, and styles. These were only retrospectively cordoned off as concerns of the twentieth century.

A final point to address is the tricky relationship between Victorian aesthetics and the broader European histories of modernism, which are usually traced through nineteenth-century France. Victorian art culture is generally known for its insularity from Continental movements, though recent scholarship has highlighted cross-Channel exchanges.[73] I would argue that the greatest European influence of Victorian art culture was felt not in the nineteenth century but in the twentieth, when modernism took an international turn, and modernist art critics like Roger Fry and Clive Bell scripted a formalist aesthetic with powerful influence on both the Continent and America. This book goes toward showing how Fry and Bell were extending values already established in the nineteenth century; thus the global turn in British modernism can be seen to have a Victorian influence behind it. In other words, a multi-stranded, internationalist modernism has an unaccounted strand emerging from Victorian culture.

The Literate Eye pursues a trajectory of controversial moments in British art writing from 1840 to 1910. Chapter 1 focuses on the early writings of John Ruskin, especially the first two volumes of his seminal *Modern Painters* (1843, 1846), to explore how the 1830s and 1840s inaugurate a "long modernism" of the nineteenth century. Though Ruskin was reduced by later critics to a self-righteous moralizer, I examine the profound influence of science on his work to show how he also argues for the necessity of visual detachment, and arrives at a surprising claim for the superiority of "the modern," particularly in his defense of the vibrant and controversial modern paintings of J. M. W. Turner. The chapter surveys a range of contexts, from photography to the post-picturesque, to narrate a dramatic clash between differing scientific models of nature, as eighteenth-century natural histories were giving way to more modern theories of mind and vision.

The second chapter examines the commentary of both experts and amateurs on the fine arts at the 1851 Great Exhibition, a spectacular display often referred to as the first World's Fair. I analyze two conflicting interpretive modes proposed by art writers opining on the most controversial exhibits. While writers for a popular audience interpreted images on a literal level, attacking what they perceived to be scandalous nude sculptures and idolatrous Catholic icons, Exhibition experts proposed a more detached, aesthetic attitude, which judged objects by their forms or styles. Art experts—professionals who would become administrators in new public art institutions like the National Gallery and the South Kensington Museum—cemented their emergent professional identity by promoting a Western, rational vision to oppose what they saw as a more "Eastern" or fetishistic attachment to art. I also show how contemporary Pre-Raphaelite paintings confounded the expectations of both groups, troubling the views of both amateurs and experts.

The next two chapters move into later moments in the nineteenth century, when visual form is adopted as the basis for a politicized idea of aesthetic utopia. Chapter 3 analyzes the contexts of the British Aesthetic movement by focusing on the writings of the movement's most famous theorist, Walter Pater. Aestheticism has often been portrayed as an apolitical cult of art devoted to "art for art's sake," especially through Pater's elusive writings, which seem to dwell exclusively on the past. Yet the chapter contextualizes Pater's formalist aesthetic against the controversial 1877 opening of the Grosvenor Gallery, where Whistler's "Nocturnes" and "Symphonies" were inspiring indignant reviews from other art critics. The chapter traces how an esoteric art philosophy transformed in the later 1870s and 1880s into a fashionable vogue, a way of life that both opposed bourgeois norms and depended upon them for its propagation. Though Pater has most often been seen as a proponent of liberal individualism, the chapter reveals his increasing investment in radical collective cultures that were prototypes for a Victorian avant-garde.

Chapter 4 follows the theme of aesthetic utopianism into the fin de siècle, analyzing progressive or socialist writers who adopted what I call a "biological aesthetics" to imagine social change. The chapter analyzes writings that blended art and biology in discussions of pattern, form, and design. Following Darwin, a variety of late-Victorian progressive thinkers made the designs of decorative ornament—on objects ranging from carpets to wallpapers—into an analogy for the futuristic society they hoped would evolve accordingly. The chapter finds a common thread of biological aesthetics in the popular science writings of Grant Allen and John Ruskin, in the Arts and Crafts theories of William Morris and Walter Crane, and—surprisingly—in the decadent literary works of J.-K. Huysmans and Oscar Wilde. All of these theorists use very Victorian metaphors to make literary arguments for what would emerge as a key modernist visual style.

In the final chapter, I move into the twentieth century to examine the most influential modernist art writer and famous promoter of a formalist aesthetic, Roger Fry. In 1910, Fry organized a controversial London exhibition of post-impressionist painters like Cézanne and Gauguin and wrote a series of celebrated essays defending their "primitive" new art styles. Though Fry is usually seen to have broken definitively with Victorianism, I show how his essays in fact showed a strong continuity with a certain Victorian worldview. Fry's defense of post-impressionism was produced concurrently with essays on African and Indian art, all of which are grounded in some of the common assumptions of late-Victorian anthropology. Both anthropology and aesthetic formalism proposed a universal common connector across primitive cultures, leading to the comparative method of peoples, artworks, artifacts, and visual forms. The abstracted images of French painters and British art critics still ranked higher on the culture scale than those created by "primitive" cultures, however, owing to Victorian-era prejudices that granted Western minds powers of will unavailable to non-Western artists.

The scientific tone of modernist critics served to entrench their formalist theories as the dominant aesthetic idea of the twentieth century, until postcolonial and postmodern critiques were leveled against them in the 1980s. The idea that a single, universal aesthetic value might define canons of beauty and worth has become increasingly untenable today, in line with the academy's philosophical turn toward more relativistic modes of intellectual approach. The assertion of relativism, however, only places a greater pressure on the discoveries of cultural history. As I will now explore, Victorian arguments for a myriad of aesthetic theories emerged from the concrete yet mutable conditions that shaped British culture across the nineteenth century.

Picturesque Signs, Picturing Science
Ruskin in the 1840s

How difficult it is to avoid substituting the sign for the thing; how difficult to keep the essential quality still living before us, and not to kill it with the word.

—Johann Wolfgang von Goethe, *Theory of Colours* (1810),
trans. C. L. Eastlake (1840)

I speak especially of the moment before the sun sinks...There is then no limit to the multitude, and no check to the intensity, of the hues assumed. The whole sky from zenith to the horizon becomes one molten mantling sea of colour and fire; every black bar turns into massy gold, every ripple and wave into unsullied shadowless crimson, and purple, and scarlet, and colours for which there are no words in the language, and no ideas in the mind, —things which can only be conceived while they are visible...Now there is no connection, no one link of association or resemblance, between those skies and the work of any mortal hand but Turner's.

—John Ruskin, *Modern Painters I* (1843)

A Long Modernism

John Ruskin's extreme personal qualities have made him an archetype of the Victorian man of letters. His high seriousness, religious conviction, extravagant prose style, and strong moral assertions are all canonized in a daunting collected works of thirty-nine volumes. Ruskin's reputation stands in particular on his writings promoting Gothic architecture, as encapsulated by his iconic chapter "The Nature of Gothic," appearing in the middle volume of *The Stones of Venice* (1853). Here he argues that the irregular shapes of Gothic cathedrals reflect the political freedom allowed to the medieval artisan, as opposed to the symmetrical shapes produced in Victorian workshops, where the workman is entirely "a slave."[1] This text would seem to cement Ruskin's status as an unabashed moralizer, valuing art not for any detached appreciation of beauty but instead for the alleged political rectitude of its producers. His reputation as a hectoring patriarch was cemented by the modernist generation that followed him; as D. H. Lawrence proposed in a letter, "the deep damnation of self-righteousness...lies thick all over the Ruskinite, like painted feathers on a skinny peacock."[2] In the classic 1932 study *The Victorian Morality of Art: An Analysis of Ruskin's Esthetic*, Henry Ladd

suggests that Ruskin's reputation suffered because he "invariably introduced a social, moral, or religious interest into the brilliant but dictatorial criticism of pictures."[3] Ruskin's name in the twentieth century had become a shorthand for the moral interpretation of art, opposed to more relativist, Kantian, or modernist modes of aesthetic judgment.[4]

Contemporary scholarship on Ruskin continues to pursue his aesthetic interests—or "interestedness"—as an unchallenged rule, focusing especially on those interests that anticipate the new moral concerns of the academy. These include Ruskin's principled anxieties about the environment, gender roles, and political economy.[5] In Amanda Anderson's important study of Victorian intellectual detachment, Ruskin appears as a key oppositional figure, his medievalist desire for a "unity of thought and action" construing "modern detachment . . . in negative terms: as debilitating alienation from organic forms of life; as a sickly privileging of rationality over creativity and spirituality; and as the baleful psychological effect of increasing materialism."[6] In Anderson's brief treatment, Ruskin shares with Thomas Carlyle and William Morris a profound antipathy toward modern innovations in detached and rational kinds of thinking. While not specifically addressed to aesthetics, Anderson's reading of Ruskin reveals the difficulty in trying to bring him into a history of more modern aesthetic ideas.

The problem is particularly vexed in the case of Ruskin's *Modern Painters,* his five-volume treatise on landscape painting (1843–60). Most readings have emphasized how Ruskin uses an aesthetic vision of nature to promote his religious beliefs, infusing his Evangelical faith into an appropriately spiritual theory of landscape painting.[7] Ruskin's faith in God and in a unified Nature is seen to express itself formally in *Modern Painters* through an organicism that produces a coherent theory of beauty across all five volumes. Though these volumes might seem like a work in progress, written over a space of seventeen years, a diverse array of scholarship reads *Modern Painters* as an organic whole.[8] These organicist readings are a logical outcome of Ruskin's traditional association with Romanticism, particularly with a Wordsworthian sanctification of the natural world.[9] Indeed, the epigraph to all five volumes of *Modern Painters* is a verse from Wordsworth's *Excursion*; the poem's speaker is quoted on Ruskin's frontispiece as "having walked with nature" and offers "my heart a daily sacrifice to Truth."

Yet in this chapter I will suggest that Ruskin's engagement with the natural world—and his invocation of natural "Truths"—is not the straightforward affair it might at first seem. Rather than seeking a coherent theory of beauty across all the volumes of *Modern Painters,* I focus on the first two volumes (1843, 1846) as distinct literary objects that speak specifically to the early-Victorian moment of their conception.[10] These concerns are far from organic or unified; already in 1844 the *Athenaeum* was complaining of "the inconsistencies promiscuously and plenteously scattered through the [first] volume."[11] The contradictions of *Modern*

Painters I and *II* are themselves eloquent, I will argue, speaking of a clash between competing models of nature and perception that defined the moment of their composition. In fact, these volumes reflect the tumultuous shifts taking place in early-Victorian science, when Enlightenment epistemologies of natural history were giving way to more flexible nineteenth-century ideas about vision, the body, and subjectivity. In the space between these two models of nature, I will suggest, a split emerges that is foundational in the history of Anglo-American aesthetics. As I rewrite the terms of "interest" and "faith" that have thus far constrained readings of Ruskin, his texts ultimately become the entry point into a new vision of the intellectual history of the 1830s and 1840s.

Ruskin's works spanned more than forty years, and over the course of time this changeable author adopted a bewildering array of positions on art and aesthetics. Perhaps most notably, his work took a distinctively social turn in the 1850s, as he began shaping his aesthetic theories around concerns of political economy and working-class activism. The change is evident in the publication history of *Modern Painters,* of which only two volumes appeared in 1843 and 1846 before Ruskin paused to write *The Seven Lamps of Architecture* (1849) and *The Stones of Venice* (1851–53). The final three volumes of *Modern Painters* appeared between 1856 and 1860, when Ruskin's views of nature, divinity, and human perception had radically altered. Rather than gesture toward a generalized "Ruskin," then, this chapter chooses to focus on a particular moment in his oeuvre, with his early writings of the 1840s—especially the ground-breaking work of *Modern Painters I.* Later chapters will address Ruskin's later writings as they came to reflect his new interests as well as the shifting cultural currents of the nineteenth century. As my argument will suggest, *Modern Painters I* is unique among Ruskin's works for its minute attention to landscape features, its influence by John Locke, and its engagement with eighteenth-century epistemologies of "picturing." *Modern Painters II,* which I discuss later in the chapter, was Ruskin's attempt to generalize rules for his theory of aesthetics—though this attempt was fraught with difficulty owing to his divided intellectual allegiances. Rather than attribute his patent contradictions to an undoubtedly idiosyncratic mind, I show how these competing currents pointed to the emergence of an unsettling aesthetic modernity, in which art was forced to respond to new epistemologies that threatened to dismantle older, universalist systems.

This chapter, then, takes the early volumes of *Modern Painters* as the platform for a wide-ranging reconceptualization of early-Victorian aesthetics. I examine a myriad of texts published around 1840, including exhibition reviews, early photographic manuals, treatises on human anatomy, optics, and psychology, even Goethe's *Theory of Colours,* first translated into English in 1840.[12] My analysis will suggest that the 1830s, something of a lost decade in literary studies, was in fact a key moment in the history of modern aesthetics. Similarly, though *Modern Painters I* and *II* are two of Ruskin's earliest publications, and appear relatively early in

the nineteenth century, I will argue that these texts show an unusual involvement with modernity. Despite clinging to eighteenth-century epistemological models, Ruskin in 1843 insistently promoted "modern painters" over the dominant old masters like Claude and Rosa. He was one of the first and most persuasive art writers to argue not only for contemporary painters but also for a certain modern sensibility. He lauds Turner because the artist's vision is new, his style progressive, and his associations fresh. This chapter, then, continues the work initiated by some recent scholarship in tying Ruskin to the later developments of modernism.[13] In my argument, Ruskin's oscillation between two models of seeing nature is a fluctuation that recurs throughout the nineteenth century. These models eventually appear, in different guises, in modernist theories of representation. If this book suggests that the uneasy overlap of Enlightenment and more modern epistemologies persists into the twentieth century, then we might call this particular historical moment the beginning of a "long modernism," which the following chapters will pursue.

The Turner Controversy

In the world of Victorian art criticism, the most controversial art works of the 1830s and 1840s were the landscape paintings of J. M. W. Turner. Compared with the realist, sharply detailed style of many mid-Victorian paintings, Turner's late works look like a strange experiment, swirling with quasi-abstract effects of light and color. Yet Turner seems an unlikely candidate for the Victorian avant-garde: unlike the Pre-Raphaelites, who formed the youthful, rebellious circle of artists opposed to the mainstream Royal Academy around 1850, Turner was an august and firmly established member of the art establishment. Elected to the Academy in 1802, he had been sending paintings to Academy exhibitions for thirty years, and consistently garnered praise from art reviewers in journals for his "poetic" depictions of nature.[14] He was the Academy's Professor of Perspective in 1812, and his financial well-being was secure. In the 1830s, he began to exaggerate certain visual effects that critics had sometimes observed in earlier works—eschewing fine details for a less finished look, playing up brilliant colors, and using paint to convey the effects of light across atmosphere and distance (figure 1.1).

These developments were not welcomed by the conservative establishment of Victorian art critics. By 1840, critics in the periodical press had established familiar tropes of Turner mockery. They routinely compared his paint to foodstuffs such as treacle, flour, and mustard; they implied he was part of a religious cult with Catholic leanings; they recommended that his pictures could be turned upside down for an equally pleasing effect; and they insinuated that his garish colors must be the result of diseased eyes. The novelist W. M. Thackeray, whose early

FIGURE 1.1 Joseph Mallord William Turner, *St Mark's Place, Venice: Juliet and her Nurse, engraved by George Hollis.* Line-engraving on paper, 1842. Tate Gallery, London. Photo credit: Tate, London / Art Resource, N.Y.

career also involved art criticism, accused Turner in 1839 of "mad exaggerations" of nature: "O ye gods! why will he not stick to copying her [nature's] majestical countenance, instead of daubing it with some absurd antics and fard of his own? Fancy pea-green skies, crimson-lake trees, and orange and purple grass . . . shake them well up, with a quantity of gambouge, and you will have an idea of a fancy picture by Turner."[15] An especially stinging criticism of Turner by John Eagles in *Blackwood's* magazine famously provoked Ruskin to write *Modern Painters* in Turner's defense. (Eagles writes that Turner's Venice is "thrown higgledy-piggledy together, streaked blue and pink, and thrown into a flour tub.")[16] Turner's critics presumed that the painter owes his public a legible image of nature, recognizable within the familiar conventions of the picturesque. Turner's own idiosyncratic eye, his "absurd antics," took his pictures outside of the conventions that governed the landscape tradition.

The unrelentingly negative press disparaging Turner's paintings in the late 1830s and early 1840s formed the immediate background for *Modern Painters I*. Though published as a book-length treatise, the volume still shares much with the contemporary periodical criticism it attacks, despite Ruskin's protestations to the contrary. "I do not consider myself as in any way addressing, or having to do with, the ordinary critics of the press," he writes in the 1844 preface to the

second edition. "Their writings are not the guide, but the expression, of public opinion" (3:16). Yet Ruskin's ostensible disdain for common critics and public opinion is belied by his insistence on responding to their arguments, beginning with the book's famous genesis as a response to Eagles's criticism. Ruskin takes his satirical, combative tone from the critics he attacks; like them, he too theorizes the proper relation between painting and the external world. His scornful response to Turner's enemies turns their own parodic terms against them:

> To appreciate the science of Turner's colour would require the study of a life, but to laugh at it requires little more than the knowledge that yoke of egg is yellow and spinage green; a fund of critical information on which the remarks of most of our leading periodicals have been of late years exclusively based. We shall, however, in spite of the sulphur and treacle criticisms of our Scotch connoisseurs, and the eggs and spinage of our English ones, endeavour to test the works of this great colourist by a knowledge of nature somewhat more extensive than is to be gained by an acquaintance, however familiar, with the apothecary's shop, or the dinner-table.
>
> (3:277)

If Turner's critics mock him for making paintings look like foodstuffs, Ruskin can mock them in turn for their own unsophisticated critical vocabulary, a discourse of mundane interiors rather than the true sublime and scientific site of landscape. (That sublimity is no doubt enhanced by the invocation of Byron, another poet who asserted truth against the attacks of "Scotch and English" reviewers.) In other words, Ruskin's choice of Turner as his battleground plants him squarely within the public debate; his *Modern Painters* is one long response to the art journalism of his time. It is easy to forget that many of the famous Victorian art treatises, which are often read in isolation today, were originally published in the periodical press. As art criticism became the ascendant mode of theorizing aesthetics for a general audience in the nineteenth century, it had both to court public opinion and to distance itself from the herd. The distinction Ruskin wants to draw between "expressing" public opinion and "guiding" it from above is a fluid line, especially as Ruskin was to become, in the years ahead, the very public voice he disdained. This ambivalence toward the public was especially pronounced in Ruskin's attempts to legislate new conventions of landscape painting. Given that Turner was so manifestly violating accustomed codes of the natural, Ruskin's defensive strategy seems highly unusual: according to Ruskin, Turner's swirling and almost abstract pictures are, in fact, visually true. I want to explore now some of the conventions governing early-Victorian representations of nature, in order to discover why Ruskin would launch such a counterintuitive argument.

Post-Picturesque: Landscapes in the 1830s

The volumes of *Modern Painters* address themselves to the specific genre of landscape painting. The books' subtitle promises, with typical Ruskinian overstatement, to prove the "Superiority" of modern painters "in the Art of Landscape Painting to all the Ancient Masters." Ruskin's critics have generally taken for granted his obsession with the natural world, owing to his well-known influence by the Romantic cult of nature.[17] But his choice of landscape painting as aesthetic battleground should not be seen as neutral or inevitable. To Ruskin's contemporaries, the defense of landscape would have been striking for its elevation of the picturesque over the venerable painting of historical scenes, reversing the eighteenth-century hierarchy of genres decreed by Reynolds' *Discourses*. The rise of landscape and genre-scene painting in the early nineteenth century is usually credited to the growing patronage of the middle class, who demanded smaller, less imposing pictures suitable for home decoration—"sublime, if you will," Thackeray proposed, "but only of a moderate-sized sublimity."[18]

In order to more fully understand what it means when Ruskin chooses landscape painting as the subject for his treatise in 1843, we need to consider the shifting valences attached to the picturesque, the English appreciation of natural scenes that came into vogue in the eighteenth century. I do not mean to describe here the whole convoluted history of this complex aesthetic phenomenon; I only want to suggest how the picturesque's long history created certain difficulties for Ruskin when he writes in its mode in the 1840s. In the first instance, the picturesque was an eighteenth-century desire to find or create natural scenes worthy of picturing. The natural world was subordinated to the spectator's orderly eye, which manipulated the scene—through Claude glass or creative painterly rearrangement—into an artificial and pleasing composition. Thus the banker Henry Hoare uprooted his estate at Stourhead Park, installing hills, lakes, grottos, and shrubbery, so that the only available prospects resembled famous landscape paintings by Claude.[19] In its earliest incarnations, the picturesque was an aesthetic of wealthy estate owners defending their right to luxuriously renovate their property by invoking universal aesthetic laws.[20] Landowners like Richard Payne Knight and Uvedale Price penned treatises in the 1790s that praised the careful wildness of rugged and irregular forms incorporated into the perfect garden.

At the same time, the Rev. William Gilpin was popularizing the picturesque aesthetic for more common readers and viewers. Accompanying the rise of domestic tourism in England, the new appreciators of landscapes did not own the property they admired; they toured through the estates of others, using Gilpin's books as guides to correct viewing. The titles of Gilpin's *Three Essays: On Picturesque Beauty; On Picturesque Travel; and On Sketching Landscape* (1792) describe a cluster of associated activities that defined the identity of a new spectator in nature. This spectator

was an amateur, a tourist, a sketcher: an itinerant viewer stalking a landscape and appropriating it aesthetically rather than financially. Richard Sha writes in *The Visual and Verbal Sketch in British Romanticism* that sketching "offered both a substitute for the act of materially possessing property itself as well as an easy and quick material record of that symbolic possession."[21] Thus the picturesque began to define a certain kind of identity associated with an aesthetic subject moving through a natural landscape. The Romantic modes of the picturesque hinged on two contradictory impulses: one was to create a true picture of nature, with all of the proper compositional elements of shade, light, and color; the other was to penetrate into nature in search of an authentic experience, distinct from the urban workaday world.[22] This paradoxical natural artifice was problematic for the theorizing of landscape paintings, which are fundamentally poetical fictions about scenes of nature.

All of these meanings of the picturesque had accrued by the early nineteenth century. By 1809 the picturesque tourist was cliché enough to be the subject of a parody by William Combe, *The Tour of Doctor Syntax in Search of the Picturesque*: "I'll prose it here, I'll verse it there / And picturesque it ev'ry where."[23] Marianne Dashwood complains in Austen's *Sense and Sensibility* (1811) that "admiration of landscape scenery is become a mere jargon . . . Sometimes I have kept my feelings to myself, because I could find no language to describe them in but what was worn and hackneyed out of all sense and meaning."[24] Marianne's ennui at the bankruptcy of picturesque terminology points to both its popularity and its resulting loss of authentic luster, a process that only accelerated into the 1830s. Though literary critics usually find that the picturesque aesthetic culminated in the nineteenth century with Romantic poetry, in fact the picturesque as a visual appreciation of nature persisted well into the later part of the century in the form of new prints and reproducible images available after 1820. In the 1830s especially, a large number of annuals reproduced picturesque views in steel engravings based on paintings (figure 1.2). These included *Turner's Annual Tour* (1833–35), *The Annual of British Landscape Scenery* (1839), *The Scenic Annual* (1838), *The Continental Annual and Romantic Cabinet* (1832), *Heath's Picturesque Annual* (1832–45), *The Landscape Annual* (1830–39), and *The Oriental Annual* (1834–40).[25] *Blackwood's* ran a regular column from 1833 to 1835 titled "The Sketcher," in which the critic explored various English landscapes and created elaborate prose descriptions comparing the scenes to famous picturesque paintings by artists like Claude and Salvator Rosa. The "Sketcher" critic was none other than John Eagles, author of the famous attack on Turner in 1836 that precipitated Ruskin's defense in *Modern Painters*. Although Eagles is usually painted by Ruskin historians as a conservative dogmatist whose old-school values were ready to be demolished by the radical Ruskin, in fact Eagles and "The Sketcher" were a part of the democratization of landscape appreciation that defined the 1830s.

FIGURE 1.2 Leitch Ritchie, "Domo D'Ossola," *Travelling Sketches in the North of Italy, the Tyrol, and on the Rhine* (London, 1832), 81. University of Pennsylvania Library.

Eagles's column confirms the emergence of a certain middle-class identity with regards to the landscape: a periodical reader who had aesthetic aspirations and the means to travel away from home. This spectator might have been carrying watercolors, a lightweight paint technology that by the turn of the nineteenth century had developed into a portable ready-made pigment.[26] Because watercolors were easier to use than oil paints, they were associated with "amateurs"— both leisured ladies and the new class of adventuring tourists in the countryside. When the *Athenaeum* in an 1844 review of *Modern Painters I* sneers that it suspects the anonymous author is "a *water-colourist,* from the tone of his critiques," the slur has all the ring of authority disdaining the newcomer.[27] This portable medium had its verbal analog in the guidebooks and hand-books that flooded the early-nineteenth-century market, touting their accessibility and ease of use. While descriptive guidebooks had been popular since Gilpin's time, the notion of a "hand-book" was an invention of the 1830s; the word was taken from the German *Handbüch* by John Murray II to describe his son's new genre of travel guidebooks to the Continent.[28] The fact that a "Hand-book of Taste, or How to Observe Works of Art" was published in 1843 suggests the ease with which this word was adopted to describe a certain type of instructional spectatorship, in which the viewing process was broken down into simple, repeatable steps.[29] The utterly mobile viewer, armed with handbook and watercolors, was ready to traverse a museum, landscape, or Continental roadway with equal intrepidity.[30]

In fact, this spectator might have been John Ruskin himself. An avid tourist in both England and Europe, an accomplished sketcher and watercolorist, a wealthy bourgeois son of new money (his father was a sherry merchant), in every way a consummate amateur: Ruskin was a product of the new aesthetic markets he sought to outdo. For by the time Ruskin came to write *Modern Painters I* in 1843, the market for picturesque views was booming and the language of landscape description was "mere jargon." The popularization and democratization of landscape viewing and amateur sketching meant that these activities were more amenable to pre-packaging in verbal guides. Because landscape viewing was already laden with a discourse of familiarity and cliché, it is no wonder that Ruskin must work so hard to discover a truer truth in nature, beyond habitual or conventional ways of seeing. When Ruskin makes landscape painting his battleground for the authentic experience of nature, he must invoke a discourse of the extraordinary to raise his own writing—and Turner's painting—above the mere everyday valuation of the natural world. Hence his turn to the rhetoric of scientific truth in nature—though the uncertain and shifting grounds for that truth ultimately created difficulties for his model of authentic vision.

Empiricism and the Mirror of Nature

British landscape painting had entered a new phase at the turn of the nineteenth century. Instead of unified or falsely symmetrical landscapes, painters began to depict actual locations, seen from a particular point of view, captured in a particular season, in the light of a discernible time of day.[31] The new visual mode was associated in particular with Turner and Constable; as the latter famously declared in an 1836 lecture, "Painting is a science, and should be pursued as an inquiry into the laws of nature. Why, then, may not landscape painting be considered as a branch of natural philosophy, of which pictures are but the experiments?"[32] The grafting of experimental science onto painting theory strongly reversed Reynolds' doctrine of universals and generalized forms.

Early nineteenth-century critics increasingly described artists as scientists of the visual. *The Hand-book of Taste* argues that readers will only truly appreciate the sculptor's art if they "make an experiment," closing the shutters and circling the sculpted figure with a candle. Forms which were previously indistinct will now leap out in "a thousand delicate undulations, producing light, shadows, and half tint," which can each be named anatomically by "an intelligent friend or artist— not a pretender, but one who really knows."[33] The artwork becomes a specimen whose authenticity—and hence its beauty—can be verified by matching its black-and-white form against the human body in nature. Through experiment the viewer can be transformed into an expert, "one who really knows," who can correlate the physiological surface with its correct anatomic label.

The *Hand-book*'s author reflects the common scientific sensibility of early-Victorian aesthetic writing, invoking what Jules David Law has termed "the rhetoric of empiricism," a "foundational optical metaphorics" of knowledge gained through the senses, especially through vision, which is based on an analogy between lucid reading and lucid seeing: "Classical empiricism . . . illustrates its claims about perception and knowledge by appealing to simple examples and analogies from common experience. 'Look at an object in your room, and then pay attention to what it is you really *see,*' empiricism counsels, adding, 'It is just like what happens as you read the words printed on this page.' We might say, then, that empiricism does not proceed so much by experiment as by examples and analogies *presented as reproducible experiments.*"[34] Ruskin's *Modern Painters I* abounds with this rhetoric of empiricism, constructing a common reader-spectator whose idea of art can be formed in the drawing room or, especially, in the garden. In chapters outlining the "Truths" of natural features such as earth, trees, or clouds, he offers numerous empiricist thought-experiments directing the reader to see for him- or herself. The chapter "Of Water, as Painted by Turner" directs, "Go to the edge of a pond in a perfectly calm day, at some place where there is duckweed floating on the surface" (3:537), in order to demonstrate the impossibility of clear reflections of both foreground and background. To prove a Truth of color, the reader is ordered to hold "a blade of grass and a scarlet flower" against a painting, to observe the drabness of paint pigment versus the brilliance of natural colors (3:280). And to learn "Truth of Vegetation," the reader must procure a leafy elm bough "and lay it on the table before you, and try to draw it, leaf for leaf." Observe the irregularity of its appearance; "there is not one line of it like another." Now compare with a branch painted by Ruskin's enemy, Gaspar Poussin: "You may count it all round: one, two, three, four . . . ; and such leaves! every one precisely the same as its neighbor" (3:589).

The recurring rhetorical move in *Modern Painters I* is one of comparison, drawn from the discourse of natural philosophy. The insistent conclusion, time and again, is that Turner's renderings are demonstrably true to external nature, while those of the old masters are demonstrably false. In many ways, the volume presents a comparative anatomy of painting-specimens. Critical focus on the book's famous word-paintings has obscured its more prosaic stated goal, which is to categorize the features of landscape paintings in the mode of a natural history treatise. After a discussion of general principles, the book contains chapters on "truths" of skies, clouds, earth, mountains, water, and vegetation. If scholars have invoked Lamb, Coleridge, Hazlitt, and Carlyle as Ruskin's important intellectual forbears, this discussion suggests that the list should also include Linnaeus, Paley, Jameson, and the English experimentalists of Ruskin's own day. Here is John Herschel, the eminent scientist and author of the influential treatise, *A Preliminary Discourse on the Study of Natural Philosophy* (1830):[35] "In the study of nature and its laws, we ought

at once...to dismiss as idle prejudices...any preconceived notion of...what ought to be the order of nature in any proposed case, and content ourselves with observing, as a plain matter of fact, what *is*. To experience we refer, as the only ground of all physical inquiry."[36] Ruskin's rejection of old-master landscape conventions is a distinct echo of Herschel's rejection of "preconceived notions" in discerning natural laws. The tests for visual authenticity in *Modern Painters I* imitate those of the early-Victorian experimental method, which often located truth in the empiricist proof of the eye. If scientists like Herschel were equating the modern with the true, Ruskin's argument for "Modern Painters" suggests a genealogy for aesthetic modernism that begins with the radical experimental attitude of Victorian science. His iconoclasm can be traced back to the influence of a new scientific worldview, overthrowing older dogmas and accepted truths.

Yet Ruskin's embrace of the stance of scientific modernity makes it more ironic that the science he invokes is largely a holdover from the eighteenth century. As Robert Hewison has observed, Ruskin's "determinedly non-speculative, non-analytical approach" was conditioned by his practice of eighteenth-century empirical sciences based on the observation of external details and structures.[37] These included geology, mineralogy, meteorology, botany, and comparative anatomy—the subjects of Ruskin's earliest publications, in Loudon's *Magazine of Natural History*. (In fact, most of Ruskin's early intellectual work was in natural history, not in art).[38] Ruskin's mode of nonintrusive scientific looking presumed that an object could be perfectly, visibly legible. In accord with the tenets of natural theology—the blend of science and religion familiar to the early Victorian moment—the appearances of nature need only to be seen to be understood as emanations from God. As Ruskin writes in *Modern Painters I*: "The laws of the organization of the earth are [as] distinct and fixed as those of the animal frame,...[and] equally authoritative and inviolable. Their results may be arrived at without knowledge of the interior mechanism; but for that very reason ignorance of them is the more disgraceful" (3:425). The authoritative laws of nature—acting with the stern power of Ruskin's Evangelical faith—can be discerned by the eye without penetration to interiors or causes.

With his catalogue of the forms and external shapes of nature, Ruskin's *Modern Painters I* creates a verbal version of the eighteenth-century projects of classification known as atlases, lavishly illustrated encyclopedias of natural objects that ranged from body parts to flowering plants (figure 1.3). The goal of these atlases, according to Lorraine Daston and Peter Galison, was to standardize the "working objects" of a discipline, "to make nature safe for science." Some atlases of the later eighteenth century took especial care with details to bestow a certain "stamp of the real"—suggesting that it would be a mistake to reduce eighteenth-century visual style to that of Joshua Reynolds's universalizing grand style.[39] *Modern Painters I* embraces the Enlightenment scientific tradition by creating

FIGURE 1.3 Albinus, "Frontal view of the skeleton," *Tabulae sceleti et musculorum*, Tab. I (Leiden, 1747). The Pennsylvania State University Library.

an atlas of landscape concerned with the minute, classifying details of form: "It will be...the imperative duty of the landscape painter, to descend to the lowest details with undiminished attention. Every herb and flower of the field has its specific, distinct, and perfect beauty; it has its peculiar habitation, expression, and function. The highest art is that which seizes this specific character, which develops and illustrates it, which assigns to it its proper position in the landscape" (3:33). Ruskin's "highest art" is an encyclopedia of natural history, distinguishing the unique physical traits of each species. The ideal painting thus takes on the character of the perfect classificatory system. Like the eighteenth-century atlas, Ruskin is interested in details only to the extent that they identify a particular species, bringing forth the object's "specific character." As Daston and Galison suggest, this combination of realistic detail and idealizing type is the method by which "the atlas trains the eye to pick out certain kinds of objects as exemplary."[40] Likewise, as Ruskin observes in a chapter on "Particular and General Truths," "The...properties which characterize man or any other animal as a species, are the perfection of his or its form and mind, [while] almost all individual differences aris[e] from imperfections; hence a truth of species is the more valuable to art, because it must always be a beauty, while a truth of individuals is commonly, in some sort of way, a defect" (3:153). Just as the atlas of natural history supplied both particular types and idealized forms cleansed of idiosyncratic detail, so too Ruskin wants a landscape painting "true to species" without distracting individuating detail.

In emphasizing each species' formal distinctiveness, Ruskin also echoes the classificatory methods of Enlightenment natural history. Michel Foucault has explained, in *The Order of Things,* why the early observational sciences embraced visual form; they wanted to exclude elements that would not be universally agreed upon, such as hearsay, smell, touch, or even color. The remaining "area of visibility...is thus only what is left after these exclusions: a visibility freed from all other sensory burdens and restricted, moreover, to black and white. This area...defines natural history's condition of possibility, and the appearance of its screened objects: lines, surfaces, forms, reliefs."[41] The black-and-white elements shaping the images of Classical taxonomy are the visual cues that Ruskin most values in his hierarchy of truths. He devotes an entire section in the early "General Principles" of *Modern Painters I* to explaining that color is a secondary quality compared to form: "If we look at nature carefully, we shall find that her colours are in a state of perpetual confusion and indistinctness, while her forms, as told by light and shade, are invariably clear, distinct, and speaking" (3:161). For example, "the colour of plants is constantly changing with the season, and of everything with the quality of light falling on it; but the nature and essence of the thing are independent of these changes. An oak is an oak, whether green with spring or red with winter; a dahlia is a dahlia, whether it be yellow or crimson;

and if some monster-hunting florist should ever frighten the flower blue, still it will be a dahlia; but not so if the same arbitrary changes could be effected in its form" (3:159). The problem of color is one of the great cruxes of *Modern Painters I*, since early on Ruskin explicitly condemns color as an important quality in painting—yet spends so much time later in the book defending Turner's controversial palette. I will return in a later section to examine Ruskin's language of colors; for now, it is enough to observe that, at least in theory, Ruskin wants to exclude color from the realm of aesthetic judgment, for the same reason that eighteenth-century scientists restricted themselves, in Foucault's terms, to "black and white": because form was perceived to be an inherent quality of the object, while color was perceived to be a quality of the perceiving eye. For Ruskin, form is the anchoring term defining "the nature and essence of the thing," apart from any fancy play with language. "Oak is oak" and "dahlia is dahlia," in a tautological construction of the object world. He enacts a mirror of nature on a literal level, making image and object perfectly reflexive.

Appropriately enough, Ruskin takes his valuation of form over color directly from Locke's *Essay Concerning Human Understanding* (1690; rev. 1700), which he read just before writing *Modern Painters I*. Cook and Wedderburn describe how saturated Ruskin's book is with Locke's terms and ideas, extending even to its treatise form, with its "elaborate classifications, divisions, and marginal summaries" (3:xix). As Ruskin tells us, Locke defines "primary qualities" like form as those that are inherent in "bodies," "whether we perceive them or no"; while "secondary qualities" like color merely "operate after a peculiar manner on any of our senses" (3:158). Like Locke, Ruskin uses visual form to create a sense of the object world as fixed and unchanging, regardless of who is looking. In fact, Ruskin's landscapes, his perfect mirrors of nature, serve to mimic Locke's model of the human mind, which works by picturing ideas on a screen.[42] In one of Locke's classic descriptions of the empiricist process, the mind is analogous to a camera obscura, and the senses are "the windows by which light is let into this *dark room*. For, methinks, the understanding is not much unlike a closet wholly shut from light, with only some little openings left, to let in external visible resemblances, or ideas of things without: would the pictures coming into such a dark room but stay there, and lie so orderly as to be found upon occasion, it would very much resemble the understanding of a man, in reference to all objects of sight, and the ideas of them" (II.xi.17).[43] In Lockean epistemology, knowledge solidifies into "objects of sight" as ideas become pictures parading by on the screen of the mind—ideally captured, in this passage, in a well-ordered art gallery. Though Locke usually appears in a genealogy leading to the skepticism of Berkeley and Hume, Locke himself was ultimately confident that the object world existed as the senses viewed it in the mind, a concrete reality extending beyond the lone perceiving individual.[44]

Given the omnipresence of Locke in *Modern Painters I*, Ruskin's construc-
tion of the ideal landscape painting takes on a certain epistemological urgency.
I would argue that Ruskin's vision of landscape, his idea that art should be a
perfect embodiment of the object world, is a version of Locke's metaphorics of
human understanding.[45] To this extent, his idea of the role of art is profoundly
conservative and antiquated—a paradox, given his arguments for "modern paint-
ers" against old-fashioned art critics like Reynolds and Eagles. As M. H. Abrams
has observed, the earliest theories of art were mimetic, stretching all the way
back to Aristotle; classical and Renaissance aesthetic theories were filled with
terms like "reflection," "representation," "counterfeiting," "feigning," "copy," or
"image."[46] Abrams is describing poetic theory, but art historians have made the
same observation about visual aesthetics. In *Art and Illusion,* E. H. Gombrich pin-
points Ruskin's *Modern Painters* as the final text in a very old tradition: "This vast
treatise is perhaps the last and most persuasive book in the tradition that starts
with Pliny and Vasari in which the history of art is interpreted as progress toward
visual truth."[47] Gombrich suggests that Ruskin is the last to base aesthetics on
external categories (like rocks, sea, or sky), as opposed to the idea that would
become prevalent in the nineteenth century, that beauty is a subjective category
found in the mind. Ruskin follows an age-old tradition in which "picturing" is
more than simply painting: it is an act of determination about the certainties in
the external world. He writes, "And let not arguments respecting the sublimity
or fidelity of *impression* be brought forward here. I have nothing whatever to do
with this at the present. I am not talking about what is sublime, but about what
is true" (3:283). Underlying Ruskin's scientific treatise on landscapes is a whole
epistemology of Truth, an edifice constructed in the eighteenth century upon a
solid foundation of "pictures."

Ruskin's Enlightenment-styled atlas of landscape reflects the broader per-
sistence of eighteenth-century modes of scientific understanding within the
early-Victorian cultural scene. The classificatory mania of *Modern Painters I* has its
analog in the most famous popularizing scientific work of the 1830s, the Bridge-
water Treatises.[48] Endowed by the bequest of the Earl of Bridgewater, this col-
lection of eight volumes, authored by the most prestigious scientists of the day,
was commissioned to summarize the current scientific knowledge across all the
animal, vegetable, and mineral kingdoms—all mustered to prove, as demanded
by Bridgewater's will, "the Power, Wisdom, and Goodness of God as manifested
in the Creation." Inspired by William Paley's *Natural Theology; or, Evidence of the
Existence and Attributes of the Deity* (1802), the Bridgewater Treatises illustrated
divine puissance by elucidating the perfection and ingenuity of natural structures.
William Whewell wrote the first volume, on physics and astronomy; other vol-
umes included Peter Mark Roget's treatise on "Animal and Vegetable Physiology"
and William Buckland's treatise on geology and mineralogy. Though expensively

produced, these works were read and reviewed by a broad array of Victorian audiences.[49] While some of these volumes proved controversial, they are usually seen as a safely conservative account of early-Victorian scientific knowledge, neatly packaging the various phenomena of nature into a divinely unified whole. With their encyclopedic coverage of all the different elements and subfields of the natural world, the Bridgewater Treatises attempt a similar project to Ruskin's *Modern Painters I,* describing in detail the physical and anatomical outlines of nature in order to prove the divine ordering of the world. If Ruskin's formalism emerged from his theological conviction that Turner's images convey the immutable truth of God, so, too, the Bridgewater scientists—like the eighteenth-century naturalists—pursued empirical research with the conviction that the revealed world was further proof of a divine shaping hand.[50] The Treatises evinced their encyclopedic coverage of natural forms by the profuse illustration of each volume (figure 1.4). For these authors, as for Ruskin, seeing is believing; the visual arguments of early-Victorian natural theology are also underpinned by a Lockean epistemology of Truth in pictures.

218

FIGURE 1.4 Peter Mark Roget, "Skeleton of the Stag," *Animal and Vegetable Physiology, Considered with Reference to Natural Theology,* vol. 1 (London, 1834), 507. Credit: Rare Book and Manuscript Library, University of Pennsylvania.

Picture Language: The Invention of Photography

For all of Ruskin's attempts to create a Lockean treatise of landscape, he must also grudgingly acknowledge that his volume is ultimately not a collection of pictures but an assembly of words. Early in *Modern Painters I* he suggests that painting is analogous to poetry, and that the two words can be used interchangeably; but at other points he bemoans the difficulty of translating Turner's sublime visual art into language: "How difficult it is to express or explain, by language only, those delicate qualities of the object of sense, on the seizing of which all refined truth of representation depends" (3:253). And later, "Words are not accurate enough, nor delicate enough, to express or trace the constant, all-pervading influence of the finer and vaguer shadows throughout his works" (3:308). Locke, too, was famously troubled by the inaccuracy of language within his philosophical system, finding that its arbitrary conventions prevented words from achieving a "natural signification."[51] At one point Locke even wishes for a picture-dictionary of natural history, a perfect visual directory of species that would avoid any confusion of linguistic naming.[52] The old idea that truth (and, for Ruskin, the best art) inheres in objects leads to a philosophy of representation by which picturing is a natural way to communicate, versus the artifice of language. A universal, godly language of vision might speak independently of the flawed human world.

If pictures were felt to have a more visceral relation to the object world than language, the appeal of a "picture language" beyond words took on a new urgency in the 1830s and 1840s, when (as Foucault and others have observed) language was becoming its own opaque object of study, increasingly untenable as a medium of transparent communication.[53] At the same time, the rise of the inductive method in the natural sciences meant that the smallest visual details could be seen to communicate nature's universal laws, creating a perfectly legible visual discourse of nature. John Herschel's *Preliminary Discourse on the Study of Natural Philosophy* (1830) finds that the iridescence of a soap bubble bespeaks the "whole science of optics" and concludes that for "the natural philosopher there is no natural object unimportant or trifling."[54] Deep principles underlie the most mundane worldly phenomena, and it is up to the iconoclastic natural philosopher to read the external world in its minute details. As Herschel quotes Shakespeare, "Tongues in trees—books in the running brooks—/ Sermons in stones—and good in every thing."[55] Similarly, Ruskin makes Turner's images speak a perfect visual language of nature, by which small details reveal larger principles: "The master mind of Turner, without effort, showers its knowledge into every touch, and we have only to trace out even his slightest passages, part by part, to find in them the universal working of the deepest thought, that consistency of every minor truth which admits of and invites the same ceaseless study as the work of nature herself" (3:544). This passage epitomizes the excesses of *Modern Painters I*, where Turner's painting and God's creation become hopelessly confused. If critics attacked Ruskin for his fanatical elevation of Turner to God-like status, the transparency between

Turner and God functions on a deeper level than mere idiosyncrasy on Ruskin's part. For if he argues that Turner's images speak with all the legible authority of God's design, then technically there is no difference between the image and the object, between the relations of details to "the universal working of the deepest thought" in both picture and in "the work of nature herself."

The currency of the desire for a perfectly legible picture language in the 1830s and 1840s is nowhere more evident than in the invention of photography in 1839—a technology whose early discourse surprisingly has much in common with *Modern Painters I*. The link is unexpected given the conspicuous visual difference between early photographic images, with their sharp details, and Turner's late paintings, with their swirling, hazy colors. Yet both kinds of picturing were constructed by writers as performing a similar cultural task, enacting a kind of vision that was truer than previous visual conventions and more direct than the tangles of written language. Mary Warner Marien has written of how photography's earliest discourse focused not on "the machines, instruments, and processes of the Industrial Revolution"—as it is now associated—but on nature, beauty, and art.[56] William Henry Fox Talbot, the chemist, mathematician, and English inventor of photography, published the first book to be illustrated with photographs under the title *The Pencil of Nature* (1844–46; figure 1.5). In the book's

FIGURE 1.5 Henry Fox Talbot, "Lacock Abbey in Wiltshire," Plate XV, *Pencil of Nature* (1844–46); reprint, New York: Da Capo Press, 1969. The Pennsylvania State University Library.

introduction, Talbot explains how his desire to invent photography was born, not in a chemist's lab, but while vacationing on the Italian shores of Lake Como in 1833. Attempting to sketch the picturesque scene using a camera obscura, Talbot was frustrated by the clumsiness of his "faithless pencil," which made a poor copy of the image cast by the machine. It was then that he thought "how charming it would be...to cause these natural images to imprint themselves durably, and remain fixed upon the paper!"[57]

In fact, the earliest photographic discourse came out of the same picturesque tradition that inspired Ruskin's *Modern Painters*—not only in the high-art realm of landscape painting, but also in the cluster of leisured and middle-class pursuits that fueled the amateur desire for a certain kind of visual truth to (or in) nature.[58] Talbot, like Ruskin, was a tourist who wanted to perfectly capture a sublime landscape through an act of picturing. Photography in the 1840s was not seen as purely mechanical, repetitious, chemical, or scientific. Rather, it was described as a kind of "natural magic" and assimilated into the discourse of drawing: the artist's phantasmal hand was nature herself.[59] Public understanding of photography via the visual arts is apparent in some of its earliest names—"photogenic drawing," "sun-painting," or, as the *Art-Union* advertised the daguerreotype in 1840, "Nature delineated by Herself."[60] Critics universally emphasized the superiority of the camera to the human artist's hand, as in the anonymously published *Handbook of Heliography, or, The art of writing or drawing by the effect of sun-light* (1840):

> [The daguerreotype] acts with a certainty and extent to which the powers of human faculties are perfectly incompetent. Not only does it delineate every object...with perfect truth in their proportions, perspective, and tint...—but it lays down objects which the visual organs of a man would overlook, or might not be able to perceive, with the same nicety that it depicts the most prominent feature in the landscape. The leaf of a rose, the blades of grass, the neglected weed, the time-stained excrescences on the knarled [sic] oak tree trunk in the landscape,...could be traced with the [utmost] accuracy...[T]hus, by a cool observer, scenes of thrilling interest in the progress of life may be transcribed and conveyed to posterity, not as they seem to the imagination of the poet or painter, but as they actually are.[61]

Because the first photographs needed bright sunlight in order to expose the sensitive paper, these early images were largely an outdoor phenomena, creating a vision of nature and landscape contiguous with conventions of the picturesque—a completely appropriate subject for a "hand-book," given photography's connections to other kinds of behavior hand-books sought to direct. If hand-books created the typical amateur spectator (of art, landscape, or foreign lands), they

also created the specter of the perfect eye who would use the book to master a new kind of looking and penetrate to the heart of the visual scene. This handbook's construction of the ideal eye—in this case, a daguerreotype—is strikingly similar to Ruskin's project in *Modern Painters I*, where Ruskin famously proposes going to nature "rejecting nothing, selecting nothing, and scorning nothing" (3:624). Like Turner's eyes, the daguerreotype is able to capture small details "which the visual organs of a man would overlook," because the human eye is blindly trapped in habit. And, just as Ruskin would have it, the tiny details of rose petals and blades of grass signify the epistemological truth of things "as they actually are," in a Lockean congruence of image and essence. In fact, the handbook's passage sounds like it might be describing some Ruskin's own drawings, whose minute exactitude mimicked the visual precision of the daguerreotype (figure 1.6).[62]

Ruskin's depiction of Turner's eyes in *Modern Painters I* offers a surprisingly exact analogy to the photographic eye as it was constructed in the 1840s. For if the discourse of early photography conflated the natural world with its fixed shadow on a two-dimensional plate, so too does Ruskin assimilate the two-dimensional elements of paintings into the three-dimensional features of the natural world. Thus he writes a natural history not of landscapes, but of landscape paintings, where the truths of painting are equivalent to truths of nature. Chapters on tone, color, and chiaroscuro are followed seamlessly by chapters on skies, earth, clouds, and water. Ruskin makes no epistemological differentiation between nature and its representation; unlike the Platonic theory of mimetic expression, the signs of representation are not demoted to a lesser level of truth, to be seen as empty shells around an originary essence. Where Locke makes a distinction between "Nominal and Real Essence" in his discussion of Ideas, Ruskin melds the two into a single category of value.[63] When, in "Truths of Vegetation," he demands that the reader compare a live elm bough with a bough from Poussin's painting, he demonstrates not a botany of leaves, but a botany of paintings: the point is to show how the leaves appear in two dimensions, "oblique or foreshortened," when seen by the human eye (3:589). Ruskin indicates a truth inhering in both objects and eyes, a physical truth-on-canvas, truth-to-representation. Color, tone, sky, and water are all *visual* categories, commensurate only as they appear on the screen of the retina (or canvas, or photographic plate). Visual data unifies all objects and all paintings in a single, two-dimensional visual field. Ruskin's Turner becomes a very strange visual agent, both an exemplary eye capturing the specific truth of the human visual field and a godly eye capturing the universal truth of Nature. Unlike the all-seeing eye of the eighteenth-century camera obscura, Turner's eye is couched in a specific viewpoint, dictated by the rules of perspective and illusionistic rendering—but these rules are Truths of nature just as solidly as the objects they depict.

FIGURE 1.6 John Ruskin, "Study of Gneiss Rock, Glenfinlas." Pen and ink with wash and chinese white, 1853. Credit: Ashmolean Museum, Oxford.

Ruskin's unusual contribution to the Western tradition of aesthetic mimeti-
cism, then, created a verbal fantasy of visual exactitude analogous to what was
becoming a new photographic reality. Although the scientific pedigree of his the-
ory was an inheritance from philosophical elites, the broader cultural appeal of
his vision of nature can be seen in phenomena ranging from the swift populariza-
tion of photography to the realist aesthetic embraced in Victorian paintings and,
especially, novels.[64] Though this mimetic ideal was quickly adopted into a series
of conventional formulas that made visual and verbal realism the mainstream
style of the nineteenth century, it is worth highlighting here the intense rhetoric
of novelty Ruskin adopts to argue against the custom-laden picturesque style of
the eighteenth century. If modernists strove to "make it new," Ruskin's *Modern
Painters I* presents a signal moment in the history of that aesthetic desire, eschew-
ing convention in favor of a sublimely unclouded perception. The rest of this
chapter will be devoted, however, to showing how the early-Victorian desire for
a mirror of nature was undercut by new scientific and philosophical ideas about
vision and what we have come to call "subjectivity," making the perfect mirror an
increasingly elusive ideal.

Sights in Time

Ruskin and his scientific colleagues desired a system of seeing and writing that
would mirror the natural world in exactly the same way to all spectators. But that
desire was accompanied by a growing suspicion of the impossibility of such a sys-
tem, given new discoveries about the irreconcilable differences between different
eyes. The notion of "subjective" versus "objective" categories of thought was filtering
into the English language from the German, where Kant in the 1790s had estab-
lished a theory of the individual mind that made it distinct from the others around
it.[65] Though the terms were regularly disdained as philosophical jargon, by 1839 J.
A. Franz could distinguish in his treatise on *The Eye* between the "objective" quali-
ties of vision, concerned with the external world and the mechanism of the eyeball,
and the "subjective" qualities of vision, which were determined by the vagaries of
the perceiver's individual mind.[66] In the following sections, I will examine how
three different versions of the subject threaten Ruskin's universalist aesthetics: first,
through a newly perceived dimension of temporality and memory in spectatorship,
unique to each viewer; second, through the new biology of associationism, which
established inevitable differences between perceiving eyes and minds; and finally,
through the uniqueness of sight proved by the idiosyncrasy of color perception.

Nineteenth-century writers on diverse subjects have often been noted for
their keen interest in historical process, evolution, and change over time. In the
observational sciences, Foucault charts the shift that enabled "the precipitation

into the old flat world of animals and plants, engraved in black on white, a whole profound mass of time to which men were to give the renewed name *history*."[67] While common perception anoints Darwin as the innovator of this evolutionary mindset, historians of science see it as a broader and earlier phenomenon of the nineteenth century. In England, Charles Lyell's *Principles of Geology* (1830–33) influentially described how minute effects of erosion, spanning eons, shaped the fossil layers of English cliffs. William Buckland's contribution to the Bridgewater Treatises, *Geology and Mineralogy with Reference to Natural Theology* (1836), went to extreme lengths to reconcile the biblical account of creation with new, emergent truths about the earth's incredible antiquity—suggesting that the days of creation in fact stretched across indefinite chasms of time. (As it happens, Buckland was Ruskin's tutor in geology at Oxford in the late 1830s).[68] Ruskin, too, displays a historical sensibility in *Modern Painters I*. Even while he models the book on an eighteenth-century natural history treatise, he writes of natural forms with a profound sense of the historical processes that have created them. "Truths of Vegetation" emerge from the growth patterns of trees and boughs, and "truths of Earth" are determined by "the tumultuous action of the emergent summits" of mountains (3:430), when "the excited earth casts off the flesh altogether, and its bones come out from beneath" (3:427). Rocks are the product of this earthly upheaval, each one rising "from the soil about it as an island out of the sea" (3:428). Ruskin's historical mindset results in his famous tendency to anthropomorphize the objects he classifies, making the landscape into a living being, or, especially, a human body—as he tells us, "Mountains are to the rest of the body of the earth, what violent muscular action is to the body of man" (3:427). His awareness of the variability in natural forms over time works against his attempts to fix and classify the correct, universally true depiction of these forms.

The problem of temporality for Ruskin's system of classification exists not only on the remote level of natural phenomena but also on the level of personal spectatorship, where the experiences, history, and memory of the individual viewer inevitably color the sight of the landscape. An Enlightenment desire for orderly classification becomes incongruous when superimposed upon a nineteenth-century *bildung* sensibility, where the self is created out of the accumulation of intense, Wordsworthian experiences in nature. The contradictory pull of the two bodies of thought is apparent in Ruskin's wonderment at Turner's foregrounds, which make him feel

> on returning to them as if I had [not] ever seen them before; for their abundance is so deep and various, that the mind, according to its own temper at the time of seeing, perceives some new series of truths rendered in them, just as it would on revisiting a natural scene; and detects new relations and associations of these truths, which set the whole picture in a different

light at every return to it. . . . The foregrounds of Turner are so united in all their parts that the eye . . . is guided from stone to stone and bank to bank, discovering truths totally different in aspect according to the direction in which it approaches them, . . . and viewing them as part of a new system every time that it begins its course at a new point.

(3:492)

This description of Turner's paintings would seem to thwart any attempts at classification. Unlike the thundering "Truths" of visual objects defined elsewhere in the book, here Ruskin invokes more timid lower-case "truths," different with each moment of viewing, and determined by the mind's whims "according to its own temper." Turner's works trick the eye into new paths—and hence "new systems"—with every gaze. That Ruskin allows this kind of indecisive viewing to enter his treatise points to a conflict in values, pitting the classificatory desires of the natural scientist against the fanciful desires of the Wordsworthian mind, mutable over time and not to be pinned down by fixed labels or pictures.

Ruskin's readers would have been struck by his use of a keyword of early-Victorian aesthetics. The mind perceiving Turner's paintings "detects new . . . associations of these truths." To Ruskin's contemporaries, associationism was the pre-eminent doctrine of beauty and aesthetics, a venerable theory first popularized in the eighteenth century. Associationism held that our sense of beauty derives from associations our mind has learned to make in response to a particular visual scene (or poetic image, or any mental stimulus). So, for example, we find landscape paintings beautiful because we associate them with memories of strolling through a pleasant countryside. Given Ruskin's statement above, it might be surprising to learn that he defined himself as a staunch anti-associationist. Yet if his greatest aspiration was to create a single aesthetic system for all objects and all viewers under the same godly eye, then a theory locating beauty in the individual mind was an anathema. Ruskin explicitly attacks the faculty of association as the source of beauty in *Modern Painters II*, saying that viewers must beware of confusing their own personal associations with the more pure Beauty inherent in God's objects (4:74). As George Landow aptly summarizes Ruskin's objections, "Associationism removes beauty from the heavens and places it within the changeable and limited territories of the human mind."[69]

Landow is content to take the early Ruskin at his anti-associationist word, but I would follow Elizabeth Helsinger in questioning this conclusion.[70] *Modern Painters I* depicts a natural world filled with features that develop and evolve over time, caught up in chains of sequence and temporality that Ruskin can only evoke through associative means. When Ruskin rebuts accusations in his 1844 preface that he wants to turn painting into a soulless kind of science, he passionately differentiates between the actions of the "mere botanist" versus those of the rigorously

observant painter. While the botanist "counts the stamens, and affixes a name, and is content," the "great poet or painter" studies plants so "that he may render them the vehicles of expression and emotion": "[The painter] associates it [the plant] in his mind with all the features of the situations it inhabits....Thenceforward the flower is to him a living creature, with histories written on its leaves, and passions breathing in its motion. Its occurrence in his picture . . . is a voice rising from the earth, a new chord of the mind's music, a necessary note in the harmony of his picture, contributing...nor less to its loveliness than to its truth" (3:36–37). Working against the natural history elements of *Modern Painters I*, Ruskin gives life and motion to the static forms outlined in each section. While the botanist pins a plant into a singular, rigid objecthood, the painter animates it into a "living creature," giving it the qualities of movement, emotion, even human voice. This animating action is explicitly associative, a "new chord of the mind's music." The flower comes alive within time-bound media, partaking of history, poetry, and music. The subtle shift of medium from painting to language underlines a crucial reason why Ruskin must, at some level, be invested in associative processes of mind: his own medium is linguistic, not visual, and his method of art criticism is itself a supreme act of association.[71] If eighteenth-century natural histories worked to isolate and fix the static forms of nature, Ruskin's *Modern Painters I* takes those flat forms and activates them within the temporal dimension of language.

Thus the same book produces two discourses spectacularly opposed: orderly languages of empirical experiment accompany epic prose animations of scenes from Turner's oeuvre. For some scholars, the book's most anthologized passages have an almost cinematic quality, as though a camera were swiveling through the painted scene.[72] The clash between botanical and historical-linguistic systems of knowledge can be aligned with the defining difference between image and language, as words add the elements of sequence and seriality to the interpretive process.[73] Ruskin's own associative flights of language work against his object-centered ideas of beauty; the use of metaphor itself is inevitably sequential, creating a chain of substitutions particular to the author's own mind. Indeed, Ruskin's wild imagery and extravagant metaphors go toward creating the distinctive writerly persona with which we are so familiar. Although his Evangelical faith drives him to theorize beauty as a fixed quality of God's objects, his metaphoric and anthropomorphic play emerges as its own idiosyncratic voice, creating a linguistic aesthetic that is eminently, devastatingly personal.

Associationism and Biological Difference

My discussion of associationism presumes that Ruskin would be familiar with the popular aesthetic theory. But it is worth dwelling for a moment on the distinctly

new manifestation the theory was taking in the 1830s, as it was influenced by new biological discoveries about the mind. Associationism today is perhaps best known as the mechanistic billiard-ball theory against which Coleridge's Romantic organicism positioned itself in *Biographia Literaria*.[74] Though associationism has most often been seen as an eighteenth-century philosophy, in fact it persisted in both aesthetic and philosophical writings into the late nineteenth century, as more than one scholar has shown.[75] Yet no one has yet observed the subtle but striking change the theory underwent after the first decade of the century—a change that resulted from new scientific discoveries about the mind, and one which posed a strong challenge to an object-oriented theory of perception. The major associationist treatise was Archibald Alison's *Essays on the Nature and Principles of Taste* (1790), reprinted three times before 1850.[76] Though Alison finds that beauty lies wholly in the mind of the perceiver, he still concludes that universal agreement about beauty can be achieved because all human minds are uniformly constituted, and will therefore follow the same associative pathways to beauty. Like Kant, Reynolds, and other theorists of taste in the eighteenth century, Alison assumes that all minds are made of the same homogenous matter, and all are governed by the same fixed laws of nature; hence a single consensus about aesthetic judgment can be reached.[77]

Yet beginning in the 1810s, biological investigations into the human sensory apparatus, or "sensorium," slowly began to erode the assumptions of human equality upon which these associative theories were based—even while lending a new biological foundation to the idea that mental processes are associative.[78] Early nerve experimentalists like Charles Bell and Johannes Müller suggested that our perception is based on an illusion: although we seem to interact directly with the world around us, in fact we have learned to convert the nervous sense data into the mirage of an external world, through acts of habitual association.[79] This new biological-philosophical idea was disseminated most influentially in England by James Mill's 1829 *Analysis of the Phenomena of the Human Mind*. In a famous chapter on "The Association of Ideas," Mill offers the sense of sight as the most "extraordinary" example of the law of association, describing how the body converts visual sense-data into an image of the world:

> When I lift my eyes from the paper on which I am writing, I see the chairs, and tables, and walls of my room, each of its proper shape, and at its proper distance ... Yet, philosophy has ascertained, that we derive nothing from the eye whatever, but sensations of colour; that the idea of extension, in which size, and form, and distance are included, is derived from sensations, not in the eye, but in the muscular part of our frame. How, then, is it, that we receive accurate information, by the eye, of size, and shape, and distance? By association merely.[80]

Unlike eighteenth-century associationism, which required an active mind to find beauty, Mill's associationism is a passive habit of sensation, a conditioned response to visual stimulus on the sensory nerves. He creates a self-conscious break between the "I" thinking and the eye seeing, looking around the room and perceiving the objects according to the dictates of his own nerves. In the theory's logical conclusion, once the body obtrudes into the perceptual process, the act of perception itself becomes open to different sights in different eyes.

This new science of mind had a profound impact on early-Victorian aesthetics, and helps to explain some of the more unusual biological excursions in art reviews of the time—for instance, when Sir Charles Morgan opens his 1834 article on taste in the *Athenaeum* with the dramatic statement, "Pleasure and pain are ultimate facts in the animal economy." No longer seeing taste as the consensus of learned gentlemen, Morgan finds it instead to lie in the human body's animal nature. "Taste is altogether an affair of sensation; and its laws are . . . no other than those of the living machines of which sensation is the attribute."[81] If the human body is a "living machine" defined by its sensitive nerves, then aesthetic judgment must inevitably become the province of a fragmented, atomized group of individual spectators. As Morgan concludes, in a daringly modern formulation, "The sensorium of each individual is, therefore, at once its own world, and its own law; and all judgments of external nature in its relations to sensation can have no other standard."[82] While Kant had made aesthetic judgment the opposite of physical desire, the discovery of perception's biological nature inaugurated a new strand of aesthetics, where the pleasures of eye and mind were dictated by the body.

Taste in the early nineteenth century therefore became literalized in a way that was to prove uncomfortable to many critics. Carlyle quipped, "Parson Alison provided us with a theory of taste which demanded that we judge of poetry as we judge of dinner."[83] Carlyle was objecting to the world-bound, earthly nature of Alison's theory, a materialism that was only exacerbated by the new biology of associationism of the 1830s. Indeed, this confusion of tastes might help to explain why "dinner" and other foodstuffs were a constant trope in the mockeries of Turner's late paintings. By using paint so as to emphasize its materiality on the canvas, Turner invoked a perceptual pleasure that could not be readily assimilated into moral or sentimental stories. Critics who accused Turner of playing with "flour" and "treacle" were expressing an anxiety about the body's participation in the aesthetic process, where human appetites and hungers might be dangerously mixed with more elevated pleasures. Thackeray's criticism, in particular, plays upon a comedic juxtaposition of high and low culture, hopelessly confusing human intellectual endeavors with more alimentary or scatological functions. (Part of the humor arises from the class-based associations of the human body— the kitchen, as the site of messy food preparation, was a place for servants and working-class people who could not control the way their bodies desired or

interacted with the elements of dinner.) Thackeray's assorted cast of well-fed Royal Academicians and drunken art correspondents are all inevitably feasting and bingeing throughout their humorous capers within the English art world. Turner's paintings only served to confirm, for Thackeray and other critics, that painting was moving in a dangerous direction when it appeared to focus merely on light and color, the elements of perception itself, when bodily desire might determine aesthetic pleasure more than the moral actions of a common mind.

How, then, does Ruskin's *Modern Painters* fit into this new and threatening bodily paradigm? As we have seen, Ruskin attempts to carefully confine his remarks within the bounds of vision's objects, whether rocks or paintings; we might remember his scornful dismissal of "impression" in favor of "truth," quoted above (3:283). Yet Ruskin is also excruciatingly aware of the body's participation in aesthetic pleasure. In the chapter titled "Taste," he defines beauty as a function of bodily sensation: "Any material object which can give us pleasure in the simple contemplation of its outward qualities..., I call in some way...beautiful. Why we receive pleasure from some forms and colours, and not from others, is no more to be asked...than why we like sugar and dislike wormwood" (3:109). Implicitly reacting against the associative idea that beauty is an active thought-process, Ruskin argues instead that our taste is a result of unthinking biology, innately installed into our bodies by God's hand. Yet by invoking sugar and wormwood, he imagines the body in the same way as the modern natural philosophers and critics who put aesthetic and bodily taste on the same physical plane. At a later point, he seems to acknowledge the danger of this biologization of taste by trying to make the body's sensory pleasure into a moral, godly emotion: "With...bodily sensibility to colour and form is intimately connected that higher sensibility which we revere as one of the chief attributes of all noble minds, and as the chief spring of real poetry. I believe this kind of sensibility may be entirely resolved into the acuteness of bodily sense of which I have been speaking, associated with love, love I mean in its infinite and holy functions, as it embraces divine and brutal intelligences, and hallows the physical perception of external objects by association, gratitude, veneration, and other pure feelings of our moral nature" (3:142–43). Here we can witness some of the mental convolutions Ruskin is forced to make by adopting different elements of contradictory philosophies. If the "the chief spring of real poetry" is the "bodily sensibility to colour and form," as other scientists of taste have argued, then there is no particular reason why God, love, or any other communal or religious virtue might be involved. Ruskin enacts a kind of rhetorical violence when he arbitrarily leaps to "associate" this bodily sensibility with "love" "in its infinite and holy functions." Once again he becomes an associationist despite himself, in his attempt to ground aesthetic pleasure in the "pure feelings of our moral nature."

The rhetorical violence persists into *Modern Painters II,* when Ruskin distinguishes between "aesthesis" and "theoria" as the sources of visual pleasure.

"Aesthesis" is mere sensual gratification, an animal-like enjoyment of visual art based in "inordinate indulgence in pleasures of touch and taste" (4:44). "Theoria," meanwhile, is a divinely appointed, moral response to beauty, instilled by God into human awareness for the admiration of divine works. Ruskin's Evangelicism drives him to reject the idea that the sensation of beauty is a willed, conscious, and individual act—what he dismisses as mere "Rational association" (4:71). Again in *Modern Painters II*, his religious faith drives him to adopt a view of the human body ironically similar to that of the modern nerve scientists, finding humans to sense beauty owing to innate, godly construction—to biology rather than to culture. While Aesthesis describes a sheer bodily effect, Theoria exceeds sense perception; yet it stops just short of willed, conscious thought, "a mediator between eye and mind," in the summation of Robert Hewison.[84] Most of *Modern Painters II* goes toward elucidating the varieties of the elevated theoretic faculty, which, significantly, Ruskin divides into the two major categories of "Typical Beauty" and "Vital Beauty." "Typical Beauty" is the beauty of forms, of types, of external and material things such as those cataloged in *Modern Painters I*. This beauty of forms Ruskin further subdivides into visual categories such as symmetry, proportion, unity, and repose—all neoclassical qualities recognizable from eighteenth-century aesthetic treatises. Ruskin again frames Typical Beauty as an Evangelical truth of pictures, exceeding mere language: "What [heavenly] revelations have been made to humanity . . . have been . . . by unspeakable words, or else by their very nature incommunicable, except in types and shadows" (4:208).

Yet alongside Typical Beauty, Ruskin defines Vital Beauty as the expressivist, emotional, and sympathetic qualities appreciated by the human understanding—appealing to our "moral faculty," in Ruskin's broad use of the term. Again, the theory of Vital Beauty avoids willed association, describing instead our innate sympathetic resonances with the appearances of living beings—beginning with plants, moving to animals, and finally arriving at humankind. Here Ruskin is careful to eschew the mere corporeal or sensual beauty of the human body as a legitimate source of visual pleasure, directing us instead to the safer regions of the human face, where the spectator inevitably looks to find emotional meaning in an artwork. The two categories of Typical and Vital Beauty are ostensibly united by their divine source: the human body is ultimately an instinctual instrument crafted by God for the reception of beautiful sensations of form or emotion. Ruskin's neat categorization of these types, however, echoing the highly ordered structure of *Modern Painters I*, serves to disguise the increasingly subjective content of his theory, as it moves away from objects and forms into the more tenuous realms of imagination, emotion, and moral feeling. For all of Ruskin's authoritative tone, *Modern Painters II* further exhibits the contradictions evident in *Modern Painters I*, as the subjective and associative qualities of beauty creep into his theory despite himself.

The inconsistencies of Ruskin's line of thinking were also apparent to some of his contemporaries, including John Stuart Mill, who followed his father in espousing associationist psychology.[85] In a review of "Bain's Psychology," Mill analyzes Ruskin's aesthetics against the grain, writing that "Mr. Ruskin would probably be much astonished were he to find himself held up as one of the principle apostles of the Association Philosophy in Art." Yet in *Modern Painters II,* Mill asserts, Ruskin defines beautiful objects as those "which powerfully recall . . . a certain series of elevating or delightful thoughts"—in other words, by a process of association. While Ruskin insists that humans are hardwired by God to perceive certain beauties, Mill proposes instead that the pleasant associations are "a case of the mental chemistry so often spoken of"; in fact, aesthetic feelings actually result from repeated sensations sinking "deep into our nervous sensibility."[86] For Ruskin, the human biology of taste is divinely unalterable; but for Mill, Ruskin's theory supports an associative-biological sense of beauty in which the mind is a sensitive plate literally scored by its experiences and memories.

This new biological idea of the source of aesthetic feelings introduces a subtle shift into early-Victorian theories of artistic creation. Influential critics of the 1830s, including John Stuart Mill, worked to redefine the Romantic artist by his unique associative mental gifts—particularly in reviews of another modern aesthetic phenomenon, the young Alfred Tennyson. Tennyson's first poetry collection, published in 1830, was the subject of articles in the associationist vein by Arthur Hallam, W. J. Fox, and Mill himself, including Mill's famous essay "What is Poetry?" (1833).[87] These reviewers all find Tennyson's poetry to be the product of a mind with a superior sensory apparatus and associative ability, enhanced by the fine, cord-like sensitivity of his nervous system.[88] Where Romantic writers figured the poet's mind as a lute or string strummed by the wind, these authors literalized the image into a biology of nerves. Poetic ability is a matter of the body, Mill writes, demanding a particular "mental and physical constitution" to achieve the most artistic "links of association."[89] The special mind of the poet—or painter, as Mill writes in "What is Poetry?"—is innately equipped with superior sensoria to produce different, original associations that will resonate with the select readers or viewers similarly gifted. Mill even uses (what else but) Turner's landscapes as key examples, finding that Turner "unites the objects of the given landscape with whatever sky, and whatever light and shade, enable those particular objects to impress the imagination most strongly."[90]

Like Tennyson's reviewers, Ruskin too works to popularize the unfamiliar works of a modern artist in the 1830s; and like them, he also theorizes an idea of artistic genius that is based in the human body. Influenced by the new science, he must acknowledge that human sensation differs depending upon the perceiver's nerves: "For supposing two people . . . perceive different scents in the same flower, it is evident that the power in the flower to give this or that depends on the

nature of their nerves, as well as on that of its own particles" (3:159). Throughout *Modern Painters I,* Ruskin pursues this bodily difference by constructing Turner as the possessor of a unique sense of vision and an original pair of eyes. Turner is "the daring innovator" whose works produce "a record and illustration of facts before unseized" (3:15). His followers have fallen away as "the master" has boldly moved into uncharted territory: "Such a mind has arisen in our days. It has gone on from strength to strength, laying open fields of conquest peculiar to itself" (3:15). Turner's paintings express "one coruscation of a perpetually active mind, like which there has not been, and will not be another" (3:135). These tropes of originality, genius, and gusto are all familiar to us from Romantic theory; but they sit uncomfortably alongside Ruskin's theory of beauty in objects rather than in unusual eyes. If true beauty is indeed true for all viewers, then the originality of the painter should be of no matter. The artist should be, as he is elsewhere, a dumb machine or an invisible mirror. But Ruskin is essentially invested in the cult of genius, the autonomous subject, and the exemplary individual in a way that clashes with his desire for a single, definable Truth of Nature. His pedagogical rhetoric, by which all readers might be educated to see as freshly as Turner, and hence made to equal him, is given the lie by his insistence on Turner's extraordinary individual sensibility, a difference that is constructed so strongly as to seem insurmountable.

Ruskin's appeal to both a universalist formalism and a romantic individualism also parallels a related conflict between communal values and idiosyncratic or personal ones. In the eighteenth century, the presumed uniformity of minds allowed for tasteful consensus; but in the nineteenth century, the discovery of innate mental differences made consensus a more difficult proposition. John Eagles attacks Ruskin for not having "the slightest respect for the accumulated opinions of the best judges for these two or three hundred years"; it is laughable, in Eagles's estimation, that Ruskin "is prepared 'to advance nothing which does not, at least in his own conviction, *rest on surer ground than mere feeling or taste.'* "[91] Eagles argues for beauty by tradition; taste is a truth established by the collective experience of perception. Hence when Ruskin invokes "mere feeling or taste," he leaps to a dangerously uncharted ground based only on individual perception. Ruskin, meanwhile, is explicitly hostile to the tendency of "modern critics" to harp on the art of the past, making a "constant ringing in our painters' ears" of "the names of great predecessors, as their examples or masters" (3:618). Yet despite Eagles's accusations, both Eagles and Ruskin share an anti-individualist bias—paradoxical (again) in Ruskin's case. Ruskin wants to argue for God's dominance over the puny eye of man, while for Eagles the dominant vision is that of tradition. Yet the two are mortally opposed over the matter of community: for Eagles the inherited, communal judgments of art are the most significant and trustworthy, while for Ruskin, the old opinions are an unwarranted interference

in the most important relationship, the lonely and sublime connection of man to God. (This celestial aesthetics becomes most pronounced in *Modern Painters II,* when Ruskin strives to make human perception into a divinely appointed gift). Thus Ruskin's conservative desire is incongruously expressed through a turn to the "modern" ("modern painters"); and the emphasis now falls on immediate, lived experience as opposed to inherited expressive forms.

"This Incurable Prismatic Madness"

All of Ruskin's contradictory epistemological allegiances in *Modern Painters I* come to a head in the volume's discourse of color. Even while he disallows color as a category of aesthetic judgment, he creates long prose fantasies glorifying Turner's colors. As we have seen, Ruskin follows Locke in his avowed disdain for color, a mere "secondary quality" that changes depending upon who is looking.[92] He announces, in his stiffest, most empirical mode, "The artist who sacrifices or forgets a truth of form in the pursuit of a truth of colour, sacrifices what is definite to what is uncertain, and what is essential to what is accidental" (3:162). Color is explicitly banished to the realm of uncertainty and accident. Why, then, does it appear so vividly in Ruskin's later descriptions of Turner's paintings, and why does he come to such vigorous defense of the artist's unusual palette?

Ruskin's entry into the color debate was most likely inspired by Turner's critics, who unfailingly focused on these colors as the greatest offense to common taste. Thackeray gleefully satirized Turner for his "pea-green skies, crimson-lake trees, and orange and purple grass."[93] Almost all of Thackeray's exhibition reviews contain some joking reference to Turner's "magnificent tornadoes of colour."[94] Anna Jameson wrote that Turner "has turned Bedlamite. Since he has been afflicted with this incurable prismatic madness, we have avoided speaking of him."[95] The *Athenaeum* accused Turner of presenting his objects "through such a medium of yellow, and scarlet, and orange, and azure-blue, as only lives in his own fancy and the toleration of his admirers, who have followed his genius till they have passed, unknowingly, the bounds between magnificence and tawdriness."[96] John Eagles, Ruskin's critical foe, practically reveled in Turner's "inconceivable jumble of colours," the "blood-red into which he delights to plunge his hand."[97] Eagles delivers a more sustained attack on Turner's colors in his review of *Modern Painters I.* Given that color is so infinitely various, he observes, certain artists are responsible for taking "a great license in all cases of colour," creating colours "not the most appropriate to the objects." A viewer might thus be led to ask, "Why is [the picture] outrageously yellow or white, or blue or red, or a jumble of all of these?—which are questions, we confess, that we and the public have often asked, with regard to Turner's late pictures—we do not acknowledge

a naturalness—the license has been abused."[98] Eagles objects to Turner's colors for the same reason that Ruskin devalues color in *Modern Painters I*: the "license" taken by the artist is too individualistic and too subjective.

Yet for all of the disparaging remarks made by Eagles and Ruskin about the lack of importance of color in art, the English school of painting was known for its mastery of color.[99] The *Athenaeum* observes of English painting in 1838 that "*Colour* also forms her transcendent distinction."[100] The early-Victorian decades were marked by a fierce interest in color experimentation by painters and scientists. Art historian John Gage writes, "During the lifetime of J. M. W. Turner (1775–1851) the study of colour in painting underwent one of the profoundest revolutions in the history of Western art."[101] Pages of the *Art-Union* and *Blackwood's* were filled with art critics discoursing on the chemistry of pigment research. Innovations in art materials in the 1830s and 1840s led to the unusually brilliant colors in paintings by Turner, Mulready, and the Pre-Raphaelites.

No doubt it was this interest that led to the 1840 English translation, some thirty years after its original publication, of Johann Wolfgang von Goethe's *Theory of Colours* (1810). Though this strange book has a number of unscientific ideas (among other things, it assigns moods to each color of the rainbow), Goethe's text is important to the world of letters for espousing color as a language of Romantic subjectivity opposed to the cold mechanism of Newtonian physics. Newton's *Opticks* (1704) had sought to make the study of light and color into a quantitative, systematized science. Reacting against what he perceived to be a tyrannical theory, Goethe proposed to "raze the Bastille" of Newton's optics by experimenting with the visual phenomena observable in his own eye.[102] Though most of his conclusions fell outside of the scientific mainstream, Goethe was taking up what was to become one of the defining experimental pursuits of the nineteenth century, the biology and physiology of mental phenomena.

The most controversial section of Goethe's treatise aligns colors with different human qualities, making color into a symbolic language of the self. Red, yellow, and orange are "plus" colors, known to excite "quick, lively, aspiring" feelings, while blues and purples fall on the "minus" side, producing "a restless, susceptible, anxious impression."[103] Goethe imagines color to be the perfect expressive language, an immediate rendering of meaning from nature: "Such an application, coinciding entirely with nature, might be called symbolical, since the colour would be employed in conformity with its effect, and would at once express its meaning."[104] Yet again we find the desire for a language of perfect picturing—but unlike Locke's picture-dictionary, or more empirical scientific atlases, Goethe imagines color as a language of human expression, speaking from humanity's most natural state of being. Rather than cutting human flaws or perceptions out of the picture, Goethe wants to make the picture itself be man's most natural, uncorrupted utterance.

It was this human language that Turner hoped to speak in the two paintings inspired by his reading of Goethe, "Light and Colour (Goethe's Theory)—The Morning After the Deluge Moses writing the Book of Genesis" and "Shade and Darkness: The Evening of the Deluge"—both executed in 1843 (figure 1.7). With their wild vortexes of pigment and blurry swathes of color, these paintings would seem to make Turner a definitive early progenitor of modernist abstraction, as he was later invoked by French impressionist painters, and as he continues to be invoked today.[105] Yet, as John Gage argues, and as any cursory reading of Goethe makes clear, these modernist interpretations ignore the profoundly symbolic and linguistic meaning that Turner, like other writers and painters in the 1840s, attached to color.[106] In *Color in Turner,* Gage writes that Turner was strongly opposed to formalist theories, and took every opportunity to "underline

FIGURE 1.7 J. M. W. Turner, *Light and Colour (Goethe's Theory)—The Morning After the Deluge—Moses Writing the Book of Genesis*. Oil on canvas, 1843. Tate Gallery, London. Photo credit: Clore Collection, Tate Gallery, London / Art Resource, N.Y.

the symbolic and literary ends to which his language of colour and form were directed," even in works "whose startling economies have invited critics to use the language of abstraction."[107] Hence Turner paints the gloomy "Evening of the Deluge" in "minus" shades of blue and black, while "The Morning After the Deluge" is rendered in more hopeful "plus" colors of yellow and orange. In the end, Turner used light and color not to accentuate these elements for their own sake, but to symbolize values from his own cultural moment.

This, then, was the dominant idea of color in the early 1840s—a discourse of color-as-language, yet another associative chain signified in the visual field. When Ruskin writes to defend Turner's use of colors in *Modern Painters I*, in perhaps the book's most magisterially polemical chapter, he uses color words to perform a strenuous feat of corporeal association. For despite his investment in the absolute and eternal qualities of visualized objects, he also wants to make his readers truly see by erasing their pre-made connections between sight and object, rewriting to give a truer sensation of objects themselves. Though Ruskin was hostile to Goethe, his defense of Turner echoes Goethe's idea of color-as-expressive-language, making words act in the way that he sees Turner's colors act.[108] In the chapter "Of Truth of Colour," Ruskin begins by disparaging an Italian mountain scene painted by Poussin. The old master's landscape, in Ruskin's most sarcastic tone, depicts bushes of "dull opaque brown" and rock "scientifically painted of a very clear, pretty, and positive brick red"; "the truth of the picture is completed by a number of dots in the sky . . . , with a stalk to them, of a sober and similar brown" (3:277–78). The immediate comparison is not, however, to a painting by Turner, but to Ruskin's own experience as he once descended the mountainside depicted by Poussin. The sun breaks through stormy clouds, and the following lengthy passage ensues:

I cannot call it colour, it was conflagration. Purple, and crimson, and scarlet, like the curtains of God's tabernacle, the rejoicing trees sank into the valley in showers of light, every separate leaf quivering with buoyant and burning life; each, as it turned to reflect or to transmit the sunbeam, first a torch and then an emerald. Far up into the recesses of the valley, the green vistas arched like the hollows of mighty waves of some crystalline sea, with the arbutus flowers dashed along their flanks for foam, and silver flakes of orange spray tossed into the air around them, breaking over the grey walls of rock into a thousand separate stars, fading and kindling alternately as the weak wind lifted them and let them fall. Every glade of grass burned like the golden floor of heaven, opening in sudden gleams as the foliage broke and closed above it, as sheet-lightning opens in a cloud at sunset; the motionless masses of dark rock—dark though flushed with scarlet lichen, casting their quiet shadows across its relentless radiance, the fountain underneath them filling its marble hollow with blue mist and

fitful sound; and over all, the multitudinous bars of amber and rose, the
sacred clouds that have no darkness, and only exist to illumine, were seen
in fathomless intervals between the solemn and orbed repose of the stone
pines, passing to lose themselves in the last, white, blinding lustre of the
measureless line where the Campagna melted into the blaze of the sea.
Tell me who is likest this, Poussin or Turner?

(3:279)

The colors of the passage take on supernatural qualities, deliberately evoking reli-
gious revelation. It is strange to remember that this passage appears in a book
repeatedly figuring spectatorship as a scientific experiment. Ruskin's shift from
Claude's "sober" and "pretty" hues to his own visual experience is a startling one,
rendered vivid by his evocative use of color-language. Many of the colors have poetic
associations—the precious substances of "silver," "emerald," "gold," and "amber,"
the blood of "purple," "crimson," and "scarlet," the organic fruits of "orange" and
"rose," and the pure, heavenly "white lustre" where the passage culminates. The
way that these color words bring in associations of other sensual experiences—
especially in the sexual undertone of the suggestive "scarlet" "flushes"—creates a
Turnerian scene that is eminently produced by, and connected to, the perceiv-
ing body. Even while Ruskin attacks psychologism and the subjectivity of percep-
tion, he uses association and metaphor to evoke the feelings of his own sublime
color perception. His attempt to reinvigorate clichés of the picturesque ultimately
implies the failure of his universalizing project, as language itself conveys a time-
bound, idiosyncratic sensory experience for Ruskin's readers.

As the previous sections have shown, this discourse of aesthetics as a function
of the body was becoming a common way of imagining aesthetic pleasure. It is
not surprising that Ruskin, too, embraces the language of the body for rhetorical
power, harnessing visceral words to convey his associative meanings. The surprise
is that he also tries to adhere to an older and incompatible mimetic theory of art.
Ultimately, he creates an inconsistent treatise devoted both to art's objects and
to its newly formed subjects—suggesting a new definition of "the modern," or
perhaps creating new intimations of modernity, for his early-Victorian readers as
well as for later audiences.

Coda: Ruskin and Modernism

The object-centered aesthetic tradition did not die in the early nineteenth cen-
tury, though the idea has often been suggested by contemporary critics. Histori-
ans as diverse as M. H. Abrams, Michel Foucault, and Jonathan Crary have argued
that a paradigm shift in the early nineteenth century banished the mimetic ideal

from the canon of modern aesthetics. Yet the longing for a language of art as a transcendently truthful picture persisted throughout the nineteenth century, to become an integral (if contradictory) element of the modernist ideal. Modernist aesthetics, like Ruskin's *Modern Painters,* was riven by two contradictory visions of art's relation to the world—one thread seeing art as an idealized record of human consciousness, another reflecting a yearning to escape the suffocating enclosure of personality, calling itself "classicism" or "impersonality." T. S. Eliot writes that "the poet has, not a 'personality' to express, but a particular medium," "a concentration which does not happen consciously or of deliberation."[109] This utopian poetics aimed to escape the human, subjective qualities of language and often invoked the metaphor of a "picture" or "image" to figure its cold, impersonal qualities. When Ezra Pound and T. E. Hulme demand a classical style of poetry—aptly called "Imagism"—that cuts directly to the object depicted, and that sheds all the fuzziness of language in favor of a sculptural, precise Truth, they are invoking a linguistic ideal of visual representation with roots in the nineteenth century and earlier. Pound theorizes Imagism in 1912 as a new poetry that "will be as much like granite as it can be, its force will lie in its truth, in its interpretive powers."[110] In the famous essay "Romanticism and Classicism," T. E. Hulme expresses his desire for a language that will get "the exact curve of the thing."[111]

Yet if Ruskin's *Modern Painters* anticipates the modernist desire for form, it also unwittingly reveals, in grand style, the potential for language to convey an unmediated record of sensation itself. The famous set-pieces from *Modern Painters I,* channeling all the fantastic and poetic associations of words into sentences that seem to pile sense upon sense, might be pointed to as early progenitors of the literary techniques of stream of consciousness. Ruskin's attacks on the conventional mundanities of old master landscapists leads him to use a language that defies all formula, even deforming language to pierce through to a psychological truth of perception. Importantly, many of these famous passages describe not Turner's paintings but Ruskin's own experience in nature. In the argument of *Modern Painters,* Turner's images are the closest possible visual approximations to the actual human perceptions of nature, as experienced by Ruskin himself. Even while he works to generalize and classify the unchanging forms of nature, *Modern Painters* is dominated by the "I" of Ruskin's own character; his language performs a psychological autobiography of his personal history in nature. Modernist prose stylists also manipulated language to imitate the unpredictable streams of thoughts and sensations. In this, they might be seen to be remaking Ruskin's linguistic process into a more deliberate and conscious artistic action.

These modernists obviously inhabit a very different world than that of Ruskin in the 1840s. Yet the contradictory scientific models I have observed to define Ruskin's early-Victorian moment—the pull between Enlightenment and Romantic modes of thinking—can also be seen to define two major aesthetic

impulses in modernism. Both Ruskin and the modernist classicists invoke linear form (over synaesthesia or sentiment) as a way of escaping the error and pitfalls of individual perception, an inheritance that can be traced directly back to the ideals of Enlightenment science. But Ruskin also shares with certain modernist prose writers the desire to convey the unspeakable intensity of perception—"pure perception"—through deployment of an abundant and enthusiastic experiment with language. This chapter has explored an especially vivid and resonant moment in the history of this divided aesthetic. I will now pursue a very different moment, as art writing moves into the realm of the professionals.

TWO

Sublime Museum
Scripting Fine Arts at the Great Exhibition

It is in the highest degree remarkable . . . that this Great Exhibition of London—
born of modern conceptions of steam power, electricity, and photography, and
modern conceptions of free trade—should at the same time have afforded the
decisive impetus, within this period as a whole, for the revolution in artistic forms.
To build a palace out of glass and iron seemed to the world, in those days, a fan-
tastic inspiration for a temporary piece of architecture. We see now that it was the
first great advance on the road to a wholly new world of forms.

> —Julius Lessing, *Das halbe Jahrhundert der Weltausstellungen* (Berlin, 1900);
> quoted in Walter Benjamin, *The Arcades Project*

Amazed I pass
From glass to glass,
Deloighted I survey 'em;
Fresh wondthers grows
Before me nose
In this sublime Musayum!

> —William Makepeace Thackeray, "The Crystal Palace"

Exhibiting Texts

John Ruskin's fierce demands for a truthful vision in art in the 1840s emerged
from both his Evangelical beliefs and his investment in a scientific ethos. His
calls for readers to conduct visual experiments in their gardens often sounded
like a lone truth-teller beseeching an ignorant herd. This individualist strain in
Ruskin's early writings contrasts with a major development in art criticism in
the 1850s, as some critics began to establish identities as new art profession-
als attached to evolving institutions such as the National Gallery and the British
Museum. As art professionals began to create a collective identity by referencing
other well-educated readers, they also asserted their expertise by demarcating
a learned kind of looking unavailable to the ignorant amateur.[1] In this chapter, I
explore art writing produced in response to the Great Exhibition of 1851—by all
accounts, one of the defining events of Victorian visual culture—in order to ana-
lyze the aesthetic values embraced by emergent art professionals. Mid-century
battles about art have always seemed remarkable for the vehemence of critics'

stylistic preferences, usually referred to as the "battle of the styles." Although historians often shorthand the victor of this battle as "Ruskinism," or the moral judgment of art, this chapter will continue to demonstrate how art judgments for Victorians were a strikingly multifaceted affair, especially as different groups competed for ascendancy in the burgeoning field of art publication. Histories of the aesthetic usually identify its origins in avant-garde experiments and manifestos; yet, as the first chapter demonstrated, Victorian art writers often used conservative ideologies to promote new ways of looking or startling new styles. In the case of the Great Exhibition, some writers invoked values of aesthetic detachment and visual form—not as part of an avant-garde art rebellion, but to highlight their own specialized expertise.

The Great Exhibition is usually described as the first World's Fair, a "gathering of all nations" that displayed over ten thousand objects from around the globe.[2] Spearheaded by the organizing efforts of Prince Albert himself, the Exhibition was devoted to showing the wondrous progress of modern industry, where Britain was pre-eminent. As the host country, Britain claimed half of the exhibition space; the rest was divided between other European countries and colonial territories. Objects were housed in a spectacular building made of glass and iron, the strikingly modern "Crystal Palace" (figure 2.1).[3]

If this first World's Fair was extraordinary for so many of its unprecedented numbers, including its acres of exhibition space, thousands of exhibitors, and millions of visitors, it was also unusual for the multitude of texts it inspired, aimed at many different kinds of audiences. The magnitude of textual production was

FIGURE 2.1 "The Crystal Palace from the northeast." Colored lithograph. *Dickinson's Comprehensive Pictures of the Great Exhibition of 1851* (London, 1852). Reproduced with the permission of Rare Books and Manuscripts, Special Collections, the Pennsylvania State University Libraries.

appropriate to the vastness of the spectacle itself; as critics have noted, the only previous events that might have rivaled the Exhibition would have been ritualized displays of state power, such as coronations or executions.[4] By contrast, the Crystal Palace exhibition was a new kind of spectacle, a modern-day mass-cultural event too large and unknown for its meaning to be easily pinned down. Hence the importance of textual scripting, as authors of varying expertises clamored to lay their own interpretive claims to the dazzling sight.

Although the Exhibition was devoted to the achievements of modern industry, some of the objects receiving the most comment at the time belonged to the category of fine art. These exquisite products became weapons in a battle for cultural supremacy amongst the Western nations, lending a heightened urgency to "the battle of the styles." By reading textual responses to art at the Exhibition, I will propose a revision to some of our critical accounts of the way Victorians interpreted art and style at mid-century. Twentieth-century critics have tended to simplify the issue by reading Ruskin's 1853 "Nature of Gothic" as a representative mid-century text, defining mainstream art judgment as an exercise in moral regulation and didactic discipline. Yet this account misses the extent to which Ruskin was writing against the grain. As the story has often been narrated—perhaps most canonically in Kenneth Clark's foundational study *The Gothic Revival*—Ruskin's *Stones of Venice* (1851–53) successfully cleansed the Gothic style of its Catholic taint, promoting a moral, socially conscious vision of art that led to the popularization of the Gothic across Victorian skylines and shop windows.[5] While Ruskin canonized the judgment of art by its moral connotations, the judgment of art by formal or structural concerns—what later came to be associated with "art for art's sake"—was an incipient idea that would only arrive at British shores in the 1870s, in the rare cult of art known as aestheticism.

Yet the literature on artworks at the Great Exhibition suggests that, in fact, there were many competing kinds of aesthetic visions. Most strikingly, there is a divide between writers courting an amateur, popular art audience and those styling themselves as art experts. Accounts aimed at a popular audience judged the quality of an artwork by its moral content, making a one-to-one connection between an image and its meaning.[6] Those claiming art expertise, on the other hand—the new bureaucrats of art like Sir Henry Cole, founder of the South Kensington (later the Victoria & Albert) museum, Ralph Wornum, eventual keeper of the National Gallery, and even Prince Albert himself—proposed a new way of looking, associated specifically with the Crystal Palace and its scientific techniques of classification and display. By examining some of the controversial art exhibits where discourses of the amateur versus the expert most sharply disagreed, we can begin to trace how different modes of aesthetic looking became representative of larger cultural transformations in the nineteenth century. If Exhibition art experts invoked formal interpretations—what they deemed the

"pure principles of art"—to cement their newly emergent professional identities, this kind of detached looking made formalism a mainstream interpretive mode of the art establishment at mid-century. Seen from this point of view, the Gothic was simply one of many styles, emptied of its historical associations and ready to be appropriated by Victorian commodity culture.

In chapter one, I explored how early-Victorian visual culture manifested an uneasy mixture of Enlightenment science and Romantic sensibility. This chapter will show how these intellectual threads were reconfigured in responses to the Exhibition, when a whole class of art writers adopted scientific detachment to arrive at a more aesthetic response to art. The moral interpretation of art was only one of many; and even ostensibly pure, formally based interpretive modes encoded more subtle narratives of cultural, national, and racial hierarchies. One aim of this chapter, then, will be to discern many different mid-Victorian eyes, whether they be publics, experts, or even Ruskins.

Arts and Industries: The Triumph of the West

Victorian spectators naturally wondered what exactly the fine arts were doing in an Exhibition devoted to proving the miracle of modern industry. Since objects were exhibited by their country of origin rather than by their classification, visitors were confronted by the disconcerting juxtapositions of reaping machines and classical-style sculptures, blocks of tin and ornate French vases. Beyond the sheer visual incongruity of the mixture, a modern-day critic might ask how art objects modeled on the styles of ancient or medieval cultures could fit, ideologically, into an Exhibition that was supposed to demonstrate the progress of Western civilization.

In fact, these art objects were taken to be the very proof of that progress, as the numerous art experts who wrote prize essays and treatises on the Exhibition never failed to point out. The elaborate classification scheme into which Exhibition objects were divided encoded in its categories a narrative of how the fine arts epitomized Western progress. There were four sections, established in a strict hierarchy, and set out by Henry Cole in the Exhibition's *Official Guide*: Raw Materials, Machinery, Manufactures, and—at the top of the pyramid—the Fine Arts.[7] Objects were therefore ranged in a spectrum from most crude and unrefined to most polished and skillfully produced. Exhibition organizers did decide to exclude painting from the show, since paintings did not seem to be objects of the material world in quite the way that sculptures were.[8] Items within the four major sections were further divided into subsections, for a total of thirty classes in all. Significantly, the fine arts were designated class number thirty, the final class of the list.

Underlying the Exhibition categories, then, was a profound idea of the ordering of matter in the human world. Prince Albert invokes this orderly vision in

his famous 1850 speech, delivered to London municipal authorities and widely quoted in contemporary periodicals and Exhibition guides: "Science discovers…laws of power, motion, and transformation: industry applies them to the raw matter, which the earth yields us in abundance, but which becomes valuable only by knowledge: art teaches us the immutable laws of beauty and symmetry, and gives to our productions forms in accordance with them."[9] These comments encapsulate the ideology of the Exhibition's four classes, which naturalized human industry and manufacture as activities contiguous with the world of nature, and saw the fine arts as the highest kind of human work upon natural materials.[10] The Prince avoids mention of human agency, focusing instead upon the "immutable laws" of both science and beauty that make the progress of Western manufactures seem inevitable, itself a force of nature. This deterministic account, arriving at the fine arts as the triumphant supreme product of Western industry, allows for the convenient omission of some of the uglier by-products of British manufacturing. Here raw materials are "yielded in abundance" rather than mined from blighted landscapes, and the methodical laws of science produce shapely objects of art rather than a flood of cheap, poorly designed wares. By portraying the production of manufactured objects as a function of nature rather than culture, Exhibition organizers could avoid some of the discomfiting social problems attendant upon Western progress.

The Exhibition classificatory system imparted a sense of majestic universality, but only the products of certain Western countries were seen to truly achieve full occupancy of all the categories. The anthropological aspect of the Exhibition's "gathering of all nations" has been striking to twentieth-century critics, many of whom point to the event as the birthplace of modern anthropology.[11] Tony Bennett aptly summarizes: "A progressivist taxonomy for the classification of goods and manufacturing processes was laminated on to a crudely racist teleological conception of relations between peoples and races which culminated in the achievements of the metropolitan powers, invariably and most impressively displayed in the pavilions of the host country."[12] Because art objects held the uppermost position in the Exhibition's taxonomy of goods, they bore a disproportionate burden in defining the competitive value of each nation's products. British art experts had to account for the galling fact that many of the most admired works of fine art were produced by other European countries, like France and Austria. While Britain could clearly claim dominance in the arts of manufacture, the fine arts were a more problematic area, especially since Britain had no distinctive national style. As we will see, many of the British art treatises on the Exhibition attempted to solve this problem by focusing not only on objects but also on a way of looking at objects, a gaze defined as advanced, civilized, and quintessentially British.

If France and Austria were threatening competitors in Britain's quest for cultural ascendancy, experts could always point to what they imagined to be less

developed non-Western countries to show the progress of their arts more gener-
ally. These comparisons seem richly ironic given that Asian textiles, ceramics, and
other luxury goods of the early-modern era far surpassed the early products of
the West. Indeed, the British taste for these goods was a major spur to imperial
trade, and domestic manufacturers tried to catch up by creating their own imita-
tive luxury items to satisfy the demand created by the superior Eastern objects.[13]
Nevertheless, the comparative trope that demonstrated the superiority of the West
in the Exhibition's discourse was incessant and ubiquitous: in every art expert's
disquisition, the judgment of art is inseparable from the advanced state of Western
civilization, as compared to other civilizations, or to the earlier state of the West.
Unilinear visions of progress were an implicit contrast to the presumed stagnancy
of Eastern or more "barbaric" cultures—though, as C. A. Bayly points out with
regards to the eighteenth century, Asian cultures were not "impotent, decadent, or
stagnant" but "were passing through a crisis in the relationship between commerce,
landed wealth, and patrimonial political authority comparable with that which
convulsed Europe in the first half of the seventeenth century."[14] The tumultuous
and variegated history of Asian empires was conveniently overlooked by art writ-
ers and others seeking to prove Britain's comparative pre-eminence in the world,
especially based upon the nation's advanced state of capitalism. The relationship of
British gentlemen to the rest of the world could be conveyed in quick shorthand
by the distinction between "civilized" and "savage," as seen in Henry Weekes's *Prize
Treatise on the Fine Arts Section of the Great Exhibition of 1851*:[15]

> As man emerges from the simple state of barbarism, and enters into the
> more complicated one of educated life, things that tend to gratify the eye,
> to ornament the abode or person, to mark distinction of rank, or posses-
> sion of power or wealth, become almost as much positive requisites as
> are the mere necessaries of life to the unsophisticated savage. As nations
> advance, labour and enterprise create wealth, and society becomes in con-
> sequence more artificial and intricate in its phases, employments more
> numerous and varied, customs and manners more costly and refined. By
> the wealth thus gained, man seeks to surround himself with luxuries of
> all kinds; every sense ... must not only be gratified, but its power, as far as
> possible, increased; the ear must be regaled by more delicious sounds, the
> eye by more pleasing forms; that which was previously constructed solely
> for use, has to be made ornamental in its shape, agreeable in its appear-
> ance, as well as appropriate to its purpose.[16]

In Weekes's account, the development of the fine arts results directly from the
advancement of civilization into the "complicated" state of capitalist production.
The wealthy (British) industrialist exists in a complex state of aesthetic sensibility,

surrounding himself with the luxurious artistic productions of the system he has mastered. In the narrative of Western progress, fine-art production and capitalism are inextricable.

It was this combination that propelled the ideology of the Exhibition's ideal products: "art-manufactures," a term invented by Sir Henry Cole in 1845, and one he and Prince Albert vigorously touted at the Exhibition.[17] "Art-manufactures" wedded the notion of fine arts with new technologies of mass production. The hope was that manufacturers would learn a lesson of taste from the styles of fine arts displayed at the Exhibition, taking these home to make their objects more beautiful, and hence, more marketable. In her essay "The Harmony of Colours as Exemplified in the Exhibition," Mary "Mrs." Merrifield suggests that the Exhibition teaches a lesson in the scientific laws of color, which English manufacturers need to learn from foreign nations—especially from France—to improve the desirability of their products on the market.[18] Her sentiment was echoed by many of the experts writing on the visual arts at the Exhibition. The Victorian desire to make British manufactured goods into more aesthetic, more well-designed objects reveals a marked shift from the consumer culture of the eighteenth century, when some of the most sought-after, luxurious items were prized for the new technologies that had gone into their production. "The new domestic and decorative goods" of the later eighteenth century, writes Maxine Berg, "from machine-woven carpets and copper-plate printed curtains to stamped brassware and pinchbeck, . . . declared modernity, enlightenment, and fashion."[19] While the rise of industrial manufactures led to a democratization of taste, enabling a greater number of British people to adorn their homes with newly minted goods, another result was the gradual decline in the quality of these goods—working inevitably to separate, with increasing intensity across the nineteenth century, the Victorian notions of "art" and "manufactures." Joseph Bizup finds that the early Victorian decades of the 1830s and 1840s witnessed a unique attempt by manufacturers to promote British industry as an aesthetic project, coinciding with all the civilized and tasteful advances of culture. This rhetoric appears in parliamentary reports on the formation of government Schools of Design (the first of which opened in 1837), and also in the *Journal of Design and Manufactures* (1849–51), founded by none other than Henry Cole.[20] The first government art schools were founded in the 1830s with the express desire that "the people" might learn the arts of design in order to improve the quality of Britain's manufactured goods.[21] The Great Exhibition might thus be seen as the culmination of a variety of early-Victorian attempts to aestheticize industrial products—attempts that seemed increasingly fraught with the difficulties attending Britain's incipient shift toward mass production and a mass consumer culture.

An overriding didactic goal of art commentaries at the Exhibition, then, was to harness sight in the service of capitalism. Indeed, a visit to the Crystal Palace

inspired the twenty-year-old William Whitely to conceive of "universal provider's shops with plate glass fronts"—leading him to innovate Britain's first department store.[22] Thomas Richards writes that the Exhibition "was the first world's fair, the first department store, the first shopping mall."[23] Crystal Palace exhibitors took pains to arrange their wares in the most attractive display possible, using all the latest scientific research on lighting, color, and visual contrast. The Exhibition was obviously a major event in the rise of "the commodity culture of Victorian England," to echo the title of Richards' book. Yet it is also useful here to point out the ways in which the Exhibition's objects exceeded and even confounded the category of commodity. The term seems increasingly inadequate given that many of these objects—such as blocks of coal and twenty-foot-tall sculptures—would never have appeared in a Victorian drawing room. None of the objects on display had price tags, and none were for sale directly from their display cases. The tremendous variety of objects on view provoked a major debate about the variety itself: the differences between kinds of objects were the subject of argument for commentators in a way that the monolithic label of "commodity" does not capture. In fact, the visual experience of the Crystal Palace would have had more in common with that of a nineteenth-century museum than that of a department store. As we will see, despite Cole's best efforts to unite "art" and "manufactures," Exhibition authors dwelled at length on the relation between high and low art, which was particularly vexed owing to the different kinds of audiences attending the event. Even while the displays were meant to improve and educate the visiting public, experts could not help but worry that spectators were not deploying suitable museum-worthy gazes, especially in the case of exhibits that dazzled, enticed, or even overwhelmed the eyes.

Ways of Seeing at the Exhibition

Descriptions of the Exhibition often rhapsodized upon the spectacle's dazzling effect on the eye. One popular song described the Crystal Palace as "a fairy structure in the sky," "so crammed with wealth from every clime," inspiring audiences "gazing there with rapt'rous eye."[24] The feeling of visual extremity was not limited to popular poetry or song; journalistic accounts, too, used ecstatic language and fantastical metaphors to evoke the visual experience. *The Times* commented on the occasion of the Palace's opening: "The eye, accustomed to the solid heavy details of stone and lime, or brick-and-mortar architecture, wanders along those extended transparent aisles . . . almost distrusting its own conclusions on the reality of what it sees, for the whole looks like a splendid phantasm, which . . . a gust of wind [could] scatter into fragments, or a London fog utterly extinguish."[25] Critics repeatedly personified "the eye" as a sentient being separate from the rational mind, seeming to behave with a will of its own—and often misbehaving, or acting in a pleasured,

irrational way. In his important book *Techniques of the Observer: On Vision and Modernity in the Nineteenth Century,* Jonathan Crary historicizes the imagining of vision, arguing that the notion of the eyeball as a flawed, mortal object was a new development in the early nineteenth century.[26] Previously, the Cartesian model of vision used a fixed, monolithic eye as the foundation for rational thought; but scientific experiments beginning at the turn of the century demonstrated the eye's fallibility, allowing for the invention of technologies like the stereoscope or diorama that could trick the eye into believing it viewed something real. When reading first-hand accounts of the Crystal Palace, one gets a visceral sense of anxieties surrounding the wandering organ of sight, especially an eye belonging to untrained viewers unleashed upon the colossal, bewildering spectacle of the Exhibition.

An amusing yet revealing example of this anxiety can be found in *Little Henry's Holiday at the Great Exhibition,* in which little Rose, sister of Henry, is blinded by all the sparkling gold ornaments. Her wise Papa compares her to a gentleman who "as soon as he began to look at one object, his attention was drawn to another; and before he could look well at that, his eye saw something else more beautiful; so he had not seen anything—properly."[27] The proposed antidote to Rose's distraction is Papa's knowledgeable discourse on the Exhibition's sights. In this sugary parable, Rose stands in for any new viewer at the Exhibition, especially any working-class visitors who had never before entered a museum. The words of wise Papa are a hokey, popular version of all of the didactic visual scripts written by Exhibition experts attempting to govern the wandering eyes of inexperienced viewers. For despite the seeming solidity of the Exhibition's classification scheme, the visitors themselves threatened to defy the careful taxonomy of goods and nations. Exhibition authors expressed an overriding anxiety that the West's own visitors would behave at the Exhibition in "barbaric" or uneducated ways, especially given the unprecedented number of working-class and provincial viewers in attendance, whose only previous analogous experience might have been a visit to the country fair. As Mrs. Merrifield opines in her discourse on colors, "Nine times out of ten the *good eye* will be found to mean the *educated* eye."[28]

Exhibition theories of vision also encoded broader emblematic desires. In Jonathan Crary's analysis, changing European models of vision were symbolic of larger shifts in notions of truth and value. Crary derives his narrative from Michel Foucault's *The Order of Things,* which traces an epistemic shift from the Enlightenment's fixed categories of knowledge to the nineteenth century's more fluid, unstable categories.[29] The metaphoric move from camera obscura to human eyeball, Crary argues, described a new corporealized model of vision in the nineteenth century, signaling "how the body was becoming the site of both power and truth."[30] Experts writing at the Great Exhibition also used visual models to represent broader discourses of knowledge. While the flawed, lustful human eye symbolized the greatest threat to rational spectatorship, authors proposed their

own treatises as antidotes to visual intransigence. Just as the wilds of nature could be tamed and utilized by (Western) man, so too "the eye"—synecdoche for the unruly body—could be disciplined by the numerous tracts of Exhibition experts.

In particular, authors who styled themselves as experts advocated for a specific kind of rational seeing, a mode of disciplined looking associated with science, especially natural history. This gaze attempted to fit objects neatly into the Exhibition's intricate classificatory system in the same way that eighteenth-century naturalists sought to categorize the natural world. Objects of all types were subjected to a kind of pedestal effect: even blocks of coal and stuffed frogs were meant to be observed with serious contemplation. The expert eye was didactic in spirit, instructing working-class Exhibition visitors to look but not to touch. It was typified in the detached attitude taken by the Exhibition experts, art writers, botanists, museum curators, chemists, professors, and other jury members who judged the exhibits. It had something akin to the experience of panoramas, dioramas, and other Victorian visual technologies where the illusion arose from a perspective distance from the visual stimulus. It would eventually be assimilated to department stores, art galleries, and other new middle-class institutions that featured objects in enticing but untouchable display. In other words, it was based on a crucial notion of distance from the object, both literally and metaphorically: seeing the object in itself, "for its own sake."

For the Exhibition public, this expert gaze was epitomized by the object enclosed in glass, a technique of display developed for the scientific study of botany and natural history. Glass was closely associated with visual technologies that exemplified the Exhibition's ideology of Western progress: the telescope, magnifying glass, microscope, even the lens in the newly invented camera, all connoted the superior vision of the West as it turned its eyes upon the rest of the world. New developments in sheet glass technology allowed for the construction of the radically modern Crystal Palace, which was, indeed, one great glass case.[31] Although, as critics have pointed out, the Palace's glass was opaque when viewed from the outside, its power lay in its symbolism. Modernity, transparency, lucidity, order and sense: the structure summed up everything in the name "Crystal." *Punch* suggested that the whole of London should be put under glass cover. "We shall be disappointed if the next generation of London children are not brought up, like cucumbers, under a glass!"[32] *Punch* also featured "Specimens from Mr. Punch's Industrial Exhibition of 1850" (figure 2.2), which displayed workers in glass cases, including "An Industrious Needlewoman," "A Labourer aged 75," "A Distressed Shoemaker," and "A Sweater." The humor lies in the revelation of an element usually disguised by a glass case, namely, the unsightly human labor which went toward creating the polished object on display.

Punch's satires make it clear that the idea of seeing objects under glass had a certain novelty in 1851. Despite the long tradition of industrial exhibitions that

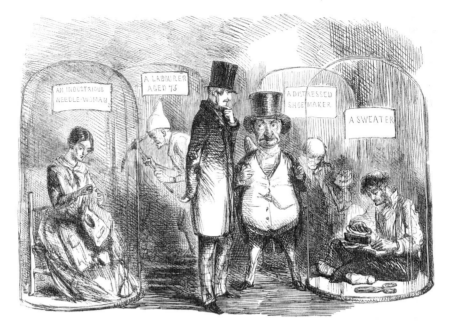

FIGURE 2.2 "Specimens from Mr. Punch's Industrial Exhibition of 1850," *Punch* 18 (1850): 145. The Pennsylvania State University Library.

preceded the Crystal Palace, this was the first time that everyday people were encouraged to view such a variety of objects on such a grand scale. The attempts by Exhibition authors to control visitors' sights were not randomly focused; certain exhibits incited acute concern and provoked more textual production. In particular, I will focus here on two displays that threatened to rupture the structuring ideologies of the Exhibition: first, the Palace's many sculptures of nude women; and second, the Medieval Court, designed by A. W. N. Pugin. In both cases, the luxurious offerings to the eye threatened to overturn the rational aesthetic distance expected of the visitor, and challenged the arcs of progress established between different countries and time periods.

Marble Seductions, Victorian Eyes

Although one might suppose that the Exhibition halls were dominated by giant reaping machines and printing presses, in fact contemporary accounts and images reveal that some of the most prominent displays inside the Crystal Palace were sculptures (figure 2.3). Occupying the highest niche in the classification scheme, sculptures embodied the most exquisite products of human labor, usually in the form of the human body itself. Some of the sculptures depicted stirring characters

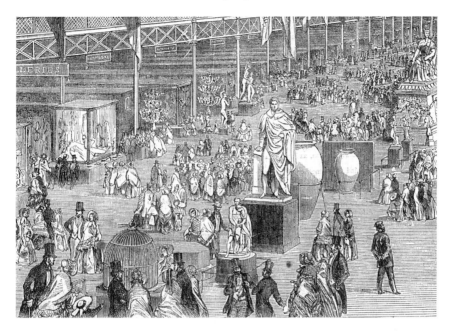

FIGURE 2.3 "The East Nave," detail, *The Crystal Palace and its Contents* (1851): 120–21. Rare Book and Manuscript Library, University of Pennsylvania.

from European history, such as William de Godfrey, a famous crusading knight; there was also a twenty-foot-tall sculpture of Queen Victoria in zinc. One of the most sensational sculptures was *The Amazon*, by the Prussian sculptor Kiss (figure 2.4). This massive bronze depicted an armor-clad woman upon a charging horse, about to plunge her spear into a tiger attacking the neck of the terrified horse. This sculpture was consistently described as a "Lion" of the Exhibition—one of its prize attractions.[33] As Little Henry's Papa explains to him in *Little Henry's Holiday at the Great Exhibition,* the Amazon is impressive for its allegorization of human rationality conquering bestiality—proving once again that "*moral force* is greater than *physical force*": "Those eyes of the Amazon can speak, and the rude brute can read their language. They shew him a calm, fearless expression, saying 'Lion! my spirit is greater than thine. Be gone! and do not show thy savageness to me.'"[34] This sculpture was taken to symbolize the recurring Exhibition ideology by which natural, savage appetite was defeated by the rational mind. Papa's allegory also suggests one reason for the great popularity of sculptures at the Exhibition: they seemed to tell relevant stories of human life, inviting narrative interpretations, especially to first-time viewers of fine arts. The art experts who analyzed sculptures in the Crystal Palace had a very different account of them, and it is this tension I want to explore.

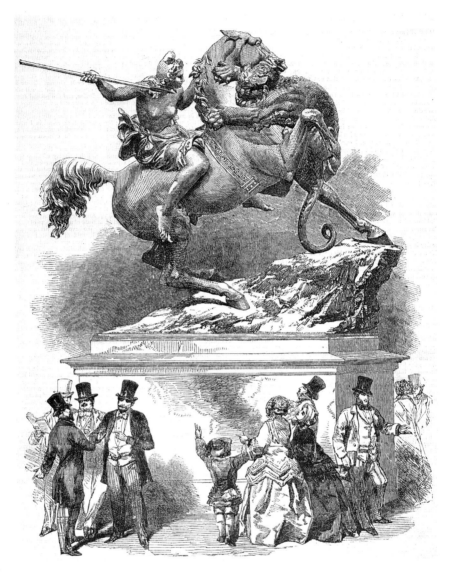

FIGURE 2.4 *"The Amazon, by August Kiss," The Crystal Palace and its Contents* (1851), 31. Rare Book and Manuscript Library, University of Pennsylvania.

Controversy swirled, in particular, around the Exhibition's numerous classically styled sculptures of nude women.[35] The Exhibition hall housed a scandalous number of sculptured naked women attached—or chained—to pedestals, offering spectators a titillating view of the naked female body. Inevitably surrounded by large crowds, these works included *The Greek Slave*, *Andromeda Exposed to the Sea Monster*, *The Veiled Vestal*, *The Circassian Slave Exposed in the Market*, *The Startled Nymph*, *Titania*, *Psyche*, *Eve with the Serpent*, and so on. Thackeray's Mr. Maloney sums up the situation with appropriate cheekiness:

There's statues bright
Of marble white,
Of silver, and of copper;
And some in zinc,
And some, I think,
That isn't over proper.[36]

An anonymous pamphlet demanded that British artists clothe their nudes with modest drapery. The indignant author, faced with a naked statue, asks, "What parent can ever stop before any such production of art, however exquisite its execution . . . or beautiful its proportion, and point out its excellences to his daughters?—what brother to his sister? . . . what friend of any worth or principle to any British female leaning on his arm?"[37] The author suggests that a trained artist might be deadened to "moral emotion" when drawing from nude figures in life; but "look at the multitudes daily crowding into that Palace—is there *one* in fifty thousand who has been *thus stoicly trained?*"[38] By definition, the artist's eye has been inured to nudity, but most of the Exhibition audience has yet to learn to see "art" instead of "women," and in the meantime drastic steps must be taken.

While the satirists of *Punch* usually took the side of popular moral indignation, mocking the pretensions of culture mavens, in this case they could not resist deflating the absurdity of the anti-nudists, and printed a mock clothing advertisement for "Rochfort Clarke's 'Sermons in Stones' " (figure 2.5): "Messrs. Smouchey, Slouchey, and Company . . . anxious to aid in the great moral movement which has, with such true delicacy of feeling, just been set on foot in reference to works of Sculpture, are now prepared to substitute for the extremely unbecoming garb of Nature, a large assortment of left-off wearing apparel," with costumes "to suit every variety of Statue, at the following moderate prices," including "A Pair of Check Pants, for Apollo Belvedere" and a "Stout Jersey shirt, for Hercules."[39] Both sculptures are illustrated in the margins, classically posed but garbed in contemporary Victorian (working-class) costume. The cartoon manages to mock at the same time the pretensions of Greek sculpture, the narrow-mindedness of religious intolerance, and the banal phraseology of Victorian advertising.

Charles Wentworth Dilke, author of a commentary on fine arts at the Exhibition, writes delicately of the nudity issue:[40]

It has been the custom of late to debase the uses of the chisel, by the exhibition of designs more fitted to the easel, a descent unworthy of the real artist, and easily tested by the remarks of the more literal class of visitors to exhibitions of this kind. The nude is a fearful field of

ROCHFORT CLARKE'S "SERMONS IN STONES."

MESSRS. SMOUCHEY, SLOUCHEY, AND COMPANY, of Holy-well Street, anxious to aid in the great moral movement which has, with such true delicacy of feeling, just been set on foot in reference to works of Sculpture, are now pre-pared to substitute for the extremely unbecoming garb of Nature, a large assortment of left-off wearing apparel; which it is hoped will meet the requirements of good taste and decency combined. The stock contains every variety of costume to suit every variety of Statue, at the following moderate prices:—

	£	s.	d.
A Pair of Check Pants, for Apollo Belvedere	0	10	0
Stout Jersey Shirt, for Hercules	0	4	6
Superior ditto, warranted to wash	0	5	9
Boy's Suits for Cupids—complete	1	15	0
Liveries for Mercury (from)	2	5	0
500,000 Straw Bonnets for Venuses at (each)	0	1	4¾
Classical Cothurni or Buckskins, for Diana	2	10	0
Doeskin Suit for Laocoon, and Eel-skin ditto for the Snakes	5	10	0
Tunic for Infant Hercules	0	12	6
Turkish Trousers for Greek Slave	0	15	0
Double-milled Overcoat for Dying Gladiator	1	1	0

N. B. A Mourning Department for Marble Widows.

Statues supplied by contract with two or three suits per annum at moderate prices—The old ones to be returned.

THE ACHILLES WAITED UPON FOR ORDERS, IF REQUIRED·

FIGURE 2.5 "Sermons in Stones," *Punch* 20 (1851): 224. Rare Book and Manuscript Library, University of Pennsylvania.

experiment to those uncultivated in the sublimity of the Greek mod-els, . . . and he [the artist] would be wise to attend to the conduct and remarks of the most illiterate observer; such is the power of the really sublime in art, that the most common-place observer stands before it with an instinctive reverence, in some cases highly amusing; even if the instant before he has uttered some waggish criticism on a less elevated production from the chisel. There is no mistake in this, and so sure as an artist listens to continued light—not to say ribald—criticism, so sure has he mistaken his fort. The power of the legitimate sculptor is to elevate the mind of the beholder, falling short of this, high art is not with him.[41]

In other words, nude sculptures chiseled in too literal detail are dangerous to the uneducated viewer. Once again, the expert worries about the responses of "the most illiterate observer," whose "ribald" comments might actually be taken as indicative of a sculpture's worth. Too much realism entails a pornographic dan-ger by which nudity might become nakedness, and a woman's sexuality might become open for comment.[42] Making the sculpture nude, as opposed to naked, lends it the character of a fetish object, where the perfect abstracted smooth-ness of the marble both presents and ultimately disguises the sexual nature of the body.

The crucial element dividing high from low art, in the estimation of learned sculpture critics, was the way in which a sculpture represented details. One

wildly popular sculpture that was universally scorned by the critics was *The Veiled Vestal* (figure 2.6). The sculptor cleverly creates the illusion of a veil, so that, as *The Yorkshire Visitor's Guide* explains it, "though many portions of the face are not touched by the veil or the chisel, the eye unconsciously fills up the outline, presents to the mind a perfect picture where there is only a very imperfect outline, and the optical illusion is complete."[43] The critic in the *Crystal Palace Cyclopaedia* attacks the image of the veil as not a "genuine effect" but a "delusion," "not a matter brought to the mind's eye by means of the sense of sight, but a trick played off upon the too credulous fancy at the expense of the organ of vision."[44] (Once again Jonathan Crary's diagnosis of the mid-century sense of vision seems apt.) The *Art Journal* complains of the crowd's preference for such works over classical sculpture, saying, "The only quality that seems to strike them [the public] is, generally, the exact representation of some trivial accessory—a veil, the coil of a rope, or the curl of a wig. The truth is, their education and pursuits naturally lead them to a lively sympathy with the industry that conquers technical difficulties; and not at all, with the genius that embodies a poetical Idea. There is, however, a vast deal of this preference of the curious over the beautiful, in the rich vulgar as well as the poor; as the admiration of

FIGURE 2.6 *"The Veiled Slave in the Market,* by R. Monti," *The Crystal Palace and its Contents* (1851), 64. Rare Book and Manuscript Library, University of Pennsylvania.

the Veiled Lady abundantly proves."[45] Although the crowds venerated the technical prowess of sculptures that created special optical effects, their admiration was seen as part of a mindless craving for bodily sensation rather than a more rational appreciation of "poetical Idea."

It becomes a repeated concern among learned critics, then, to expect certain responses from certain classes of viewers. Less-educated viewers were seen to consume sculpture as a kind of mass-culture entertainment, and to appreciate only its superficial qualities: the technical reproduction of detail, sensational tricks of the eye, or representation of a lurid tale. Critics claiming the status of expert, on the other hand, judged sculptures based on how closely they approximated classical ideals of form. Greek sculpture was exemplary because it struck a perfect balance between the real and the ideal, combining a scientific analysis of the human body—defining symmetrical ratios for the ideal human form—with an abstracted, unreal smoothness proper to the representation of divinity. In his *Prize Treatise on the Fine Arts*, Henry Weekes explains why Greek sculpture, embodied by the Apollo Belvedere, is perfect: "[T]he absence of a too servile or literal imitation of nature spiritualizes the form, lifts it into the supernatural, keeps the spectator at a respectful distance, and separates him from it as far as man is from God."[46] Again, the underlying notion of distance defines the aesthetic vision, a rational appreciation of form rather than an immediate, sensational, or emotional response.

A disdainful attitude toward an ignorant public had been in currency at least since Wordsworth's preface to *Lyrical Ballads*, and, like Wordsworth, the Exhibition art critics also value originality as opposed to mere "servile" copyism. Perhaps the entrenchment of these Romantic categories—which seem to respond to the powerful machines scattered in amongst the sculptures—explains why Cole's attempt to wed art and manufactures was doomed to fail. The learned critics valued sculpture for all of the ways it differed from a machine-made product. As the *Crystal Palace Cyclopaedia* critic contemptuously writes of *Andromeda in Chains*, "[T]here is no honour in producing in bronze an article which any manufacturer of hardware could make by the dozen."[47] Yet—as no Victorian art expert would want to admit—a classical-style sculpture does share certain qualities with machine-made objects. The symmetry, smoothness, regularity, and finish of sculpture were all typical of the products of machine labor—as Ruskin famously argued in his defense of the Gothic.

In fact, when Ruskin's ideas in *Stones of Venice* are contextualized against the body of writings at the Exhibition, they begin to seem increasingly idiosyncratic. In "Nature of Gothic" he attacked Greek style for its symmetrical and mindless repetition. Yet even while he scorned the machine-like nature of Greek art, most art professionals were praising the Greeks for their graceful

forms, which, it was thought, were influential in cultivating the "rude" people of the British north. Exhibition art experts routinely explained the ignorance of the British public by the fact of their innate, northern roughness, as opposed to the inherently cultured blood of southern European countries like Italy and Greece (an idea Ruskin recapitulates in his essay on the Gothic, with reversed valences of value).[48] The art experts hoped that the Exhibition would serve as "a lesson in taste," in which the high art of the Greeks diffused down to common people. As the *Crystal Palace Cyclopaedia* writes, "For the first time almost in our history the common people of England are brought familiarly into contact with, and derive instructions from, the clear, definite, and brilliant conceptions of the Greeks."[49]

Indeed, despite the popularity of the Gothic style, it was Greek culture that defined the pinnacle of civilization for the Victorians. Even though this classical culture had reached its height more than two thousand years earlier, art critics still found ways to place it high in the Exhibition's classificatory scheme, because Greek culture epitomized the mixture of scientific, philosophical, and artistic thought that Victorians desired to emulate. In *The Victorians and Ancient Greece,* Richard Jenkyns describes the cultural capital associated with Greek art: "People easily came to associate museums with Greek sculpture, and Greek sculpture with culture at its most 'museumified' . . . Grecian sculpture . . . became a visible symbol of social or cultural pretentiousness; the emperor, in a double sense, had no clothes."[50] Greek sculpture was a key cultural signifier not only within the elite art space of the museum but also for art writers claiming expertise, whose detached gaze accorded with the progressive Western vision prized by the Exhibition.

Britain's elevation of Greek sculpture coincided with some of the other powerful classificatory ideologies of the Exhibition, especially those of color and race. Richard Jenkyns writes, "Whiteness suggested simplicity, limpidity, lucidity; it was often mentioned in connection with the Greeks even when sculpture was not in question."[51] Though Jenkyns does not speak explicitly of race, his comment suggests that the Victorian admiration of Greek sculpture was based upon a racist anthropology of color. White, smooth marble connoted a pure, classical physique superimposed upon the desexualized upper-class Western body.[52] This snowy perfection was opposed in the Victorian mind by the darker-skinned, sexualized bodies of foreign women from Eastern or African countries. The so-called "Hottentot Venus," an African woman displayed in England early in the century, was a well-known figure in the Victorian eye; that she was ironically dubbed a "Venus" points to an association with Greek sculpture. William Whewell's essay "On the General Bearings of the Great Exhibition on the Progress of Science and Art" is a classic anthropological statement of the Exhibition.[53] Whewell depicts women of the South Pacific as the lowest people on the culture chain: "From Otaheite,

so long in the eyes of Englishmen the type of gentle but uncultured life, Queen Pomare sends mats and cloth, head-dresses, and female gear, which the native art of her women fabricates from their indigenous plants."[54] The women are practically synonymous with the natural products of their art.

The entrenched mid-Victorian ideology of color and culture was challenged by the most popular, influential, and controversial of any of the sculptures—indeed, any of the exhibits—found in the entire Exhibition. This was *The Greek Slave* (figure 2.7), by the American sculptor Hiram Powers, "which was thrust forward in such a prominent position," complained the *Crystal Palace Cyclopaedia,* "and upon which King Mob lavished so much wild and unmeaning encomium."[55] Displayed under a red velvet canopy in the American section of the hall, the sculpture of a nude girl chained to a pedestal portrayed a touching and titillating scene,

FIGURE 2.7 Hiram Powers, *The Greek Slave,* marble, 1851, after an original of 1844. Yale University Art Gallery, New Haven, Connecticut. Photo credit: Yale University Art Gallery / Art Resource, N.Y.

ensuring that the sculpture was always surrounded by admirers. The *Official Cata-logue* describes the scenario: "The artist has delineated a young girl, deprived of her clothing, standing before the licentious gaze of a wealthy Eastern barbarian. Her face expresses shame and disgust at her ignominious position, while about her lips hovers that contemptuous scorn which a woman can so well show for her manly oppressor."[56] The plight of the young girl about to be sold into slavery occasioned much sympathy and much bad poetry.[57]

On the face of it, this sculpture should have been yet another triumph of Western art, proving the connection between the ability of Western artists and the advancement of its civilization. Although, by British standards, America was just slightly lower than Britain on the scale of advancement, it was still considered very much a part of Western progressive culture. Yet America was unforgivably flawed in many British eyes for its continuing practice of slavery. The concerns of the British Anti-Slavery Society dominated public forums in the early 1850s, and they convened a meeting during the summer of 1851 as the Exhibition was in full swing.[58] Many commentators in the British press made the ironic contrast between the beauty of *The Greek Slave* and the misery of African slaves in Amer-ica—a comparison made most directly by a famous John Tenniel cartoon in *Punch* (figure 2.8), in which a "Virginian slave" appears in the same pose as *The Greek Slave*, exposed on an auction block next to an American flag.[59] The *frisson* of the cartoon arises from the play of white versus black, with the shocking substitution of an African woman for the marble Greek.[60]

The art experts who commented upon *The Greek Slave* almost universally ignored not only the controversial connection to American slavery, but even the fact that the figure was supposed to be a slave. The most common basis for their evaluation of the sculpture was, again, its formal approximation of the classical ideal. Charles Wentworth Dilke, in his *Reminiscences of the Crystal Palace,* writes, "The plaintive calmness of the downcast figure, the faultless symmetry of the limbs, and the easy repose of the position, make this statue the centre of a bevy of admiring spectators... We recommend it to the artist, the statuary, and, as the *Athenaeum* would say, to the lover of the beautiful."[61] James Ward tentatively dis-agrees, not wanting to make an outright attack on a sculpture of this sensitive subject. He finds that "the artist's mind does not appear to have been severely disciplined in the beauty of form, and the nicely-adjusted anatomy of the female figure. The arms hang as though they didn't belong to the figure; the left hand seems mechanically placed in its present position, and has little affinity with the feeling which seems ready to burst her very heart." He concludes that the figure is "a defective representation of a cruel, yet touching, incident."[62] The learned critic of the *Crystal Palace Cyclopaedia* unleashes a load of scorn upon the sculpture, find-ing it utterly divergent from antique ideals of posture and proportion. He also attacks the description of the sculpture's scenario in the *Official Catalogue* for its

FIGURE 2.8 "The Virgin-
ian Slave," *Punch* 20 (1851):
236. The Pennsylvania State
University Library.

THE VIRGINIAN SLAVE.

INTENDED AS A COMPANION TO POWER'S "GREEK SLAVE."

unhistorical explanation of the slave's nudity—"the knowledge of which deprives
the work of that legitimate charm which attaches to the nude figure of ancient art,
wherein an obvious innocent unconsciousness of *dishabille* prevents all compunc-
tions on the score of propriety." He angrily concludes that the sculpture is a "poor
copy of the 'Venus di Medicis,' with a romance attached to give it a relish"; it is "a
bad beginning for American art, which must produce something more *genuine* if it
intends to take rank with the schools, bygone and to come, of Europe."[63]

These last comments suggest the difficulty of America's status in the Exhibi-
tion's hierarchy. Composed of former colonies, it was a robust producer of raw
materials, but its products of culture seemed doomed to inferior status when
compared with those of Europe.[64] Ironically, when the critic demands something
more "genuine" from America, he really asks for a more genuine imitation of the
classical model, which was the paradoxical stamp of advanced high culture. The

art experts often invoked the words "servility" or "enslavement"—but used them to attack an unoriginal style or a machine-like detail, rather than making any direct political statement. When *Punch* portrays an enslaved African woman in the pose of *The Greek Slave*, it satirizes not only the pretensions of America to join the cultured world of Europe, but also the very notion of culture that Europe holds dear, as epitomized by the art experts' obsession with antique form.

The sentiment of *Punch*'s cartoon was prefigured in a very different genre in an 1850 sonnet composed by Elizabeth Barrett Browning, as Powers' sculpture was en route to display in England. This sonnet is important because, while reproducing the familiar Exhibition ideologies of cultural comparison, it also juxtaposes both kinds of constructed spectatorship we have been examining—both the aesthetic detachment of the art experts and the more emotional, immediate view of popular audiences:

Hiram Powers' Greek Slave[65]

They say Ideal Beauty cannot enter
The house of anguish. On the threshold stands
This alien Image with the shackled hands,
Called the Greek Slave: as if the artist meant her
(The passionless perfection which he lent her,
Shadowed, not darkened, where the sill expands)
To, so, confront man's crimes in different lands,
With man's ideal sense. Pierce to the centre,
Art's fiery finger! and break up erelong
The serfdom of this world. Appeal, fair stone,
From God's pure heights of beauty, against man's wrong!
Catch up, in thy divine face, not alone
East griefs, but west, and strike and shame the strong,
By thunders of white silence overthrown.

Barrett Browning's sonnet also expresses the sentiments of the *Punch* cartoon, playing upon the same surprising misalignments of color, culture, and morality brought about by American slavery. Though America ought to be associated with the West and whiteness—of marble, skin color, and moral fiber—here the nation takes on the blackened character of Eastern despots. These wrongs are passionately conveyed using direct address and beseeching punctuation. But the sonnet also takes a detached view toward the sculpture, depicting the figure as both woman and art object, an "alien Image" removed from the flesh of human experience. Barrett Browning invokes the same associations of Greek culture as those of the art experts, portraying classical sculpture as the embodiment of "Ideal Beauty"

and "passionless perfection," a deliberately mute and "divine" figure looking down from "God's pure heights." On one hand, this combination of classically inspired detachment and political passion seems futile, given that the mute Greek figure, constrained by the stark forms of the classical ideal, is supposed to "pierce" the status quo with its "fiery finger." The final line heightens the sense of impotence, with the sculpture threatening only oxymoronic "thunders of white silence."

On the other hand, though, the Exhibition ideology that dictated the hierarchy of cultures was powerful enough to bring about the creation of the Crystal Palace. This ideology itself might be seen as a "thunder of white silence," capable of "shaming" a Western country into falling into the proscribed order. The British sense of racial-moral superiority to other countries was a crucial factor in its decision to abolish slavery there earlier in the century. The underlying racial dogma of the poem is embodied in the key descriptor "shadowed, not darkened": the innately white sculpture is not stained by her circumstances, either sexually or morally, as opposed to races of the East, who will inevitably be "darkened" by their own foreign natures. The sonnet's plays on white and black imply that slavery is more acceptable and even expected in the East, due to racial proclivities, while its presence is shocking in the "shadowed, not darkened" West. Even while the poem argues for the radical overthrow of American slavery, it does so using all of the anthropological stereotypes that would soon appear at the Exhibition, including the trope of a classically inspired, rational, and white Western eye.

Gothic *fetiche*: Pugin's Medieval Court

If the British glorification of antique art seems paradoxical in light of its desire to prove itself the most advanced civilization on earth, then another glaring inconsistency in that narrative of progress could be found in the Exhibition's Medieval Court. According to many visitors, to step into this court was to step back into the thirteenth century, entering a magical atmosphere of history and faith. Designed by A. W. Pugin and other Birmingham design and manufacturing firms, the court displayed ecclesiastical ornaments on one side, and on the other hand-crafted domestic furniture in the Gothic style (figure 2.9).

This medievalized space must have been an extraordinary spectacle when seen against the ultra-modern glass and iron structure of the Crystal Palace. Yet despite their contrasting visual and historical styles, both Palace and Court used modern materials to create a phantasmagoric realm for spectators. Amid the different spaces of the Great Exhibition, the Medieval Court was a world within a world. A correspondent for *The Journal of the Great Exhibition of 1851* describes the court in terms evocative of Ruskin: "There [in the Mediaeval Court] the Gothic element reigns supreme. It was worshipped of yore in the great stone books

FIGURE 2.9 "The Medieval Court at the Great Exhibition." Colored lithograph. *Dickinson's Comprehensive Pictures of the Great Exhibition of 1851* (London, 1852). Reproduced with the permission of Rare Books and Manuscripts, Special Collections, the Pennsylvania State University Libraries.

of the middle ages—the cathedrals. It reared itself in vast towers and fretted pinnacles—it flung itself into dark and shadowy aisles...It piled up, stone-like, the vistas of forest trees, and made a counterfeit presentiment of the solemn glades where the Teuton nations sacrificed to their deities. All was vast, grand in conception, and gloomily vigorous in execution."[66] Pugin's Court summoned up images of prehistoric grandness, along with a disquieting extremity of worship entailing gloomy (and thrilling) "sacrifice." In her essay on colors at the Exhibition, Mrs. Merrifield censures the Court for displaying "too much ornament; too much positive colour; too much unsubdued splendour; scarlet and gold meet the eye in every direction, and overpower it with their brilliancy."[67] In the end, most critics dismissed the Medieval Court as backward and outdated; as the *Crystal Palace Cyclopaedia* critic writes, "[T]he decorative fancies which in real Medieval works become curious to us as matters of comparative history, are lifeless, tame—not to say absurd—when copied in a more enlightened age."[68]

The Medieval Court was a lightning rod for controversy before the Exhibition even opened. Its designer, Pugin, was a Catholic convert and one of the most outspoken defenders of the controversial faith. In 1851 Catholicism was drawing venomous attacks in the popular press because of the so-called "Papal aggression": for the first time since the Reformation, Pope Pius IX had created a

Catholic hierarchy in England, instituting Nicholas Wiseman as the Cardinal of Westminster Cathedral in September 1850. Consequently, the year of the Exhibition saw intense anti-Catholic sentiment, with every week bringing new accounts of monastic abuses, Mariolatry, the prurience of the Catholic clergy, and vicious attempts to convert innocent English Protestants.[69]

Pugin brazenly invited the anti-Catholic fire by placing a massive cross prominently in his Medieval Court. In March of 1851, after complaints from Evangelicals, Lord Ashley wrote to the Prince and the Foreign Secretary that he feared "a Popish chapel was being erected inside the exhibition."[70] The *Times* received a flood of indignant letters. The Foreign Secretary suggested to Lord Ashley that "It wasn't a crucifix, only a cross, and Pugin had agreed to place it in a corner."[71] Prince Albert defended himself to the Prime Minister by protesting that he had already forbidden the Belgians to exhibit waxwork models of the Pope and twelve cardinals as a setting for a display of Brussels lace. "But," the Prince wrote, ". . . I cannot prevent crucifixes, rosiers, altar plate, etc. . . . Those who object to their idolatrous character must be relieved to find Indian Pagodas and Chinese Idols in other parts of the Exhibition."[72]

The controversy surrounding the cross in the Medieval Court encapsulates one facet of the larger mid-century debate about spectatorship. Why would an Indian pagoda or Chinese idol be safe for Western eyes, while the Catholic cross is so disturbing? The answer lies not simply in the difference between cultures but in the way that different cultures were seen to consume their objects. If the Exhibition's culture scale dictated that Indian and Chinese cultures were less progressive than the West, this inferior status was embodied by their magical, fetishistic attachment to objects. For the Court's critics, when Pugin placed a Catholic cross in British quarters, he threatened to undermine the whole narrative of Western progress by expressing a very un-Western, immediate symbolic attachment to the object. Prince Albert, himself one of the Exhibition's art experts, suggested that the most advanced eye will be equally detached from all of the objects on view. He takes a predictably rational approach to the controversial objects, a perspective echoed by other Exhibition art writers.

The best expression of the rational approach to style was Ralph N. Wornum's influential and prize-winning essay, "The Exhibition as a Lesson in Taste." In 1853 Wornum would become the keeper and secretary of the National Gallery; he was an early professional in the Victorian art world.[73] Wornum's essay traces the history of styles from ancient through modern. He finds that the least developed styles are those which are purely symbolic, like Egyptian hieroglyphics, while the most advanced are those that use ornament "solely for their effect as delightful objects to the eye"—such as, unsurprisingly, the Greek. "It is not until we come to Greece that we find the habitual introduction of forms for their own sake, purely as ornaments, and this is a very great step in art." Within Wornum's scheme of value, the Medieval Court is an aberration. He writes,

Where the thing is not made for its own sake or the use it may be of, but purely as an embodiment of the old bygone idea that originally caused it [i.e., Catholicism], it is merely a cowl to smother all independent original thought or ingenuity, and by preserving symbolism as principal in all efforts would reduce Art much to what we find it in India, or rather China. Indeed, except in the most obvious forms of superstition, this court already presents a striking similarity in taste to that of the Indian works, in its rude undefined details, and in richness of material.[74]

Once again, the Gothic style is evocative of the "backward" civilizations of India and China, even though the styles look nothing like each other. (Catholic art was also linked to Indian and Chinese art in the British mind for the imperial relation to all of these cultures, via Ireland; indeed, Wornum's characterization of Indian or medieval art as being both unrefined and rich in material is phrased in terms that might describe the quintessential colonial export.)[75] Wornum also ignores the fact that classical Greek style was often symbolic, as when it was used to worship pagan gods. Yet by now we can understand Wornum's oversight; if antique style was a signifier of the aesthetic vision of the art expert, then by definition it was *not* symbolic. Wornum writes that classicism embodies, in an oft-repeated phrase, "the pure principles of Art," an ideology of abstract principles of visual form separated from direct symbolic meaning.[76] Wornum's notion of taste resembles a Kantian disinterestedness, and his detached vision of ornament "for its own sake" seems a direct inheritance from Enlightenment, secular modes of seeing.

Although Wornum objects to the medieval revival on an aesthetic level, he does not resort to some of the more violent anti-Catholic rhetoric unleashed by the popular press. His attack takes place on the level of idea, rather than emotion. Art expert Henry Weekes takes a similar tone, explaining why medieval art is safe for the modern viewer: "Reason has now so firmly established her throne amongst us, that there can be no further danger of the Arts being again perverted to the wrong purposes they formerly were; and they who differ from, as well as they who assent to, the religion under which the great works of ancient days were produced, may now look upon them without the slightest danger of being led backward in their judgment by the associations with which they are connected."[77] Weekes describes Gothic art as though Catholicism were a dangerous temptation, to which the Arts will not succumb since they are now protected by reason. In this language of seduction and resistance we can detect a similarity to the nude sculpture controversy; both scandals raise the specter of an unwholesome, "perverted" relationship to the human body. Catholicism itself was relentlessly portrayed as a cult of lasciviousness, embodied by its ornate Gothic style. Mrs. Merrifield's reaction to the Medieval Court's colors has an expressly physical tinge, fearing that the scarlet and gold will "overpower" the vulnerable spectator.[78] No wonder

that the Exhibition's rationalist ideology, by which British reason conquers the desiring eye, was so threatened by Pugin's Medieval Court.

The disinterested rationalism of art experts like Wornum and Weekes was not a popular view of Catholic art. A vicious anti-Catholic *Punch* satire of 1851, entitled "The Genteel View of the Papal Aggression," ridicules the idea that Gothic style can be separated from religious content. The inspired satire takes the form of an indignant letter supposedly written by an aristocratic lover of art, whose prose is larded with pompous French phrases and art jargon. Addressing "Thou Dense Old Punch," the author wishes that the journal would stop attacking the "Roman Catholic hierarchy":

> Cannot you understand that we—the cultivated classes, I mean—have quite ceased to consider the question with reference to material fact, and vulgar—or common sense? We regard it entirely in an aesthetic point of view—as a matter of Taste: and this is what renders your coarse actualities so shocking to us . . . So far as we are concerned with the Papacy historically, we survey it in its colour, its contour, and proportion—*comprenez-vous?*
>
> Inquisitions, *Les Huegenots* affairs, and the like, are merely the darker shadows, necessarily required to bring out the lights and brilliant tints of the Grand Picture . . . And you cannot suffer a little Papal Aggression! "*En verite, mon ami,* I would advise you, before going any further in polemics, to *emparer* yourself of some notion of the Aesthetic Principle. Your disgusted reader, FLEUR DE BELGRAVIE.
>
> [Punch replies:] I flatter myself I know what the "aesthetic" principle is, pretty well. A certain calf of gold was made once, I believe, on that "principle."...And on precisely the same "principle," I take it, does the negro grovel before his *fetiche*.[79]

This satire lays open some of the profound philosophical issues underlying the two competing modes of vision. From *Punch*'s populist standpoint, the rationalist "aesthetic principle" is a synonym for absolute relativism, where all ideas are examined for their form alone, while moral or religious concerns are irrelevant. Thus the heinous violent acts committed by the Catholic Church are merely "dark shadows" alongside the formal beauty of their religious objects. The satire implies that the aesthetic principle is a privilege of aristocratic classes, whose insulated luxury exempts them from the anxiety of moral concern. *Punch*'s reply to the aristocrat insinuates that his aesthetic principle is actually a thinly veiled form of atheism, or, even worse, idolatry, akin to the adoration of the golden calf or African fetish worship. In other words, though the aesthetic eye might pretend to ignore the moral or religious content of images, its love of form is in fact just another version of heathen fetishism.

Though the neo-Catholic aristocrat positions himself above the rabble, *Punch* portrays him as no better than African natives—a link that also gestures to Britain's

imperial dynamic, by which the great colonial rivals like France, Portugal, and Spain all showed "idolatrous" and Asian or African tendencies owing to their Catholicism. As C. A. Bayly notes, this early Victorian version of anti-Catholic racism was distinctive for its emphasis on a culture's ostensible moral qualities, and emerged in Britain as "the dominant public discourse of a new Christian imperialism."[80] Popular anti-Catholic sentiment thus made an easy alignment of stereotypes by which British aristocrats might transform into neo-Catholic, idol-loving, fetish-worshipping, artistic Frenchmen. The very gorgeousness of the Gothic takes on a racial quality, which threatens to infect any potential English worshippers.

Pre-Raphaelites: Exhibiting Time

Punch's anti-Catholic satire appears with an illustration, a sketch of a diminutive angry painter, bearded and bereted, shaking a fist in front of a medieval painting (figure 2.10). The sketch suggests that the speaker is both an aristocrat

THE GENTEEL VIEW OF THE PAPAL AGGRESSION.

HOU DENSE OLD *Punch*,

"PRAY let me prevail upon you to abandon the line you have taken in reference to the Roman Catholic hierarchy. *A cet égard*, you have quite *manqué votre coup*—that is the universal opinion of all who move in good society. You plant your guns all wrong—on the old forsaken ground of history, ethics, and logic; and all your shots fly wide of the mark. *Bête* that you are, don't you know that all the world—the world of intellect and refinement, I mean—ignores that prosaic realism? Besides, it is quite *de mauvais goût* to argue on stakes, fagots, racks, thumbscrews, and horrid things of that sort, by mentioning which you only produce exasperation, and convince nobody, among the *gens comme il faut*, whatever may be your success with the *canaille*.

"Cannot you understand that we—the cultivated classes, I mean—have quite ceased to consider the question with reference to material fact, and vulgar—or common sense? We regard it entirely in an æsthetic point of view—as a matter of Taste: and this is what renders your coarse, hard actualities so shocking to us. You joke—or reason, which comes to the same thing—as if we would condescend to estimate the consistency of a BORGIA's conduct, for instance, with the claims of

FIGURE 2.10 "The Genteel View of the Papal Aggression," detail, *Punch* 20 (1851): 37. Rare Book and Manuscript Library, University of Pennsylvania.

and an artist. For most viewers, the medieval and Catholic revivals were both inextricably linked to the controversial paintings of the Pre-Raphaelites, who had been causing a sensation at the Royal Academy since the summer of 1850. Though this rebellious group of young artists had been exhibiting work with the mysterious initials "P.R.B." since 1848, it was only in 1850 that the meaning of the acronym became widely known, resulting in a wave of hostile press.[81] Embracing a "Pre-Raphaelite" painting style of fourteenth-century Italy, artists Dante Gabriel Rossetti, John Everett Millais, and William Holman Hunt depicted romantic scenes of knights and ladies—and deliberately courted links to Catholicism. The public mind thus freely associated Pre-Raphaelitism with the architecture of the Gothic revival, though the revived styles and historical periods were completely different. The outcry raised by both Pre-Raphaelitism and Pugin's Medieval Court points to the way that religious art at mid-century bore a disproportionate burden in the battle of styles—suggesting that the threat of Catholicism in the visual sphere exceeded the challenges of mere doctrinal argument.[82] Anna Jameson, writing in the introduction to her 1848 *Sacred and Legendary Art,* describes how until recently "any inquiry into the true spirit and significance of works of Art, as connected with the history of Religion and Civilisation, would have appeared ridiculous—or perhaps dangerous: —we should have had another cry of 'No Popery,' and Acts of Parliament forbidding the importation of Saints and Madonnas."[83] English Protestant viewers were suspicious of visual arts that performed a spiritual function, since these were seen to draw dangerously close to Catholic idolatry and "Popery." Catholic art, like the controversial displays at the Great Exhibition, threatened to make British spectators into lustful icon-worshippers. Jameson goes on to reassure her readers that she will take an "aesthetic" rather than a religious approach to her subject—an attitude soon to be adopted by Exhibition art experts.

The critical uproar greeting Pre-Raphaelitism in 1850–51 prefigured many of the same desires and anxieties surrounding the major visual scandals at the Great Exhibition. Pre-Raphaelite paintings offered a seductive attraction similar to Pugin's Medieval Court: both manifested the Victorian desire to reclaim, revisit, and concretize the past, appealing to the era's well-known penchant for historicism rendered in an alluringly realistic visual form. Stephen Bann has written of how early-Victorian mass-culture entertainments like panoramas satisfied this delight in the detailed visual resurrection of historical scenes—scenes that were often Catholic, Gothic, and monastic.[84] Yet the press response to Pre-Raphaelitism in 1850 was largely negative, often spectacularly so. If some mid-Victorian art sensibilities demanded a progressive, scientific way of looking and painting, the Pre-Raphaelites confounded these demands by deploying a super-sharp, finely detailed style to depict subjects from the distant past, such as medieval stories and Catholic imagery.

Reviewers dwelled especially on the problem of the body in these images, which rendered figures in awkward poses, blending the flatness of early Italian painters with the realism of actual bodies. For instance, John Everett Millais's *Lorenzo and Isabella* (1849) portrays a banquet scene not by elaborating on rounded characters along the full length of the table, but by moving to the table's protuberant edge, foregrounding the odd postures and narrow physiognomies of the story's main figures (figure 2.11).

In part, the press attacks on these figures were simply rehashing old prejudices about Catholicism, whose followers stereotypically pursued both ascetic self-torture and voluptuous sensuality. But the reviews were also responding to the Pre-Raphaelites' contradictory combination of a scientific, almost photographic visual style with old-fashioned subjects and postures. Art experts like Ralph Wornum, who attacked Pugin's Medieval Court, also objected to the Pre-Raphaelite project for its deliberate confusion of the progressive timeline of art history. Both the Exhibition and the nascent discipline of art history depended upon a linear narrative of progress—in the case of art history, scholars narrated a triumphant march in painting from stylized medieval figures toward a perfect, scientific illusionism epitomized by the Italian Renaissance paintings of Raphael.[85] When Rossetti and Millais adopt the name "Pre-Raphaelite" as a moniker, their choice resounds as a deliberate battle-cry against the powerful developmental

FIGURE 2.11 John Everett Millais, *Lorenzo and Isabella*. Oil on canvas, 1849. Image © National Museums Liverpool, Walker Art Gallery.

tale of Western art. In his 1850 review of the Pre-Raphaelites, Ralph Wornum retells the familiar narrative of art's evolution from its "swaddling clothes" in the Middle Ages to its culmination in the High Renaissance, as epitomized by Raphael's perfect union of "matter" and "spirit." Medieval art, Wornum writes, "was employed in mortification of the flesh"; Pre-Raphaelitism similarly distorts bodies, such that "few ordinary observers . . . can look on it without a shudder." Yet Pre-Raphaelitism's almost photographic visual style aligns it with the Western progress Wornum embraces at the Exhibition. He ultimately refuses to condemn the painters outright, concluding, "we wish them to persevere, but in the spirit of world-artists, not ascetic fanatics."[86]

Reviews aimed at a more popular audience tended to reject Pre-Raphaelite artworks, but also had to negotiate a problematic confusion of values. In particular, John Everett Millais's 1850 painting *Christ in the House of His Father* drew extreme ridicule for its shockingly realistic, even wart-ridden depiction of the Holy Family (figure 2.12). Just as popular voices accused art experts of immoral detachment at the Great Exhibition, so too critics attacked Millais's painting for its scientific anatomization of religious figures. *Punch* parodied the image as a medical illustration from "Cooper's Surgical Dictionary," suggesting that the figures with their "emaciated bodies, their shrunken legs, and tumid ancles," perfectly illustrated "the scrofulous or strumous diathesis." Millais's "mechanical" abilities are impressive, *Punch* concludes, but he ought to stick to medical illustration and "leave the Testament alone."[87] Charles Dickens wrote a famous,

FIGURE 2.12 John Everett Millais, *Christ in the House of His Parents*. Oil on canvas, 1849–50. Tate Gallery, London. Photo credit: Tate, London / Art Resource, N.Y.

scathing review of Millais's picture titled "Old Lamps for New," where he accuses the painter of subscribing to a "Pre-Galileo Brotherhood" for the backward flatness of his figures. Yet in the very same review, Dickens also charges Millais with blasphemy for updating the scene of the Holy Family to a modern urban gin shop. Millais is guilty in Dickens's eyes of *both* too much modern realism and too much retrograde medievalism.[88]

Attacks on Millais's painting crystallized around the figure of the Virgin Mary, in many ways foreshadowing the same charges popular critics would level against the Crystal Palace's nude sculptures. Dickens raged that Millais's Mary would "stand out from the rest of the company as a Monster, in the vilest cabaret in France."[89] The painting's gritty details lead Dickens to describe the Virgin Mother as a French whore in a dance hall—just as the female sculptures at the Great Exhibition teetered on the balance between naked and nude, depending upon who was looking. The painting's excessive realism, in Dickens's eyes, opens the female figure up to sexual attack. Millais' visual impropriety also suggests a violation of class boundaries; like many critics, Dickens rewrites Millais's Holy Family as inhabitants of the London slums. *Tait's Edinburgh Magazine* complains, "Mr. Millais gropes in lanes and alleys till he finds a whining, sickly woman, with a red-haired, ricketty bantling, transfers them with disgusting fidelity to his canvass, and tells us that is the representation of all that awakens our holiest, purest, and most reverential sympathies."[90] The painter's repulsive "groping" evokes both his urban slumming and his impertinent realism, as the visual details convey an inappropriate, lecherous intimacy with the Virgin's holy body. In using a scientific vision to see symbolic characters as though they were actual people, Millais offends against both popular and professional viewpoints. Opposing popular opinion, he refuses to give sacred figures the reverential, idealized treatment they traditionally receive. Flying in the face of professional values, he bestows a scientific style on Catholic subject-matter and flattened bodies, defying the relations between form and content prescribed by the Greeks.

Some Pre-Raphaelite criticisms also foreshadowed political narratives that would come to dominate at the Great Exhibition. The critic writing for *Tait's Edinburgh Magazine* assails the Pre-Raphaelites with the usual litany of "retrogression" and "backwardness"; but he also compares their cramped treatment of human bodies to the physical imprisonments carried out by other, less advanced cultures: "A child's foot is beautiful; therefore, says the Chinaman, crush the woman's foot into the child's shoe. A hornpipe may be danced in fetters; therefore iron is a better material for fleshings than silk." Likewise, the Pre-Raphaelites study the early artists and "read their lessons backwards. The Genius was once in the bottle; therefore, to attain greatness, [they] compress him into the bottle once again."[91] The awkward bodies of Pre-Raphaelitism reflect a double move backwards, both a literal cramping of the features and a metaphorical shrinking down into the

historical ignorance and political tyranny of the Middle Ages. Hence the paint-
ing of these tortured bodies is comparable to Chinese foot-binding and Ameri-
can slavery, since all combine Eastern ways of looking with political despotism.
Underlying this critic's accusations is the familiar story of Western development
told at the Great Exhibition. The most progressive artistic vision, an innately
British rationalism, ought to depict more Greek-styled, perfectly proportioned
bodies, wrought in the realistic three-dimensional space discovered in Renais-
sance Italy. This Raphaelesque visual style and corporeal treatment is a crucial
marker by which Britain distinguishes itself from other, more backward cultures.
To move deliberately away from this style is to regress, socially—thus embracing
the political evils of Eastern, American, or Catholic cultures. These art criticisms
are striking for the way that they encode assumptions about nation and politics
into their valuations of style.

The power of these ideologies can also be seen in their adoption by defend-
ers of the Pre-Raphaelites. Writing in *The Germ,* the Pre-Raphaelite little maga-
zine, F. G. Stephens also claims progress as a value, declaring "that which does
not advance falls backward."[92] In fact, Stephens argues, early Italian artists "came
nearer to fact," and "were less of the art, artificial"—as opposed to the "refined
or emasculate treatment of the same subject [the Virgin Mary] by later artists."[93]
Like Wornum and the Exhibition art experts, Stephens advocates realism as a
value; but he rewrites traditional art historical narratives to make *quattrocento*
Italian painters the masters of the real, especially for their "simple attention to
nature in detail."[94] Ruskin takes a similar line in his 1851 pamphlet supporting the
Pre-Raphaelites. Despite arguments to the contrary, Ruskin insists that the Pre-
Raphaelites do not imitate the errors of the Early Italians; "there is not a shadow
of resemblance between the two styles. The Pre-Raphaelites imitate no pictures;
they paint from nature only."[95] These painters are perfectly suited to Ruskin's
ideal, with their contradictory combination of nature-based realism and medi-
evalist subject matter. "If they adhere to their principles, and paint nature as it is
around them, with the help of modern science, with the earnestness of the men
of the thirteenth and fourteenth centuries, they will...found a new and noble
school in England." Ruskin combines the "modern" values of *Modern Painters* with
the more social concerns of *Stones of Venice*. The Pre-Raphaelites possess the lucid
sight in nature of *Modern Painters* alongside the moral "earnestness" and "honesty"
Ruskin associates with Gothic style.

Here we can observe the real idiosyncrasy of Ruskin's ideas, and also the real
power of his rhetoric. Ruskin straddles the divide we have been tracing between
discourses of the amateur and the expert at the Great Exhibition: he both reads
images symbolically *and* praises the notion of a penetrating scientific eye.[96] He
adopts the tone of both expert and amateur, marshalling the factoids of Vene-
tian imperial and architectural history while expressing the moral indignation

of popular attitudes. Hence the Pre-Raphaelites are admirable both for doing "justice to the intensity of [their] perceptions" and for rejecting the moral lax-ness of the Italian Renaissance, its "indolence, infidelity, sensuality, and shallow pride."[97] Because of Ruskin's idiosyncrasy, perhaps "Puginian" would more accu-rately denote a symbolic interpretation of visual objects. Pugin writes in his 1843 *Apology for the Revival of Christian Architecture,* "The history of architecture is the history of the world: as we inspect the edifices of antiquity,...the belief and manners of all people are embodied in the edifices they raised."[98] Pugin uses his Catholic faith as a springboard for moral judgments about architecture, praising the Gothic style and condemning the "degraded" Renaissance. Before Ruskin's 1851 *Stones of Venice,* Pugin was the most well-known British popularizer of the idea that architecture has an intrinsic morality—as seen when *Fraser's Magazine* in 1843 defines the verb "to Puginise" as the tendency "to mix up political and theo-retical speculations with architectural ones."[99] In Pugin's 1852 obituary notice, *The Times* wrote: "It was he who showed us that our architecture offended not only against the laws of beauty, but against the laws of morality."[100]

Ultimately, Ruskin, Pugin, and the popular *Punch* cartoons all demanded a very different kind of looking than did the Pre-Raphaelites. The lucid images and luminous visual details of (early) Pre-Raphaelite paintings suggest a detached and transparent style of vision that accords with the Great Exhibition and its progres-sive timeline. Ruskin and Pugin, meanwhile, subscribe to a notion of vision that twentieth-century shorthand has come to call "Ruskinian": that is, seeing objects as inseparable from their moral history and the material circumstances of their production. In the end, it is a great irony that Ruskin has been credited with cleansing the Gothic style of its Catholic taint, since, in the context of the Exhi-bition debate about the signification of the visual, Ruskin's theories share some-thing with the Catholic faith itself. If Catholicism venerated the image as a vessel of belief, and saw material objects literally transubstantiated into the body and blood of God, in the same way Ruskin's Gothic stones embodied the hands of the workers who produced them. For all of Ruskin's vituperative anti-Catholic senti-ment in *The Stones of Venice,* he still vividly maintains a sense of the body, morality, politics, and "interest" behind objects. History in his gaze is made concrete as something that can be recaptured, revived, even resurrected. The discourse of mid-century art experts writes against this immediacy of objects, especially in the equation of the Medieval with the Oriental: both are accused of too much splendor, too rich a materiality. They connote the fleshly body uncontained by science or style, naked rather than nude. It can come as no surprise that Ruskin disliked the Exhibition; as he scoffs in a revealing parenthesis in *The Stones of Ven-ice,* it was "neither a palace nor of crystal."[101] Ruskin's entire project in *The Stones of Venice* might be seen as a mirror text to the Exhibition, a vision of irregular architecture and opaque objects constructed in opposition to the glass and iron

of the Crystal Palace. In *Stones* Ruskin writes of the history of Venice as a warning to his British readers; it was Venice's "worldly spirit" and "national criminality" of commerce that brought about the empire's ruin (9:24–25). The grand enterprise of the Exhibition, which was one large paean to the benefits of free trade, finds its perfect symbolic expression in the detached gaze of the bureaucrat who wanted to unite "art" and "manufactures."

Victorian Eclecticism: The Birth of Kitsch

If twentieth-century accounts of mid-Victorian style conclude that Ruskin's popular, resonant writings fueled the Gothic craze, my account of Exhibition art writing will suggest an alternative critical narrative. It should be remembered that the Gothic was not the only mid-Victorian style, and, for that matter, not every designer was implacably locked in the much-discussed "battle of the styles." In fact, England was notable for its lack of a distinctive style or school, a fact which Victorian art critics repeatedly lamented. But for the art experts who analyzed taste in the Exhibition, England's lack of its own style became a point of pride: unlike other less advanced nations, whose narrow belief systems aligned them closely with a single style, England's more rational, detached position allowed it to choose from any style in an intelligent and rational eclecticism. As Owen Jones writes in his Exhibition essay "Colour in the Decorative Arts,"[102] "We possess the inestimable advantage of living in an age when nothing of the past remains a secret; each stone of any monument of every clime has told its tale, which is now brought within reach of our own fire-sides: yet, hitherto, how little we have shown ourselves worthy of this great privilege! The ease with which our knowledge might be obtained has made us indifferent of its acquirement, or led us to substitute an indolent and servile imitation for an intelligent and imaginative eclecticism."[103] The global reach of the British Empire has brought the historical monuments of all nations into domestic purview, especially through the print medium, which can diffuse "tales" to every Victorian hearth. This ranging of foreign cultures and ages in a Victorian library seems a miniature version of the Exhibition itself, a visual ordering of "stones" and "tales" for widespread domestic consumption. Here eclecticism becomes the sign of a thoughtful reading and rational interpretation of the past. Its "intelligence" is enabled by the era's unique scientific advancement, which allows Victorians to survey the past with a comparative, historicist eye. In Digby Wyatt's essay "Form in the Decorative Arts," the judicious selection of a style takes on all the objectivity of a scientific experiment:[104] "Styles...may be regarded as storehouses of experiments tried, and results ascertained, concerning various methods of conventionalizing, from whence the designer of the present day may learn the

general expression to be obtained, by modifying his imitations of nature on the basis of recorded experiment, instead of his own wayward impulses alone."[105] Wyatt's artist selects a style using the scientific method, phrased in the language of experiment and result. Victorian eclecticism proposes a myriad of possible styles, each one available to be scientifically tested. Style here does not imply an attitude toward another culture's history; rather, science itself becomes the metaphor for invoking tradition, surveying the styles of the past from a single lofty viewpoint.

For Sir Henry Cole, Britain's eclecticism epitomizes a universalist approach to style. In his essay "On the International Results of the Exhibition of 1851," Cole writes that Britain is "the most cosmopolitan nation in the whole world," and, like the Exhibition itself, "composed of *all* nations," its races ranging from Saxons to Celts to "Hindoos, probably even Negroes." He quotes an article in the *Times*: "The average Englishman is a born cosmopolite, and to that mixed composition he owes the universality of his moral affinities and mental powers. No country in Europe has harboured so many migrations, whether as conquerors, as allies, or simply as guests, and no people are so free as we are from the follies of nationality."[106] Cole equates the eclectic style with an ideology of variety, tolerance, internationalism, and free trade: it is the result when different national styles are allowed to compete against each other without constraint. Eclecticism is itself a "gathering of all nations," and English progress is epitomized by a new hybridity. The mixtures of style are a sign of healthy change, development, even evolution.

In this chapter, I have outlined a loose distinction between ways that amateurs and experts looked at art at the Great Exhibition. The popular viewpoint judged art by more immediate qualities like its narrative, symbolic, or literal elements, while experts took a more detached view based on the object's formal elements. I would like to conclude on a note of complication, by pointing out how these viewpoints do not match up neatly with later developments in formal or popular judgments. We can observe a disjunction, for example, in Sir Henry Cole's discourse as an art expert and his role in the afterlife of the art objects on display at the Great Exhibition. Bolstered by the Exhibition's success, Cole was able to divert some of the displayed art into a new museum, the South Kensington (later the Victoria and Albert) Museum of Design. As director of the South Kensington for more than twenty years, Cole became one of the most powerful art bureaucrats of the later nineteenth century. His great hope was that the South Kensington's collection would educate both British manufacturers and working-class spectators, enabling them to "improve taste" through the study of correct forms.[107] His emphasis on the formal qualities of art, therefore, was instrumentalist and market-oriented—a far cry from the "art for art's sake" movement that would also adopt a formalist aesthetic in the 1870s.[108]

A similar postscript can be appended for amateur perspectives at the Exhibition. For all of the popular investment in the emotional and moral evaluation of art, the very popularity of a style was enough to commodify it—a process that often distanced the object from the qualities it was supposed to embody. When the Gothic style takes its place in the Victorian skyline, its shapes appear there not necessarily because architects and patrons believed that they were making a moral, historically resonant choice. The Gothic was a *style,* one among many, a visual assemblage of ornaments divided from direct symbolic signification when transformed into Victorian fashion. It becomes difficult, in the end, to distinguish between the effects of seeing style as an aesthetic principle, as did Exhibition art experts, and seeing style as a commodity, as did bourgeois spectators. Both worked to empty form of its historical content, its context, its mode of production, its religious or moral symbolism. When middle-class audiences purchased objects in a particular style, or objects made up of many different styles, they were not necessarily consuming those objects as the result of moral or historical judgments. The marketing of eclectic styles initiated by the art-manufactures on display at the Great Exhibition seems a signal moment in the history of British kitsch—a category of art object that contrasts the authentic Gothic theorized by Ruskin and Pugin. As Matei Calinescu observes, "Kitsch may be conveniently defined as a specifically aesthetic form of lying...It appears at the moment in history when beauty in its various forms is socially distributed like any other commodity subject to the essential market law of supply and demand. Once it has lost its elitist claim to uniqueness and once its diffusion is regulated by pecuniary standards...'beauty' turns out to be rather easy to fabricate."[109] Kitsch objects, with their mass-produced aesthetics and pre-packaged stylistic formulae, offer no social commentary or moral challenges to the industrialist status quo. Indeed, they bespeak a majority culture deeply at home with the status quo. To the extent that Victorian eclecticism creates a mishmash of objects from all periods, countries, and cultures, it is also a function of the industrialization of British visual culture more generally. Critics have always seen a great irony in the fact that Ruskin's beloved Gothic was taken up by Victorians to adorn every material facet of the capitalist system he despised, from factory architecture to machine-made commodities. Now, perhaps, we can begin to understand some of the other scripts that motivated this process.

Pater's New Republics
Aesthetic Criticism and the Victorian Avant-Garde

> Coleridge, in one of his fantastic speculations, refining on the German word
> for enthusiasm—*Schwärmerei*, swarming, as he says, 'like the swarming of bees
> together'—has explained how the sympathies of mere numbers, as such, the random
> catching on fire of one here and another there, when people are collected together,
> generates as if by mere contact, some new and rapturous spirit, not traceable in the
> individual units of a multitude.
>
> —Walter Pater, "The Bacchanals of Euripides" (1878; 1889)

Conditions of Music

If the Great Exhibition marked the arrival of Britain's age of kitsch, that profusion of factory-produced wares would seem to inhabit a very different world than the rarified one of the British aesthetes who flourished in its wake. Yet the same economic conditions that enabled the production of inexpensive art also helped to inspire the knots of artists and writers who rebelled against those conditions. The Great Exhibition indicated a trend toward the democratization of culture in Britain, as members of the lower-middle and working classes attended the spectacle in unprecedented numbers. As Victorian art displays drew a larger and more varied audience, however, one inevitable result was the increasing commodification of the art experience. The world exhibitions that would continue throughout the century epitomized the entwining of the art and business worlds so characteristic of nineteenth-century Britain—an enmeshment also evident in the Royal Academy itself, an exhibition space catering to middle-class tastes by often selecting works with familiar subjects and conventional visual styles.[1] For this reason, among others, it has been complicated and at times controversial to describe avant-garde formations that developed in Victorian Britain, reflecting a larger difficulty in discussing continuities between Victorian and modernist aesthetics.[2] In this chapter, however, I show how Victorian commodity culture in fact accompanied an emergent avant-gardism; both of these elements are theorized as a new kind of sociability in the writings of Walter Pater, the most well-known representative of Britain's Aesthetic movement. Pater's essays capture one of the

defining ironies of aestheticism, that a philosophy devoted to the sublimely indi-
vidualistic experience of art emerges, in the later 1870s, as the basis for a group
identity, a commodity fashion, even a utopian politics. This chapter will explore
how formalist artworks came to epitomize the ultimate art-commodity in Victo-
rian culture, even while formalist philosophy served as the basis for an aestheti-
cized political utopia, later to be recognized as a British avant-garde.

Pater has often been portrayed as a key transitional figure between the nine-
teenth and twentieth centuries. In the midst of the implicit divide between periods,
his works have seemed less like Victorian productions than like eerie presentiments
of a modernist, or even a postmodernist, sensibility.[3] Surveys of modernism regu-
larly begin with the three-page "Conclusion" to Pater's *The Renaissance*, where he
calls upon readers to abandon their fixed systems, habits, even religions, in exchange
for the "hard, gem-like flame" of aesthetic experience. His essay "The School of Gior-
gione" makes a similarly subversive claim, arguing that the form of art, especially
the sensuous materiality of paint, is the best criterion for aesthetic judgment. In his
famous summation of the formalist idea, "all art constantly aspires towards the con-
dition of music." Clement Greenberg, the twentieth-century critic whose writings
most influentially shaped modernist notions of high art, adopted Pater's theory in
a famous 1940 statement of principles; in "Toward a Newer Laocoön," Greenberg
makes music the figure for a perfectly abstract visual art and cites Pater's essay in a
footnote as more eloquent on the concept "than any single work of art."[4] Green-
berg's appropriation of the Victorian essayist promotes an idea of intellectual history
in which thinkers arrive at aesthetic truths by the lights of their own remarkable
discernment, rather than by engaging with the conditions of their own moment.[5]

Pater's embrace of formalism invites an ahistorical treatment of his theory, in
keeping with British aestheticism's reputation for social and political disengage-
ment more generally. If the most striking elements of a painting are its shapes or
colors, then the particulars of its narratives or social content—all the communal
values of Victorian bourgeois culture—become merely incidental. Pater's works
are now inseparable from the movement whose rallying cry was "art for art's
sake"; the catchphrase conjures up an idyllic and irresponsible dream-world of
art, safely removed from the hard facts of the outside world. In Peter Bürger's
well-regarded *Theory of the Avant-Garde*, aestheticism is framed as the necessary
apolitical precursor to modernism, while the modernist avant-garde trium-
phantly ushers art back to social and political realities.[6] As Kenneth Clark quips in
his introduction to a 1961 edition of *The Renaissance*, aestheticism has been most
notable to the twentieth century as "a passing phase" for "Prime Ministers."[7]

These suspicions hovering around the art movement and its most famous
spokesman are furthered by Pater's own critical interests, which seem insistently
obscure and even backward-looking. Essays on topics like Renaissance paint-
ers and Greek myths seem very distant from the tumultuous Victorian present.

Phrased in Pater's distinctively baroque idiom, his works defy easy contextualiza-
tion, especially in their studied avoidance of the subject of modern art. In this
chapter, however, I show how Pater's writing actually participated in very public
debates in the 1870s and 1880s about criticism, spectatorship, and art's social
world. I focus in particular on the later 1870s and early 1880s, in the wake Pater's
1873 *Renaissance*, when high-art aesthetic philosophy was being transformed into
a widespread cultural fashion. The vogue for aestheticism was encouraged by a
new public culture of institutions and events, the most significant of which was
the opening of the Grosvenor Gallery in 1877. This avant-garde space displayed
works by controversial artists like Edward Burne-Jones and James McNeill Whis-
tler; reviewing the new gallery, John Ruskin gave Whistler's paintings such a fero-
ciously negative review that the artist sued the critic for libel in 1878. These
scandals, or milestones, served to popularize a movement that was ironically
shaped around an aesthetic theory of radical individualism. By contextualizing
high art theory alongside the popular and fashionable culture it inspired, this
chapter will reveal that how the seemingly ahistorical and individualistic philoso-
phy of aestheticism—which made "art for art's sake" into a formalist creed—
served as a rallying point for an incipient Victorian avant-garde.

In 1877 Pater planned to issue a new volume of essays, though the book was
cancelled at the last minute. It was to have been titled *School of Giorgione and Other
Studies,* and to have included a series of essays on Greek myth that had appeared
as journal articles in 1875 and 1876. The intended book proposed an odd mix
of subject matter, returning to the topic of Renaissance painting with an essay
on Giorgione alongside new material on ancient Greek myth. Yet these essays
all show an essential continuity for dramatizing phenomena of group dynam-
ics and sociable interactions. Though Pater has usually been seen as an architect
of individualism, and his aesthetic project an offshoot of Mill's liberalism, this
chapter will trace Pater's turn after his 1873 *Renaissance* toward more manifestly
social phenomena and collectivist ideologies. The rituals of mass worship, the his-
tory of mythmaking, as well as the schools of art history all share this interactive
quality. Formalism plays a key role as the basis for spiritual group experiences,
intermingling art spectatorship with a subversive history of Western religions.
Pater's demand for a formalist mode in verbal and visual arts is not merely a
prescription for a new style but also an imagination of a whole new way of life.
His quietly rebellious ideals, his embrace of aesthetic sociability, and his desire
for art utopias all point to a group dynamics that would become a signature mode
of modernism. More broadly, the new institutions of aestheticism, its coterie art
circles, break-away galleries, and fashionable commodification would all become
cornerstones of twentieth-century art culture. The chapter concludes by suggest-
ing that the Aesthetic movement in both theory and practice laid the groundwork
for Britain's distinctive forms of the avant-garde in the twentieth century.

Authorizing Subjective Criticism

The scandalous aura surrounding Pater's 1873 *Studies in the History of the Renaissance* might give the impression that the book appeared like a bombshell on the Victorian cultural scene. In fact, Pater was one of a small but significant group of critics writing a new kind of art theory in the later 1860s, when many of the essays that would comprise *The Renaissance* were first published in magazine form. What Pater called "aesthetic criticism" in the preface to *The Renaissance* is now often called subjective criticism: the term refers to a distinctive kind of Victorian prose, a personal, unpredictable, and highly wrought evocation of the art experience.[8] Most Victorian art criticism did not consider itself subjective and strove mightily to avoid the appearance of being so. As the figure of the art critic became a familiar professional type on the cultural scene in the 1860s, critics shored up their position by weighting their opinions with a sense of objective authority. P. G. Hamerton, one of the most recognizable art critics of the 1860s, published an 1863 article in *Cornhill Magazine* devoted entirely to the subject of "Art Criticism." He lists eleven categories that an art critic must master to fully occupy his office: among these, the critic must ideally paint and draw; he must travel; he must develop a sense of sympathy; and, most importantly, he must learn the long histories of both literature and art, so as to be able to translate epic visual narratives for an ignorant public.[9] The work of professionalization was to establish the boundaries of unique knowledge separating the amateurs from the experts. Having gained that knowledge, however, the professional art critic became both a special person and a voice for the everyman, a master of the common lingua franca. As Kate Flint concludes in her survey of the "rôle of the art critic," "Possession of shared knowledge, and shared opinion, was considered far more important than the activation of the individual eye."[10] In the face of this larger trend, the practice of subjective criticism was a willful and determined move away from the mainstream.

Highly personal and poetic responses to art had been familiar to the English canon since Hazlitt's essays at the beginning of the nineteenth century. Yet when tracing the specific influences leading to a new kind of writing—and a new kind of art valuation—in the 1860s, the most dominant and overwhelming force was, ironically enough, John Ruskin. The irony is marked because Ruskin, who had taken such a rebellious stand against established art critics in the 1840s and 1850s, was by this time transformed into an established force himself, as affirmed by his appointment as the first Slade Professor of Fine Art at Oxford in 1869. His writing adopted an increasingly dictatorial tone as his authority increased, buttressed by the use of a vocal moral code in art judgment. For these reasons he is usually seen as an opponent to aestheticism and its subversive stylings. Yet Ruskin's own literary works also modeled the qualities of subjective criticism as, into his late career, he launched into ever greater idiosyncratic fantasias, encompassing realms

of political economy, environmentalism, and myth. The final volume of *Modern Painters,* published in 1860, presents a fierce mélange of botanical structures and mythic types in Turner's paintings, unhinged from a strictly Christian imagery.[11]

Ruskin's unique linguistic flights established a powerful model for the subjective criticism of a new generation of writers, including Walter Pater and Algernon Swinburne.[12] The older author wrote with the confident presumption that his readers shared his values and could easily follow his bizarre associative leaps; younger writers of the 1860s took a similar license, but deliberately flouted the presumed cultural code. The doctrine espoused by aesthetic writers was subsumed under the flaming label of "art for art's sake," first translated by Swinburne into English in 1868 from the French phrase *l'art pour l'art.* Swinburne was not describing a new style of painting but a new mode of interpretation; his phrase appears in an 1868 study of William Blake, an artist from a previous century, who was enjoying a vogue among the Pre-Raphaelites. "Art for art's sake first of all, and afterwards we may suppose all the rest shall be added to her . . . The one fact for her . . . worth taking into account . . . is simply mere excellence of verse or colour . . . [L]et us hear no more of the moral mission of earnest art. . . . Philistia had far better . . . crush art at once, hang or burn it out of the way, than think of plucking out its eyes and setting it to grind moral corn in the Philistine mills."[13] Swinburne's assault on the moral judgment of art is phrased as its own grimly humorous moral crusade, echoing Ruskin's own vituperative excesses. His middle-class "Philistines"—to be dubbed so again the following year in Arnold's *Culture and Anarchy*—are comically violent and immoral in their perceived enslavement of art.

In Swinburne's distinctive art writing of the late 1860s, individual sensibility creates poetic meaning and spectatorship is dramatized as its own extreme sensation. His "Notes on Designs of the Old Masters at Florence" (1867), a meandering meditation on an exhibition of old master drawings, produces impressions that seem singularly modern and even French. In a lengthy section devoted to a series of Michelangelo heads, Swinburne scripts them to embody the archetypal *femme fatale*: "In some inexplicable way all her ornaments seem to partake of her fatal nature, to bear upon them her brand of beauty fresh from hell; . . . the bracelets and rings are innocent enough in shape and workmanship; but in touching her flesh they have become infected with deadly and malignant meaning. . . . [H]er hair, close and curled, seems ready to shudder in sunder and divide into snakes . . . She is the deadlier Venus incarnate."[14] The Victorians had always looked to the Renaissance as a source of titillation—sexual, murderous, or otherwise; but these transgressions were safely distanced by the intervals of history and geography. Swinburne makes his Renaissance impressions too personal, and too modern, to bear weight as mere transcription of the Italian source material. His prose seems less a reflection of Michelangelo than of his own recent poetry

collection, *Poems and Ballads* (1866), whose perverse subject matter incited an outcry that led the publisher to withdraw the first edition. If his poems showed a fascination with powerful and pain-inducing women, the verses also manipulated sound into a dense pattern previously unknown in English prosody. That density also appears in the sibilant sounds of Swinburne's prose, rich with alliterations meant to evoke the sensual (and snaky) female body. In subjective criticism, the writing itself has become the point of the exercise, revealing the soul of the spectator more than the accepted sense of the image.

Unlike Pater, Swinburne does not make his art writing a vehicle for broader meditations on philosophy, mythography, or historical modes of thought. His depiction of female sexuality, drawn straight from Baudelairean "hell," highlights the deathly aspects of sexual love—as opposed to Pater, who dwells more upon the erotics of death itself. Pater's Mona Lisa, the "vampire" of weary flesh, is a symbol emptied of sex appeal, his Medusa a terrifying vision of spectator fixity rather than of sexual overpowerment. Pater's linguistic effects are more subtle, hinging on elusive "traces," to use a favorite term, as opposed to Swinburne's more loud and lush stylings. Yet Swinburne also voices an art-for-art's-sake mantra that would come to be closely associated with Pater, in the preference for forms and colors in art above all other considerations. In his 1868 "Notes on Pictures at the Royal Academy," Swinburne espouses a flagrant formalism later to be reconfigured as a major tenet of visual modernism. This value is signaled, crucially, by the use of musical vocabulary. Writing of Albert Moore's *Azaleas* (figure 3.1), he rhapsodizes: "His painting is to artists what the verse of Théophile Gautier is to poets, [embodying]...an exclusive worship of things formally beautiful....The melody of colour, the symphony of form is complete:...its meaning is beauty; and its reason for being is to be."[15]

Swinburne's formalist values in art emerged contemporaneously with those of other influential aesthetic critics in the late 1860s. Sidney Colvin, an early supporter of aesthetic artists, argues in an important *Fortnightly* article on "English Painters and Painting in 1867" that the "prime greatest object of pictorial art" is "the perfection of forms and colours."[16] Colvin elects artists like Dante Gabriel Rossetti, Edward Burne-Jones, and Albert Moore as the leading painters of the new art style. William Michael Rossetti, another well-known art critic and brother to Dante, was also one of Whistler's few apologists in the 1860s. He writes in 1867 that Whistler's "aim is not so much to reproduce facts, or present a story of any kind, so as to execute a work of art in which the conception and sentiment of the art itself shall be paramount."[17] Whistler himself promoted a theory of visual formalism by his choice of musical titles, influenced by examples of French synaesthesia like Gautier's 1849 poem "Symphonie en blanc majeur."[18] The first of Whistler's musical titles was bestowed in 1867 when he dubbed a domestic arrangement of women *Symphony in White, No. 3*; he then went back and

FIGURE 3.1 Albert Moore, *Azaleas*. Oil on canvas, 1867–68. Dublin City Gallery, The Hugh Lane. Image courtesy of the Dublin City Gallery, The Hugh Lane.

renamed earlier paintings as *Symphonies Nos. 1* and *2*. These linguistic interventions of Swinburne, Colvin, W. M. Rossetti, and Whistler himself suggest that the formal judgment of artworks was already established, at least among an elite circle, during the time that Pater was composing *The Renaissance*.

Pater made his own contribution to this moment with his 1868 review of William Morris's poetry, which was to become the kernel for his "Conclusion" to the *Renaissance*. Attainment to a "quickened, multiplied consciousness," Pater informs us, is best achieved through "the poetic passion, the desire of beauty, the love of art for art's sake."[19] It might seem surprising that Pater's famous Conclusion emerges from a review of poetry rather than of visual art. Paintings and sculptures would seem to belong more to the sensuous material world celebrated by Pater than literary art. Yet poetry and painting had a special link in late-Victorian aesthetic culture. The three major artforms of aestheticism, as it would soon develop, were poetry, painting, and aesthetic criticism. This is not to say that aestheticism did not influence other media; aesthetic novels did surface in odd forms, most notably Pater's *Marius the Epicurean*.[20] Yet aesthetic artforms like poetry and painting were distinctive for being exactly concerned with formal questions such as composition or prosody. If Victorian novels ostensibly presented a kind of mirror to nineteenth-century society, aesthetic art aimed for a more removed, visibly molded, or artificial presentation. The intersection between poetry and painting—a salient quality of aestheticism to even its earliest critics—has this formalist desire at its root. It was up to aesthetic criticism to translate these formalist aims for a larger public, even while enacting its own theories in carefully shaped, poetic prose.

Though Pater's *Renaissance* was not published until 1873, the most important pieces were already published in magazine form in the previous decade—suggesting the extent to which the work emerged from the radical critical context of the later 1860s. Appearing in 1867 was "Winckelmann," the essay that was to become the philosophical core of *The Renaissance*. It seems like a joke on Pater's part that a book devoted to the study of the Italian Renaissance takes as its central figure an eighteenth-century German critic. Yet it is Winckelmann who "reproduces for us the earlier sentiment of the Renaissance. On a sudden the imagination feels itself free."[21] This essay argues for formalist values using not the figure of music but that of sculpture; following Hegel, Pater argues that Greek sculpture, of all the media, most fully achieves "pure form" (169). In 1867 Pater is more interested in reworking Hegelian aesthetics for Victorian readers than in battling overtly with other critics.[22] That battle would be fought more explicitly in his 1877 "School of Giorgione," examined below. Pater's critical values are more implicitly modeled in the figure of Winckelmann himself, who is not an artist but a critic. The German adventurer plunges into the world of the art he studies, embracing the sensuousness of both Greek sculpture and eighteenth-century Rome. Pater delights in narrating biographical details that Victorians would have found shocking, such

as Winckelmann's fake conversion to Catholicism to gain access to Rome, and his love affairs with young Roman men whose bodies resemble those of Greek sculpture. No wonder that Mrs. Pattison was to conclude, with other critics, that Pater's "work is in no wise a contribution to the history of the Renaissance."[23]

The familiarity of Pater's volume has perhaps obscured how striking it is that a book consisting mainly of art history essays so perturbed the Victorian intellectual scene. The scandal highlights the way in which Pater's historical accounts, which might seem somewhat opaque to our eyes, spoke clearly to his readers as a commentary on his own day. Pater follows Swinburne in using old master artwork as a platform for implicitly modern meditations, whose modernity was made most apparent in the *Renaissance*'s controversial conclusion. The Rev. John Wordsworth, Pater's Oxford colleague, wrote him a now famous letter outlining his metaphysical disappointment. "I cannot disguise from myself that the concluding pages adequately sum up the philosophy of the whole; and that that philosophy is an assertion that no fixed principles either of religion or morality can be regarded as certain, that the only thing worth living for is momentary enjoyment and that probably or certainly the soul dissolves at death into elements which are destined never to reunite."[24] Pater's philosophy moved against the collectivist codes of Victorian morality and religion. The crowning thing, the gem-like flame of experience, could only belong to an individual spectator driven by the question, "what is this song, or picture . . . *to me?*" His essays celebrate the extremes of Renaissance individualism, parading a series of heroic painters and daring storytellers whose feats authorize his own subversive acts of subjective criticism. Like Swinburne, Pater appropriates cultural patrimony for his own atomistic ends.

With its sinuous argument for the freedom of individual judgments, Linda Dowling has called *The Renaissance* a document of liberal humanism, a vital brief in the ongoing culture wars between Victorian progressives and conservatives.[25] The political reverberations felt by Pater's contemporaries can be seen, for example, in W. J. Courthope's 1874 essay assailing "Modern Culture." For the Tory critic, Pater-styled culture is an "Academic Liberalism" in which "the individual mind is the measure, and, in a sense, the maker of all things,—a conclusion which destroys all distinction between what is true and false, while it bases knowledge on pure sensation."[26] Accusations against aestheticism as a solipsistic or hyper-individualistic phenomenon reflected the deeply private philosophy formulated by Pater and Swinburne in the 1860s. This groundwork heightened the sense that, before 1873, aestheticism was the remote production of a small clique. Avant-garde painters seemed to exist only on the fringes of the larger Victorian consciousness; Whistler's painting experiments were largely scorned by critics, and other aesthetic painters such as Rossetti and Burne-Jones avoided public exhibitions altogether to escape hostile reviews. As Sidney Colvin bleakly assessed the situation in 1867, any painter with aesthetic leanings and a more pictorial style "struggles in the cold

shade of popular neglect and critical antagonism;...the press sneers, the public shrugs its shoulders and passes on; no one attempts to sympathise with him or meet him half way."[27] Yet only ten years later, Oscar Wilde was to write of "the new revival overtaking the country."[28] The Aesthetic movement was tied to a growing popular consciousness, a progressive wave borne along under the flag of self-culture. Art writers increasingly took it upon themselves to interpret the new movement for an inquisitive public—a task to which Pater, too, addressed himself, though in a distinctively oblique manner.

Popular Critics in the Exquisite Gallery

Pater's attention to modern art—and modern criticism—is most marked in his 1877 essay "The School of Giorgione." Although the essay seems to extend his interest in Renaissance art, and was indeed added to the 1888 edition of *The Renaissance*, this piece shows a more evident engagement in contemporary controversy and critical debate. Here Pater clearly enjoins in the battle over what kind of criticism is best. Though he had announced in the 1873 preface to *The Renaissance* that art criticism has no fixed rules, his 1877 essay disobeys this creed by proposing tenets for an "aesthetic criticism" whose opposite is "popular criticism." So he opens the essay with a kind of war-cry: "It is the mistake of much popular criticism to regard poetry, music, and painting...as but translations into different languages of one and the same fixed quantity of imaginative thought," thus ignoring "the sensuous element in art." The greatest error of popular critics is to read visual art as though its only aim were to transmit a message or narrative—as though it were "literature." Yet "in its primary aspect, a great picture has no more definite message for us than an accidental play of sunlight and shadow for a few moments on the wall or floor: is itself, in truth, a space of such fallen light, caught as the colours are in an Eastern carpet, but refined upon."[29] Pater's terms ironically echo the eighteenth-century hierarchy of genres, in which "a great picture" was a history painting narrating an epic of national or mythic import. Aesthetic painting, by contrast, makes its effects out of the simple play of light on the wall. For Pater the best art emphasizes sensuous form—drawing, color, or composition—rather than narrative content. He prefers poetry that is "lyric" (with the unmistakable musical resonances of the word), formally perfect, rather than poetry like that of Victor Hugo, which works only to convey a "moral or political aspiration" (107). The essay makes no room for artworks with messages; famously, "all art constantly aspires towards the condition of music" (106).

For all his disparagement of political art, Pater's aesthetic theory takes on a distinctly political cast when seen in the context of a controversial art event that was rousing an incendiary response from "popular critics" at the time. If terms

of debate had been simmering since the late 1860s, they erupted spectacularly in the art press during the time that Pater composed his essay in the summer of 1877. May of that year had seen the opening of the new Grosvenor Gallery, an elegant and intimate public exhibition space established as an alternative to the dominant Royal Academy show.[30] This event served as a lightning rod for critics to dispute the merits and faults of aesthetic versus academic art, and provoked Whistler to sue Ruskin for libel in the dramatic 1878 trial. I want to explore now the links between institutions, art styles, and criticism in the later 1870s in order to contextualize Pater's essay, whose details I will explore further below.

Situated on fashionable Bond Street in London, the Grosvenor Gallery was founded by Sir Coutts Lindsay and his wife using their own funds. The new gallery quickly became a desirable ticket for the social elite. The Grosvenor's modes of selection and display were a deliberate response to those of the Royal Academy, whose hegemonic grip over the art world was regularly bemoaned by artists and critics. To gain acceptance to the Academy exhibition, paintings had to pass before an elite selection committee of Academicians, known, often ironically, as "the hanging committee." This august body habitually rejected works perceived as daring or innovative. In the Academy's crowded exhibition hall, paintings were crammed together frame-to-frame and sometimes placed such that "only a giant or a child can catch a glimpse of [them]" (figure 3.2).[31] Yet artists had to work

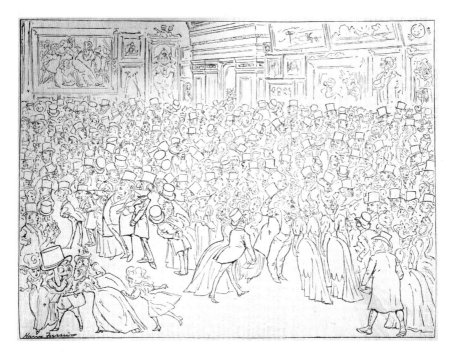

FIGURE 3.2 Harry Furniss, "Strictly Private View, Royal Academy," *Punch* 98 (1890): 214. The Pennsylvania State University Library.

within this system if they wanted to become known and successful. Painters with more avant-garde tendencies like Edward Burne-Jones and Dante Gabriel Rossetti stopped submitting their works to the Academy altogether.

Lindsay hoped to alleviate some of the Academy's problems by inviting a limited number of artists to show their work in his gallery, and by giving each painting a space of its own.[32] Where the Royal Academy had a frenetic atmosphere that critics disparaged as circus-like, the Grosvenor was remarkable for the pains Lindsay took to make his gallery look like a private room in an aristocrat's house, complete with china, furniture, and potted plants (figure 3.3).

The new gallery also challenged the Royal Academy in its featured artworks. Sir Lindsay invited such controversial artists as Burne-Jones, who had been avoiding the public eye after charges of indecency greeted his previous exhibition seven years earlier, and Whistler, who was already notorious for giving his paintings musical titles that transformed men and women into "arrangements" and "symphonies." Contrasts of the Grosvenor with the Academy became a familiar refrain for the cultural elite, as seen in Oscar Wilde's *Picture of Dorian Gray,* when Lord Henry declares that Basil must exhibit his portrait at the Grosvenor Gallery: "The Academy is too large and too vulgar. Whenever I have gone there, there have been either so many people that I have not been able to see the pictures, which was dreadful, or so many pictures that I have not been able to see the people, which was worse. The Grosvenor is really the only place."[33]

During the time that he composed "School of Giorgione," Pater was aware of the commotion being caused by the Grosvenor exhibition in London. Oscar Wilde, then an undergraduate correspondent at Oxford, sent Pater a copy of his review of the Grosvenor show.[34] When Pater singles out the "popular critics" for attack, he subtly but unmistakably inserts himself into the current debate between the Royal Academy and the Grosvenor. The kind of art and criticism that Pater disdains as popular—paintings that told stories, and critics who judged paintings based solely on those stories—pointed directly to the Royal Academy. Shearer West has written of how the Academy specialized in the tradition of a "British school of art," derived from Hogarth, in which paintings delivered moral lessons of modern life encapsulated in distinctly legible narratives.[35] This style was associated with painters like William Powell Frith in his blockbuster scenes *Derby Day* (1858; figure 3.4) and *Railway Station* (1862), and critics like Tom Taylor for the *Times,* who published pamphlets dissecting Frith's paintings into a series of moralizing narrative episodes.

While scholars today have found these paintings to be richly multilayered, Victorian critics with more avant-garde inclinations tended to deride Academy artworks as safe, staid, and highly anecdotal.[36] Henry James, reporting on the British art scene for American readers back home, ridiculed Academy pictures for targeting the "taste of a particularly unimaginative and unaesthetic order—[that] ... of

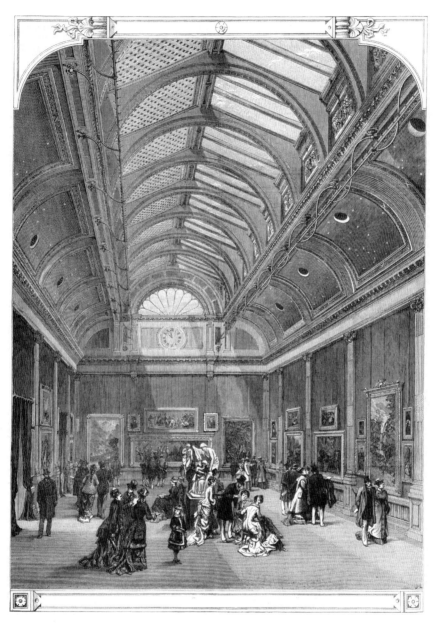

FIGURE 3.3 "West Gallery, The Grosvenor Gallery of Fine Art, New Bond Street," *The Illustrated London News* (May 5, 1877). Image courtesy of the Yale University Library.

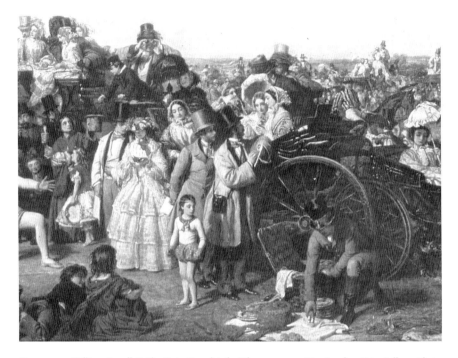

FIGURE 3.4 William Powell Frith, *Derby Day,* detail. Oil on canvas, 1862. London, Tate Gallery. Photo credit: Tate, London / Art Resource, N.Y.

the British merchant and paterfamilias and his excellently regulated family." These pictures inevitably featured "a taking title, like a three-volume novel or an article in a magazine," and embodied "some comfortable incident of the daily life of our period, suggestive more especially of its . . . proprieties and familiar moralities."[37] Whistler, practicing his own belligerent form of art criticism, similarly mocked what he perceived to be the transparent and sentimental narratives of Academy images: "The British subject! Like a flash the inspiration came—the Inventor! And in the Academy there you saw him: . . . hands on knees, head bent, brows knit, eyes staring; in a corner, angels and cogwheels and things; close to him his wife, cold, ragged, the baby in her arms; he had failed! The story was told; it was its clear as day—amazing! The British subject! What."[38] For James and Whistler, as for many commentators, these paintings were inseparable from the upwardly mobile bourgeois viewers who frequented the Royal Academy, especially the first-time gallery visitors who were both audience for and patrons of art in the later nineteenth century.[39] The public preferred spectacle, splash, story, and sentiment, depicted in a realist manner that could be discerned by even the most amateur eye.

By contrast, most critical opinion held that the paintings at the Grosvenor needed a special kind of education to be appreciated. A disgruntled reviewer for the *Daily News* exclaimed, "It may all be very well and the pictures may please the learned, but they are not what the public is accustomed to. The spectator

feels inclined to cry anxiously, 'Where is the baby?' for babies and cradles are but inadequately represented in the Grosvenor Gallery . . . [T]his is not in accordance with the practice of the Royal Academy and with the traditions of British art."[40] While the Royal Academy was seen as the bastion of middle-class family values, the Grosvenor was cordoned off as a realm demanding a privileged mode of see-ing, a training of sensibility that Henry James deemed "a reminiscence of Oxford, a luxury of culture."[41] This mention of Oxford invokes both the exclusive body of the gallery's spectators and, more specifically, Pater himself, whose controversial 1873 *Renaissance* had tied him inseparably to the elite university. If "Oxford" con-noted a hot-bed of high-minded aesthetic philosophy, the Grosvenor represented the institutionalization of artists and artwork expressing that philosophy.

The Grosvenor artist most insistently singled out for his "learned," "esoteric," and "freakish" aesthetic was not Whistler (despite his modernist credentials) but Edward Burne-Jones.[42] Henry James writes of how Burne-Jones was "quite the lion of the exhibition," a "lionship . . . owing partly to his 'queerness.'"[43] Victorian critics harped on the fact that all of Burne-Jones's figures—especially the lan-guid female angels in his "Days of Creation" series at the Grosvenor—had the same expressions, the same features, and the same poses (figure 3.5). Influenced by the example of early Italian *quattrocento* painters like Botticelli, his intensely stylized images were suspiciously "decorative" for contemporary reviewers. Their perceived flatness, repetition, pattern, and abstraction moved these pictures away from the realist transcription of nature and the narrative mode of imagery. H. Heathcote Statham ridiculed Burne-Jones's repetitive angels: "[T]heir faces have the same gentle vacuity of sentiment; they stand in a row, . . . and only by the contents of the crystal globes they hold, the last of which exhibits a little Adam and Eve, do we find out what they are . . . intended to symbolize." Statham concludes that the form of the paintings overwhelms their ostensible subject matter, raging, "[I]t seems incredible that in the present day a grown man should . . . bestow all this beauty of colour and manipulation upon such a piece of child's scenery."[44]

While Burne-Jones's pictures drew the most interest, and the most fire, at the Grosvenor, Whistler too added to the gallery's aura of eccentricity. Burne-Jones's controversial works were still worthy of critical debate; but Whistler's images were almost universally panned, even by more progressive critics like Oscar Wilde and Henry James. Whistler's work at the Grosvenor was the subject of a scathing attack by Ruskin in *Fors Clavigera*, spurring the artist to sue him for libel and resulting in the sensational court case in 1878. Ruskin wrote, "Sir Coutts Lindsay ought not to have admitted works into the gallery in which the ill-edu-cated conceit of the artist so nearly approached the aspect of wilful imposture. I have seen, and heard, much of Cockney impudence before now; but never expected to hear a coxcomb ask two hundred guineas for flinging a pot of paint in the public's face."[45] Even Walter Hamilton, whose favorable 1882 history *The*

FIGURE 3.5 Edward Burne-Jones, *The Days of Creation: The Sixth Day*. Watercolor, gouache, shell gold and platinum paint on linen-covered panel, 1870–76. Harvard Art Museum, Fogg Art Museum. Bequest of Grenville L. Winthrop, 1943.459. Photo credit: Imaging department © President and Fellows of Harvard College.

Aesthetic Movement in England devotes an entire chapter to the Grosvenor Gallery, spends pages disparaging Whistler. He alludes to a farce running at London's Gaiety Theatre, *The Grasshopper,* in which a foppish artist displays a masterpiece titled "Dual Harmony": "All London crowded to see his picture, which represented the boundless blue ocean beneath a burning sky, or if reversed, showed the vast sandy desert under a blue and cloudless one. And the merry laughter over his simple red and blue picture probably had more effect in discrediting these ridiculous travesties of art than all Mr. Ruskin's powerful articles."[46] Not coincidentally, the artist's name in this production was "Pygmalion Flippit," presumably for the ease with which his pictures could be turned upside down.[47]

Whistler's work amplified the threatening tendency critics found in Burne-Jones, Moore, and Watts, deliberately emphasizing color and light at the expense of representative subject matter. His style was tied in the Victorian mind to painterly experiments across the Channel, carrying "to the extreme the principles of the French *impressionistes,*" according to the *Illustrated London News.*[48] His use of title words like "nocturnes" and "scherzos" smacked strongly to critics of "foreign terms."[49] Yet his images also shared a visual commonality with Turner's late style, a fact adverted to by Ruskin's defense lawyer at the trial. That a critic had once described Turner's *Snow Storm* as "a mass of soapsuds and whitewash"—without being charged with libel—was a salient point in Ruskin's defense.[50] But while Turner had largely gained acceptance as a great English artist by the 1870s, Whistler still hovered outside the canon, a position he cultivated with his infuriating titles.

Indeed, the debate about critical language surrounding the Grosvenor can be extended to include these provocative titles, which formed a focal point for the Whistler controversy. Despite visual similarities between paintings by Whistler and Turner, the artists' aesthetic differences were encapsulated by their title choices. Some of Turner's most impressionistic, diffuse artwork came attached with lengthy titles narrating epic tales in miniature: *Snowstorm—Steam-Boat off a Harbour's Mouth making Signals in Shallow Water, and going by the Lead* (1842); or *Van Tromp Going About to Please His Masters, Ships a Sea, Getting a Good Wetting* (1844). The choice of painting title in the late 1860s and 1870s became its own kind of art criticism or theory, moving beyond illustrative caption to a more allusive, suggestive, or ambiguous relation. Albert Moore's decorative female figures had titles like "Apricots" and "Azaleas," shifting emphasis away from personhood toward the canvas's decorative aspect. Unlike the allegorical tradition, which made women into figures for lofty ideals like Charity or Hope, these titles made women into patterns. In *The Times* Tom Taylor angrily attacked Whistler's title choices, "as if the colour of the dress imported more than the face; and as if young ladies had no right to feel aggrieved at being converted into 'arrangements.'"[51] If Turner's titles served to shape or control narrative meaning, aesthetic titles worked to radically unhinge meaning, in an open-ended kind of symbolism associated with modernist technique.

Whistler's modernist doctrine, as epitomized in his musical titles, has now become inseparable from Pater's own formulation in "School of Giorgione": "All art constantly aspires towards the condition of music." At the trial, Whistler's lawyer summed up the theory by finding an analogy between music and painting, "for music is the poetry of the ear, while painting is the poetry of the eye"; or, as the *Illustrated London News* grudgingly allowed, Whistler's paintings did indeed "render, as it were, a vague rhythmical echo of nature in a few hasty, more or less harmonious tones."[52] Yet Whistler's musical theme was largely misinterpreted by the popular press, who accepted that there could be a correlation between artistic media without acknowledging the more controversial aesthetic doctrine underneath. The "condition of music" indicated not actual music but a radical and even anarchic dispensing with agreed-upon meaning, telescoping aesthetic experience down into to the body of the beholder. A critic in 1878 tied Whistler's titles directly to "Mr. Pater's criticism," accusing both of clothing "unadulterated nonsense in the garb of profundity," and concluding that a "musician is not elevated in his art by being called a tone-poet, nor is a picture improved in value when it is termed a 'Harmony in Blue,' a 'Symphony in Red,' or a 'Polka-Mazurka in Tartan Plaid.' "[53] Both Whistler's titles and Pater's aesthetic criticism used a musical vocabulary to authorize personal sensation as the most important criteria of artistic perception.

The linguistic rivalry of competing criticisms reached a climax in the 1878 trial of *Whistler v. Ruskin*. Although Whistler was suing Ruskin for libel, most of the trial turned upon the evaluation of Whistler's own artworks. If Ruskin's side could prove that his harsh criticism was legitimate, then he could successfully defend himself against the libel charges. Journalists covering the trial gleefully detailed incongruous scenes of jury members handing round works of art and artists being deposed in the witness box. The trial asked witnesses to testify "objectively" as to the worth of Whistler's paintings—the sign of worth being, in the court of law, the amount paid for the painting. The odd disjunction between aesthetic appreciation and legal judgment was noted by Henry James, in whose ironic appraisal "a British jury of ordinary taxpayers was appealed to decide whether Mr. Whistler's pictures belonged to a higher order of art."[54] Even Whistler's critics detected something incongruous in the artistic demands of the law. As the *Saturday Review* commented, "Art is not bootmaking, and the excellence of a work of art cannot be fixed by any amount of evidence, however eminent the source from which it proceeds."[55] Most trial commentators, even Whistler's hostile attackers, seemed to accept the idea that beauty consists of relative qualities, not to be defined by a single critic or standard.

Whistler adopted the view during the trial—and in belligerent statements that followed—that only artists with professional expertise ought to be making comments on pictures. As he fulminated in his post-trial pamphlet *Whistler vs. Ruskin: Art and Art Critics,* "A life passed among pictures makes not a painter—else

the policeman in the National Gallery might assert himself."[56] If the trial drama-
tized what Whistler called the clash of "the brush and the pen," then he placed
himself unambiguously in the camp of the artists, dismissing most criticism as
amateur drivel.[57] Yet the fact that he chose to bring a lawsuit in the first place
suggests that he gave more credence to critics than he claimed, an idea supported
by his own bristling art-critical pamphlets fired off in the wake of the trial. And
his choice of painting titles, intersecting blatantly with a literary art doctrine that
had been scripted by aesthetic critics since the 1860s, aligned him with a critical
practice that he could not simply disavow. By taking Ruskin to court, Whistler
implied that there was a standard for art criticism that Ruskin had disobeyed or
contraverted—a claim at odds with the more radical implications of Whistler's
own painting titles. This discrepancy was noted and ridiculed by observers like
Walter Hamilton, who concluded that the trial "showed the folly of appealing
to a prosaic British Jury on a question of pretended transcendental art."[58] Some
recent scholars have taken this trial to epitomize two kinds of elitism facing off
against each other, as Whistler's snobbish art professionalism opposed Ruskin's
taking of the moral high ground.[59] Yet I think the intense publicity surrounding
the trial points in another direction, revealing a new, widespread interest in the
terms and responsibilities of art criticism.

Whistler v. Ruskin gave another concrete form to the trope of contrast that
dominated accounts of the Grosvenor versus the Academy. Given the attacks on
the gallery and the resulting trial, one might presume that Victorian art culture
was starkly divided between progressives and conservatives, between old-guard
art fixtures like Ruskin and upstart avant-gardists like Whistler and the Grosve-
nor painters. Pater's own attacks on "popular critics," contrasted by his prefer-
ence for "aesthetic critics," would seem to confirm this schism. Yet these divisions
are not really accurate to the complex world of 1870s art culture. Contrasts
between the two art institutions were often exaggerated by the partisan critics
who reviewed them. The Grosvenor displayed subject pictures telling discernable
stories, while Albert Moore, a supremely decorative painter, regularly showed
his work at the Academy. Lindsay went out of his way to invite Academicians to
display at the Grosvenor so as to avoid the appearance of hostility. In 1878, the
newly elected president of the Royal Academy was Frederic Leighton, whose
antique and exquisite scenes aligned him with the Aesthetic movement in the
eyes of many Victorian critics.[60] At the trial, Burne-Jones—a prime producer
of aesthetic artworks—testified on behalf of Ruskin, confirming that Whistler's
paintings exhibited a "sketchy" and "unfinished" style. These blurred boundaries
raise the question of why art critics so strongly highlighted the cliquish distinc-
tiveness of the Grosvenor artists. As this discussion will have begun to suggest,
their artworks were only one part of a larger set of values and lifestyles attached
to the new gallery.

The Victorian Giorgione: Dante Gabriel Rossetti

I have proposed that Pater's "School of Giorgione" takes up the terms of critical debate surrounding the avant-garde artworks displayed at the Grosvenor Gallery. I want to look more closely now at some of the specific terms of Pater's 1877 essay, in order to draw further links between his seemingly elusive art history and the real-world events of aestheticism in the 1870s. While Whistler and Burne-Jones were the most obvious practitioners of a musical aesthetic at the Grosvenor, Pater actually anoints another artist as the modern inheritor of Giorgione—Dante Gabriel Rossetti, whose pictures did not appear in the new gallery. (Rossetti was invited by Lindsay, but declined for fear of negative publicity.) Rossetti is the only modern British artist mentioned in Pater's essay, and stands out all the more for the rarity of Pater's references to contemporary art. Writing of Giorgione's *Fête Champêtre*, Pater describes the painting as "a favourite picture in the Louvre, subject of a delightful sonnet by a poet whose own painted work often comes to mind as one ponders over these precious things" (114). In a footnote, Pater names Rossetti as the painter-poet he has in mind.

Rossetti was an apt choice for a modern Giorgione since, beginning around 1860, his paintings had begun to adopt a striking new style, divesting themselves of familiar legible narratives. These "Venetian" paintings, as they were dubbed at the time, sensually rendered the faces and torsos of women without any framing story (figure 3.6).[61] Art historian Elizabeth Prettejohn notes how the new paintings moved "resolutely away from Victorian conventions for narrative painting. There is no action, and no specific emotion is dramatized; the figures do not even inhabit a particular moment in time."[62] Not surprisingly, Rossetti feared to exhibit these sensual images in public, selling them directly to patrons. Yet the public was aware of Rossetti's artistic projects since his works were occasionally reviewed in the art press, usually by Pre-Raphaelite critics such as F. G. Stephens, who viewed the paintings in the artist's studio.[63]

Moreover, Rossetti had received glaring publicity as the subject of a scurrilous attack in the press in 1871, when Robert Buchanan smeared his poetic circle as the "Fleshly School of Poetry." When the Grosvenor controversy exploded onto the scene in 1877, Rossetti's presence was felt everywhere, as critics inevitably perceived the gallery to be an offshoot of the "fleshly" aesthetic, condemning it as "a merely artistic lounge for the worshippers of the Fleshly School of Art."[64] Despite—or even because of—Rossetti's refusal to show works at the Grosvenor, critics still linked the gallery's aura of exclusiveness with the painter's tendency to "show his productions only as a special favour to a special circle," as H. Heathcote Statham fumed. Statham dilates at length on Rossetti's absence from the Grosvenor, accusing the painter of being a "high priest" whose "worshippers" "kiss the hem of his garment and see nothing but perfection in his work; and if we inquire, why this mystery and privacy? we are

FIGURE 3.6 Dante Gabriel Rossetti, *Bocca Baciata (Lips that Have Been Kissed)*. Oil on panel, 1859. Museum of Fine Arts, Boston. Photograph © 2009 Museum of Fine Arts, Boston.

gravely rebuked, and asked on what principle an artist is bound to make public his work at all?"[65] Colleen Denney concludes in her analysis of the Grosvenor Gallery that Rossetti's "spirit hovered over the whole undertaking."[66]

As these comments would suggest, Rossetti was increasingly portrayed as the artistic leader of the newly visible art movement. The art collective surrounding him was almost universally designated as a "school": "the Aesthetic School," in Walter Hamilton's benevolent formulation,[67] or, in Harry Quilter's more hostile account, a "new school" demanding "spurious devotion to whatever is foreign, eccentric, archaic, or grotesque."[68] At the trial *Ruskin v. Whistler,* the defense

lawyer twice asked Albert Moore whether he was "a member or disciple of a particular school of art," attempting to discredit Moore's testimony by insinuating that both he and Whistler belonged to the same suspicious aesthetic clique.[69] While the "school" was an art-historical term used since the seventeenth century to outline distinctions of history and nationality (OED), in the 1870s the term was also harnessed to attack any kind of offensive or exclusive partisanship, of the kind memorably decried by Matthew Arnold in *Culture and Anarchy*. ("Culture," Arnold writes, "tends always thus to deal with the men of a system, of disciples, of a school; with men like Comte, or the late Mr. Buckle, or Mr. Mill.")[70] In attacks on aestheticism, the school also took on overtones of a Catholic conspiracy, as Victorians still identified Catholicism with indecent secret societies and blank-minded followers or disciples. The taint of the Catholic school also likely lingered from the early days of the Pre-Raphaelites, when, as we saw in the previous chapter, Rossetti deliberately courted Catholic associations. So it seems overdetermined that critics would label aesthetes as a "new school," given the way the art movement combined the term's associations with art-historical, religious, philosophical, and political notions of collectivity.

These resonances undoubtedly inflect Pater's arguments in "The School of Giorgione." Though the essay ostensibly analyzes the works of the Renaissance painter Giorgione and his followers, Pater's celebration of Giorgione's "school" has strong reverberations with contemporary aesthetic culture. The essay's most immediate targets are the influential art historians J. A. Crowe and G. B. Cavalcasselle, whose recent work had debunked attributions of some of Giorgione's most famous paintings.[71] Crowe and Cavalcasselle were initiators of what would later become the institutional techniques of art history, using scientific methods to make careful determinations of a painting's true maker. Pater resists this development, asserting that mere authorship cannot fully encompass the phenomenon of Giorgione's influence. The "aesthetic philosopher," he writes, cares less for "authentic" paintings than for "the Giorgionesque"—"an influence, a spirit or type in art, active in men so different as those to whom many of his supposed works are really assignable. A veritable school, in fact, grew together out of all those fascinating works rightly or wrongly attributed to him; . . . out of the immediate impression he made upon his contemporaries, and with which he continued in men's minds; out of many traditions of subject and treatment, which really descend from him to our own time, and by retracing which we fill out the original image" (116). Pater subtly tweaks the art historical school to indicate not only Giorgione's Renaissance imitators but also the modern Victorian painters who embrace a Giorgionesque style, as exemplified by Rossetti. The "school of Giorgione," as it turns out, is not merely a Renaissance phenomenon but also a spirit enduring into the present day—and not merely a group of producers, but also a band of admirers, all bound together by an "impression" "continuing in men's minds." Pater's school models an image of

pleasurable collectivity in which imitators, disciples, and aesthetic critics all gather together in the same elite circle.[72] That nineteenth-century aesthetic painters were insistently labeled a "school" with Rossetti at the helm brings the spirit of Pater's Giorgione even closer to the scandals of modern art.

Also significant here is that Giorgione's school consists not merely of Venetian-style colors but an interest in "subject"—that is, in an image's content. This fact seems to contradict Pater's formalist mandate; if one judges a painting only for its fall of light or for its tapestry-like patterns, the actual subject-matter should be irrelevant. Yet Pater's essay does not follow through on its initial theoretical premises. Instead, as he moves through Giorgione's paintings, he dwells not on their paint or composition but on their subject matter, especially scenes of music and performance. While making a famous statement for formalism, this essay offers a very different emphasis from modernism's stringent formulations. The essay actually offers two contradictory theories: one, that each art should be judged by the handling of its own materials (a claim we would recognize in modernism), and two, that each art constantly strives toward other arts, what Pater names "*anders-streben*"—hence, famously, the arts aspire toward music, "music being the typical, or ideally consummate art, the object of the great Anders-streben of all art" (106). When we examine what actually qualifies as "Giorgionesque," it becomes clear that Pater is less invested in honoring the materials of each medium than in keeping morality and didacticism out of all arts—a political subtext evident when he grants an artwork its own rebellious agency: art is "always striving to be independent of the mere intelligence, to become a matter of pure perception, to get rid of its responsibilities to its subject or material" (108). No wonder that Pater praises heroic painter-poets like William Blake and, especially, Rossetti, whose status as the most famous Victorian art renegade must have burnished the artist's credentials as a modern Giorgione.[73]

Pater illustrates Rossetti's *anders-streben* with reference to a particular picture, Giorgione's well-known pastoral idyll, the *Fête Champêtre* (figure 3.7).[74] Rossetti's "delightful sonnet" appears in the 1870 collection that brought him "fleshly" fame. In the painting, two costumed men and two naked women recline in an Italian countryside. One man plucks at a lute, and one woman holds a flute near her lips; the other woman pours water out of a jar. With its languorous figures and leisurely pursuits, this painting strikes a dominant chord in Pater's essay.[75] In Rossetti's sonnet, the sound of falling water mingles with dying strains of music, performing a melancholy and lyric sensuousness. Like Rossetti, Pater makes the *Fête Champêtre* the locus for the meeting of Renaissance past with Victorian present, and for the mixing of poetry, painting, and music. It seems no coincidence that Manet chose this image for the scandalous 1863 remake, *Déjeuner sur l'Herbe* (figure 3.8). Manet's painting updates Giorgione's picnic to a contemporary scene of two clothed male dandies, presumably artists, lounging in the grass with two naked female models.[76] Though there is no evidence that Pater knew of Manet's painting,

FIGURE 3.7 Titian (Tiziano Vecellio), or Giorgione, *Fête Champêtre (Concert in the Open Air)*. Oil on canvas, 1508. Louvre, Paris. Photo credit: Erich Lessing / Art Resource, N.Y.

both artist and critic find a suggestion of modernity in Giorgione's pastoral scene of clothed men and nude women, evoking contemporary art-making alongside liberated indulgence.

The Giorgionesque subject-matter most appealing to Pater is any variation on the idea of "play": wearing fine costumes, playing musical instruments, relaxing at parties, and, not least of all, the play of light across a painting. These instances of playfulness suggest that Pater's essay correlates an aesthetic art style with an aesthetic lifestyle, whose trappings partake of the essay's broader didactic aim. Over and above the seeming abstractions of the "musical law," the "School of Giorgione" hints at a social program of which art spectatorship is only the most visible symbol. The program is apparent when Pater praises Giorgione for his invention of the genre picture, otherwise known as a conversation piece or "cabinet picture," whose subjects, significantly, were the first in the history of art to serve purposes other than those of Church or State. Pater writes of them as "those easily movable pictures which serve neither for uses of devotion, nor of allegorical or historic teaching—little groups of real men and women" (110). These paintings were meant for private consumption, moving out of the public world into the private cabinet, the home, the boudoir. In a crucial passage, Giorgione's invention of genre scenes is portrayed as both the history of painting's privatization and the history of private life itself:

FIGURE 3.8 Edouard Manet, *Le Déjeuner sur l'Herbe (Luncheon on the Grass)*. Oil on canvas, 1863. Musee d'Orsay, Paris. Photo credit: Erich Lessing / Art Resource, N.Y.

Those spaces of more cunningly blent colour, obediently filling their places, hitherto, in a mere architectural scheme, Giorgione detaches from the wall. He frames them by the hands of some skilful carver, so that people may move them readily and take with them where they go, as one might a poem in manuscript, or a musical instrument, to be used, at will, as a means of self-education, stimulus or solace, coming like an animated presence, into one's cabinet, to enrich the air as with some choice aroma, and, like persons, live with us, for a day or a lifetime. Of all art such as this, art which has played so large a part in men's culture since that time, Giorgione is the initiator.

(111)

Pater offers a parallel history of both paintings and persons in what is essentially a retelling of the popular Victorian idea of the Renaissance, with its cult of individuals and its larger-than-life personalities. Where previous paintings were mere "obedient" place-holders, quietly conforming to the walls of powerful institutions, Giorgione's paintings are "detached from the wall" to circulate freely in the world of private views. The liberated, person-like paintings are mirrored by their

spectators, who are not passive consumers but active players, moving paintings into their homes and using images as though they were "musical instruments" apart from any dictated program. This passage enacts a move that occurs often in Pater's essays, as the history of Renaissance art subtly mutates into a proscription for modern living and for contemporary art-viewing procedures. The shift happens in Pater's use of pronouns, which modulate from the "he" of Giorgione to the mysterious "one" of an ahistorical spectator, finally arriving at "us," as the painting comes to "live with us, for a day or a lifetime." Pater's language transforms the paintings into modern-day "persons" who enter the bedroom ("cabinet") as "animated presences," and remain there to sustain the erotic dialogue of aesthetic culture.

The Giorgionesque picture, then—of which the *Fête Champêtre* is a signal example—also becomes a scene depicting modern art enjoyment, a languorous party scene for young Victorian men and women cloistered in private. That Pater imagined the Giorgionesque not merely as a two-dimensional painterly style but also as an atmospheric space for the experience of beautiful moments can be seen in a passage from the 1877 essay cancelled in later *Renaissance* editions, when he wonders who "in some such perfect moment, . . . has not felt the desire . . . to suspend it in every particular circumstance, with the portrait of just that one spray of leaves lifted just so high against the sky, above the well, forever?" Is there a place "wherein these desirable moments [might] take permanent refuge"? "Well! in the school of Giorgione you drink water, perfume, music, lie in receptive humour thus forever, and the satisfying moment is assured" (242). In this fantasy of stopped time, the reader seems to have literally entered the picture—into the *Fête Champêtre,* to be exact, as confirmed by the "spray of leaves . . . above the well." The School of Giorgione is literalized into a place, a haven in which spectators might "take permanent refuge." The intimate "you" of the final sentence brings the reader into the utopian space of aesthetic critics, reclining together in their own private party.

Pater's Giorgionesque, then, creates an idyllic space mirroring the fraught and famous rooms of the Grosvenor Gallery in 1877. The essay's utopian desires are realized by the actuality of the Grosvenor; with its trappings of a furnished room in a gentleman's house, the gallery imitated a private cabinet that might serve as Pater's longed-for refuge. Both rooms are constructed as spaces of exclusive contemplation, safe from the thronging demands of the crowd. As one critic commented in 1877, Coutts Lindsay used décor to create the marvelous illusion "that this is not a public picture exhibition, but rather a patrician's private gallery shown by courtesy of its owner."[77] Pater's essay captures a confusion that was also evident in reviews of the gallery: formalism, or "the Giorgionesque," is portrayed as both a style and a space, a materialistic painterly technique as well as a gallery displaying that technique. These two sides of the Giorgionesque, defining the aesthetic school surrounding Rossetti, encapsulate a driving contradiction that became more pronounced into the later 1870s. Subjective criticism, with

its anarchic and lonely impressionism, its preference for "musical" art forms and its tendency to move away from direct reference or legible meaning, was also becoming recognizable as its own distinct group affiliation. A philosophy devoted to personal interpretive freedom was now becoming, ironically enough, a popular fashion—a tension evident in Pater's essay, whose Giorgionesque school encompasses both Renaissance artists and modern spectators. Let us turn now to examine the increasingly popular face of the Aesthetic movement.

Aesthetic Fashion: "Art Crazes and Art Culture"

The Grosvenor controversy, the Whistler trial, and Pater's writings after 1873 all reflect a particular context of the 1870s, as the doctrine of "art for art's sake" was materializing into a broader cultural movement. If the more theoretical facets of aestheticism—especially the proto-modernist appreciation of visual form—had already been established in the late 1860s, the 1870s witnessed a widespread bourgeois embrace of aestheticism. A disembodied theory of visual art style was being transformed into a fashionable upper-middle-class vogue. Harry Quilter, in his hostile 1880 account of "The New Renaissance," likens the shift to the spread of a "morbid" disease that has migrated "from pictures and poems into private life," infecting home decoration, women's dresses, and the personal etiquette of its devotees.[78] Aestheticism gained a new visibility with the opening of the Grosvenor Gallery in 1877; it also achieved publicity in the abundant parodies and denunciations that filled the pages of late-Victorian periodicals. In 1876 W. H. Mallock began serializing his ingenious satire, *The New Republic,* in *Belgravia* magazine, following in book form in 1877. Linda Dowling has suggested that the book's resounding success, with its effeminate "Mr. Rose" an obvious stand-in for Pater, resulted in Pater's withdrawal from the competition for a poetry professorship at Oxford in March 1877.[79] Mallock's satire worked with the other aesthete mockeries and critiques to popularize the very phenomenon they disparaged, ensuring that the identity of the Aesthetic movement was molded as much by critics from the outside as it was by the artists who embraced it.

George Du Maurier's cartoon parodies of aesthetes in *Punch* magazine—first appearing in 1873, and then accelerating into the 1880s—were one such shaping influence on the movement. His "Modern Aesthetics," published in February 1877, reveals how "art for art's sake"—a visual style—was being transformed into a full-blown aesthetic identity (figure 3.9). The cartoon depicts what would become a frequent scene of aesthete mockery, as a group of gallery spectators stand before a work of art. A foppish "Ineffable Youth" faces off against a "Matter-of-Fact Party," defeating him by sheer stupid force of will to insist upon the inscrutable beauty of a painting.

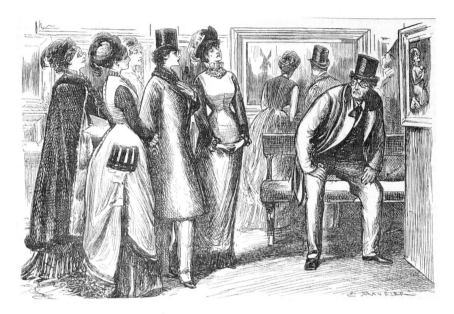

FIGURE 3.9 George Du Maurier, "Modern Aesthetics," *Punch* 72 (1877): 51. The Pennsylvania State University Library.

Matter-of-Fact Party. "But it's such a repulsive *subject*!"

Ineffable Youth. "'Subject' in Art is of no moment! The *Picktchah* is beautiful!"

Matter-of-Fact Party. "But you'll own the *Drawing's* vile, and the *Colour's* beastly!"

Ineffable Youth. "I'm cullah-blind, and don't p'ofess to understand D'awing! The *Picktchah* is beautiful!"

Matter-of-Fact Party (getting warm). "But it's all out of *Perspective*, hang it! and so abominably *untrue to Nature!*"

Ineffable Youth. "I don't care about Naytchah, and hate Perspective! The *Pickchah* is *most* beautiful!"

Matter-of-Fact Party (losing all self-control). "But, dash it all, Man! where the *dickens* is the *beauty*, then?"

Ineffable Youth (quietly). "In the Picktchah!"

[*Total defeat of Matter-of-Fact Party*.][80]

The "ineffable youth" quickly dispatches with all of the traditional criteria for aesthetic judgment. His calm pronouncements are a parody of Pater's subjective criticism, where the only standard of beauty is whimsical preference; and his taste satirizes the formalist aesthetic, where subject is no matter and truth to Nature is a bore. The cartoon insinuates that the dandy's praise of the "ineffable" is mere fraud, as spurious as his affected accent. Du Maurier's aesthetic parodies feature a

cast of social-climbers and pretentious know-nothings, suggesting how art criti-
cism and aestheticism threatened to confer a social superiority that bypassed tra-
ditional channels of class power. (Hence Ruskin attacks Whistler's formalist art
as paint flung by "cockney impudence.") If aestheticism offered a powerful new
method of self-fashioning, a claim to distinction based in nothing more than the
sensation and expression of visual pleasure, that development seemed noxious to
conservatives like Du Maurier.

Class confusion radiated in particular from aestheticism's unique combi-
nation of high style and physical pleasure. For *The Renaissance* shaped an elite
identity around a philosophy of bodily sensation—a province that was typically
associated with the working classes. An 1873 review of *The Renaissance* worries
that Pater offers no "criterion of 'pulsations'"; thus "the housemaid who revels
in the sensation novels of the 'London Journal' holds with Mr. Pater—only less
consciously—that it is pulsations that make life worth the living."[81] The "pulsa-
tions" of aesthetic pleasure in Pater's theory might become, for alarmed critics,
the sordid indulgences of a housemaid's masturbatory romance reading. Aestheti-
cism's suspicious relation to the body was a recurring theme in Mallock's satiri-
cal *New Republic,* especially in the Paterian character of Mr. Rose. In one of the
book's running jokes, Mr. Rose's grandiose soliloquies are constantly undercut
by the intrusion of the body—when, for instance, a list of exquisite sensations
ends with "the shining of a woman's limbs in clear water."[82] Mallock's jabs reflect
a pattern common since the "mustard" jokes of Turner's time, as critics debase
high art theory with the vulgar humor of an implicit or explicit working-class
body. The threatening link of elite philosophy to corporeal thrill was especially
palpable in the formalist values of the aesthetic critic, since the appreciation of art
for its lines, shapes, and colors was quintessentially a pleasure sited in the body,
and hence linked for Victorians to other kinds of immoral pleasure. While critics
often attacked formalism for its associations with a lascivious heterosexuality, as
in the examples cited above, at other times this fleshly aesthetic was also aligned
with the gender transgressions of aesthetes, especially men who effeminately
devoted themselves to the passive appreciation of beauty. Formalist art was there-
fore often attacked in distinctly sexualized terms, for an "unhealthy," "unnatural,"
and "artificial" style that was rhetorically opposed to heterosexual normativity.[83]

Implicitly responding to these attacks, Pater's writing in the later 1870s
engages in a rhetorical project to refine bodily sensation into a socially acceptable
basis for philosophy. One of his methods is to weave physical impressions into the
formation of the higher self—as in his 1878 autobiographical essay "The Child
in the House," where the child's sensations in nature prepare the adult to take
aesthetic pleasure in art. The process of maturation is furthered by contact with
"actual, feeling, living objects; a protest in favour of real men and women against
mere grey, unreal abstractions" (186–87). Physical pleasure is pursued not for

some base indulgence but for the philosophical perfection of the perceptive con-
sciousness, always attuned to the world's sensuous matter. Pater also transmutes
bodily sensation into high-art philosophy by harnessing a ubiquitous vocabu-
lary of class. Words like "refined," "consummate," "exquisite," and "the quintes-
sence" recur throughout his texts. In a Giorgionesque painting light is "caught
as the colours are in an Eastern carpet, but refined upon" (104), implying a link
between formalist art judgments and aristocratic commodity culture. Indeed,
the "musical law" of formalism also "holds good of all things that partake . . . of
artistic qualities, of the furniture of our houses, and of dress, for instance, of
life itself, . . . and the details of daily intercourse" (108). The aesthetic eye, which
applies "art for art's sake" to all the external or material rituals of life, is drawn
toward the expensive, collectible objects found in the houses of the upper classes.
For, as Pater writes in an 1878 essay on Shakespeare's *Love's Labour's Lost*, "what
is called fashion . . . occupies, in each age, much of the care of many of the most
discerning people, furnishing them with a kind of mirror of their real inward
refinements, and their capacity for selection. Such modes or fashions are, at their
best, an example of the artistic predominance of form over matter . . . and have a
beauty of their own."[84] Though Pater does not mean to refer merely to aristocrats
here, his metaphorical comparison between discerning aesthetes and a fashion-
able elite makes the two groups difficult to disentangle.

Pater's language of class suggests how his esoteric philosophy might have
become available for translation into a commodity craze. Evidence of one's own
aesthetic sensibility could be showcased in material possessions like clothes and
decorative objects (figure 3.10).[85] Aesthetes themselves became known as col-
lectors of valuable pieces—Rossetti was famous for the furnishings of his house
at Cheyne Walk, in a bohemian London neighborhood. As T. Hall Caine remi-
nisced in 1882, "Japanese furniture became Rossetti's quest, and following this
came blue china . . . In a few years he had filled his house with so much curi-
ous and beautiful furniture that there grew up a widespread desire to imitate
his methods; and very soon artists, authors and men of fortune . . . were found
rummaging, as he had rummaged, for the neglected articles of the centuries
gone by."[86] As aesthetes became Victorian celebrities, books appeared providing
tours through their artistically designed homes. In Mary Eliza Haweis's *Beautiful
Houses: Being a Description of Certain Artistic Houses* (1882), the reader could take
a linguistic tour of homes belonging to the painters Lawrence Alma-Tadema
and Frederick Leighton, narrated in prose with a strongly aesthetic flavor.
Celebrity culture likewise inspired middle-class culture, and a series of home
decoration handbooks were published for the amateur aesthete. These included
W. J. Loftie's *A Plea for Art in the House* (1876), Agnes and Rhoda Garrett's *Sug-
gestions for House Decoration* (1877), Jakob Von Falke's *Art in the House* (1879), and
Mary Haweis's *The Art of Decoration* (1881). The fashionable commodity culture

FIGURE 3.10 Robert W. Edis, "A Drawing Room Corner," frontispiece, *Decoration & Furniture of Town Houses* (London, 1881). Courtesy of the University of Pennsylvania Library.

of British aestheticism, whose heyday ranged from approximately 1873 to 1885, was one of the most visible—and most ridiculed—facets of the art movement and its associated lifestyle.

The commodification of aestheticism is all the more ironic because the one of the movement's driving impulses was to critique the mercantile values of bourgeois culture, turning instead toward more "exquisite" experiences and objects. Satirists delighted in the contradiction, and many cartoons mocked the incongruity of high-minded aesthetic philosophies phrased to embrace vulgar commodity culture. George du Maurier ran a series of popular "Chinamania" cartoons in *Punch* in which women appeared in various states of devastation or delight depending upon the state of their porcelain collection. In the most well-known of these, an aesthetic bride clutches an elaborate china teapot and declares to her husband, "Let us live up to it!"[87] (figure 3.11). A reviewer of the "Pre-Raphaelites in England," reporting for an American audience in 1876, writes, "We have now in London pre-Raphaelite painters, pre-Raphaelite poets, pre-Raphaelite novelists, pre-Raphaelite young ladies; pre-Raphaelite hair, eyes, complexion, dress decorations, window curtains, chairs, tables, knives, forks, and coal-scuttles."[88] In *The New Republic,* Mr. Rose finds proof that the aesthetic lifestyle has triumphed in

FIGURE 3.11 George Du Maurier, "The Six-Mark Teapot," *Punch* 78 (1880): 194. Courtesy of the Rare Book and Manuscript Library, University of Pennsylvania.

THE SIX-MARK TEA-POT.

Æsthetic Bridegroom. "IT IS QUITE CONSUMMATE, IS IT NOT!"
Intense Bride. "IT IS, INDEED! OH, ALGERNON, LET US LIVE UP TO IT!"

the "enormous sums" now paid for "really good objects" (264). For many critics, aesthetes seemed to be embellishing basely acquisitive desires with a pretentious and superficial philosophy. For followers of the movement, however, the purchase of beautiful objects became a sign of affiliation with a daring and progressive lifestyle.

Aestheticism's growing popularity accompanied significant changes in Britain's upper-class social world. As Leonore Davidoff has traced, before the 1870s wealthy businesspeople and manufacturers were largely excluded from the echelons of "Society." But after an agricultural depression in the 1870s eroded the wealth of the landed aristocracy, persons with financial assets became more eligible to enter into Society's elite circles.[89] The admittance of "parvenus" to Society, with money earned in the industrial or banking trades, coincided with the emergence of the Aesthetic movement, which therefore seemed to some critics to be a social distinction for sale. Aestheticism appears in a new light when considered as a class phenomenon distinct from Pater's philosophical essays or Rossetti's shimmering poems. The parodies that portrayed aesthetes as social climbers gestured to social shifts extending beyond the world of art. The Grosvenor Gallery, in particular, was seen to be tinged by the questionable hue of trade. Lindsay's wife Blanche, who helped to bankroll the venture, was a member of the Jewish Rothschilds' family and heiress to a banking fortune.[90] Many of the patrons of aesthetic painters like Whistler, Burne-Jones, and Rossetti fell into the "parvenu" category—most famously Francis R. Leyland, the Liverpool shipping magnate who commissioned Whistler's peacock room.[91] The Grosvenor's mercantile tint was also increased by the fact that its paintings were actually for sale, though, as Henry James observed, insofar as the "beautiful rooms in Bond Street are a commercial speculation, this side of their character has been gilded over, and dissimulated in the most graceful manner."[92] From a more progressive vantage point, the Lindsays prided themselves on being among the first to open up rigid social circles to "contact with the distinguished folk of art and literature."[93] In other words, exceeding mere fashion, aesthetic painting—and the linguistic productions that contributed to its cultural value—created a particularly marketable kind of commodity, which played a special role in the reconfiguration of Britain's class system in the 1870s.

Significant in the emergence of modernism, aestheticism worked to create a new kind of art commodity. While "decorative painting" in the earlier nineteenth century had referred to the architectural imagery adorning walls and furniture, the Grosvenor exhibition marked the arrival of decorative painting as a new kind of ornamental high art, "detached from the wall," in Pater's phrase. Some of Whistler's paintings, in particular, were seen to take this quality to an extreme. Henry James dismissed the pictures as mere "incidents of furniture or decoration" (165); the *Daily Telegraph* seemed to take a page from Pater when it compared Whistler's

works to "the pattern of a Turkey Carpet."[94] At the trial, William Powell Frith testified that the paintings had beautiful color but nothing that "you could [not] get from a bit of wallpaper or silk."[95] Numerous critics used the language of home décor and "upholstery"—sites of aestheticism's fashion vogue—to deride Whistler's more abstract images. The paintings became the most prominent examples of the expensive commodities that were creating the aesthetic lifestyle. The images seemed deliberately to mimic these valuable goods.

The trial dramatized vividly the problem entailed when high art becomes a fashion. In the words of Ruskin's lawyer, "There is at present a mania for what is called Art. It has become a kind of fashion among some people to admire the incomprehensible and to say of something that cannot be understood, 'It is exquisite.' *(Laughter)* So too in painting."[96] The idea that Whistler's paintings were being valued out of "mania" rather than out of any sound art principles led to the most controversial and most-discussed topic at the trial, namely, the pictures' expensive price tag. Whistler admitted that he could "knock off" a painting in one or two days, but he felt no compunction about charging for it the exorbitant price of two hundred pounds. If Ruskin proposed that painting was a visual and manual labor and should be valued accordingly, Whistler stood for a new, aesthetic definition of worth, in which art was a status commodity and its cost determined simply by its desirability. Whistler was not as much of a renegade as he might appear by this description, since he saw the artist as a trained professional whose paintings ought to be valued for a lifetime of study rather than for a lengthy production process. Yet his perspective contributed to a new notion of aesthetic worth that was distinct from any evidence of visual industry.

Dianne Sachko MacLeod has documented how many newly wealthy Victorian patrons invested in art that narrated stories confirming middle-class values of labor and honesty—a clear return on one's money's-worth.[97] The Whistler trial depicted a different kind of art patronage, in which shipping magnates proved their upper-class sensibilities by investing in avant-garde art styles. As MacLeod is careful to point out, some *nouveaux riche* collectors patronized aestheticism out of a true desire for a religion of art, while others were only concerned with the attendant social cachet. For some observers at the time, however, the narrative of the trial was clearly an allegory for new money itself: Whistler's paintings seemed to offer an aesthetic or fashionable shortcut to class, not gaining status through legitimate channels but "knocking it off" through a series of poseur purchases. The repeated charges of "sham" and "hoax" that dogged not only Whistler's pictures but also the entirety of aesthetic self-presentation all pointed to the newly visible gap between art's use value and its fetish or status value, a gap that Victorians described using scoffing terms like the "ineffable" or the "unutterable," literally beyond words or legibility. Pater's writing, which was also deemed to partake of the "incomprehensible," must be seen as contributing to the transformation of

aesthetic art into a new kind of status commodity.[98] Formalist art, with its delib-
erate opposition to legibility or message, thus contributed to the creation of a
new kind of cultural capital. This trend would become amplified into the twen-
tieth century, as increasingly abstract images commanded ever larger price tags,
and were cast as pinnacles of an unspeakable sublime.

The tangible realities of money and class underpinning the rise of the new
art movement underline a disjunction between aesthetic theory and practice.
The detached aesthetic spectator, an abstract and rather ghostly individual, seems
to have often had real knowledge of British industrial culture or other kinds
of middle-class professionalism. Similarly, theory and practice differed in the
imaginary versus actual geographies of aesthetic commodification. Pater's essays
locate aesthetic spectatorship within the exquisite landscapes of Italy and Greece;
the presumptively English eye absorbs the art of the past like a tourist moving
through both space and time. The aesthetic spectator was also sited at Oxford,
which became associated with the movement beginning with the meeting there
of the Pre-Raphaelite artists in the late 1840s and culminating in Pater's own
influence. Yet the romantic and intellectual sites of aesthetic imagination were
contrasted by industrial cities like Birmingham and Glasgow, whose factories and
workshops manufactured aesthetic goods.[99] Asian nations such as China, Japan,
and India also contributed to the British aesthetic lifestyle; when Arthur Lib-
erty's "East India House" opened on Regent Street in 1875, selling Asian fabrics,
his shop quickly became known as the major outfitter of inexpensive aesthetic
wares. Liberty's was a gathering place for all the major artists of the Aesthetic
movement, including Rossetti, Moore, Burne-Jones, and Whistler.[100] Japanese
imports, in particular, greatly influenced the visual styles of aesthetic art; these
objects often adorned artistic British homes in eclectic displays that disguised
any evidence of their culture of origin.[101] Japanese goods even became a short-
hand for the process of abstraction itself, as in "School of Giorgione," when Pater
invokes the "abstract" techniques of "Japanese fan-painting" to characterize the
Giorgionesque style (104). While formalist theory proposed a sensuous viewing
experience for an implicitly English, upper-class, male body, the realities of aes-
thetic production entailed a much broader and differentiated web.

These material manifestations of the Aesthetic movement all highlight how the
seemingly hermetic mantra of "art for art's sake" began to connote, by the later
1870s, a fashionable lifestyle enabled by Britain's geographical channels of wealth
and imperial power. It is striking that the recognized practitioners of aesthetic crit-
icism—cultural elites like Pater, Swinburne, and Sidney Colvin—wrote largely
about high arts like painting and sculpture to promote the tenets of "art for art's
sake," while the commodity fashion of aesthetic living expanded to encompass all
kinds of domestic objects. Pater does mention household items in "The Child in
the House," but these are burnished more by their homely place in his memory

than by any loftier status in a canon of art. For the most part, Paterian subjective criticism created a formalist aesthetic around a highly exclusive set of artworks— Italian Renaissance paintings and classical sculptures—even while, in the larger cultural imaginary, formalism was becoming attached to a lifestyle of fashionable commodity consumption and an attitude opposed to mainstream social codes. The anti-establishment pose of the aesthete, however, was somewhat belied by the commodity culture that supported his lifestyle, an accumulation of status that was dependent upon the very bourgeois culture aestheticism set out to critique.

Art, Myth, and Spiritual Form

This chapter has been tracing how the formalist aesthetic, which began as a hermetic and individualistic philosophy among a few art elites, gained popularity— and notoriety—for cultural associations beyond the seemingly pure, detached mode of art consumption that it promoted. I want to turn now to consider some of the political aspects of Paterian formalism—a move that is invited by Pater's idealization of the formalist "school," as artists and spectators alike gathered into a collective centered around the shared experience of sensuous perception. The "School of Giorgione" is one of a series of utopian collectives limned by Pater in the 1870s and into the 1880s, culminating in his idealized depiction of early Christianity in *Marius the Epicurean* (1885). Pater's admiration for these exclusive communities reveals that formalism was not merely the basis for a fashionable lifestyle, but also the intellectual focal point for a utopian political culture, a fervent belief embraced by the aesthetic critic against the grain of a relativist, historicist, and skeptical sensibility. Pater's notion of a formalist collectivity, I will suggest, is one important origin for British avant-gardist thought in the later nineteenth century.

Pater seems to have been deeply attracted to the idea of the secret society, admiring groups that ranged from the Orphic cult of the *Greek Studies* to the Pythagorean brotherhood in *Plato and Platonism*.[102] These desirable collectives are important given Pater's repeated moves to compare ancient cultures to the present day, particularly in his comparative studies of religion. It is by now a critical commonplace that aestheticism was a "religion of art," placing art into the spiritual vacuum left by the loss of a unifying religion and the rise of secular culture.[103] But Pater's analyses of religion—particularly in his studies of Greek myth in the later 1870s—exceed this simplistic equation, instead depicting religious beliefs as complex historical formations with both aesthetic and political dimensions. He invokes the "comparative science of religions" to describe his method—a skeptical approach that implicitly contains within itself the negation of all religions, since no single faith can be elevated as the unassailable Truth.[104] His studies of the Greek religion are thus less theological than anthropological, analyzing the

beliefs that united different sects of Greeks over time. For Pater, as I want to now discuss, "spiritual form" becomes the binding agent holding together people in synchronic time, while also ensuring a continuity over time in the historical progression of religions evolving across centuries in Western history.[105] Visual formalism is just one unifying aspect of a larger philosophical investment in cultural coherence across space and time—a potentially conservative yearning that Pater invests instead with subversively transformative, utopian elements.

Pater's most important myth study is the long essay on "Demeter and Persephone," published in two parts in *The Fortnightly Review* in 1875–76. Here he explores the process of myth-making itself, as a diffuse oral tradition solidifies over time into highly shaped mythic figures and artworks. Using somewhat idiosyncratic terminology, he describes the evolution of myth as a three-part process, beginning with an oral, "mystical" phase, moving to a written "literary" phase, and culminating in a sculptural "ethical" phase. Thus he traces how the earliest accounts of Demeter, the earth-mother, emerged in "the form of an unwritten legend, living from mouth to mouth," as primitive responses to the earth and its shifting aspects (91). Pater's account of myth formation is permeated with political language, as artists channel the will of the people. The oral roots of Demeter's story ensure that it is "the work of no single author" but "the whole consciousness of an age"; the poet who recorded the myth is "the spokesman of a universal, though faintly-felt prepossession," a gradual group awareness expressing a "common temper" (101). Whereas in "School of Giorgione" Pater disdains popular critics for their moral claims on art, in the myth studies he values the "popular mind" as the bearer and congealer of the mythic body. In the myth's more developed stage it "has solidified itself in the imagination of the people, they know not how" (102). Pater evinces an ambivalence toward the crowd that is a familiar marker of experimental aesthetics. He dislikes the conformist nature of mainstream critics, but still desires the energy accompanying a mass movement for change or rebirth. He wants to retain the classist distinction surrounding initiates while opening the doors to an ever larger cultural group. And even as he celebrates individual self-culture, he realizes that followers, popularizers, divine worshippers—in a word, "the people"—are a crucial part of the rise of religious or aesthetic movements. This is a highly aestheticized account of a political process, in which art-makers and storytellers become the ones to focalize the desires of a people at large. Pater's mythic political culture, while valuing the popular sensibility, is not really a democratic vision: the gods and the artists who mold their features are superior beings who put the final polish on Greek culture's more primitive aspects.

Pater's theory of myth formation combines an aesthetic and political idea of representation, in which artworks body forth the beliefs of the Greek people. Visual artworks, in particular, recur throughout the essays on myth: it is as a

visual icon that the myth achieves its final phase, Pater's suggestively named "ethical phase," when persons and stories have arrived at their most concentrated, characteristic, and highly symbolic forms.[106] Pater's allusions to the visual arts enable mythic figures to transcend time and space, eventually to be unified in the eye of the Victorian aesthetic critic. Demeter is thus transmuted from ancient myth to modern woman as her type recurs in the visual arts across the ages. As an icon she transcends her Greek moment, appearing again as a peasant woman or as the Virgin Mary in images limned by Giotto, Botticelli, William Blake or François Millet. This transformation might seem to neutralize the potential subversiveness of the mythical actors, as Demeter is hardened into a static, sculptural image. Yet Pater's phases of development are not rigid divides so much as permeable layers. Each interpenetrates the other, allowing for the rebellious and sensuous behaviors of Greek characters to come alive within the Victorian present. Pater's leaps across history also imply that the social formation of Greek mythic culture might be animated in modern times, much in the same way that Giorgione's school extended from a Renaissance circle into the present day. The politicized relationship between the people and the artists who represent them might not be merely a phenomenon of the Greeks. Modern artists, too, might play a political role, though the political work seems highly aestheticized and idealized.

Pater's study of Greek religion locates a tension between individual creativity and collective affiliation, a tension reflected in the dialectic between the oneness of static, formally perfect artworks and the multiplicity of shifting persons or behaviors that these artworks represent. The mythic relationship between the one and the many is most fully embodied by that of the gods and their worshippers. This relationship is depicted in lurid detail in Pater's 1878 essay "The Bacchanals of Euripides," which centers on the wild female followers of Bacchus.[107] In Euripides' play, the Maenads wreak the god's revenge upon king Pentheus by tearing him to pieces. Yet rather than vilify these women as monsters, Pater admires their ecstatic ritual, describing their primal dance of spring as a poetic remnant of an earlier and more primitive Greek past.[108] Pater makes these riotous women embody the sensations of mass passion that animate a crowd, prone to the "ecstasies" and "wild dancing" that spring has inspired "in all times and places" (56). He invokes Coleridge's German term "*Schwärmerai*," "like the swarming of bees together," to explain "how the sympathies of mere numbers, as such, the random catching on fire of one here and another there, when people are collected together, generates as if by mere contact, some new and rapturous spirit, not traceable in the individual units of a multitude. Such swarming was the essence of that strange dance of the Bacchic women: literally like winged things, they follow, with motives, we may suppose, never quite made clear even to themselves, their new, strange, romantic god" (56–57). The Maenads sacrifice their individuality to gain an ecstatic experience available only to the collective. Their ritual thus

serves as a revision to *The Renaissance*'s more lonely pleasures. Pater's depiction oscillates abruptly between the "coarse," "animal" nature of the dance and its aesthetic solidification into sculptural friezes—artworks, significantly, "delighting in colour and form" (58). Formalism, partaking, as we have seen, of both physical pleasure and aesthetic detachment, serves here as a mediating link between the carnal ritual and its rendering as sculptural artwork. The artwork lends order to what seems a completely unruly, rebellious experience. The political dimensions to Euripides' play, implicit in Pater's essay, are anti-authoritarian and carnivalesque: the patriarchal King Pentheus is punished by maddened women who, while serving at the behest of Dionysus, also become the embodiment of the god themselves, achieving in their dance a powerful, gruesome, and sensual satisfaction. The political status quo is challenged by a collective that, again, is not really democratic so much as cult-like and aesthetic.

As the Maenads become the embodiment of Dionysus' will, their collective action implies that the god contains within himself their manic multitudes. In all of Pater's myth studies, as the gods are traced from their early to late stages, they appear in multiple guises over time with many faces or phases. In Pater's 1876 essay "A Study of Dionysus," the wine god occupies both an early and late phase, transforming from a rough peasant god to a whitened deity worshipped by a clique of sophisticated Athenians (39). Similarly, Persephone is a "twofold goddess" of both summer and winter: "there is ever something in her of a divided or ambiguous identity" (110). Pater uses the phrase "spiritual form" to describe the way that gods embody different Greek responses to the natural world—as seen in the subtitle to the essay on Dionysus, "The Spiritual Form of Fire and Dew." The plasticity of spiritual form, emanating from myth's roots in an indistinct oral tradition, creates "that indefiniteness which is characteristic of Greek mythology, a theology with no central authority, no link on historic time, liable from the first to an unobserved transformation" (101). The mutable theology of ancient Greece is implicitly contrasted to the Judeo-Christian tradition, with its clear point of historical origin and its monotheistic authority centered in a single, stern god.

The political overtones to Pater's account are made explicit in "Demeter and Persephone" when he moves to critique Plato, whose *Republic* dogmatically prohibited any stories in which gods shifted their shape. As Pater explains, Plato's rule emerged from the philosopher's "instinctive antagonism to the old Heraclitean philosophy of perpetual change," which led him to promote "a rigid, eternal immobility. The disintegrating, centrifugal influence, which had penetrated, as he thought, political and social existence, making men too myriad-minded, had laid hold on the life of the gods also, and, even in their calm sphere, one could hardly identify a single divine person as himself, and not another. There must, then, be no doubling, no disguises, no stories of transformation. The modern reader, however, will hardly acquiesce in this 'improvement' of Greek mythology" (119). Pater extends a kind

of collectivity to myths themselves, in all their varied and ambiguous aspects. If a myth's multiple versions are evident in an array of visual forms across the ages, that multiplicity has its roots in the diverse stories that have earlier gone toward the myth's creation. This collective culture is aligned with a subtle politics of "myriad-mindedness," proposing a more multiform version of "political and social existence." Once again Pater injects the Victorian moment into his discussion when he adverts to the "modern reader," who is quietly folded into the group of myriad-minded Greek listeners. While it might seem that there is a conflict between the ambiguous shapes of mythic figures and their concentrated "spiritual form," in fact Pater embraces a historicism that refuses to privilege any one form over another. The diverse shapes of the gods across history, frozen in fragments of surviving artworks, together align into an idealized polity spanning the ages, almost like an art gallery or "House Beautiful," as Pater names the imaginary space housing the collected arts of the West.[109] As in the "School of Giorgione," the various artworks gathered under a single rubric—in this case, representations of a mythic figure over time—have their mirror in a collective of people, both art-makers and consumers or listeners, who are gifted with the potential to transform "political and social existence."

Pater's New Republics

The political subtext to Pater's mythic collective also gestures toward the politics of culture in his own moment. Contemporary critics understood aesthetic philosophy to be issuing a political challenge to middle-class values, even if the challenge was expressed in the form of a benign and idealized utopianism. If aesthetes dismissed the middle classes as "Philistines," they preferred to imagine rule by a tasteful elite, one that might form a new aristocracy assembled by talent rather than by birth. The political threat posed by aestheticism is evident in W. H. Mallock's satire *The New Republic*. The book's very title refers to the utopian program understood to be encoded in aestheticism's claims for art, even while mocking the movement's grand Platonic pretensions. In a climactic speech, the Paterian Mr. Rose outlines his "Utopian" program by ranting against all of the necessary offices of modernity, the "barbarous faces set towards Parliament, or Church, or scientific lecture-rooms, or Government offices, or counting-houses."[110] Instead, he prefers to spend his time indoors surrounded by beautiful things. Rhapsodizing upon "our new Republic," he imagines that the tasteful house might be turned inside out, making the whole world into one exquisitely decorative interior. "In our ideal state, . . . our London—the metropolis of our society, . . . taste would not there be merely an indoor thing. It would be written visibly for all to look upon, in our streets, our squares, our gardens."[111] The London of the future would offer only "museums," "gardens," "picture-galleries"—sites of upper-class,

passive contemplation rather than manly action.[112] Rose's revision of the gendered spheres promises stark political decline as the utopian city subsides into a moribund museum ruled by effetely tasteful men.

It was apt that Mallock chose Plato's *Republic* as the platform for his satire. Pater was long fascinated by this classic work, and it recurs throughout his writings; we have already noted its presence in the *Greek Studies*. Of all Plato's works, *The Republic* is the most overtly political. The book sets forth guidelines for the utopian state, what Pater would later translate as the "City of the Perfect."While Pater obviously disagrees with some of Plato's tenets—especially the philosopher's rigid attempts to reign in the marginal and subversive cultures of Athens, as famously embodied in his banishment of poets from the Republic for their mendacity—much of Plato's utopia evidently appealed to Pater, and was adopted to aesthetic ends. Importantly, Plato's vision of political life is founded upon an aesthetic education. The state's elect guardians, the philosopher-kings, are trained to rule through a regimen of "music" that encompasses all the artistic activities pertaining to the Muses. Young Marius, the protagonist of Pater's historical novel, undergoes just such a training when he embraces the "New Cyrenaicism": by studying music "in that wider Platonic sense," he works to attain "a wide, complete, education" that approaches "a kind of religion."[113] The figure of music—the basis for Pater's formalist theory—is also a Platonic symbol of self-culture, uniting aesthetic spectatorship with the political work of social regeneration.

That Plato's *Republic* serves as a recurrent subtext in Pater's *Marius the Epicurean* lends a more utopian and political edge to a novel that has most often been read as Pater's own spiritual autobiography.[114] With its tale of a young Roman man progressing from pagan worship toward an ascetic Christianity, *Marius* has seemed to confirm, for many readers, Pater's retrenchment in the wake of the *Renaissance*'s scandal; it apparently serves as his corrective of what had been misunderstood as a shallow philosophy based in aimless pleasure-seeking.[115] Yet, as I want to now suggest, *Marius* recapitulates Pater's investment in subversive formalist collectives in a way that makes it difficult to see the novel as a quiet retreat. *Marius* seems more an assembly of philosophical essays than a sharply plotted Victorian novel, exemplifying Pater's tendency to push the bounds of literary genre and lending to the sense that the novel counts as a kind of aesthetic criticism.[116] In fact, the novel makes aesthetic criticism into the basis for a rebellious collective—in this case, early Christianity—with a surprising investment in formalism, again combining aesthetics and religion in a manner similar to the myth studies. While set in the era of second-century Rome, *Marius* constantly adverts to the modern age, addressing the Victorian circumstances of aestheticism itself. Rather than recommending Christian conversion to its aesthetic readers, Pater's novel portrays a developmental pathway for one young aesthete that points the way toward wholesale cultural regeneration.

Young Marius develops by moving through a series of collective Roman cultures, from rural to urban and back again. While Pater has often been aligned with Wordsworth's Romantic cult of nature, his novel celebrates an aesthetic lifestyle that is distinctively urban and cosmopolitan.[117] Marius's idyllic rural childhood does not represent a lonely innocence in nature so much as an early pre-history of human activity, indicating the arc the novel will trace from "cultivation" to "culture"—both sharing the same etymological root, as Pater knew.[118] In *Marius*, as in the myth studies, the country and the city describe the two faces or phases of human endeavor, one primitive and rough, the other urbane and sophisticated.[119] When, in a famous aside, Pater apologizes for his novel's numerous leaps from the ancient world to the Victorian present, he sites the historical link between the two eras in their cities: "That age and our own have much in common—many difficulties and hopes, [so] let the reader pardon me if here and there I seem to be passing from Marius to his modern representative—from Rome, to Paris, or London" (2:14). If aestheticism was a phenomenon of cities, especially the London of the Grosvenor Gallery, Rossetti's bohemia, and Whistler's "cockney impudence," then Pater makes Rome an earlier incarnation of the dynamic British urban center, arriving there, significantly, via Paris, birthplace of *l'art pour l'art*. Marius's Rome, like Pater's London, epitomizes an imperial capital, showcasing an eclectic array of historical styles, hosting a confusion of religions, and, as the barbarians mass at the borders, teetering on "the eve of decline" (1:172). Hovering above the tumult of Rome is the Platonic ideal of the Perfect City, "a divine order, not in nature, but in the condition of human affairs—that unseen Celestial City, Uranopolis, Callipolis, *Urbs Beata*" (2:39). Utopia exists not as a natural paradise but as a more artificial creation of "human affairs," actively made by the urban collective.

It is Rome's public culture that encourages Marius to become a student of rhetoric and an artist in prose. Amid the "modern traits" of Rome is "this spectacle, so familiar to ourselves, of the public lecturer or essayist" (1:153). Marius desires to become, like Pater, an aesthetic critic. The Roman rhetorician echoes (or prefigures) the Victorian aesthetic critic by performing as "the eloquent and effective interpreter" of his own understanding "of the beautiful house of art and thought which was the inheritance of the age" (1:153). Pater's hypothetical Roman critic finds his inspiration in history, as does Pater himself.

Yet in the case of *Marius*, the historical novel is also a utopian novel with an eye cast expectantly toward the future. When Marius emerges from his cloistered childhood into the more cosmopolitan world of Pisa and Flavian's circle, he discovers a new culture that is "modern" for its "voluntary archaism," improving "by a shade or two of more scrupulous finish, on the old pattern." Marius senses that a "new era . . . might perhaps be discerned, awaiting one just a single step onward—the perfected new manner, in the consummation of time, alike as

regards the things of the imagination and the actual conduct of life" (1:48). The perfection of culture is imagined quite literally as an artwork, a communal product of innumerable refinements. Marius's yearning for the futurity of "a new era" perhaps seems surprising, given that it is set in the world of old Rome. Yet this passage captures the utopian desires bound up in aestheticism's turn to history. More than merely a retrograde nostalgia, historicism could also serve as a conduit for radical newness. Much Victorian modernism indeed involved a rewriting over past texts and artworks toward experimental and challenging ends, as exemplified by Pater's own novel.

Marius advocates for the utopian reworkings of culture on levels both personal and collective. At the individual level, the chief task of the aesthetic critic is to discriminate, to create new orders from old elements, to rearrange, or to re-decorate. On a more collective level, Roman culture evolves toward a new and comely Christianity that is a re-ordering of older, pagan traditions. The early Christian church at Cecilia's house is portrayed as the most tasteful recombination, as

> evidenced in the selection and juxtaposition of the [house's] material . . . consisting almost exclusively of the remains of older art, here arranged and harmonised, with effects, both as regards colour and form, so delicate as to seem really derivative from some finer intelligence. It was the old way of true *Renaissance*—being indeed the way of nature with her roses, the divine way with the body of man, perhaps with his soul—conceiving the new organism by no sudden and abrupt creation, but rather by the action of a new principle upon elements, all of which had in truth already lived and died many times.
>
> (2:95)

Cecilia's house, like Christianity itself, is a new house populated by "new people" (2:116), yet made up of older ideas, images, and materials. The new religion is attractive not for its mystical truth but for its beauty of "colour and form," a rebirth that recalls Pater's own earlier espousal of the Renaissance. The subversive edge is sharpened here by his suggestion that "the divine way" with the human soul might be to reincarnate new spirits from old ones—a religious idea that is not quite Christian.[120]

Pater's idiosyncratic depiction of the new religion makes it difficult to conclude that aesthetic critics are meant to abandon pagan ways in exchange for a righteous Christianity. Marius does not reject paganism so much as assimilate it into his new faith. The novel radically challenges the attributes that Victorians usually attached to the different religions. *Marius*'s pagan worshippers, more than mere pleasure-seekers, also display an austere *ascêsis,* as seen in Cornelius's martial orderliness and in Marcus Aurelius's Stoicism. Early Christianity, meanwhile, is

an aesthetic religion whose militant character is softened by "an influence tending to beauty, to the adornment of life and the world" (2:114). Christ himself has an aspect of "the Good Shepherd, serene, blithe and debonair, beyond the gentlest shepherd of Greek mythology" (2:114). The gay shepherd and divine mother of the novel's ending deliberately echo the earlier worship of Dionysus and Demeter. This Roman moment of early Christianity, a "beautiful, brief, chapter of ecclesiastical history!" (2:120), marks a flowering of the religion before its descent into a mean puritanism, when it was to become "sour, falsely anti-mundane," with "a bigoted distaste . . . for all the peculiar graces of womanhood" (2:122). Pater's preferred mode of Christianity is worldly, aesthetic, and feminist. It is not even clear whether this is "Christianity" at all.[121] *Marius*'s final religion appears to be one choice among many, and even offers itself as an allegory for the modern aesthetic revival, the rise of a new religion in weary, disillusioned Victorian times.

What Pater says of early Christianity he also says again, later, of Plato's philosophy. In both bodies of thought

> the seemingly new is old also, a palimpsest, a tapestry of which the actual threads have served before, or like the animal frame itself, every particle of which has already lived and died many times over. Nothing but the life-giving principle of cohesion is new; the new perspective, the resultant complexion, the expressiveness which familiar thoughts attain by novel juxtaposition. In other words, the form is new. But then, in the creation of philosophical literature, as in all other products of art, form, in the full signification of that word, is everything, and the mere matter is nothing.[122]

This key passage rewrites the formalism of art as just one manifestation of a larger philosophical truth. Form is "everything": it captures the expressiveness of a philosophy, an artwork, or a religion. Pater's obsession with form serves to articulate his sense of relativism, by which all the various religions and philosophies might be considered on an equal level. By discriminating the forms of art or philosophy, the aesthetic critic can observe what are essentially Darwinian lines of descent, as the shapes of ideas reproduce across history like living, animal bodies. That both early Christianity and Plato's philosophy have "lived and died many times" repeats the famous language describing the vampiric Mona Lisa; da Vinci's visual art icon becomes a formal and philosophic vessel for Pater's historicist beliefs. His idea of form ultimately connotes a materialism that seems both sensuous and agnostic, born out of and propagated across the "flaming ramparts of the world" (*Marius* 1:134).

Marius's mystical turn to religion, emptied of real belief, asks to be read politically. The destination of Marius's spiritual quest is ultimately the shared experience summed up in the book's final "holy family" or "strange family" of group worship (2:98, 2:107). While individualism remains a core value in Pater's utopia,

cultural regeneration is only possible in the midst of a like-minded group of prac-
titioners willing to work toward a communal ideal. The City of the Perfect will
be governed by an elite school of aesthetic critics, modern citizen-rulers with an
eye trained to discriminate. While, as we have seen, Pater does not follow Plato
to the letter, he likes the thought-experiment by which utopia would be ruled not
by professional politicians but by artistic philosopher-kings. Plato's vision appeals
to Pater's own elitist notion of schools, of initiates, of deep-thinking leaders as
modeled by Marcus Aurelius. Though Pater ultimately critiques Aurelius for his
callousness during the blood-soaked Roman games, the king embodies certain
traits that resonate with Pater's values. He is literally a king who is also a philoso-
pher; he writes conversations with himself in a mode Pater deems the same as
that of the "modern essayist," desiring "to make the most of every experience that
might come, outwardly or from within" (2:47). In Aurelius, as in Marius himself,
Pater suggests that the searching, ruminative qualities of the aesthetic critic might
also be those of the ideal political leader.

The larger forces that Pater attempts to reconcile in *Marius*, as in most of his
late writings, are not so much paganism versus Christianity—which both have
so much in common in his account—as they are the conflicting tendencies of
culture to fragment or cohere. Pater describes these forces in an 1880 essay on
Greek sculpture, defining the "two opposing tendencies" of Greek history to be
"centrifugal" and "centripetal," one based in "principles of separatism" and "indi-
vidualism," the other governed "under the reign of a composed, rational, self-
conscious order."[123] He repeats this account in *Plato and Platonism* when noting
how the Perfect City of *The Republic* is Plato's attempt to counterbalance the
dissolution of Athenian culture—a disintegration that speaks aptly to the late-
Victorian scene. The competing human propensities for asceticism versus hedo-
nism portrayed in *Marius* have their larger cultural analogs in the tendencies of
culture to factionalize or unite. Insomuch as Pater's version of early Christianity
represents a reconciliation of these forces, it points to how Victorian aestheticism
itself, as a "spiritual form" devoted to art, might also be a gathering force for the
centering and shaping of culture. *Marius* presents an odd solution to the eclectic
confusion of Victorian modernity in the form of an unshakable belief in form
itself, even while hinting at disbelief in any single doctrine.

Victorian Avant-Garde

In tracing Pater's discourse of ideal collectivity after 1873, this chapter moves
in a different direction than scholarship that has usually placed him in a tradi-
tion of early nineteenth-century ideologies of the subject, most prominently
liberalism and Romanticism.[124] Pater's debt to Romanticism—especially to

Wordsworth—cannot be disputed; his essays, in effect, create dreamworlds of nature and memory. Yet his writings cannot be completely subsumed under the category of this earlier movement. Romanticism connotes an art of private subjectivity and inwardness opposed to more public functions and official claims. The quintessential text of Romanticism is the lyric poem; with its illusion of transcendent privacy, the poem seems to be an overheard confession with no particular time or audience.[125] But while Pater admires lyric poetry as the best kind of poetry, his essays are not themselves lyric poems. The atmosphere of private exclusivity curtaining his works does not change the fact that he addresses himself to a public audience, alludes to contemporary art debates, and engages in the widespread contest to decide the best kind of criticism. The polemical nature of his writings— as perceived by his critics—lends a political urgency to his utopian vision, which seems less a private reverie than a public claim. This reading of Pater will seem counterintuitive, especially because of the way his art-for-art's-sake formalism was appropriated by modernism to define a perfect and timeless quality of art. Yet the ageless space of the House Beautiful looks different when we remember that it is a slightly modified version of the 1877 Grosvenor Gallery, a pseudo-boudoir in a gentleman's house that also exhibits art for public display. Pater's aesthetic critic functions as a mouthpiece for the aesthete's private sensations and ruminations, a translator of his own bodily pleasures for a larger audience. Like the rhetorician lecturing in Rome's public square, he is "the eloquent and effective interpreter, for the delighted ears of others," of his own travels in the "beautiful house of art" (*Marius* 1:154). Despite aestheticism's mirage of timelessness and its performances of privacy, Victorian readers and spectators understood the movement to exist on the cutting edge of modern times and to project itself into futurity.

Pater's school of aesthetic critics, then, speaks to the formation of a Victorian avant-garde. Though the doctrinaire avant-garde is most recognizably a phenomenon of the twentieth century, this chapter has been tracing what is essentially a nineteenth-century pre-history of the avant-garde, furthering my larger project to locate continuities between Victorian and modernist aesthetics. The Aesthetic movement concentrates many qualities that had been emerging in Britain's experimental art scene. If the most obvious example of an early British avant-garde was the Pre-Raphaelites, with their attacks on the Raphaelesque canon and their little magazine *The Germ,* it was only later in the century that new art styles came to be identified with a certain bohemian group identity. In the 1860s, coinciding with the emergence of subjective criticism, avant-garde circles formed around William Morris at Red House and D. G. Rossetti at Tudor House on Cheyne Walk. The Tudor House's initiates included Algernon Swinburne and Simeon Solomon, each with their own counter-normative sexualities and corresponding art styles; they lived among Rossetti's eccentric collections and numerous weird pets.[126] For these artists, more than simply making new-looking art, "it became the duty of a *life*

style to contest the bourgeois order."[127] If one of Pater's greatest aims was to link a visual art style with a new lifestyle, that desire was realized in the actual history of the Aesthetic movement. While aesthetic artworks have perhaps seemed too beautiful and too visually pleasing to demarcate a truly anti-bourgeois avant-garde, this chapter's recovery of aesthetic debates shows how these artworks were just as offensive to Victorian audiences as modernism's anti-art or signed urinals were for twentieth-century audiences. By contextualizing aestheticism in its moment, we can locate the rebellious politics encoded in its utopian aspirations.

Yet if aestheticism intimated qualities of an avant-garde, it is striking how the British version differed from more orthodox avant-gardes found in nineteenth-century France. Across the Channel, rebel artists gleefully deployed rhetorics of military violence and masculine virility to attack mainstream art practices and institutions. Charles Baudelaire derides this tendency in his countrymen in notebooks of the early 1860s: "On the Frenchman's passionate predilection for military metaphors. In this country every metaphor wears a moustache . . . Holding the fort. Carrying the flag high . . . More military metaphors: the poets of combat. The *littérateurs* of the avant-garde."[128] Baudelaire scorns the avant-garde's attraction to qualities of destructiveness, nihilism, rhetorical violence, futurism, and machismo. The Paterian aesthete, meanwhile, has been seen to be characterized by qualities such as stasis, languor, effeminacy, nonviolence, and a fixation on the past as the best path to the future. While French bohemianism was created out of an underclass of disenfranchised second sons and impoverished artisans, the British rebel class was largely upper-middle class and educated at Oxford. Rather than basing their anti-bourgeois politics of art on an idea of class revolt, British aesthetes organized their rebellion around metaphors of gender and sexual freedom. These historical roots might help to explain the unusual manifestation of the avant-garde in modernist Britain, when rebel art groups were divided between a more Continental-style, militant Vorticism or Imagism and a distinctively British Bloomsbury group, with its upper-class Oxbridge members, its pacifism, its Omega Workshops producing decorative arts, its adoption of art for art's sake, and its largely queer constituency.[129]

Aestheticism's experiments in painting, poetry, and decorative arts, among others, conveyed the sense that a whole utopian social world might be constructed out of art. In the midst of all this various art-making, aesthetic criticism served a crucial role as translator and interpreter of the movement for a broader audience. The social program of aestheticism, its didactic purpose and philosophy of values, was most clearly articulated in the essays of Walter Pater. For the Victorian avant-garde, Pater was the writer of manifestoes, albeit rather peculiar versions of the genre. While he eschews violence, his writings constantly touch on a subtle thematics of revolt organized around an elite group identity. Martin Puchner has recently written that the manifesto "belongs to a world in which art

is produced collectively and where collective declarations invest much energy in labels such as naturalism, symbolism, . . . and many lesser-known coinages"; in this way the manifesto writer "seeks to differentiate himself from rival 'schools' and isms."[130] Pater's battle of the "isms" revolves around the definition of criticism, as "aesthetic criticism" becomes the basis for his vision of Britain's aesthetic school. From this perspective his writings serve as wholly doubled texts, addressing simultaneously the histories of art and the practices of modern aesthetes.

Yet in one key sense, Pater's manifestoes differ from those of the militant modernists. For Pater avoids hard assertions of dogma and doctrine. His refusal of forthright statements is itself a political expression, an opting-out from violent assertions of Truth toward a more radical relativism. This distinction makes it even more ironic that Clement Greenberg invokes Pater's "School of Giorgione" as an ancestor in the modernist march toward abstraction. Though Greenberg agrees with Pater that "all art constantly aspires towards the condition of music," the later critic's dogmatic obsession with purity—framed in political terms that eventually led him to espouse abstract expressionism as the height of a patriotic, American individualism—strikes a much more authoritative note than Pater's more cautious preferences.[131] Greenberg's stark adherence to a doctrine of purity contrasts Pater's liking for variegation as symbolized by Dionysus's spotted leopard skins, a visual rendering of all the ways that men are "myriad-minded." What Pater locates as the pleasure of myth, as we have seen, is the playful mythic depiction of "doubling," "disguises," and "stories of transformation."[132] In this, Pater's modernism seems prescient of that of James Joyce—not for Joyce's own youthful aestheticism so much as for their shared investment in doubleness, punning, and disguise as a way of life as well as of language.[133] Mythic figures in the works of both authors allow for a literary transmuting of self into other, outlining personhood in states of shape-shifting or perpetual flux. In *Ulysses,* Joyce conveys these values by making a villain of a violent Irish patriot, while the hero, in a climactic scene, transforms into a woman. For Pater, as for Joyce, duality or disguise is itself a political stance opposed to any kind of dogma or cultural constraint. Of course, Pater would not recognize a mythic hero in a character who was lower-middle class and Irish; his utopian collective was unwaveringly sited within the British cultural elite. Yet Pater's faith in myth as the shimmering summation of all Western beliefs, images, ideas—a theory of forms unattached to any single form—seems relevant to describing some of the later fictional techniques of literary modernism, by which impressionistic prose was shaped and ordered through the repetition of just such mythic forms.[134] Pater's formalism might thus be placed not only within the visual history of abstraction but also within a literary history of formal experimentation—both of which can be seen to emerge from the particular contexts and contingencies of the late-Victorian world Pater was attempting to reshape.

Socialist Design at the Fin de Siècle
Biology, Beauty, Utopia

Everything made by man's hands has a form, which must be either beautiful or ugly; beautiful if it is in accord with Nature, and helps her; ugly if it is discordant with Nature, and thwarts her; it cannot be indifferent: we, for our parts, are busy or sluggish, eager or unhappy, and our eyes are apt to get dulled to this eventful- ness of form in those things which we are always looking at.

—William Morris, "The Lesser Arts" (1877)

There is grandeur in [the fact that]...from so simple a beginning endless forms most beautiful and most wonderful have been, and are being, evolved.

—Charles Darwin, *On the Origin of Species* (1859)

Form is everything. It is the secret of life.

—Oscar Wilde, "The Critic as Artist" (1890)

"This eventfulness of form"

The luxurious world of British aesthetes has often seemed a distant one to the fiery socialist art communities of the 1880s and 1890s. Aestheticism's orientation around passive consumption would seem to offer a sharp contrast to the active productions of radical crafts-makers, who saw the decorative arts as political symbols of a more egalitarian society. The Arts and Crafts movement has traditionally been seen as a legacy of Ruskin's social conscience, producing art objects in the name of progress for working people.[1] Yet, as we have just seen, aestheticism's political subtexts and public presence gave it a more active role than might be visible to our contemporary eyes. And in this chapter, I explore how certain late-Victorian writers espoused anti-realist visual styles in the name of progressive social change.[2] Though many of these authors were also artists, their writings and theories align them with the tradition of art writing that this book has been outlining, prescribing didactic goals for the best consumption and judgment of art.

The rise of the aesthetic has typically been located in an avant-gardist formalism that avoids any legible political message. Here, though, I show how certain

late-Victorian artists instilled a defiant message into their formalist shapes that was lost in the retrospective march toward modernism. The medievalist nostalgia of some late-Victorian radicals has often made it difficult to perceive their engagement with modernity. Reacting against the received mantra of progress, these thinkers espoused what might be deemed an anti-modern modernism, arriving at aesthetic and political innovations by challenging mainstream models of development. As this chapter will pursue, the unique battleground for the politics of the aesthetic at this moment was mapped using the terms of the biological sciences. The political function of formalist art at the fin de siècle was enabled by the unusual biologization of art objects that occurred in the wake of post-Darwinian theories of culture.

It might seem surprising that an anti-realist style in art was marshaled to promote socialist politics, given that the idea of visual form—an emphasis on shape, line, color, and composition leading to a non-imitative style in art—would seem to preclude any kind of political reading. If the formalist visual styles of the later nineteenth century are usually gathered under the rubric of "art for art's sake," the fin-de-siècle socialist movements seem a far cry from this subversive aesthetic development. The connection is further vexed by the remarkable reception history of late-Victorian aesthetic socialism, as epitomized by critical treatments of its most illustrious advocate, William Morris. One strain of twentieth-century criticism canonized the works of Morris and his followers as valuable precursors to modernist aesthetic experiments, leaving their old-fashioned, idealistic politics by the wayside. Nikolaus Pevsner's influential *Pioneers of Modern Design* (1936, 1949) traces a direct path from Morris and the British Arts and Crafts movement to the German Bauhaus group and the functionalist style of the 1920s.[3] Jerome McGann's *Black Riders* asserts that William Morris's art-books are "the forbears not merely of early modernist procedures like imagism, vorticism, and objectivism, but of important later developments in visual and concrete poetry."[4] Yet a separate critical tradition eschews aesthetics to focus instead on politics, celebrating Morris's political work for its contributions to the rise of the British labor movement. In E. P. Thompson's classic biography *William Morris: Romantic to Revolutionary,* Morris's innovations in the decorative arts appear as mere stepping stones on his path to socialist activism.[5] In other words, Morris has been invoked as the progenitor of both an abstracted modernist style and the Labour Party in Britain—but never at the same time.

My argument will reveal how Morris, along with certain socialist colleagues, attached innovative aesthetics to utopian politics using metaphors inspired by Darwinian biology. Darwin himself made an important contribution to the history of design in *The Descent of Man,* where his careful analysis of bird feather patterns went to support the theory of sexual selection. The discourse of pattern initiated by Darwin was adopted by a variety of late-Victorian progressive thinkers

who made the designs of decorative ornament into an analogy for the futuristic society they hoped would evolve accordingly. While modernist or formalist aesthetics are in many ways opposed to the social-change projects of writers like John Ruskin, Walter Crane, and William Morris, I argue that these theorists still borrowed heavily from the Darwinian discourse of aesthetics, focusing especially on botany, plant breeding, and organic pattern as the cornerstones of a futuristic decorative utopia. My discussion focuses on these thinkers to disaggregate them from a broader "Arts and Crafts" designation, since the phenomenon of Arts and Crafts itself is too complex and variable to be contained by the examination here. Instead, this chapter analyzes a spectrum of fin-de-siècle writers who used biological aesthetics to argue for social or political amelioration, only some of whom belonged explicitly to Arts and Crafts groups. If the Darwinian study of pattern and form itself prefigures a modernist visual value of secular detachment, especially in the realms of design and architecture, at the fin de siècle these kind of visual forms were made to speak in art writing to a progressive politics.

In the first instance, writers fused biology, aesthetics, and progressive politics in order to disseminate new scientific ideas to a popular audience. Grant Allen and John Ruskin, in particular, marketed scientific ideas to laypeople by analyzing the beautiful forms of flowers and fruits. The rise of popular science writing in the later nineteenth century accompanied emergent mass-reading markets more broadly, and led to the imbrication of aesthetic and biological ideas packaged for "the people." Tropes of beauty and pattern in popular science writing overlapped with the Darwinian tropes that surfaced in the socialist-aesthetic theories of Walter Crane and William Morris. For Arts-and-Crafts socialists, an anti-realist style in art, visible in the patterns twining on wallpapers and furniture, became the symbol of an organic life freed from the grinding oppression of a commodi-fied, machine-dominated world. Unfortunately for these theorists, their writings and hand-made art objects only served to create even more desirable commodities, which were easily assimilated into the capitalist system they were meant to challenge.

The chapter's final sections move to show how British aesthetic socialism shared surprising commonalities with European decadence, an art movement that also invoked a biological aesthetics of pattern and form. These two types of fin-de-siècle aesthetic-politics come together, paradoxically, in the figure of Oscar Wilde. Despite his upper-class lifestyle, Wilde too was a declared social-ist, a Darwinian thinker, an anti-realist, and an advocate of the decorative arts. Though critical hindsight has usually classified William Morris as "Victorian" and Oscar Wilde as "modernist" (or even "postmodernist"), this chapter works to locate both thinkers in a more liminal category particular to the fin de siècle, when progressive politics urgently contributed to the scripting of a new visual style that would fuel the sights of modernism.

Aesthetic Socialism: The House Beautiful

Beginning in 1873 and continuing into the mid 1890s, an economic downturn in England incited workers to demonstrate by the thousands for employment and higher wages. The labor movement garnered widespread sympathy from the middle classes in what historian Gertrude Himmelfarb has called "a massive surge in social consciousness," and many bourgeois intellectuals devoted themselves to the problem of reform.[6] Socialism was "the capacious label," as Himmelfarb puts it, under which many different groups ranged themselves. Perhaps the very looseness of the term allowed such diverse thinkers as William Morris and Oscar Wilde to align themselves with it.[7]

A distinctive strain of late-Victorian socialism proposed that art was the labor that would revolutionize modern capitalist culture. William Morris was the most famous exponent of this aesthetic socialism; his voluminous socialist writings, published lectures, and utopian novel *News From Nowhere, or an Epoch of Rest,* all preached the saving power of art.[8] Morris looked longingly back to a golden pre-capitalist age in which "all handicraftsmen were *artists*," working with their whole, sentient beings rather than performing the repetitive, mindless tasks demanded by the modern Victorian workshop.[9] The most characteristic art forms of Morris's utopia are not the high arts of painting and sculpture but the decorative arts or "lesser arts," as he polemically titled one of his socialist lectures. Morris championed the artfully designed, functional objects of everyday life as an act of political defiance against the establishment of the Royal Academy, which disdained to accept decorative artisans into its ranks. For Morris, medieval art was ideal for its lack of distinction between high and low forms; it was a unified decorative art "given as freely to the yeoman's house and the humble village church, as to the lord's palace or the mighty cathedral."[10]

The deep symbolism Morris attached to the decorative arts is apparent in the decisive opening scene of his utopian novel, *News from Nowhere*. Here William Guest wakes to discover that he has miraculously been transported to a socialist England of the future, which looks remarkably like England of the fourteenth century. The first person he meets in this new world, Dick the boatman, is dressed medievally in fine-spun clothes and a striking belt buckle of "damascened steel beautifully wrought."[11] Judging this expensive-looking item, Guest assumes that he is dealing with a "refined young gentleman" who is playing boatman for a day. Only later in the scene does Dick reveal that, in fact, he has carved the belt buckle himself. The object is not a sign of class, as it would be in Victorian England, but a symbol of Dick's artistic skill with his hands, his "practical aesthetics," as he proudly calls it (16). The carved belt buckle signals the amazing transformation wrought in Morris's utopian England of the future: the small, artfully crafted, useful item defines a new kind of unalienated labor and a new idea of a classless society.

Morris's theories uniting art production with socialist politics were instrumental in the formation of new progressive workshops loosely grouped as the Arts and Crafts movement of the 1880s.[12] Decorative art was to be no longer degraded by its commercial existence but now produced for its own sake, in conditions similar to those governing the high arts. Products spanned the realms of decorative and domestic life, including wallpapers, books, furniture, and stained glass. Theorists of the movement wrote essays and lectures on the minutest elements of their specialty craft, in which every aesthetic choice had a political aspect.[13] The greatest overarching symbol of the movement was the house, since it united under one roof all of the arts that capitalist practices had divided, and hence embodied the much-repeated ideal of the "unity of the arts." It is no coincidence that the frontispiece to *News from Nowhere* depicts Morris's own house—the Kelmscott Manor, built in the sixteenth century—as the place in utopia where the novel begins (figure 4.1).

Contributors to the Arts and Crafts movement provided wares for the new "House Beautiful," the label describing a popular surge in design reform. The public, moral quality of this movement highlights the extent to which Pater's subversive aestheticism had been adopted by a popular mainstream. The extraordinarily diverse output of polymathic late-nineteenth-century artists—who created not only paintings but a whole range of objects for the aesthetic interior—speaks to the larger cultural vision of the House Beautiful as a social symbol (figure 4.2).

The ideal self who was to occupy the House Beautiful is theorized in the lectures of the young Oscar Wilde as he toured America in the early 1880s. Here Wilde exhorted the rough citizens of the New World to create beauty around them in the cultured manner of the Aesthetic movement, or "English Renaissance," as his first lecture was titled. These lectures are a curious amalgam of Pater's beauty-worship and Morris's socialist aesthetics—at this early stage in his career, the emphasis decidedly on the latter.[14] In an 1882 lecture titled "The House Beautiful" Wilde entreats his audience, "Have nothing in your house that has not given pleasure to the man who made it and is not a pleasure to those who use it. Have nothing in your houses that is not useful or beautiful. . . . Let us have everything perfectly bare of ornament rather than have any machine-made ornament; ornament should represent the feeling in a man's life, as of course nothing machine-made can do; and, by the way, a man who works with his hands alone is only a machine."[15] That Wilde still finds the "useful" and the "beautiful" complementary here is a sign of his Morrisian influence; by the 1890s the two words would be opposites in his critical vocabulary. These impassioned lectures—which covered everything from hatracks to bookbinding—proposed an intimate connection between the self and the objects decorating one's house. Good objects were to have all the qualities of a good person: honest, original, giving pleasure to others, and emanating all the signs of diligent labor.

FIGURE 4.1 William Morris, *News from Nowhere,* frontispiece, Kelmscott Press Edition, 1891. Courtesy of the Beinecke Rare Book and Manuscript Library, Yale University.

FIGURE 4.2 Walter Crane, "My Lady's Chamber," wood engraving, frontispiece to Clarence Cook, *The House Beautiful* (New York, 1878). Reproduced with the permission of Rare Books and Manuscripts, Special Collections, the Pennsylvania State University Libraries.

Darwin and the Beauty of Biology

If late-Victorian socialism in its myriad forms gained followers owing to a fear among middle-class activists that culture was becoming anarchic, the sense of political crisis was also heightened by new discoveries in the realm of the life sciences. Darwin's theories proved remarkably open to appropriation by social thinkers, who used them to explain, with sweeping totality, the advanced states of human progress or decline.[16] Darwin's writings worked toward producing what I am calling the biological aesthetics that became prevalent among late-Victorian social theorists, including some members of the Arts and Crafts movement. Before speaking more specifically about the biological inflections of late-Victorian political theories, I want to examine the aesthetics apparent in Darwin's writings themselves.

While Darwin's work has often been analyzed in trajectories of the history of science, it has rarely been seen as contributing to a cultural history of Victorian design. Though he is not usually read as an art writer, however, Darwin is obsessed with notions of "form" and "pattern." His writings are replete with a rhetoric of the beautiful, especially in his description of the shapes and colors of nature. He writes, "We see beautiful adaptations in every part of the organic world," and asks the aesthetic question, "How have all those exquisite adaptations of one part of the organisation to another part, and to the conditions of life, and of one organic being to another being, been perfected?"[17] The final ringing sentence of the *Origin of Species* finds "grandeur" in the fact that "from so simple a beginning endless forms most beautiful and most wonderful have been, and are being, evolved."[18] Darwin's enthusiastic perception of beauty in every natural form allows him to make more appealing a theory that strongly challenged conventional Victorian visions of nature.

For all of Darwin's rhetoric of beautiful patterns, his mechanistic explanation of how organisms evolve was devastating to any contemporary notions of freedom or agency. His theory of natural selection presented a causality independent of conscious volition, making nature into the exertion of ironclad laws or forces—a vision disturbing to Victorians not only for its "red in tooth and claw" associations but also for the apparent lack of purposiveness or teleology in the natural world. Even in Darwin's 1871 *Descent of Man and Selection in Relation to Sex* (rev. 1874), which examines the role of sexual-aesthetic choices in the pattern development of animals, the process of sexual selection once again circumscribes "choice" within the instinctual demands of an organism's drive to reproduce. This text, in particular, creates an insistent and complex discourse of pattern that powerfully influenced late-Victorian aesthetics. In *Descent of Man,* Darwin theorizes the process of sexual selection in order to explain the large body of evidence found in the shifting patterns adorning the petals, feathers, furs, or skins of different species.

The entirety of this book is devoted to the analysis of ornament in nature, with important implications for the human perception of beauty.

On a general level, the *Descent of Man* is one long catalogue of comparative behaviors between humans and animals, especially in the realm of aesthetic choice. Thus it is "undoubtedly a marvelous fact that [a female bird] should possess this almost human degree of taste."[19] Darwin even describes the ultimate home decorator of the natural world in the "Great Bower-bird," whose nest is a bird version of the House Beautiful; this bird collects shells, stones, feathers, and other aesthetic objects to decorate its nest "with the utmost taste": "These highly decorated halls of assembly must be regarded as the most wonderful instances of bird-architecture yet discovered."[20] Darwin's examples do not insist on the animalistic qualities of human behavior so much as on the rational and human-like qualities of animals, as seen in section headings on "Curiosity," "Memory," "Reason" and "Sense of Beauty."[21]

Alongside this humanistic rhetoric, Darwin sets up the figure of the artist as a recurrent straw man and metaphoric enemy in his attempt to prove that the patterns in nature exist without the movement of a divine paintbrush. In a lengthy, two-chapter analysis of the "ocelli," or eyespots, on peacock and pheasant feathers, Darwin uses numerous illustrations to demonstrate that, although the eyespots evince a remarkable three-dimensional "ball-and-socket" effect, looking as though they had been painted by a divine hand, they have in fact evolved from a more basic pattern of spots and stripes, and are the logical product of tiny variations over many generations of birds (figure 4.3). "That these ornaments should have been formed through the selection of many successive variations, not one of which was originally intended to produce the ball-and-socket effect, seems as incredible as that one of Raphael's Madonnas should have been formed by the selection of chance daubs of paint made by a long succession of young artists, not one of whom intended at first to draw the human figure."[22] The governing force of sexual selection becomes the metaphorical equivalent to the acts of "a long succession of young artists," despite the fact that no human or divine agency wields the paintbrush. Darwin chooses as the basis for aesthetic comparison "Raphael's Madonnas," the height of beauty in canonical Victorian art histories. He utilizes a familiar rhetoric of aesthetics and painting to outline what is fundamentally a very alien vision of nature, driven by "the selection of many successive variations" rather than any Raphael-like creator.

Yet as Robert M. Young has influentially observed, Darwin's use of aesthetic analogies in nature ultimately resulted in the broader misunderstanding of his theory among both scientists and laypeople. The term "selection" unwittingly granted a human-like agency to nature; and the confusion was magnified by Darwin's own line of reasoning, which made an analogy between the artificial selections of human breeding and the natural shifts in species brought about by a Malthusian struggle

toward the left-hand upper corner, the feather being held erect, in the position in which it is here drawn. Beneath this thickened part there is on the surface of the ball an oblique almost pure-white mark which shades off downward into a pale-leaden hue, and this into yellowish and brown tints, which insensibly become darker and darker toward the lower part of the ball. It is this shading, which gives so admirably the effect of light shining on a convex surface. If one of the balls be examined, it will be seen that the lower part is of a browner tint and is indistinctly separated by a curved oblique line from the upper part, which is yellower and more leaden; this oblique line runs at right angles to the longer axis of the white patch of light, and indeed of all the shading; but this difference in the tints, which cannot of course be shown in the woodcut, does not in the least interfere with the perfect shading of the ball.[46]

FIG. 56.—Part of Secondary wing-feather of Argus pheasant, showing two, a and b, perfect ocelli. A, B, C, etc., dark stripes running obliquely down, each to an ocellus. [Much of the web on both sides, especially to the left of the shaft, has been cut off].

[46] When the Argus pheasant displays his wing-feathers like a great .fan, those nearest to the body stand more upright than the outer ones,

FIGURE 4.3 Charles Darwin, illustration showing the evolution of ocelli on bird feathers. *The Descent of Man and Selection in Relation to Sex* (London, 1871). Courtesy of the University of Pennsylvania Library.

in the wild. "In moving from artificial to natural," Young explains, "Darwin retains the anthropomorphic conception of *selection,* with all its voluntarist overtones."[23] Significantly, Darwin's anthropomorphic metaphors often made nature into an artist. In the *Origin of Species,* the chapter titled "The Struggle for Existence" announces: "We have seen that man by selection can . . . adapt organic beings to his own uses through the accumulation of slight but useful variations, given to him by the hand of Nature. But Natural Selection, as we shall hereafter see, . . . is as immeasurably superior to man's feeble efforts, as the works of Nature are to those of Art."[24] While Darwin intends here to demonstrate nature's superior power over humans in the molding of species, the real effect of his comparison is to suggest that nature shapes species just as humans do, and that both kinds of breeding are also a kind of artwork. A reader might thus conclude that nature works as an artist does. In Gillian Beer's summary, Darwin's portrayal of nature as a guiding hand that develops creatures' most useful characteristics "points to the benevolism of his view of nature, despite his full awareness of how harsh life may be to specific individuals."[25] Despite the anti-teleological thrust of Darwin's theory, then, his language of aesthetics became an important authorizing source for many different late-Victorian social theorists, most of whom refused to follow through to the theory's more deterministic ends.

Popular Science: Physiological Aesthetics

Darwin's language of biological beauty itself had a precursor in various works of popular science published earlier in the nineteenth century. If the Victorian art world was transitioning from one of aristocratic privilege to middle-class fashion, science too was emerging as the avid pursuit of middle-class amateurs. As Lynn Barber observes, "By the middle of the century there was hardly a middle-class drawing-room in the country that did not contain an aquarium, a fern-case, a butterfly cabinet, a sea-weed album, a shell collection or some other evidence of a taste for natural history."[26] Treatises on natural history often had an aesthetic dimension, in part because the natural world easily lent itself to terms of beauty and wonder. Mid-Victorians learned to see nature closely and intently, especially under the lens of the widely popular microscope. The specimens of nature were now valued "*as objects,*" writes Lynn Merrill, "as material possessions with all the satisfying virtues of the concrete."[27] Amateur collectors, armed with nets or jamjars, might collect species in the same way that they collected portraits, engravings, or other modest works of art.

Microscopy in particular inspired numerous how-to manuals, many of which conveyed an aesthetic pleasure in forms and patterns. Isobel Armstrong finds that these manuals display "crystalophilia" in their language of translucent "quartz and semi-precious stones."[28] Also distinctive, I would add, are their recurring tropes of the revelation of beautiful structure. J. G. Wood's *Common Objects of the Microscope* (1861) celebrates "the lovely structures which are revealed by the microscope," "whose wondrous beauty astonishes and delights the eye."[29] Philip Gosse's treatise on seaside microscopy glorifies "the wondrous variety, the incomparable delicacy, elegance, beauty, the transcendent fitness and perfection of every organ and structure."[30] While Darwinism focused upon the transformation in forms over time, microscope manuals presented images caught in stilled time; yet these pictures had something in common with Darwin's ensuing works, for their minute study of visual forms detached and autonomous from an originary context.

Wood's *Common Objects* illustrates the eye-catching patterns obtained from a variety of microscopical images, including those of common plants like lilac and willow (figure 4.4). The rows of patterns show striking visual similarity to the images illustrating Owen Jones's *Grammar of Ornament* (1856), one of the most influential mid-Victorian texts on pattern design (figure 4.5). Jones sounds like a microscope manualist when he writes that the "beauty of form" depends upon "no excrescences; nothing could be removed and leave the design equally good or better." While Jones's book illustrates the patterns of cultures across history, from ancient art to the present day, the resulting effect is not a historical progression so much as a synchronic collection of pattern possibilities ranged alongside each other. A "grammar" suggests exactly this contemporaneity. As Jones sums up his guiding principle, "All ornament should be based upon a geometrical

FIGURE 4.4 J. G. Wood, "Cells of Common Plants," Plate I, *Common Objects of the Microscope* (London, 1861). Courtesy of the University of Pennsylvania Library.

FIGURE 4.5 Owen Jones, "Renaissance Ornament, No. 7," Plate LXXXI, *Grammar of Ornament* (London, 1856). Courtesy of the Rare Book and Manuscript Library, University of Pennsylvania.

construction."[31] Jones's values of "fitness, proportion, [and] harmony" echo the early-Victorian tenets of natural theology, in which anatomical structures show a perfect utility implanted by a divine designer.[32] Both the microscope and the decorative object provided opportunity for detailed focus upon pattern itself, dissociated from an object, stilled into an isolated and inorganic assortment of lines and curves.

Popular accounts of Darwinian science maintained this interest in beautiful colors and autonomous forms, even while analyzing more organic, less geometric shapes and animating these within a shifting, time-bound rhetoric. The popular aesthetics of Darwinism are captured in the writings by one of the theory's most prolific supporters, Grant Allen. While Darwin was famously hesitant to apply his conclusions directly to the world of English humans, his popularizers had fewer qualms.[33] In *Physiological Aesthetics* (1877), Allen argues that the human sense of beauty is a biological function of the human body: it is shared with the animal kingdom from which it has evolved. Allen's theory of beauty takes its cue from Darwin's *Descent of Man* and later botanical works. Darwin showed how sexual selection created the aesthetic sense in animals—especially, as we have seen, in the realm of bird feathers, where females always chose the brightest, most colorful, and most elaborate patterns. Hence the sense of beauty is utilitarian, serving to aid the species in reproduction. Questions of form and color were especially pressing in the plant world. Many of Darwin's later works of the 1870s and 1880s analyzed how the often bizarre shapes and patterns of plants had evolved along with insects to promote cross-fertilization. Allen extended these conclusions into the human world; in "Dissecting a Daisy," he explains that the human pleasure in color "has descended to us men from our early half-human frugiverous ancestors. The bright hues of fruits and flowers seem to have been acquired by them as attractive allurements for the animal eye, and as aids to cross-fertilisation or the dispersion of seeds."[34] Indeed, as Allen relates, flowers themselves only exist owing to evolutionary history. In *The Colour-Sense* he describes a prehistoric world that was unyieldingly green, "one unbroken sea of glistening verdure," until insects began to perceive minute color differences in plants.[35] Hence flowers are "Our Debt to Insects," as is titled his 1884 article in the *Gentleman's Magazine*.

Allen's articles appeared in publications ranging from middle-class monthly magazines (*Cornhill, Macmillan's*) to popular science journals (Richard Proctor's *Knowledge*) to specialist periodicals for emergent science professionals (*Nature, Mind*).[36] His articles for a popular audience focused most often on botany, as seen in titles like "Strawberries," "Honeysuckle," "From Buttercups to Monk's-hood," or "What is a Grape?" Nature-themed sciences like botany and biology were key sites of later-Victorian science popularization, in part because Romantic poetry and picturesque imagery had made the accessible objects of nature into a proving ground for middle-class sensibility. If Allen wanted to convince his readers of the truth of Darwinism, his best gambit was to invoke the flowers and fruits familiar from English meadows and gardens.

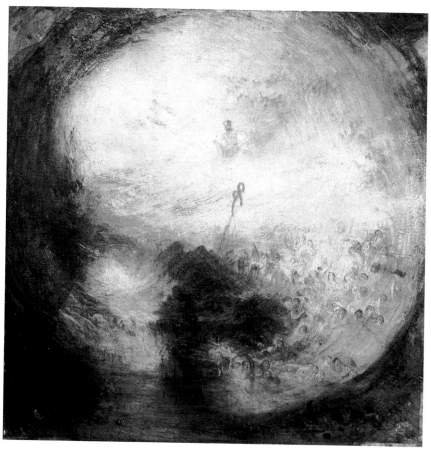

FIGURE 1.7
J. M. W. Turner, *Light and Colour (Goethe's Theory)—The Morning After the Deluge—Moses Writing the Book of Genesis.* Oil on canvas, 1843. Tate Gallery, London. Photo credit: Clore Collection, Tate Gallery, London / Art Resource, N.Y.

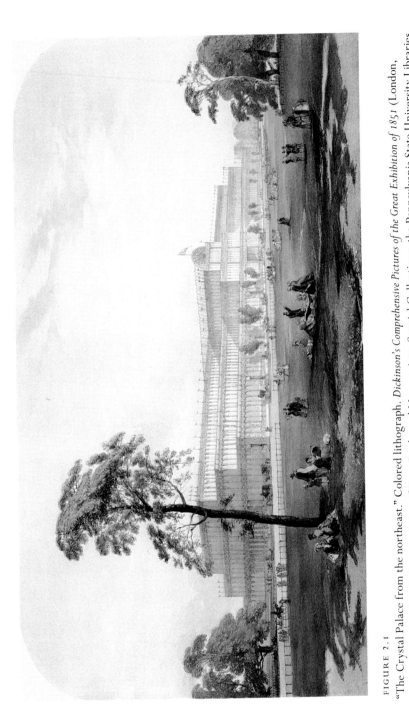

FIGURE 2.1

"The Crystal Palace from the northeast." Colored lithograph. *Dickinson's Comprehensive Pictures of the Great Exhibition of 1851* (London, 1852). Reproduced with the permission of Rare Books and Manuscripts, Special Collections, the Pennsylvania State University Libraries.

FIGURE 2.9

"The Medieval Court at the Great Exhibition." Colored lithograph. *Dickinson's Comprehensive Pictures of the Great Exhibition of 1851* (London, 1852). Reproduced with the permission of Rare Books and Manuscripts, Special Collections, the Pennsylvania State University Libraries.

FIGURE 4.2

Walter Crane, "My Lady's Chamber," wood engraving, frontispiece to Clarence Cook, *The House Beautiful* (New York, 1878). Reproduced with the permission of Rare Books and Manuscripts, Special Collections, the Pennsylvania State University Libraries.

FIGURE 4.10
William Morris, The 'cray' chintz floral pattern. Printed at Merton Abbey, Surrey, 1884. Victoria and Albert Museum, London. Photo credit: Erich Lessing / Art Resource, N.Y.

FIGURE 5.1
Henri Matisse, *La Fille aux Yeux Verts (The Girl with Green Eyes)*. Oil on canvas, 1908. San Francisco Museum of Modern Art. Bequest of Harriet Lane Levy. © Succession H. Matisse, Paris / Artists Rights Society (ARS), N.Y.

FIGURE 6.1

Barnett Newman, *Adam*. Oil on canvas, 1951–52. Tate Gallery, London. © 2009 The Barnett Newman Foundation, New York / Artists Rights Society (ARS), New York. Photo credit: Tate, London / Art Resource, N.Y.

As we saw in chapter 1, John Ruskin's *Modern Painters* drew on a "post-picturesque" tradition to revivify the middle-class voyage into nature. Allen's articles take Ruskin's formula one step further, narrating nature rambles in the style of "The Sketcher," only to launch into Darwinian explanations for the botanical sights observed. In the work of popularization, Allen combined narratives of historical development with the meticulous observation of plant and animal features.

In "A Mountain Tulip," for example, Allen opens by describing the arduous hike up a beautiful "almost untrodden tourist trackway,...so much the better for those wandering naturalists who love to ramble among unhackneyed scenes, and to spy out wild nature in all her native loveliness." Resting alongside a mountain stream-bed, he spies the goal of his adventure, the mountain tulip, and invites the reader to "unravel together the clues and tokens of its romantic history." This history, it turns out, hearkens back to a primeval, glaciated European landscape, when arctic plants once bloomed everywhere; after the ice age started to warm, the tulips were eventually limited to the high, snowy regions. Even while Allen lists off with clinical accuracy the various species common to alpine climates, he concludes with a romantic nod to the "isolated relics of an order that has long passed away."[37] Allen's narrative recapitulates the point he makes in most of his popular works, that the ability of humans or animals to distinguish beauty in forms and colors, making minute comparisons within species, is the engine driving evolutionary change. Thus the delicate red lines tracing the face of the tulip petal "are in fact honey-guides for the mountain insects," who "repay the flower for its honey by carrying pollen from blossom to blossom."[38] The minute discriminations of pollinating insects have their analogy in the careful observations of the naturalist himself, whose own sense of floral beauty has descended from the same motivations as that of the insect. While the larger purpose of insect or animal comparisons serves the function of plant evolution, the act of comparison itself is an autonomous judgment similar to that of microscopic detachment, separating the pattern or color from the animal or plant to which it is attached.

It is ironic that Allen adopts a Ruskinian formula of picturesque tour when elsewhere, as Jonathan Smith has argued, Ruskin was his particular nemesis, to be scorned for unscientific and vague aesthetic theories.[39] While Ruskin made his natural journeys speak to the glory of God, Allen's more secular goal was to popularize a theory with potentially frightening and inhuman connotations—the "secularization of wonder," in Bernard Lightman's assessment.[40] Allen trespasses onto Ruskin's territory because he takes Darwin's conclusions into the realm of human taste, products, and talents. If Herbert Spencer was the reigning late-Victorian sociobiologist, Allen's specialty was the sociobiology of aesthetics. Like Ruskin's *Modern Painters,* Allen too engages in the drama of forms versus narrative in the realm of aesthetics. In the high-flown conclusion to an essay on "The Origin of Fruits," Allen rewrites the logic of the famous closing moment of the *Origin of Species* when Darwin marvels that the "elaborately constructed forms" of "a tangled bank" have all been produced

from the same natural laws, and have all emerged from a small number of simple creatures; thus "from so simple a beginning endless forms most beautiful and most wonderful have been, and are being, evolved." In Allen's version,

> What . . . a noble prospect for humanity in its future evolutions may we not find in this thought, that from the coarse animal pleasure of beholding food mankind has already developed, through delicate gradations, our modern disinterested love for the glories of sunset . . . , for the gorgeous pageantry of summer flowers, . . . for the exquisite harmony which reposes on the canvas of Titian, and the golden haze which glimmers over the dreamy visions of Turner! If man, base as he yet is, can nevertheless rise to-day in his highest moments so far above his sensuous self, what may he not hope to achieve hereafter, under the hallowing influence of those chaster and purer aspirations which are welling up within him even now toward the perfect day![41]

Darwin's account marvels at the evolution of simple organisms into myriad new forms; Allen's version, by analogy, marvels at the evolution of the human search for food into a "disinterested" and autonomous aesthetic sense. The colors of fruits transition into the colors of paintings by Titian and Turner. The passage also expresses an undisguised faith in human progress, a faith echoed in Allen's own increasingly vocal socialist politics.[42] (As he was to write in an 1893 article "The Political Pupa," "England is passing through something like the chrysalis stage in its evolution . . . There will be a new heaven and new earth for the men and women of the new epoch").[43] The development of the human sense of beauty also promises a similar evolution in the political realm, as suggested by Allen's almost divine-seeming "perfect day." As this phrasing would suggest, though Darwin's theory pointed decisively away from teleological explanations in nature, it also lent itself to developmental theories of culture, including those of socialism. If the Darwinian focus on pattern and form prefigured a modernist visual value, it also opened the door to aestheticized arguments for progressive politics.

Ruskin's Political Botany

Given that botany was a major battleground for popular science in the 1870s and 1880s, it should come as no surprise that Ruskin, too, entered the fray. As early as the fifth and final volume of *Modern Painters* (1860), Ruskin was analyzing plant structures for their relevance to the human world. His most explicit botanical work was *Proserpina* (1875–86), which first appeared in widely spaced parts from 1868 to 1886. This highly personal treatise on English plants, "Studies of Wayside Flowers," combines precise botanical illustrations and descriptions with Ruskin's own idiosyncratic interests. While Herbert Spencer practiced sociobiology by using Darwinian metaphors

to interpret human systems and behaviors, Ruskin took an opposite approach, using human systems and mythologies to interpret the forms of nature. Most critics have highlighted Ruskin's contemptuous treatment of Darwin in *Proserpina*, a part of his ongoing campaign against the base materialisms of modern science.[44] Yet Ruskin proves himself remarkably familiar with new scientific research, acknowledging distasteful facts—such as the sexual purpose of flowers—while attempting to divert the focus away from "these obscene processes and prurient apparitions" (25:391). Both Ruskin and Darwin, for all of their differences, are concerned to explore the minute botanical structures of plants in order to arrive at larger systemic claims about nature—and, by implication, the human role within the natural world.

Ruskin's botanical writings are important here because they capture the tension between form and narrative in an aesthetics of nature, while also adding a political dimension to the judgment of beauty. *Proserpina* contains many of the same contradictions we earlier observed in *Modern Painters,* as Ruskin struggles to negotiate his allegiances to both the observational sciences and the human-centered storehouses of myth and language. In his plant treatise, though, a subjective vision of nature more clearly predominates, even while his investment in detailed plant forms is evident in the illustrations he himself made to accompany the text (figures 4.6a,b).

FIGURE 4.6A, B John Ruskin, Studies of Daisy and Leaf, *Proserpina* (1875–86), in *The Works of John Ruskin,* Library Edition, ed. E. T. Cook and Alexander Wedderburn, vol. 25 (London, 1903–12), 304, 314. The Pennsylvania State University Library.

Proserpina focuses in particular on plant names in relation to their structures, as Ruskin negotiates the literal ties between word and image. He protests the nonsensical modern system of botanical nomenclature, practiced by Darwin and Huxley, which names flowers after "diseases" and "vermin," as opposed to his own preferred method, which would name flowers in connection to "the loveliest fancies and most helpful faiths of the ancestral world" (25:436). His ideal system would feature a humanistic ordering of plants and flowers, steeped in classical mythology, and founded upon their typology within human association and memory.

Ruskin's biological aesthetics become manifestly political in his metaphoric comparisons between plant structures and human communities. Hence "a perfect or pure flower" is an "unbroken whorl," while an "imperfect" or "'injured' flower, is one in which some of the petals have inferior office and position, and are either degraded, for the benefit of others, or expanded and honoured at the cost of others" (25:389–90). It would seem that imperfect flowers are also comparable to the defective condition of modern England. Ruskin's Tory-radical politics are faintly discernible throughout *Proserpina,* visible in a botany that combines socialist communities of flower petals with the authoritative order exerted by the plant stem over the whole plant. The "governing stem" asserts a "royal or commandant character" over the "little" and obedient leaves (25:484). The highest and most noble flower forms are distinct and clear, while flowers whose "petals lose their definite character" are "to be looked upon as affected by some kind of constant evil influence" (25:466). While Victorian flower books traditionally ascribed human meanings to various species of English flowers, Ruskin's botanical writings are unique for their discernment of political meanings within the carefully observed structures of plant forms.[45]

For all of their idiosyncrasy, Ruskin's late writings draw upon a series of popular late-Victorian conceptions that might be crudely summarized as follows: that the workings of nature can be explained by analogy with human-centered narratives of myth or faith; that the hierarchies of political systems are either immutable like the natural world or progressing and declining like organic bodies; and that the aesthetic beauty of visual forms can be used to indicate the truth value in interpretative modes, whether of nature, or politics, or the two together—as seen both in Darwin's discourse of beauty and in Ruskin's activist botany. Ruskin's attempt to form the perfect social body in aesthetics, politics, and botany can be seen to have culminated in the founding of the Guild of St. George in 1871. Modeled on a monastic ideal, the Guild was to be an orderly community of laborers who would farm and practice traditional crafts, all under Ruskin's personal leadership. Tenets included a strong social hierarchy, a dress code, Guild-issued currency for staple items, and the tithing of members.[46] Though these ambitious plans were never fully realized, in part

because of clashes with English law, a small museum was erected near Sheffield in 1875. The museum was to display collections for the education of working artisans, and *Proserpina* was one of a series of unfinished "grammars" through which Ruskin intended to create and illustrate a new system of natural history.[47] Though Ruskin's Guild has often been dismissed as an outlandish utopian flop, it served as an important precursor to the Arts and Crafts guilds of the 1880s— not only for its medievalist bent and concern for working men, but also in its didactic use of biological aesthetics to promote its political agenda.

Patterning the Sociobiological Body

While Ruskin never became a designer of decorative ornaments, his carefully detailed drawings from nature—many of which ended up in the collection at the Museum of St. George—demonstrated his close observation of natural patterns. Though he attacked Darwinism, he also was influenced to adopt biological language and figures into his aesthetic writings. Even while Victorians tended to reject many of Darwin's actual proposals, and many confused Darwinism with Lamarckism, the broader controversy gave biological tropes a new authority in Victorian culture.[48] In particular, as the century progressed, the connection between human hands and the patterns they create was increasingly biologized. For designers of the decorative arts, pattern itself became a biological proposition. The second half of the nineteenth century saw a wave of books published on pattern and ornament that are striking for their biological rhetoric. These books included F. Edward Hulme, *Principles of Ornamental Art* (1875), *Plants, Their Natural Growth and Ornamental Treatment* (1874), and *The Birth and Development of Ornament* (1893); and Lewis Foreman Day, *Every-Day Art: Short Essays on the Arts Not Fine* (1882), *Anatomy of Pattern* (1887), and *Nature in Ornament* (1892). Lewis Foreman Day's 1882 essay "The Nature of Art" uses illustrations of apple branches to show how plants themselves have "ornamental" characteristics, and how much of the ornament in decorative art "is in reality borrowed from nature" (figure 4.7).[49] Christopher Dresser, one the foremost decorative designers of his day, was also a botanist who published *Unity in Variety as Deduced from the Vegetable Kingdom* (1859). Dresser wrote a series of articles on "morphology" and "vegetable structure" in the 1860s, around the time he published *The Art of Decorative Design* (1862). These works show a range of attitudes toward Darwinism itself. Dresser, for example, proposed an unabashed natural theology in which beautiful patterns in both art and nature proved the genius of God's design.

The writer who marshaled perhaps the most Darwinian account of patterns was the Arts and Crafts guild member, Walter Crane. A professor of design at the Manchester Municipal School of Art, Crane created designs for wallpapers,

Study of a branch
of an apple
tree.

forms which
are in themselves sug-
gestive of ornament.
And there is in the
world such infinite
variety, that he who
needs must cling always to nature's skirts has
scarce occasion to let go his hold. Not seldom it
will be found that the characteristic features of a
plant, for example, are at the same time the most
ornamental ; so that, in adapting it to ornamental
design, he may emphasise instead of obliterating
its individuality.

So essentially ornamental is the growth of some
plants, that a closer study of nature shows how many
a decorative detail which we have been in the habit
of looking upon as evidence of consummate skill
in design, is in reality borrowed from nature.

Studies of the growth
of the apple, and adap-
tation of them to inlaid
panel.

In the same way, when we come to adapt
a study from nature to the purposes of design,
we often find that we have, all unconsciously, re-
produced some quite familiar form of ornament.

E 2

FIGURE 4.7 Lewis Foreman Day, "Studies of the Growth of the Apple," *Every-day Art: Short Essays on the Arts Not Fine* (London, 1882), 50–51. The Pennsylvania State University Library.

textiles, ceramics, and tiles, as well as print illustrations for a variety of books. He also penned numerous treatises on pattern and ornament. In his 1892 essay "On the Structure and Evolution of Decorative Pattern," Crane develops an aston-ishing—and, to our eyes, astonishingly crude—theory of the development of aesthetic patterns according to evolutionary laws. He writes,

> It would be interesting to trace the different treatment of the same decora-tive unit by different races and in different countries, and to hunt them down to their primitive type. I have often thought it would be possible to classify patterns, like plants, into species and genera. The analogy between the two is perhaps nearer than is commonly supposed, for each is subject to those general laws of existence which control the existence of all art no less. [Here Crane attaches the following footnote:] Patterns, like plants, illustrate, in their arrangement and structure, those broad principles which divide the world of design—the symmetrical, the alternate, and the spiral systems.[50]

Crane argues that patterns, like plants, can be classified into different species based on their structures or skeletons. In effect, he gives patterns a biological life

of their own, strangely autonomous from the hand of any specific artist. Patterns are beholden to the larger mechanistic law of their general design, "much as a backbone is a necessity to a vertebrate."[51] As in nature, the most successful decorative patterns are the ones most adaptable to different conditions, and hence most likely to "reproduce." When a pattern best adapts itself to its materials and methods of production, as well as to its intended spaces or objects, then "we have only another instance of survival of the fittest."[52]

Crane's weird vivification of ornament enables him to unite biological pattern theory with human race theory. In an 1898 essay on "The Racial Influence in Design," Crane suggests that patterns have evolved differently among different races and nations; thus square patterns are typical of the logical, fact-seeking people of the North, while circular patterns are "figurative of the greater suppleness and sensitiveness to beauty of the Southern."[53] Crane repeatedly refers to patterns themselves as "races" descended from "the primitive circle and square." And his analysis invokes gross racial stereotypes to lend a scientific veneer to his design theories—such as a link between the African jungle's stripes of light and a preference for striped patterns among the "dark races."[54]

The surprise in these crude racial theories, to modern eyes, is that Crane uses sociobiology to argue for progressive politics. Social Darwinism, then and now, was the catchphrase for the "survival of the fittest," in Herbert Spencer's coinage, as humans competed within the brutal world of laissez-faire capitalism. While many Victorian political theorists used Darwinism to defend unfettered capitalist competition, another strain of late-Victorian thought invoked Darwinian metaphors to argue for social change. Walter Crane uses biology to critique capitalism by invoking a racialized notion of "the collective," which is both biologically and socially superior to any single individual. In the final rousing chapter of his 1898 book *The Bases of Design,* titled "Of the Collective Influence [in Design]," Crane includes a remarkable series of photographs depicting American school children drawing patterns on chalk boards, in order to demonstrate the "Natural Variation in Repetition of Ornamental Forms" (figure 4.8). Like Darwinian patterns in nature, human ornament combines collective, universal patterns with change over time, wrought by individual "variation." When a single schoolchild draws a pattern slightly differently, he or she works to further the evolution of the human species as a whole.

Crane also illustrates his chapter on "Collective Influence" in *The Bases of Design* with photographs of anonymous artisans laboring to produce patterned objects, creating a sense of the collective race channeled into the patterns of its products (figure 4.9). In championing the nameless artisan, Crane describes the "gradual evolution" of the impressive Gothic cathedrals over the years of the Middle Ages, and asks, "Can we name the inventors of these changes, the evolvers of these beauties of our constructive art? Do we not feel that by their

Chap. X.
Of the
Collective
Influence

In the primitive ornament of all peoples we
find the same or similar typical forms constantly

Natural
Variation in
Repetition of
Ornamental
Forms.
Primary
school
children
drawing on
the black-
board.
Philadelphia

recurring, the germs of pattern design after-
wards developed, complicated, and refined upon :

the chequer, the zigzag, the fret, the circle, the
spiral volute, the twisting scroll—can we ascribe
their invention to any individual mind or hand ?
340

FIGURE 4.8 Walter Crane, "Natural Variation in Repetition of Ornamental Forms," *The Bases of Design*
(London, 1898; reprint, Garland, 1977), 340. The Pennsylvania State University Library.

very nature they could not have been claimed by any individual mind alone or
have reached perfection in a single lifetime? They are the natural result of a free
and vital condition in art, moved by the unity of faith and feeling, wherein men
work together as brothers in unity, each free in his own sphere, but never iso-
lated, and never losing his sense of relation to the rest."[55] Crane's progressivist
rhetoric makes the cathedral builders into representatives of the human species,
who "by their very nature" achieved perfection over time. The grand time scale
of the cathedral mirrors that observed by Darwin as species change across a
series of generations. Crane rewrites the monastic ideal of Ruskin and Carlyle
into a Darwinian success story, in which the arts of society have "evolved" owing
to the united brotherhood of mankind. In Crane's system, patterns can magi-
cally reproduce apart from human agency for the same reason that the cathe-
drals slowly and triumphantly emerged: both arts transcend the actions of any

Chap. X.
Of the
Collective
Influence

Tapestry
Carpet
Weaving

upon the polished copper roller than they ever do on the cloth.

Well, it may be said, the remedy is with us —with the designers. We have only to use

our invention in producing good and attractive designs, adapted to the process and material, and the factory and the machine will do the rest. It is conceivable, certainly, that where the object is *solely* to produce something at once beauti-

346

FIGURE 4.9 Walter Crane, "Tapestry Carpet Weaving," *The Bases of Design* (London, 1898; reprint, Garland, 1977), 346. The Pennsylvania State University Library.

single artist, instead affirming the value of a culture—and a species—as a whole. Crane's biological tropes allow him to consider aesthetics at both a personal and a collective level. The human species benefits from choices made by individual designers, which are represented by the sinuous evolution of patterns that seem to live and move. His version of Victorian formalism is a distinctive fin-de-siècle articulation in its use of a biological model to argue for the political rewards of an aesthetic program.

The Garden-Rose: William Morris and Shapely Socialism

For many late-Victorian social theorists, including Walter Crane, evolutionary language often masked a thinly grasped Darwinism that sounded more like Lamarckism.

Writers frequently expressed the belief that environment had a biological impact on both humans and their artworks. Crane writes that art "must be influenced for good or ill by external and social environment, just as a tree takes its character from certain qualities of soil and climate, . . . these external and social conditions affecting . . . both art and its producer."[56] As Martin Fichman notes, before the advent of germ plasm theory in the 1880s, which established that heritable traits are not affected by environment, many biologists themselves "found it difficult to distinguish between natural selection and Lamarckism."[57] This confusion was evident in the several varieties of late-Victorian sociopolitical theory that appropriated biological metaphors, from free-trade individualism to communist socialism. Historian Diane Paul observes that the general "biologism of culture" prevalent in the late nineteenth century drove many leftist thinkers to espouse Lamarckian notions of the corrosive environmental effects on the human species. "Given the assumption that acquired characters are heritable, it follows that poor environments, whether natural or cultural, are almost inexorably bound to be reflected biologically." Late-Victorian leftist thinkers could only conclude, Paul writes, that "all deprived populations, including the proletariat, would be genetically 'lamed'."[58]

Walter Crane's friend and colleague, William Morris, also espoused a Lamarckian idea of environmental effects on humans and their art. Morris's art lectures premise their utopian vision upon "the healthy human animal" liberated from social oppression. In his 1884 lecture "How We Live and How We Might Live," Morris shapes his theory of the good life around the features of the human body. "I claim good health; . . . to enjoy the moving one's limbs and exercising one's bodily powers; to play, as it were, with sun and wind and rain; . . . to be well-formed, straight-limbed, strongly knit, expressive of countenance—to be, in a word, beautiful."[59] This ideal physical state is currently impossible for the modern working poor, who suffer under constant anxiety, bad housing, no access to natural beauty, and no leisure time or amusement. Morris uses Lamarckian reasoning to argue that the ugliness of the poor can be solved by the betterment of their living conditions:

> [I]n the course of time they [good conditions] would . . . gradually breed such a [healthy] population, living in enjoyment of animal life at least, happy therefore, and beautiful according to the beauty of their race. . . . [Indeed,] the very variations in the races of men are caused by the conditions under which they live, and though in these rougher parts of the world we lack some of the advantages of climate and surroundings, yet, if we were working for livelihood and not for profit, we might easily neutralize many of the disadvantages of our climate, at least enough to give due scope to the full development of our race.[60]

Like Walter Crane, Morris's finds that the "racial" or animal qualities of humans are the result of both their natural and political environment. He echoes the racial commonplace that the English, classified as "Northern people," were doomed by their climate to be more craggy, tough, and logical than their graceful, warm-climated Southern neighbors. Yet, he suggests, the effects of the English climate might be tempered by a move to a socialist system, to ensure the "full development of our race"—both physically and socially. The eugenic effects of this breeding are evident in the perfect population of Morris's utopia in *News from Nowhere*.[61] William Guest cannot stop marveling at the universal beauty of Nowhere's inhabitants. Old Man Hammond, the character who serves as Guest's guide to utopia, confirms the beautification of the people by a comparison with photographs from the nineteenth century, connecting "this increase of beauty directly with our freedom" (53). As Hammond aphoristically sums up the new situation, "Pleasure begets pleasure" (53).

The beautiful residents of Nowhere have apparently attained physical perfection by the corporeal act of art-making: art entails a pleasurable labor that strikes a middle ground between freedom and form, a kind of enjoyable bondage willingly undertaken. By making labor into a desirable, artistic pursuit, Morris manages to evade the greatest threat looming over socialist utopias, that of subordinating individual expression to collective order. His desire to navigate between the poles of autonomy and order is apparent in his theories of pattern design, which use biological metaphors to accomplish this goal. In "Making the Best of It" (1879), a lecture devoted to recommendations on home decoration, Morris begins with the garden and moves indoors from there. The long opening analysis of the garden inflects all of his ensuing comments, implying that the house itself is ideally a kind of garden, especially when decorated with the right kind of nature-inspired patterns—perhaps of the type manufactured by Morris & Co. (figure 4.10).

In Morris's view, the best garden strikes a balance between complete wildness and the showy, sculpted, "ugly big garden" found in the suburbs of London.[62] Similarly, he likes the moderate breeding of the "garden-rose," which shows a "new beauty of abundant form," as opposed to the extreme cultivation of the "florist's rose," which is now the size of "a moderate Savoy cabbage" and scented as strongly.[63] Morris sees the excessive breeding of shop roses, or "sham roses," as he disdains them, to be perfectly analogous to the process of commodification itself; these capitalist plant breeders have "missed the very essence of the rose's being," thinking "there was nothing in it but redundance and luxury" and "exaggerat[ing] these into coarseness, while they threw away the exquisite subtlety of form, delicacy of texture…which [makes]…the true garden-rose…the flower of flowers."[64] Morris admires the wild rose, but his allegiance ultimately lies with the garden-rose, whose natural loveliness has been heightened by man's hand.

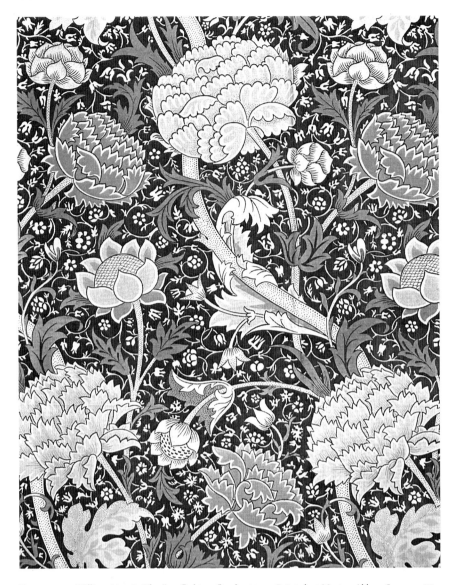

FIGURE 4.10 William Morris, The "cray" chintz floral pattern. Printed at Merton Abbey, Surrey, 1884. Victoria and Albert Museum, London. Photo credit: Erich Lessing / Art Resource, N.Y.

The garden-rose becomes an overarching symbol for the true art of design, combining natural beauty with artful human fashioning.

Moving inside the house, Morris also uses metaphors of plant cultivation to delineate the patterns on the wall. Eschewing pure geometry on the one hand and the exact imitation of objects on the other, he prefers designs both orderly and organic; "every line in a pattern should have its due growth, and be traceable to its beginning."[65] Patterns should not be merely copied; they must show

"change, the token of life." And "no stem should be so far from its parent stock as to look weak or wavering."[66] The notion of a pattern having a "parent stock" is terminology taken directly from that of plant breeding. Morris's vision of patterns is not quite the Darwinian struggle for survival depicted by Walter Crane. Instead, his imagery is more evocative of Darwin's greenhouse, with the careful cultivation of species and the selection of traits over generations. The artist is comparable to a farmer or horticulturalist and the pattern is an obedient plant. Morris's rhetoric actually reflects one of the major platforms for Darwin's arguments: Darwin himself often adverted to the role played by human cultivation in the transformations of plant and animal species. An English tradition for centuries, agricultural breeding—or "artificial selection," in Darwin's terms—was a familiar practice to most of his readers, with results evident to the most ignorant layperson. Darwin's *Variation of Plants and Animals Under Domestication* (1868) outlines a dizzying array of British experiments in the natural world, with chapters ranging from horses to peacocks to ornamental trees. Despite the antiquity of the domestication tradition, however, Morris's use of the trope seems strikingly modern given its prominence in Darwinian argument. And his notion of cultivation is deliberately modern in its attack on "shop-roses," the ultimate symbols of a modified and commodified nature. Even, then, while Morris rails against the linked terms of "modern science," "modern commerce," and "modern thought," he still uses a Darwinian trope to model the ideal social relations, in a manner similar to other late-Victorian sociobiological arguments.[67]

Morris's political beliefs, framed using metaphors of plant cultivation, also lead him to promote an anti-realist style in art. As he asks his audience in "Some Hints on Pattern-Designing" (1881), wouldn't they prefer "to be reminded...of the wild-woods and their streams, with the dogs panting beside them;...[as opposed to] a few sham-real boughs and flowers, casting sham-real shadows on your walls with little hint of anything beyond Covent Garden in them?"[68] Formalism here connotes the poetry of woods and streams, while visual realism connotes the "sham" quality of profitable and inauthentic commodities—"sham" no doubt to be found in abundance at Covent Garden, London's largest flower market. Realism in patterns makes their images fake in the same way that commodities are fake, disguising the labor that has gone into their creation. Morris also imbues his pattern preferences with political meanings on a more systemic level. As he explains, an ideal pattern must give "rest" in its forms because man "is an animal that longs for rest like other animals"; whereas realism, or "scientific representation," "involve[s] us in the problems of hard fact and the troubles of life, and so once more destroy[s] our rest for us."[69] Merely imitative patterns are thus bound up in all the negative qualities of modern-day capitalist culture, with its competitiveness and oppression of working men. Not coincidentally, this discussion of pattern styles echoes the subtitle of *News from Nowhere*, "An Epoch of Rest": the ideal pattern offers a

visual counterpart to a politics of cooperation and peace. For Morris, the perfect pattern has "stems" supported by their "parent stock," evincing "mutual support and unceasing progress"—in adorning a wall or carpet.[70] That Morris uses these words to describe a visual style demonstrates how his pattern theories are directly overlaid by notions of Darwinian cultivation and socialist politics, making wallpaper patterns display all the features of an ideal human (or plant) community.

Morris's formalist ideals here are markedly divergent from modernist tenets, even while he advocates for visual styles that would be influential in the twentieth century. As he writes, "No pattern should be without some sort of meaning."[71] Though Morris's patterns verge on visual abstraction, and much of his pattern advice contains strictly formal instructions, he still strenuously avoids art for art's sake. He even mocks the "bilious-looking yellow-green" of the Aesthetic movement, a color he acknowledges having supposedly brought "into vogue."[72] Victorian critics often mentioned Morris in their assaults on the Aesthetic movement, in part because he created objects that went to adorn aesthetic homes. Yet Morris wants to resist this association because he is keenly aware of the ties between aesthetic culture and commodity culture, which I explored in the previous chapter. In practice it seems he was unsuccessful in his resistance—indeed, one persistent criticism of his work has highlighted the obvious disjunction between his socialist theories and business realities. His design firm, Morris & Co., produced painstakingly handcrafted works that only the wealthy could afford.[73] In his writings, Morris uses the discourse of patterns as a way to idealize both the natural world and the organization of humans within that world.

Morris promotes formalist pattern-work on decorative objects as a key symbol for perfect cultivation in nature. In "The Lesser Arts," his account remakes nature into a formal, shapely structure, ranged into a flawless pattern of field and river and mountain. The best decorative arts "do not necessarily imitate nature, but . . . the hand of the craftsman is guided to work in the way that she does, till the web, the cup, or the knife, look as natural, nay as lovely, as the green field, the river bank, or the mountain flint."[74] Art objects like cups or knives blend seamlessly into mountain or river, all shaped by the mysterious hand of nature. Morris's scheme establishes an analogy between the abstracted art object, the orderly natural world, and the controlled socialist collective—a scheme whose converging orderly systems are best symbolized by the island-state of England itself. For

> the land is a little land . . . : there are no great wastes overwhelming in their dreariness, no great solitudes of forests, no terrible untrodden mountain-walls: all is measured, mingled, varied, gliding easily one thing into another: little rivers, little plains, swelling, speedily changing uplands, all beset with handsome orderly trees; little hills, little mountains, netted over with walls of sheepwalks: . . . it is neither prison nor palace, but a decent home.[75]

In this idyllic England, the patterns of man are inseparable from the patterns of nature. "Little hills" and "little mountains" are complemented by rows of "orderly trees" and "walls of sheepwalks" installed by human hands. Morris's England is deliberately beautiful, and not sublime—no "great wastes" or "great solitudes" closed off to human visitation. The sublime aesthetic connotes wildness, features out of proportion to the whole, and an isolationist ethos; instead, this country is cultivated, domesticated, "measured" into pattern and form. England's island is a happy medium between prison and palace, symbolized by the "decent home," a nation-state version of the House Beautiful.

Morris brings this vision of England to life in *News from Nowhere*. The design notions in his utopia are strikingly consonant with those in his lectures on design. As Old Man Hammond explains, the country "is now a garden, where nothing is wasted and nothing is spoiled, with the necessary dwellings, sheds, and work-shops scattered up and down the country, all trim and neat and pretty" (61). The great forests are preserved so that they can be harvested for timber; the overarching ideal is one of Nature tamed into a shapely wilderness. Nowhere's people don't "stand any nonsense from Nature in their dealings with her" (62). As to the buildings, Hammond disdains the "tumble-down picturesque"; "like the mediaevals, we like everything trim and clean, and orderly and bright" (62). The design elements of the countryside are close mirrors of the political system of the new England, in which everyone fits neatly into the small community gatherings. Here, too, the garden-rose might serve as the perfect symbol for the utopian relationship between humans and the natural world, both cultivated (or bred) into order and beauty. Morris's seamless interweaving of nature and culture is also reflected in the ubiquitous decorative arts of Nowhere, which emerge as symbols of utopia's formally perfect society.[76]

In the end, there is something vaguely eerie about Morris's cheerful and orderly utopia, with characters that all present the same looks, speech, and actions. Aldous Huxley's *Brave New World* takes the same collective brightness and makes it the basis for everything wrong in his dystopia. Although the citizens of Nowhere are not dominated by a state power, their lives are still eminently controlled—of their own free will, Morris suggests. Yet the actual possibility of free will seems doubtful in a utopia where most differences between people have been erased. True variety seems impossible when the community exerts such perfect control over the social and natural environment. All the elements of the garden-state are planned and cultivated; all the people possess healthy white bodies, descended from good English stock. As Hammond explains, political parties do not exist any more because no one strongly disagrees (73). He himself is an anachronism in his own world, since the Greek spirit of "criticism" and "curiosity" is no longer necessary in this world of concrete actions and immediate pleasures (113). As he says of Dick and Clara, "I don't think my tales of the past interest them much. The

last harvest, the last baby, the last knot of carving in the market-place, is history enough for them" (45). In this perfectly cultivated world, life itself becomes pure form, an eternal present with no need for history or change.

The metaphor of plant cultivation or the garden-rose ultimately allows Morris to sidestep some of the uncomfortable philosophical conundrums attending the politics of art production and art appreciation—for example, the extent to which a state apparatus can enforce collective behavior while still enabling individualist expression or judgment. Morris does not want to acknowledge a truth that was evident at Morris & Co., that art-making and art consumption often flourish in the most unequal of societies. For all of his metaphorical ingenuity, plants do not possess free will in the way that humans do, either gardened or in the wild. By comparing human artistry to plant cultivation—or humans themselves to plants—Morris downplays the unpredictability and capriciousness of human desire, a key element in the kind of art he himself valued. For all of his Victorian arguments, however, this discussion has worked to write him into a new trajectory of modernism—one not predicated merely upon a visual history of design, but upon late-Victorian ideological commitments and aspirations. These accrued to patterns that would come to seem decidedly modern.

The Microscope and the Lily: Decadent Biology

The promoters of biological aesthetics I have discussed so far—Grant Allen, Walter Crane, John Ruskin, William Morris—all used botanical or Darwinian tropes to advocate for a socialist or progressive politics. For these thinkers, the evolutionary narrative promised a unilinear progression from capitalism to a less exploitative and more unified society of the future. I want to briefly consider now a related version of fin-de-siècle biological aesthetics, in the literature and theory of decadence. Though utopian socialists and world-weary decadents would seem to occupy very different worlds, in fact both groups often drew upon the same Darwinian, decorative, and patterned figures to make their aesthetic claims. Histories of modernism regularly begin with the decadent movement as an early example of aesthetic detachment, in a trajectory that tends to obscure the movement's nineteenth-century context.[77] My reading sees the late-Victorian milieu as its own unique moment in which decadence and socialism shared a common cultural language.

The engagement of decadent writing with biological thinking might at first seem incongruous, since decadence has often been portrayed as a reaction against the claims of scientific positivism—glorying in states of irrationality, perversion, reverie, and baroque style, all meant to fly in the face of scientific values of utilitarianism, discernible truth, and social amelioration.[78] Yet Christine Ferguson argues that both decadence and scientific culture provoked similar fears in Victorian audiences,

especially as seen in what seemed a terrifying reality of scientific progress: "that it is impossible to be useful without first being useless, that a science can only be progressive when freed from the imperative to fulfill practical purposes and confirm moral truisms."[79] Pure science was feared for pursuing materialism to extreme ends, gathering knowledge for its own sake with a careless momentum that might bring about the same social disintegration promised by decadence. Though Ferguson's article focuses most closely on the medical sciences and vivisection, her argument seems especially relevant to the conclusions being arrived at by Darwinian science, with its anti-teleological description of nature and its vision of humans as animals or worse.

Both decadent art and modern science at the fin de siècle inspired anxieties about the coldly detached attitude of experimenters in the worlds of art or knowledge, who seemed to have no larger concern for the collective. These fears are captured to entertaining effect in Arthur Conan Doyle's popular fictional character, Sherlock Holmes, who first appears in a story with the richly suggestive title "A Study in Scarlet" (1887). The preternatural detective combines traits of the decadent with those of the scientist, blending *ennui,* reveries, and craving for excitement with a cold-blooded enthusiasm for research into the criminal underworld.[80] Thus Holmes describes the pattern of blood staining the floor beside a bludgeoned victim as a "study in scarlet," making the crime scene into a Whistler painting. The corpse is portrayed as "the finest study I ever came across: a study in scarlet, eh? Why shouldn't we use a little art jargon. There's the scarlet thread of murder running through the colourless skein of life, and our duty is to unravel it, and isolate it, and expose every inch of it."[81] Holmes's mention of "duty" seems superficial when compared with his delight at the sensation of the crime, in what is essentially the complete aestheticization of murder. The "study" or "case" of academic and medical knowledge implies a disinterested approach analogous to Whistler's reduction of realistic scenes into aesthetic patterns, both with potentially radical results. The character of Sherlock Holmes reveals the similarities between subversive manifestations in late-Victorian science and art: both pure science and decadence shared an interest in forms for their own sake, inspiring a pleasure that seems profoundly antisocial.

Holmes's decadent individualism and anti-establishment sensibilities are ultimately recuperated in the stories' broader racial and imperial narratives. The brilliant British detective uses his highly evolved deductive sense to master the atavistic races who threaten from the outposts of empire.[82] Conan Doyle's portrayal of various racialized criminals produces a Darwinian account of culture familiar to much late-Victorian fiction and theory. Decadence itself emerged from a biological vision of cultures, in which civilization had ripened into a too-advanced state and was now falling into decay.[83] In a famous, hostile account of decadence, the French writer Paul Bourget finds that "[t]he social organism becomes decadent as soon as individual life becomes exaggeratedly important under the influence of acquired well-being and heredity." Bourget

makes an analogy between decadent social disintegration and decadent liter-
ary style, linking the state of society with that of the artwork in a manner simi-
lar to Arts and Crafts theory. "A style of decadence is one in which the unity
of the book breaks down to make place for the independence of the page,
in which the page breaks down to make place for the independence of the
sentence and in which the sentence breaks down to make place for the inde-
pendence of the word."[84] The anarchic politics of decadence indicated both an
over-stylized literary elaboration and the biological breakdown of society into
its individual parts. If the socialist House Beautiful used the unity of the arts to
envision a communalist utopia that was also a healthy organism, the decadent
artwork took the same organic image and moved in the opposite direction, as
the socio-aesthetic organism decayed into useless, atomistic fragments.

In particular, decadence used imagery from home decoration—often a
weirdly biologized décor—to convey its aesthetic and social principles. In Joris-
Karl Huysmans's *À Rebours* (1884), known as "the breviary of decadence," pro-
tagonist Des Esseintes locks himself away in a mansion to carry out his perverse
aesthetic experiments—many of which involve adventures in ornament.[85] Like
News from Nowhere, *À Rebours* is also essentially a plotless novel with utopian over-
tones captured in decorative artifacts. Des Esseintes' decorative choices substitute
for plot developments; numerous pages are devoted, for instance, to his selection
of wall color and pattern, though he ignores the furniture, whose potential use-
fulness would ruin the effect. All of Des Esseintes' energies go toward creating
an excess of decorative façade, in a deliberate and flamboyant performance of
"art for art's sake." Nihilistically denying any other possible redemption or goal,
Des Esseintes' ornamental pursuits produce an utter materialism of bodily sen-
sation, especially visual sensation. These exercises in artifice amount to a vocal
and absurdist rejection of the Romantic idea of nature, which Des Esseintes dis-
misses as "this eternal, driveling, old woman."[86] "Nature had had her day, as he
put it.... Really, what dullness! the dullness of the specialist confined to his nar-
row work. What manners! the manners of the tradesman offering one particular
ware to the exclusion of all others. What a monotonous storehouse of fields and
trees! What a banal agency of mountains and seas!" (47). Des Esseintes' scornful
attack on nature reads almost as a parody of Arts and Crafts admonitions to turn
to nature for artistic inspiration. Yet Huysmans shares with the Arts and Crafts a
disdain for artworks whose realist style reflects a whole set of bourgeois values,
including those of specialization and commercial trade.

And while *À Rebours* positions itself "against nature," the novel also suggests
that nature cannot be escaped—not truly Darwinian nature, which has decreed
that Des Esseintes is the final degenerate member of a rapidly dwindling blood-
line. It comes as no surprise that Des Esseintes' experiments with home décor
also extend into the botanical world, where he delights in collecting the freakish

wonders of nature. William Morris, in providing his advice on gardening, had warned against selecting "grotesque," "foreign" or "jungle" plants for the English garden—all the types that Des Esseintes chooses to include in his botanical bestiary.[87] As Whitney Davis observes, Huysmans is drawn to the plant species that were also featured in botanical treatises by Darwin, such as carnivorous plants, "opening greedy horns capable of digesting and absorbing real meat" (140–41) and orchids "at once cold and palpitating" (134).[88] Some of the plants themselves look like animals, with leaves "the color of raw meat" (137), and others even display symptoms of syphilis, "veined with scarlet rash and damasked with eruptions" (137). These perverse botanical collections inspire Des Esseintes to meditate upon human achievements within the new state of nature:

> "It is true," pursued Des Esseintes, ... "that most often nature, left alone, is incapable of begetting such perverse and sickly specimens. She furnishes the original substance, the germ and the earth, the nourishing womb and the elements of the plant which man then sets up, models, paints, and sculpts as he wills. Limited, stubborn and formless though she be, nature has at last been subjected and her master has succeeded in changing, through chemical reaction, the earth's substances, in using combinations which had been long matured, cross-fertilization processes long prepared, in making use of slips and graftings, and man now forces differently colored flowers in the same species, invests new tones for her, modifies to his will the long-standing form of her plants, polishes the rough clods, puts an end to the period of botch work, places his stamp on them, imposes on them the mark of his own unique art."
>
> "It cannot be gainsaid," he thought, resuming his reflections, "that man in several years is able to effect a selection which slothful nature can produce only after centuries. Decidedly the horticulturists are the real artists nowadays."
>
> (144–45).

This passage might be read as a classic decadent account of the human triumph over nature, in which plant cultivation symbolizes the complete transformation and taming of wild species into artificial ones. Yet *À Rebours* does not portray a completely artificial world so much as an erasure of the lines between artifice and nature, since human hands can reproduce natural textures and shapes, while nature itself can be molded into new and unknown "forms" and "tones." This erasure also figures into Darwin's *Origin of Species*, where both natural selection and artificial selection are invoked to prove the truth of species mutation. Rather than fearing the cruelty of nature revealed by Darwin's theory, Des Esseintes perversely finds cause for celebration at the new powers granted to human hands.

His perversion of nature also links formalist style to an implicitly queer sexuality, as the antihero forgoes heterosexuality in favor of decorative experiments within his own house.[89] Yet Des Esseintes' revisionary view of nature is also richly ironic, since he is in fact physically prostrate before nature's iron will; his sickly and unfit body will certainly die without reproducing. Des Esseintes himself is a Darwinian failure, caught up in the inescapable and cruel laws of natural selection. The triumph over nature celebrated here is an equivocal one at best.

Although Des Esseintes' puny physique is a stark contrast to the healthy, fit citizens of Morris's Nowhere, both books celebrate the role played by humans in taming nature. Morris asserts that his beautiful utopia is itself natural, despite the extreme control that humans exert over their environment; Des Esseintes asserts that horticulturalists have accomplished the true conquest of nature, despite the organic metaphors of decadence that dominate the book. In both novelistic worlds, the exquisite decorative object symbolizes the ideal relationship between human hands and nature—though Morris's decorated objects are more evidently useful than Des Esseintes'. In both utopian visions, the unspoken enemy is a specter of complete wildness and utter lack of domestication, a brutal Darwinian free-for-all that would result (or has resulted) in a completely shapeless and ugly society.

If *À Rebours* were to be illustrated in a fitting visual style, the pictures—or patterns—would have been drawn by Aubrey Beardsley, the major British artist of decadent biology. Beardsley's subversive designs lent a decadent twist to the Arts and Crafts examples of William Morris, as a brief comparison will reveal. A representative page from William Morris can be taken from the Kelmscott Chaucer (1896), often considered one of the finest privately printed books ever made. With its handmade paper, designed fonts and borders, and illustrations by Edward Burne-Jones, the individual components of the book are united into a majestic decorative object. The opening page depicts Chaucer reading within a walled garden, surrounded by bursting yet orderly foliage, birds perfectly ranged on the tree, and a river spiraling neatly down from distant mountains (figure 4.11). The organic pattern of grapes and vines twining round the borders echoes the design of Morris's wallpapers. With its themes of medievalism, cultivation, unity, and form, this page-image embodies a socialist politics of communalism alongside its vision of the shapeliness of human products in nature.

Beardsley's illustrations to the *Morte D'Arthur* (1893–94) appeared in print before the Kelmscott Chaucer, but were obviously influenced by the Kelmscott-style books that Morris had been producing since 1891. Like the Kelmscott books, Beardsley's pictures illustrate medieval subject-matter surrounded by an organic and highly patterned border. But Beardsley's borders also teem with thorny vines that sprout unnatural creatures such as satyrs and insectile butterflies. In his *Morte D'Arthur* design "La Beale Isoud at Joyous Gard" (figure 4.12), a woman stands in a walled garden surrounded by imagery that is far from virginal. Her voluptuous

FIGURE 4.11 Opening illustration, *The Works of Geoffrey Chaucer*. Illustrations by Edward Burne-Jones, engraved on wood by W.H. Hooper, printed by William Morris at the Kelmscott Press, Hammersmith (London, 1896). Courtesy of the Rare Book and Manuscript Library, University of Pennsylvania.

FIGURE 4.12 Aubrey Beardsley, "La Beale Isoud at Joyous Gard," *La Morte D'Arthur (The Birth, Life, and Acts of King Arthur)* (London, 1893–94). Courtesy of the Rare Book and Manuscript Library, University of Pennsylvania.

body is mirrored by the sexualized fruits dangling in the pattern surrounding her, suggestive of breasts and genitals.[90] The highly stylized patterns bespeak a nature sculpted by human artistry, with rows of orderly trees and even, at the lower left, branches that appear to be grafted onto a parent tree. The horticulturalist image highlights the picture's themes of both artificial, formalist treatment and the underlying perversity of Darwinian nature, in which human behavior is controlled by sexual drives, especially by female sexual choice. That Isoud's sweeping gown is adorned with peacock feather patterns suggests a source in both the Aesthetic movement and in Darwin's *Descent of Man*. Beardsley's decadent imagery echoes Arts and Crafts visual style in unity and pattern, even while hinting that the socialist-medievalist account of nature is an ironic joke.[91] It is fitting that Beardsley was recruited to illustrate the cover of Grant Allen's scandalous New Woman novel *The Woman Who Did* (1895), in which Allen used his Darwinian knowledge of sexual selection to assail the outmoded ritual of marriage. Beardsley's cover design excludes human figures, choosing instead to depict the stylized forms of three identical, lush flowers. In decadent design, the usefulness of beauty for sexual reproduction also authorizes a uselessness of aesthetic patterning, as the creation of visual forms becomes a new, human-centered value to replace outmoded, idealistic values of the past.

Oscar Wilde's Decorative Arts

Oscar Wilde is perhaps the ultimate Victorian modernist, with his paradoxical allegiances to both decadence and socialism. While popular perceptions of Wilde's luxurious lifestyle have sometimes made his socialist commitments seem insincere, scholars have found important sources for his progressive politics in his Irish background, his radical parents, his tutelage by Ruskin at Oxford, and his participation in aesthetic philanthropy in the East End, among other things.[92] In this section, I analyze Wilde's political allegiances in connection to the biological aesthetics this chapter has been tracing, particularly in a formalist discourse of the decorative arts. Wilde was an inheritor of the Arts and Crafts tradition of William Morris, a link that often has been lost in more postmodern appropriations of him.[93] Historians usually draw a distinction between Wilde's early lecture tours of the 1880s, when beautiful objects might still be useful, and the mature essays of the 1890s, when he denies any functional value in art. Yet Wilde's theories thrive on paradox, and the organicist and socialist strains of his thinking are no exception. Though he rejects Morris's principles that art must be useful or authentically natural, he still resorts to Darwin-inspired accounts of human and social development in envisioning a utopian and aesthetic future.

Wilde's debt to biology might not be apparent at first, given his lacerating attacks on the natural world. He mocks the cherished Arts and Crafts idea that nature supplies art with its best material. In the heretical essay "The Decay of Lying" (1889; 1891), Wilde follows Huysmans with a decadent assault on the centuries-long English tradition of finding nature to be beautiful. On the contrary, he informs us, "what Art really reveals to us is Nature's lack of design, her curious crudities, her extraordinary monotony, her absolutely unfinished condition."[94] After making the famously outrageous claim that the Impressionists invented London fogs, he explains the serious philosophical point underlying the joke: "For what is Nature? Nature is no great mother who has borne us. She is our creation . . . Things are because we see them, and what we see . . . depends on the Arts that have influenced us" (986). The witty, light-hearted tone of the essay almost obscures its radical proposal. Not only is Nature distinct from human perception, but it is also inferior, and dependent on the mind for its very existence. The essay establishes a series of binaries based on the fundamental disjoint of nature and mind. Associated with Nature is the odious world of "facts" and the realist style in art; associated with Mind is the luminous world of "romance" and the formalist style in art. In this value scheme, "lying" and "artifice" are preferable to a slavish representation of sordid reality. To "lie," or to make art, in Wilde's opinion, is to assert the power of the Mind—the power of human will—over and against the messy, brutish world of nature.

So Wilde chooses to celebrate the decorative arts for very different reasons than Morris. If, for Morris, the cup, web, and knife blend seamlessly into a natural

landscape, for Wilde these objects are admirable for their superiority to that landscape. Where Morris prefers decorative art for its usefulness, Wilde likes the decorative for its palpable and limitless abstraction. "[F]rankly decorative ... art ... is, of all our visible arts, the one art that creates in us both mood and temperament. Mere colour, unspoiled by meaning, and unallied with definite form, can speak to the soul in a thousand different ways. The harmony that resides in the delicate proportions of lines and masses becomes mirrored in the mind" (1051). In realist or didactic art, the message must tyrannize over the spectator; but in formalist art, the spectator is free to arrive at whatever interpretation he or she likes. "Just as on the flowerless carpets of Persia, tulip and rose blossom indeed and are lovely to look on, though they are not reproduced in visible shape or line; ... so the critic reproduces the work that he criticises in a mode that is never imitative, and part of whose charm may really consist in the rejection of resemblance" (1032). Decorative works transform natural objects into art, just as aesthetic criticism transforms the beheld artwork into a new and wonderful literary creation. In "The Critic as Artist," Wilde makes the formalist style a shorthand for self-consciousness, critical spirit, choice, free thought—all the critical values he wants to promote.

How, then, does the natural world enter into Wilde's theories? Like Huysmans's *À Rebours,* Wilde too dramatizes an aesthetic triumph over nature that is underwritten by a sociobiology of decadence, as implied by the "decay" alluded to in "The Decay of Lying." Yet Wilde fundamentally differs from Huysmans in his commitment to a vision of collectivity, as expressed in his essay "The Soul of Man Under Socialism" (1891). This essay paradoxically advocates for socialism via a defense of the Individual—a heroic, critical mind that ideally develops like a biological organism, at once multiple and whole. "It will be a marvelous thing—the true personality of man—when we see it. It will grow naturally and simply, flowerlike, or as a tree grows ... It will never argue or dispute. It will not prove things. It will know everything" (1084). Wilde employs organic metaphors to attack the humanistic notion of the self as singular and unified, ironically using the language of essentialist biology to theorize a multiple identity composed of different parts or masks. He develops his notion of the organicist individual across his essays, as in *De Profundis,* when he writes of Christ as the perfect, multiply whole individual: "[Christ] pointed out that there was no difference at all between the lives of others and one's own life. By this means he gave to man an extended, a Titan personality. Since his coming the history of each separated individual is ... the history of the world ... Culture has intensified the personality of man. Art has made us myriad-minded" (926). The Paterian word "myriad" recurs as an ideal in Wilde's writing, as in *The Picture of Dorian Gray*: "To [Dorian], man was a being with myriad lives and myriad sensations, a complex multiform creature" (112). The "myriad mind" of the ideal individual can unite many different creeds, experiences, values, and aesthetic judgments into a single, complex force of will.[95]

It is Wilde's unique contribution to political history that he advocates social-
ism as the system most enabling to the development of the myriad mind. In "Soul
of Man," Wilde makes the individual a miniature image of the larger society, with
both person and populace existing in aesthetic, multiform parts, like a "many-
petalled rose," as Vivian describes art in "Decay of Lying" (987). Even the working
poor are entitled to this aesthetic self-development, though their attainment of it
is impossible under what Wilde calls the "Tyranny of want" (1080). The greatest
threat to Individualism for the middle classes, he suggests, is the corrupting influ-
ence of material greed. "Private property . . . has made gain, not growth, its aim. So
that man thought that the important thing was to have, and did not know that the
important thing is to be." (1083). Once again the goal of the self is "growth"—like
an organism—rather than "gain." Wilde makes socialism into a byword for free
thinking and free will, in whatever myriad forms these might assume. "Socialism is
not going to allow herself to be trammelled by any hard and fast creed or to be ste-
reotyped into an iron formula. She welcomes many and multiform natures. . . . She
has the attraction of a wonderful personality."[96] By personifying socialism as a mag-
nanimous woman, Wilde can evoke associations with both art and nature, whose
feminine "multiformity" fits perfectly into his aesthetic philosophy. As this loose
formulation would suggest, he is less interested in outlining a functional political
program than in pursuing a philosophical project across his essays, one which is
especially concerned with the role of human will in the natural world.

Wilde's socialist theory is founded upon the biological aesthetics he shares
with Crane and Morris. His essay on socialism is rife with biologized rhetoric: he
describes "fetid dens" that have literally degraded the bodies and minds of the poor,
he discusses "healthy" versus "unhealthy" art (146), and he declares that Individu-
alism "is the differentiation to which all organisms grow" (155), concluding that
"Evolution is the law of life, and there is no evolution except towards Individual-
ism" (155).[97] For Wilde, governments might be changed or overthrown in a way
that nature cannot. Indeed, the laws of Nature exert an unchanging and inargu-
able authority over human action. In "The Critic as Artist," he writes of the law of
Heredity: "By revealing to us the absolute mechanism of all action, and so freeing us
from the self-imposed and trammelling burden of moral responsibility, the scien-
tific principle of Heredity has become, as it were, the warrant for the contemplative
life. It has shown us that we are never less free than when we try to act" (1040). If
all of our actions are governed by our biological inheritance, Wilde suggests, then
we are freed from worrying about the possible moral consequences of our deci-
sions. Yet this complete biological determinism paradoxically allows him to more
strongly theorize the contemplative life, since the Mind can somehow transcenden-
tally escape the laws of nature that bind us. He describes this freedom of Mind as
also biological—giving a Darwinian twist to the notion of Mind as complex organ-
ism, in what is one of the more bizarre passages in "The Critic as Artist":

And yet, while in the sphere of practical and external life it [the scientific principle of Heredity] has robbed ... activity of its choice, in the subjective sphere, where the soul is at work, it comes to us, this terrible shadow, with ... gifts of strange temperaments and subtle susceptibilities, ... complex multiform gifts of thoughts that are at variance with each other, and passions that war against themselves. And so it is not our own life that we live, but the lives of the dead, and the soul that dwells within us is no single spiritual entity, making us personal and individual ... It is something that has dwelt in fearful places ... It is sick with many maladies, and has memories of curious sins ... It can help us to leave the age in which we were born, and to pass into other ages ... It can teach us how to escape from our experience, and to realise the experiences of those who are greater than we are ... Do you think that it is the imagination that enables us to live these countless lives? Yes; it is the imagination; and the imagination is the result of heredity. It is simply concentrated race-experience (1040–41).

While Heredity controls our actions in the practical world, in our mental world it grants us a strange freedom to experience other ages and other lives through a kind of evolved collective unconscious, a biological inheritance of "concentrated race experience." The organic personality, once again "complex" and "multiform," here gains its multiplicity through evolution. This passage borrows heavily from Pater's famously sinister evocation of the Mona Lisa, whom Pater had transformed into a symbol for the evolutionary philosophy by which humanity is "wrought upon by, and summing up in itself, all modes of thought and life."[98] But whereas Pater's symbol is never really applied to the modern consciousness, Wilde grants a Mona-Lisa mind to every critical Individual. Our bodies might be slaves to biology, he seems to say, but we can still direct the probing awareness of our mind towards an evolution of self, by accessing different moments of our inherited racial consciousness.

In other words, Wilde's myriad mind develops both spiritually and biologically. Within his scheme, the decorative arts thus become a double symbol, representing both the art form best enabling the growth of the Mind, and also the myriad mind itself, always developing in many aesthetic parts, like an abstract flower on a Persian carpet. If critics have perceived a utopian quality to Wilde's aesthetic philosophy, we can begin to understand how biological aesthetics contribute to that utopianism, as he uses biology itself to authorize the defeat of nature.

Wilde's novel, *The Picture of Dorian Gray*, dramatizes the paradoxes of autonomy and bondage through his play with biological aesthetics. Artworks in this novel are both decorative *and* biological, having an organic life of their own—most obviously the uncanny portrait of Dorian, which minutely records the traces of his corruption while his own body appears miraculously youthful. Indeed, Dorian's

portrait exhibits all the signs of a living creature. And the painting is not the only artifact of culture exhibiting biological qualities. In the novel's notorious chapter eleven, Dorian Gray is "poisoned" by a book—a phrase which, in the context of this analysis, can be taken surprisingly literally. The poisonous book has a physical impact on Dorian that is tallied on the portrait's grotesque face.

The fantastic flight of fancy in *Dorian Gray*'s eleventh chapter is, in fact, a twisted realization of the utopian theories Wilde proposes in his essays. Here we see Dorian experimenting with myriad creeds and systems, developing his individual will through the pursuit of varied and conflicting ideologies. As in "The Critic as Artist," the novel also proposes that the mind is an organism whose imagination is a biological inheritance: to Dorian, "man was a...complex multiform creature that bore within itself strange legacies of thought and passion, and whose very flesh was tainted with the monstrous maladies of the dead" (112). In chapter eleven, we discover that Dorian has been influenced equally by the "strange poisonous germ" of his ancestors and by the lives of the historical characters who invade his imagination. Both in essays and novel, the act of contemplation is strangely biologized, so that forms of thought are heritable, or even literally "poisonous." "There were times when it appeared to Dorian Gray that the whole of history was merely the record of his own life, not as he had lived it in act and circumstance, but as his imagination had created it for him, as it had been in his brain and in his passions" (113). As he reads, Dorian's physical self—his "brain" and "passions"—becomes the record of human history, in a kind of Lamarckian process of influence and adaptation.

Given the novel's interplay with Wilde's essays, it comes as no surprise that every chapter prominently features some kind of decorative art. For if the essays make the decorative arts a symbol of the Mind's force over any external conditions or social message, then the novel manifests this power of Mind with its relentless parade of beautiful objects. Every scene takes place within a heavily decorated interior—beginning with the book's opening, as Lord Henry lounges on Persian pillows while Nature performs before him like a Japanese screen. The Persian carpet, Wilde's great symbol for the transformative process of Mind upon nature, appears in a speech by Lord Henry: "I should like to write a novel...that would be as lovely as a Persian carpet, and as unreal. But there is no literary public in England for anything except newspaper, primers, and encyclopaedias" (45). Lord Henry seems to refer to the very novel that creates him as a character. The "unreality," or formalism, of Wilde's own novel is accentuated by the narrative's lingering over small decorative objects, its screens, cigarette-holders, jewels, and elaborate book-bindings. In chapter eleven the plot grinds to a halt to describe at length each of Dorian's collections, his elaborate costumes, ornate religious items, exotic musical instruments, opulent gemstones.[99] No wonder Wilde declared in a spirited defense of *Dorian Gray*, "My novel is an essay on decorative art."[100]

Yet if Wilde's novel is a fictional realization of his utopian critical theories, it also dramatizes some of the dystopian possibilities attending those same theories. Dorian's biological imagination allows him to develop his will to an individualist extreme, but he is still ultimately caught up in the deterministic laws against which human will is powerless. Because he has been "poisoned" Dorian must become morally corrupt; and by the end of the novel, even his seemingly benevolent gestures are revealed to be helplessly evil. His obsession with decorative objects ultimately functions, in the novel's later parts, to depict a biologized dystopia of the will: his over-attachment to the forms of things, to the beauty of objects for their own sake, unrelieved by moral sense or intellectual askesis, leads to an excess of desire, even a kind of addiction. After he murders Basil, Dorian is seized by the urge to smoke opium—at which point Wilde gives us a lengthy description of the drug's ornate receptacles, "a small Chinese box of black and gold-dust lacquer, elaborately wrought, the sides patterned with curved waves, and the silken cords hung round with crystals and tasselled inplaited metal threads" (140).[101] These elaborate, decorative details replace any murmurs of Dorian's conscience, intimating the complete collapse of will described as he flies toward the opium den: "There are moments, psychologists tell us, when the passion for sin, or for what the world calls sin, so dominates a nature, that every fibre of the body, every cell of the brain, seems to be instinct with fearful impulses. Men and women at such moments lose the freedom of their will. They move to their terrible end as automatons move" (144). The "terrible end" of the addict is also the inevitable end of Wilde's novel. The mechanism of novel's fatedness is biologized, as Dorian's unregulated pursuit of the beautiful wreaks its revenge upon his body. While Wilde's essays imagine a socialist utopia of aesthetic freedom accessible through form, the novel gives us a glimpse of a dystopia of form, in which the possibility of freedom is ruined by an excess attachment to the material world.

If decadence combines a fantasy of stopped time with the dread reality of organic time, the ending of *Dorian Gray* points to the inescapable fate awaiting Christians and decadents alike. The juxtaposition of these two kinds of time also figures in Morris's *News from Nowhere,* with the linear tale of revolution and rebirth contrasting the inert moment of utopia, as well as in Huysmans's *À Rebours,* in which the static account of collections and perceptions gives way in the end to an ambiguous Christian conversion. In all three novels, Darwinian accounts of nature both script the end of time and support the notion of a grand pause, especially in the mastery of time implied by human breeding and the cultivation of nature. These novels and essays ultimately serve to question the extent to which humans can master the environments that surround them. This is one reason why the decorative arts are such conspicuous symbols in each of the works, mediating between the twining patterns of nature and the sculpted works of human hands. Glittering above any functional or programmatic account of progressive

politics, decorative objects represented the utopian ideal of human order and control within nature, both individually and collectively, in the face of the apparent Darwinian undermining of any real human autonomy.

In gesturing to the importance of these late-Victorian versions of formalism for ensuing modernist productions, I might point to the crafts communities of the Bloomsbury Omega Workshops, the organicist poetry theories of the New Critics, or even the spare, functionalist designs of early twentieth-century architecture, as described by Nicholas Pevsner.[102] Yet it seems less important here to argue for a direct lineage from these Victorian thinkers into the twentieth century than to suggest a broader influence captured in the antinomian ideal of the "decorative." While modernist writers tended to disdain decorative art as feminine and irrelevant, for the late Victorians the decorative—perhaps even more so than "art for art's sake," though certainly in conjunction with it—became a kind of war-cry, a claim for useful uselessness, in the command to observe pattern itself as a philosophically meaningful idea. The cultural history of Victorian biology has been shown to play a surprising role in the shifting formalisms of the late nineteenth century, both visual and verbal; this scientism of culture was a persistent discourse into the twentieth century, even as aesthetic socialism became a Victorian relic.

Primitives and Post-Impressionists
Roger Fry's Anthropological Modernism

For along with the pictures that reality presents to the eye, there exists another
world of images, living or coming into life in our minds alone, which, though
indeed suggested by reality, are nevertheless essentially metamorphosed. Every
primitive artist, when endeavouring to imitate nature, seeks with the spontaneity
of a psychical function to reproduce merely these mental images.

— Emmanuel Loewy, *The Rendering of Nature in Early Greek Art* (1907)

The graphic arts are the expression of the imaginative life rather than a copy of
actual life...[Art] presents a life freed from the binding necessities of our actual
existence.

—Roger Fry, "An Essay in Aesthetics" (1909)

I believe in reality as Cézanne or Caliban believe in it."

—Gertrude Stein, notebook (1909)

Theories of the Modern and the Tribal

Historians have often acknowledged the relation of the Bloomsbury Group to
its Victorian predecessors. The Omega workshops, for example, which pro-
duced avant-garde household wares between 1910 and 1914, had obvious roots in
the Arts and Crafts movement of the previous century.[1] Roger Fry, Bloomsbury's
eminent art critic, wrote essays on "Art and Socialism" and dwelled on the ethics of
art spectatorship in a manner familiar from Victorian meditations. Yet the dominant
move in contemporary scholarship, especially in the study of British art movements,
has been to underline a break between the nineteenth and twentieth centuries.[2] In
many ways, the narrative of that break was scripted by modernists themselves—as
when Virginia Woolf memorably quipped that "on or about December 1910 human
nature changed."[3] Woolf's selection of this seemingly random date in fact refers to
what is perhaps the most controversial art show ever held in Britain: the 1910 exhi-
bition of post-impressionist paintings at the Grafton Gallery in London.[4] Here the
British public was introduced to—and scandalized by—the modern French paint-
ings of Cézanne, Gauguin, and Matisse. The furor greeting this exhibition seems to

confirm that Britons were confronting a novel and heretofore unknown aesthetic phenomenon, forced for the first time to contend with the new visual styles of modernism. Woolf's comment, for all of its sweeping absurdity, implies that the new art style accompanied a whole new way of envisioning human consciousness in both literature and art—a foundational narrative in the history of aesthetic modernism. In this chapter, however, I will argue that the post-impressionist controversy rehearsed tropes on both progressive and conservative sides that were familiar from the nineteenth century; and that the exhibition's organizer, Roger Fry, used very Victorian arguments to convert the public to the new formalist style.[5] Rather than tracing a stark distinction between Victorian didactic realism and modernist detached formalism, this chapter will continue to demonstrate how the rise of the aesthetic— so canonically outlined by the art writings of Bloomsbury critics—emerged from structures of knowledge and canons of value established in the nineteenth century. Specifically, this chapter will explore how British critics marshaled the discourses of primitivism to defend the new visual style.

Despite the uproar, outrage, and general mockery that the post-impressionist exhibition inspired, the artworks it showcased were quickly accepted as the cutting edge of visual arts in Britain. The show cemented Roger Fry's reputation as the most influential taste-maker of his day. Current scholarship on Fry usually quotes art historian Kenneth Clark's summation: "In so far as taste can be changed by one man, it was changed by Roger Fry."[6] Fry, along with his friend, the art critic Clive Bell, became famous for the essays that defended post-impressionism. These essays have become canonical as early and influential arguments for a formalist aesthetic, valuing art for its shapes, composition, and color rather than for its message or imitative realism.[7] As one art historian remarks, "Fry's name and the term 'formalism' have become inseparable in the historiography of modernism."[8] In traditional narratives of modernism, Fry and Bell are the founders of an aesthetic that would come to triumphant fruition with the non-representational canvases of abstract expressionism in the 1950s, as theorized by the powerful New York art critic Clement Greenberg. This critical trajectory is apparent, for example, in the classic textbook *Modern Art and Modernism: A Critical Anthology* (1982), which begins with excerpts from Clive Bell's *Art* (1914), Fry's famous "Essay in Aesthetics" (1909), and Fry's "The French Post-Impressionists" (1912)—and then moves seamlessly to three essays by Clement Greenberg, beginning with "'American-Type' Painting" (*Partisan Review* 1955).[9] Though this narrative of modernist origins has been strongly challenged in recent years by scholars in both literature and art history, it was foundational in these fields for much of the twentieth century.

The smooth transition from British art theories to American abstract painting created the illusion that modernist French art spontaneously inspired certain critics to discover the universal truth of formalism. In this chapter, however, I contextualize modernist formalism by examining how the writings of Fry and

Bell on post-impressionism shared a certain continuity with earlier Victorian discourses—specifically, with debates within late-Victorian anthropology about the art of so-called "primitives."[10] In their essays defending post-impressionism, Fry and Bell praise the French artists for their "primitive" and "barbaric" style. Many French modernist painters, it is well known, were inspired by colonially acquired tribal objects to create new painting styles, most famously when Picasso studied an African mask and arrived at cubism.[11] Rather than examining the creative methods of French painters, though, I will analyze the idea of modernist primitivism through the published debates of English critics. In moving away from masterpieces of visual art toward the more prosaic words of British periodical writers, I demonstrate how the intellectual history of taste is mediated by a language of critics and theorists that is easily lost in the retroactive construction of aesthetic canons.

If, in the last twenty years, scholars have reassessed some of the philosophical assumptions underpinning high modernism, an important moment in that revaluation took place in 1984 when the New York Museum of Modern Art hosted an exhibition titled "'Primitivism' in 20th Century Art: Affinity of the Tribal and Modern." This now notorious show serves as a useful introduction to the modernist embrace of primitivism in visual art, since it rehearsed the long-standing ideology that was established in early defenses of post-impressionism, when Roger Fry argued that visual form is a universal indicator of the human capacity for aesthetic creation. Similarly, the MoMA show proposed a universalist vision of beauty by displaying modernist European masterpieces alongside examples of tribal art from Africa, Oceania, and other non-Western locales. The tribal objects were selected according to their formal resemblances to canonical European works. The show's catalogue defended the "ahistorical juxtaposition" of tribal and modern art by suggesting that "the art-making process everywhere has certain common denominators, and as the great ethnologist Robert Lowie quite rightly observed, 'the aesthetic impulse is one of the irreducible components' of mankind."[12]

Yet despite the optimistic blurb in the catalogue, the MoMA exhibition was assailed by art historians and anthropologists alike for what was revealed to be a hopelessly outdated modernism—that is, an ideology of universal formal beauty that suppressed differences between cultures, as well as disguised the violent colonial history underlying the acquisition of the tribal objects.[13] Objecting to the ostensible "happy family" of artworks on display, anthropologist James Clifford supplied an alternative, untold story, which he labeled as one of "reclassification": "This other history assumes that 'art' is not universal but is a changing Western cultural category. The fact that rather abruptly, in the space of a few decades, a large class of non-Western artifacts came to be redefined as art is a taxonomic shift that requires critical historical discussion, not celebration. That this construction of a generous category of art pitched

at a global scale occurred just as the planet's tribal peoples came massively under European political, economic, and evangelical dominion cannot be irrelevant."[14] Critical response to the MoMA show revealed that modernist formalism had a history intimately tied to the rise of anthropology and high art, and coinciding with the "massive" imperial project of turn-of-the-century Europe. This chapter pursues an important moment in that history, when influential cultural critics used an art philosophy to transform ethnological objects into high art. In my argument, that transformation was intimately tied to a Victorian tradition of art and anthropological scholarship, as well as to the institutions, periodicals, galleries, and other components of the British art world that were established in the nineteenth century.

Not only did Edwardian critics use primitivist rhetoric to advance post-impressionism, but they also simultaneously turned their eyes toward new, non-Western regions of the world as sources of high-art objects. In the same year that Roger Fry promoted the post-impressionist show, he also published two significant essays on "Bushman Painting" and "Oriental Art." Until recently, these essays have been largely omitted from contemporary discussions of modernism.[15] Fry's formalist aesthetic, as he promoted it in 1910, seems to defy contextualization, claiming an aesthetic value above any particular time and place. Yet as this chapter will argue, the very claim to universalism arose from the distinct peril of dissolution threatened by the new epistemologies of empire. Even while the Victorian-era hierarchy of cultures informed the shaping of modernist anthropology, the empire was enabling the influx of new collectible objects and the introduction of foreign visual styles. Incipient threats of cultural relativism and political instability were neutralized, I argue, by comparable distancing moves in both anthropology and high-art theories. Both late-Victorian anthropology and aesthetic formalism envisioned their objects in a stilled envelope using the rational eye of Western science, and both proposed a universal common connector across primitive cultures, leading to the comparative method of peoples, artworks, artifacts, and visual forms. Fry and Bell invoke a new authentic self enabled by contact with primitive cultures, but they also ultimately affirm the superiority of the British critical faculty by theorizing a universal formalist beauty that British eyes are uniquely endowed to apprehend.

The claims of modernist formalism extended the utopian projects we have been examining in the nineteenth century; yet the chapter ultimately discerns two very different kinds of primitivist utopianism. While the most familiar primitivist fantasies offered Westerners tantalizing glimpses of an unrepressed and primal sensuality, Fry and Bell argue for formalism as an intellectual purification of art, a conceptual abstraction that is the most sublime kind of thought and emotion. In this they were continuing the Enlightenment endeavor to rationalize form—a project that Victorians also engaged in, as we saw in chapter 1 with Ruskin's use

of eighteenth-century modes of classification through form. Fry adapts Victorian anthropological tropes to theorize an art of pure form, not instinctual or basely corporeal, but advanced, progressive, bespeaking all the qualities that Victorians attached to British culture itself. This vision of the best art as a scientific, conceptual art appears again in Clement Greenberg's iconic essay on "Modernist Painting," thus establishing a long Victorian ancestry to the canons of twentieth-century abstraction. The chapter concludes by noting that a number of British critics and connoisseurs served as curators for burgeoning American art collections in museums and galleries into the twentieth century. The cultural power of these taste-makers, as the chapter suggests, emerged from their unique training in aesthetic ideologies shaped by Victorian Britain.

The 1910 Post-Impressionist Scandal: Victorian Redux

On November 5, 1910, a blockbuster show of post-impressionist French paintings opened "with a bang" at the fashionable Grafton Gallery.[16] The English traditionally celebrate November 5 as Guy Fawkes Day, in remembrance of a foiled plot to blow up the Houses of Parliament. Art critics in 1910 were quick to observe the likeness between the historical event and the incendiary art show. On display were paintings by French artists Cézanne, Gauguin, and Matisse, as well as the Dutch Van Gogh. None of the images were completely abstract, or even cubist, and most depicted common, recognizable objects. Matisse's *Fille aux Yeux Verts* (*The Girl with Green Eyes*; 1908), for instance, depicts a girl in clearly fashionable dress with familiar objects on the mantle behind her, including Chinese vases and a classical torso (figure 5.1).

Yet the paintings' styles looked so unlike the more realist canvases to which the British public was accustomed, that some reviewers accused the artists of attempting literally to destroy the Western visual canon. The press persistently compared the new art movement to anarchism, complete with bombs and threats of violence. Holbrook Jackson's review of the post-impressionists was titled "Pop Goes the Past!"[17] *The Times* reviewer declared, "Like anarchism in politics, [post-impressionism] is the rejection of all that civilization has done, the good with the bad."[18] *The Spectator* blamed the radical art on the French political tradition: "[I]n France a reform movement always has its section who are for barricades, the guillotine, and the Anarchist's bomb."[19] Perhaps the anarchist comparisons seemed apt because the images threatened to dislodge the scaffolding of Western perspectivalism. Cézanne's canvases, especially, were observed to put still lifes into a strange, flat, decorative space that warped the illusion of three-dimensional space characteristic of Western art since the Renaissance. To destroy the illusion

FIGURE 5.1 Henri Matisse, *La Fille aux Yeux Verts (The Girl with Green Eyes)*. Oil on canvas, 1908. San Francisco Museum of Modern Art. Bequest of Harriet Lane Levy. © Succession H. Matisse, Paris / Artists Rights Society (ARS), N.Y.

of space, critics implied, was also to destroy the institutions represented within that space.

The controversy was immensely profitable for the exhibition, which drew huge crowds. In the first month more than fifty articles, reviews, letters, cartoons, and parodies appeared in daily papers and journals.[20] Certainly a stance of

intense dislike allowed critics to generate sensational copy. Many of the rabidly attacking critics were extending the British tradition, popular since Turner's days, of making humorously exaggerated attacks on newfangled art styles. It was extremely popular for critics to diagnose the post-impressionists with insanity. Robert Ross suggests that the paintings were only interesting to "the student of pathology and the specialist in abnormality"; he describes Van Gogh as "the typical . . . degenerate of the modern sociologists."[21] T. B. Hyslop, the superintendent doctor of Bridewell and Bedlam, two of England's most notorious insane asylums, published an essay titled "Post-Illusionism and the Art of the Insane." The essay compares post-impressionist painting with that of the degenerates under Hyslop's care; in both groups, "sensation and perception of colour, form, and perspective become impaired."[22]

Much has been made of the initial critical ruckus generated by post-impressionism in 1910. However, as this book will have made clear, the controversy reflected a familiar relation among the public, the critics, and aesthetic experiment that had become entrenched in later Victorian England. The reception of Whistler and Burne-Jones in the 1870s produced similar terms of disgust and shock from the public and "popular" critics, while a few "aesthetic" critics stood up to defend the new art styles. The response in 1910 demonstrates how these trends had been continued and intensified from the nineteenth century.

One conspicuous development is that the aesthetic critic was now portrayed as an eminently powerful—and potentially fraudulent—character on the cultural scene. Two *Punch* satires of November 1910 equate the offensive new French art to the lofty jargon used by charlatan critics to sell the art to the public. In "Post-Impressionist Problems," the headnote introduces a scene at the Grafton Galleries where a crowd attempts to understand "works which they have been assured by the only people who know represent the Apotheosis of French Art, and, incidentally, the annihilation of all previous artistic standards."[23] In the ensuing snippets of dialogue, well-meaning, mystified members of the public are informed of their ignorance by pompous critics and aesthetes, some of whom quote directly from the post-impressionist exhibition catalogue. The parody creates a mock-paranoid atmosphere in which mysterious, undecipherable art standards are deployed by "the only people who know." "Mr. Rumbell Wetheram, an eminent Art Critic," is likely a parody of Roger Fry, who was already a well-known art critic by 1910; *Punch* has him stammering out replies to an inquisitive female viewer as though he were making them up on the spot. Another satire published a week later announces itself as "A further notice, in the manner of the gusher-critics of the Post-Impressionist School."[24] Here art-critical language is parodied as a series of baroque locutions peppered with absurd French-isms: the artists have "declared a *guerre au mort* against draughtsmanship," and allow the spectator to "revel in a Gargantuan banquet of artistic *hors d'oeuvre*

and decadent *entremets.*" The following painting reviews amusingly juxtapose fancy French lingo with sooty industrial subject matter—as in "Fog in a Coal Mine." These comic scenarios implicate the critics in a boondoggle scheme to sell fake goods to the public, reflecting the real importance of critics in the commodification of avant-garde art.

The *Punch* columns establish that by 1910, the art critic was no longer a retiring Paterian presence, ensconced within a closed circle of aesthetic young men, but was instead a powerful and visible player in the writing of high culture. *Punch's* parody of the connoisseur might have taken its cue from the *Burlington Magazine for Connoisseurs,* established in 1903 and joint-edited by Roger Fry beginning in 1909. The creation of a magazine dedicated to connoisseurs and collectors points to the increasing availability of these identities to middle-class readers. Ironically enough, this expansion leads the magazine's editor, Robert Dell, to introduce the inaugural issue in 1903 with an attack on "equality" as the "Fata Morgana" that has ruined the contemporary art world by eroding the refined taste of discerning collectors: "With everything 'equal to' a better which an ingenious commercialism foists on us, something is lost of the keen edge of perception . . . Distinctions are obliterated for want of the perceiving eye by and for which they exist."[25] As an antidote to the modern lack of discriminating taste, the *Burlington* editor recommends to readers "the cultivation of an austere Epicureanism, an attentive and rigorous weighing of values" as produced by the study of ancient art.[26] Dell's definition of taste as both "austere" and "Epicurean" seems a direct inheritance from Pater, whose subtle discriminations have now become the province of all who would style themselves connoisseurs.

While the connoisseur had become by the turn of the twentieth century an identity distinct enough to garner its own magazine, it had also generated a series of anxieties surrounding its role in the commodification of the very art works it was supposed to be disinterested toward. Robert Dell concludes his 1903 introduction to the *Burlington* by attacking so-called "tipsters of the sale-room," the collectors who aim to collect "one and the same time works of art and money." The magazine calls instead for a reader-collector "who is also a sincere *amateur,* a true lover of the arts"—as opposed to the professional connoisseur, whose occupation was becoming increasingly lucrative.[27] The paragon of the profiteering connoisseur was Roger Fry's mentor, Bernard Berenson, who became notorious for parlaying his assessments of "authentic" old masters into a tidy sum when he made the sale to wealthy American collectors.[28] Although Fry was less opportunistic than Berenson in his activities as a connoisseur, and expressed hesitations about the impact of commerce on art valuations, still he supported himself financially through his art-critical activities.[29] His letters testify to his constant money worries, and the magnitude of his published art writing resulted directly from his need to support himself. According to Elizabeth Prettejohn, between

the years of 1900 and 1906 alone Fry published 491 periodical articles, includ-
ing exhibition reviews and book reviews.[30] Once again we are reminded that a
modernist aesthetic theorized to oppose bourgeois commercial art was in fact
quickly consumed by the very spectators it supposedly disdained. The expansion
of art collecting and connoisseurship in the early twentieth century also suggests
that post-impressionist paintings should be considered within the context of a
ballooning market for every kind of collectible, art and otherwise. Widespread
demand for precious objects that would bestow distinction upon a collector
or a museum led to the traffic in and commodification of every kind of visual
rarity, ranging from antiques to French paintings to colonial artifacts. In every
case, these exchanges were moderated by new art professionals, whose writings
helped to influence both the aesthetic and monetary value of an object.

Elizabeth Prettejohn argues that post-impressionism gained rapid accep-
tance with the British public because the new art fit into preexisting categories
developed in Victorian Britain. She identifies metaphoric "structures of discrim-
ination" in the writings of Victorian critics like F. G. Stephens, who disdained
the mediocre "acres of rubbish" hanging at the Royal Academy.[31] It had become
a critical commonplace in the late nineteenth century that the art world con-
tained only a few works of distinction; by 1910, post-impressionist works were
poised to take up the mantle of aesthetic worth. The "structures of discrimi-
nation" erected in the Victorian period, I would also suggest, were more than
tropological. They additionally resulted from institutional shifts, such as the
move away from the centralized power of the Royal Academy and its old-guard
academicians toward smaller exhibition spaces like the Grosvenor and Grafton
Galleries. As the identity of art collector opened to more people, an increasing
number of specialist art periodicals catered to a middle-class or upper-middle-
class readership. These new structures of discrimination accelerated the project
of discrimination itself, which became the dominant mission of museum displays.
Beginning in the 1880s, museums started to move away from their original pur-
pose of audience education, orienting toward a more specialized, competitive
collection-building. Rather than presenting objects for the purposes of training
British manufacturers or morally improving middle-class audiences, museums
were now expected to compete internationally with a scholarly emphasis on
"the aesthetic standards of objects on display."[32] In other words, a whole host of
institutional and commercial pressures were working to solidify the categories
of high art, putting critics into a new powerful role among the visual elite in
anointing the art that would fill those categories. As we will see, the structures
of discrimination in the early twentieth century extended well beyond the world
of art, as design objects were made to bear the symbolic weight of the cultures
that produced them.

Post-Impressionist Primitives

In the first flurry of hostile reviews of post-impressionism, many critics accused the painters of creating a degenerate, primitive, and barbaric art. Charles Ricketts wrote, "To revert in the name of 'novelty' to the aims of the savage and the child—out of lassitude of the present—is to act as the anarchist, who would destroy where he cannot change."[33] T. B. Hyslop, the superintendent of Bedlam, suggested that these artists, like the insane, were reverting to a primitive mental state: "Certain of the insane . . . lose . . . the power of giving adequate expression to what is actually perceived. Thus the pathological process underlying reversion to a primitive type of simulation of barbaric art is frequently characteristic of brain degeneration."[34] Hyslop follows Max Nordau in ascribing avant-garde art styles to a biological cause, a disease of the brain to which artists and aesthetes are especially prone.

These accusations of primitivism followed in part from the statements of the show's defenders, who deployed the term as a positive development in art. The exhibition courted associations with primitivism from the start, beginning with an advertising poster for the show decorated with a Gauguin painting titled *Poèmes Barbares,* or "Barbaric Poems" (figure 5.2). The poster depicted a half-nude Tahitian woman posed next to a squat, dark, Polynesian idol. Gauguin's images were especially titillating to the London audience for their depictions of foreign female nude bodies rendered in bold, exotic colors. The prurient biography accompanying these images added to the scandal: it was well-known how Gauguin, rejecting the restrictive codes and superficiality of Parisian culture, had departed for Tahiti to live amongst the simple people there, and even married a Tahitian wife. One historian described her as "chaste Tehura, who had never seen a white man."[35] The story of Gauguin's deliberate immersion in primitive life gave a sense of potency and virility to the barbaric style he was seen to create on canvas.

Roger Fry also magnified the primitivist effect of the French paintings by choosing provocative decorations for the Grafton Gallery rooms. As his biographer Frances Spalding reports, Fry "discovered some bold patterned cloths printed in Manchester for the African market" and bought samples to decorate both the exhibition and his Bloomsbury haunts.[36] Virginia Woolf describes the same phenomenon in her biography of Fry, evoking his frenetic activity in preparation for the Grafton Gallery exhibition. Pictures "stood upon chairs . . . bold, bright, impudent, almost, in contrast with the Watts portrait of a beautiful Victorian lady that hung on the wall behind them." According to Woolf, Fry's enthusiasm extended not only to the French art but also

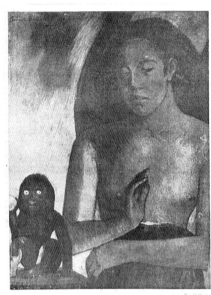

MANET
CEZANNE
GAUGUIN
VANGOGH
MATISSE
&

NOV· 8
TO
JAN· 15·

GRAFTON·GALLERY
MANET AND THE
POST·IMPRESSIONISTS

FIGURE 5.2 "Grafton Gallery: Manet and the Post-Impressionists." Exhibition poster, 1910 (with a repro-
duction of Gauguin's *Poèmes Barbares,* 1896). Courtauld Institute of Art Gallery, London. Credit: The Samuel
Courtauld Trust, Courtauld Institute of Art Gallery, London.

to the stuffs [fabrics], to the pots, to the hats. He never seemed to
come into a room that autumn without carrying some new trophy in
his hands. There were cotton goods from Manchester, made to suit the
taste of the negroes. The cotton goods made the chintz curtains look
faded and old-fashioned like the Watts portrait. There were hats, enor-
mous hats, boldly decorated and thickly plaited to withstand a tropical
sun and delight the untutored taste of negresses. And what magnificent
taste the untutored negress had! Under his influence, his pressure, his
excitement, picture, hats, cotton goods, all were connected. Every-
one argued. Anyone's sensation—his cook's, his housemaid's—was
worth having. Learning did not matter; it was the reality that was all-
important.[37]

Woolf affectionately satirizes Fry as a colonial explorer arriving with "trophies" from Africa—or, actually, from Manchester. She plays on the incongruous contrast between high art pictures and gaudy, Africa-bound commodities. In her mocking comparison, both the philistine British public and the natives of Africa need to be educated to consume the primitive style of French paintings or Manchester goods. It is a revealing comparison, since, in my argument, both Fry's theory of post-impressionism and Britain's colonial policies in Africa were founded upon similar anthropological assumptions to be examined more closely below. When Woolf transmutes race into class, and the "untutored negress" becomes a British housemaid, she echoes a tradition popular since Mayhew and Dickens to describe the British working classes as homegrown primitives. Given, then, Fry's dramatic visual packaging of the post-impressionist pictures, it is no wonder that critics attacked them as "barbaric."

Fry and his supporters also used verbal rhetoric to cast the post-impressionist canvases as primitive. The word appears five times in Desmond McCarthy's introduction to the exhibition catalogue, assembled from Fry's notes. McCarthy writes, "Primitive art, like the art of children, consists not so much in an attempt to represent what the eye perceives, as to put a line round a mental conception of the object. Like the work of the primitive artist, the pictures children draw are often extraordinarily expressive."[38] In other words, the primitive style of the post-impressionists could claim a greater expressiveness or emotion than mere realism. Roger Fry, too, adopted the terms of primitivism to attack realism in an article published in *The Nation* on November 19, 1910:

> [The Post-Impressionists] are in revolt against the photographic vision of the nineteenth century, and even against the tempered realism of the last four hundred years...[They have] stumbled upon the principles of primitive design out of a perception of the sheer necessities of the actual situation...Why should the artist wantonly throw away all the science with which the Renaissance and the succeeding centuries have endowed mankind? Why should he wilfully return to primitive, or, as it is derisively called, barbaric art? The answer is that it is neither wilful nor wanton but simply necessary, if art is to be rescued from the hopeless encumbrance of its own accumulations of science [i.e., realistic style]...[The Post-Impressionists] are cutting away the merely representative element in art to establish...the fundamental laws of expressive form in its barest, most abstract elements."[39]

Fry invests the French painters with a primitive interiority and authenticity that opposes the machinic, "photographic" realism of the modern West, with all of

the industrialist connotations attached to this illusionistic style. Yet for all of his disdain for inheritances of the nineteenth century, as we will see, his terms are founded upon certain familiar assumptions emerging from a confident Victorian worldview.

Visualizing Victorian Anthropology

Given that Fry defends post-impressionism by celebrating the primitive, it seems contradictory at first to invoke Victorian anthropology as an influential generative discourse. After all, the Victorians are notorious for promulgating a biological science of comparative cultures that underwrote their racist colonial domination over those they deemed primitive.[40] As many historians have observed, however, the comparative method contained the seeds of its own undoing, and ultimately led to the leveling of Western culture alongside other foreign cultures that came under the anthropological gaze. The early decades of the twentieth century have been seen by historians of anthropology as the moment when the evolutionary model of cultures could no longer be sustained.[41] The first work to espouse a complete cultural relativism, anthropologist Franz Boas's *The Mind of Primitive Man*, was published in 1911. So the first decade of the twentieth century was not one of smug colonial assumptions, but rather a period of intellectual destabilization. The following debates about art objects and material culture take place on this unstable terrain, resulting in the conflicting discourse that we would expect from attempts at rational criticism at this time.

The impact of anthropology on art discourse at the turn of century began with the early shaping of the social science discipline itself. The nascent field of anthropology was acutely dependent upon visual models, artifacts, and displays to communicate its theories, especially as it was working in the shadow of the wildly popular international exhibitions. Successors of Britain's 1851 Great Exhibition, these exhibitions now created elaborate theatrical spectacles of colonial cultures: the Franco-British Exhibition of 1908 featured the wholesale reproduction of native African, Indian, and Irish villages, complete with imported native performers. Annie E. Coombes suggests that anthropologists, lacking university affiliations and academic reputations, were forced to engage in popular visual methods to gain credibility and to establish their field in the public eye. "By 1908, any difference between the supposedly distinct domains of 'scientific' and 'popular' knowledge regarding the colonized subject had been effectively obscured for a large proportion of the public who visited these exhibitions."[42] The international exhibitions are now well-known for their influence upon a generation of modernist painters and writers who embraced primitivism. Yet they also had a more structural impact upon the worlds of visual art and anthropology, creating foreign cultures and their objects as the quintessential

valuable items of display.[43] Anthropology museums blended the road-show theatrics of the exhibitions with the new high-art sensibility of late-Victorian art museums. Even while the art museum was becoming a more exclusive space of high culture, creating art spectatorship as its own inimitable experience, the art museum also became the prototypical model for other kinds of museum experiences at the turn of the century.[44] In anthropology museums, primitive objects behind glass revealed titillating glimpses into another culture, while also conveying the aura-laden value of high art commodities (figure 5.3).

Anthropology was established, then, as a primarily visual field, dependent for its authority upon artifacts on display. Anthropology museums combined theatrical entertainment, scientific disquisition, and aesthetic presentation to convey theories about the development of foreign cultures. A famous example of what might be called anthropology's "speaking displays" was the arrangement of collections at Oxford's Pitt Rivers Museum.[45] Pitt Rivers, a late-Victorian anthropologist, revolutionized techniques of ethnographic display by ordering his objects according to their morphological forms, or what he designated their "Typology." Given that in both "prehistoric objects" and in "the arts of savage nations, the dates cannot be given," Pitt Rivers suggested recourse to "the sequence of type." He

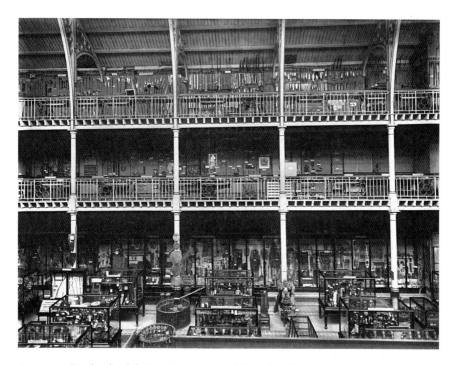

FIGURE 5.3 "South side of the Pitt Rivers Museum." Photo by Alfred Robinson, c. 1895–1901. PRM 1999.19.1. Pitt Rivers Museum, University of Oxford. Courtesy of the Pitt Rivers Museum, University of Oxford.

thus arranged objects such as weapons, ornamented jars, and other tribal products according to an evolutionary scheme in which "simple forms have preceded complex ones."[46] Pitt Rivers wrote essays between 1867 and 1875 outlining his theory for different types of tribal objects, but these were only collected and published in 1906, under the title *The Evolution of Culture and Other Essays*.[47] Here Pitt Rivers examines inert objects as though they were biological forms, arguing that a timeline can be found for their production by analyzing gradual changes in shape and design. At the Pitt Rivers Museum, objects were displayed in a similar series, implying a chronology of development and degeneration according to their "evolutionary" changes in form (figure 5.4).

Pitt Rivers' research in the 1870s was an early incarnation of what had become scientific-aesthetic dogma by the 1890s. A series of publications written by scientists and anthropologists—some of which appeared in the previous chapter—analyzed ornament and decoration in order to make evolution-based claims about the relations between human cultures. These included Alfred C. Haddon's *Evolution in Art: As Illustrated by the Life-Histories of Designs* (1895) and Henry Balfour's *The Evolution of Decorative Art* (1893). Significantly, the decorative arts became a critical locus for the proof of evolution in human objects, which were taken to be biological indicators of the states of human races, past and present. This logic was a biologized extension of assumptions already present at the Great Exhibition, as we saw in chapter 2. The decorative arts were produced as visual evidence by scientists who did not consider themselves to belong to the art world. "I profess to be neither an artist nor an art critic," writes A. C. Haddon in the opening of *Evolution in Art*, "but simply a biologist who has had his attention turned to the subject of decorative art. One of my objects is to show that delineations have an individuality and a life-history which can be studied quite irrespectively of their artistic merit."[48] Despite Haddon's disclaimer, the fact that a biologist could publish an influential book on art points to the blurred lines in turn-of-the-century writing between art history, anthropology, biology, and museum curatorship. (Haddon was curator of the Horniman collection in London.) Henry Balfour is another example of a figure not classifiable by contemporary disciplines: he wrote on the "evolution of decorative art," published articles on the evolutionary forms of musical instruments, held the influential position as curator of the ethnographical department at the Pitt Rivers Museum, and became president of the Royal Anthropological Society in 1904. While nineteenth-century histories of art usually started with Egyptian or Assyrian art, beginning around 1890 they had to go back further, all the way to primitive art, to make comprehensive and authoritative claims for their evolutionary timelines.

In particular, decorative objects were exhibited as proof of a developmental timeline that ranged continuously from cultures of the distant past to the civilized West of the present. These accounts were the logical extension of the Darwinian

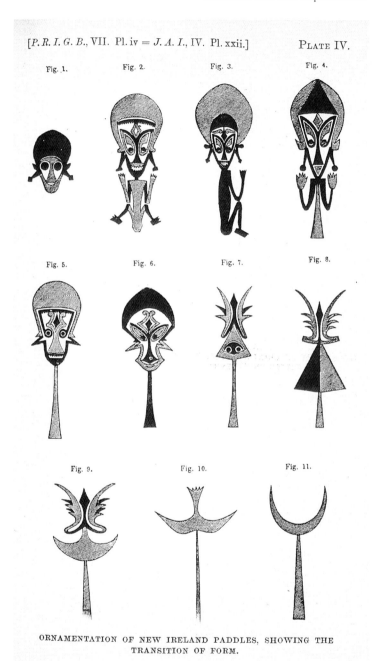

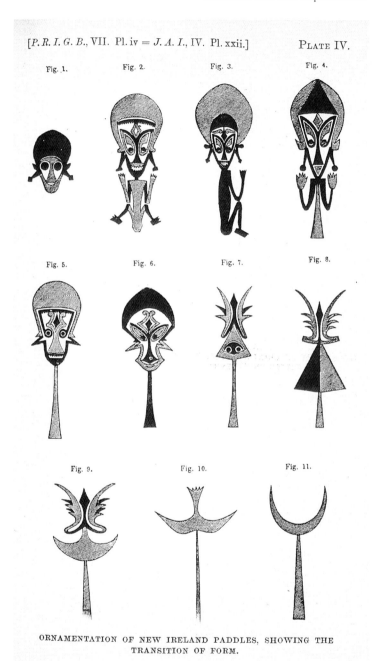 ORNAMENTATION OF NEW IRELAND PADDLES, SHOWING THE
TRANSITION OF FORM.

FIGURE 5.4 A. Pitt Rivers, "Ornamentation of New Ireland Paddles, Showing the Transition of Form," *The Evolution of Culture and Other Essays* (Oxford, 1905; reprint, AMS, 1979). The Pennsylvania State University Library.

pattern books examined in the previous chapter, taking decorative objects as an easy shorthand for biological truths—and timelines—delineating their creators. Henry Balfour gives a standard Darwinian account in the introduction to his *Evolution of Decorative Art,* making the history of design seamlessly interweave with the history of all human culture:

> The Art of Design must, we know, have had a continuous history, and have grown up gradually from simple beginnings, at first by easy stages, involving but slight intellectual efforts, steadily progressing until it has become an essential element in our surroundings, absorbing a vast amount of complex reasoning, the result of the accumulation and combination of simple ideas, which are the outcome of experience during countless ages.[49]

It is somewhat incongruous to imagine the "Art of Design," or the skills needed to produce a vase or a basket, "absorbing a vast amount of complex reasoning," but the image makes sense if one believes, as Balfour does, that vases and baskets have an organic connection to the culture that made them. The choice of "complex reasoning" also seems strange, with reference to the design of decorative objects, since one would expect a sense of beauty or aesthetic skill to be more appropriate qualities—but once again, the wording is dictated by a pre-existing ideology. "Complex reasoning" is the crucial trait by which civilized cultures are distinguished from primitive ones. If Western civilization was distinctive for its ability to change and progress along the evolutionary timeline, modern primitive cultures were somehow prevented from enjoying this kind of change. As Balfour explains, "There can be little question that in the various races of modern savage and barbaric peoples we have instances of 'survival' from early conditions of culture, as also of physical development; that many of these races are, in fact, not only low in the culture scale, but also essentially primitive; that their upward progress has from various causes been arrested or retarded, and that they have thus dropped behind in general advance towards civilisation."[50] Modern primitives, in other words, have not simply degenerated from some previous cultural renaissance, but persist in a state of unchanging primacy having lost their ability to progress. This doctrine of modern primitive peoples as "survivals"—theorized by many Victorian anthropologists—led some late-Victorian scientists to attempt to reconstruct the cultures of prehistoric humans by examining the artifacts of "modern savages."[51] As Balfour observes, since the actual history of decorative art "is lost and can never be written, ... we are reduced to reasoning from analogy," studying modern primitive races so as to "throw light upon" the actual developmental history of art.[52] The British empiricist tradition, reasoning from the seen to the unseen, here becomes a way for scientists to create speculative histories of their own origins. In these texts, the visual arts and visual evidence converged

to allow scientists to "see" back into primordial history. In the following sections, I will explore how various peoples from Africa, India, and elsewhere were utilized by the British as examples of modern primitives. The late-Victorian formation of the discipline of anthropology coincided with a kind of scientific objectification that took its authority from overwhelmingly visual metaphors.[53] These metaphors worked to create the Other as a detached, definable object, automatically exoticized by the very nature of the spectatorial model of knowledge.

Significant Form: Bell, Frazer, and Pure Aesthetics

Within the realm of art history, it is counterintuitive to read the post-impressionist theories of Roger Fry and Clive Bell into this anthropological model of cultures. For if the anthropological culture-scale placed Britain at the top for its tradition of empiricist reasoning, that superiority was embodied by the visual style of Western realism. Mainstream Victorian art histories rehearsed the cliché that Greek sculpture and Renaissance perspectival paintings symbolized the intellectual enlightenment of the West. The triumph of Western rationalism was manifested in the progress of its art toward photographic realism.[54] In chapter 1, I outlined a continuity in epistemology between the photographic reproduction of reality and the Lockean model of empirical knowledge. This tradition became a part of the "image of objectivity" that still informs tropes of contemporary scientific observation.[55] When Roger Fry writes, in a passage cited above, of "the science with which the Renaissance and the succeeding centuries have endowed mankind," the word "science" has both disciplinary and stylistic meanings. Contrasts between civilized realism and barbaric abstraction appear in the art histories of Haddon, Balfour, and Pitt Rivers, who observe the degenerative tendencies of primitive ornament as it moves from a realistic imitation of nature to a series of conventionalized and increasingly abstract copies. Balfour attributes this degeneration to the laziness of the primitive mind, an "unskilfulness or carelessness on the part of the potters, who…successively allowed the various attributes to drop out, leaving them to the imagination, as it was easier to do this than to represent in full a somewhat complicated design."[56] Balfour automatically assumes that the best image is the most realistic; it comes as no surprise that primitive objects inevitably degraded this ideal.

Despite mainstream Victorian art preferences, however, Fry and Bell argue for the aesthetic superiority of an anti-realist formalism. They were attempting to reverse centuries of received opinion about the preeminence of the empiricist, illusionistic style, in favor of a style associated with primitive cultures. Yet their method was not to reject the entire host of assumptions that buttressed the culture pyramid. Rather, they realigned the values within the hierarchy of cultures to elevate their preferred style, so as to make formalism (what Bell famously dubbed "significant

form") the new representative achievement of Western culture. They employed the whole arsenal of anthropological, empiricist models at their disposal.

Though Fry does not use the term "primitive" in his famous 1909 "Essay on Aesthetics," his theory deploys a rhetoric of visual science and empiricism traditionally associated with Western progress. Indeed, his argument for a non-mimetic style in art focuses, oddly enough, on two technologies inextricable from realism: the cinematograph and the mirror. How do these sharply detailed modes of looking favor a non-realist or abstracted visual style? Fry suggests that both the cinematograph and the mirror allow for the spectatorship of actual life at a distance, without any need to react. "If, in a cinematograph, we see a runaway horse and cart, we do not have to think either of getting out of the way or heroically interposing ourselves. The result is that in the first place we *see* the event much more clearly."[57] Images on a movie screen, safely removed from the audience, enable a visual detachment that is usually impossible. Likewise, when we look into a mirror "it is easier to abstract ourselves completely, and look upon the changing scene as a whole... The frame of the mirror makes its surface into a very rudimentary work of art, since it helps us to attain to the artistic vision."[58] Fry invokes mimetic devices to describe the formalist, aesthetic eye, yoking the rational mind to a mode of visual judgment detached from any immediate object, narrative, or emotional response. His choice of cinematograph as the theory's essential symbol embraces the cutting edge of visual technology, enlisting the rhetoric of Western progress to bolster his argument for a more advanced, albeit non-mimetic aesthetics.

Fry's definition of aesthetics stresses the positive effect of framing an image, whether in movie or mirror. The frame allows for the spectator's emotions to be "felt quite purely, since they cannot, as they would in life, pass at once into actions of assistance."[59] The word "pure" appears everywhere in Fry's essays, encapsulating a key motif in modernist aesthetics. For Fry, purity is a Kantian category, removing beauty from political, social, or sensual concerns. The idea resonates with other modernist dogmas, like that of the purity of medium. The desire for aesthetic purity also evokes the specter of race theory, coinciding with the turn-of-the-century efflorescence of publications and societies devoted to eugenics. Ezra Pound and T. E. Hulme's sculptural aesthetics and Wyndham Lewis's calls for social cleansing all seem to originate in the modernist desire for an art purified of social (and racial) disorder.

There is also, I would suggest, a connection between Fry's claims for purity and the anthropological discourse of culture. Historian of anthropology James Clifford observes, in terms suggestive for this analysis, "Culture, even without a capital *c*, strains towards aesthetic form and autonomy."[60] Anthropology scholars like Clifford and Johannes Fabian have pointed out that the anthropological analysis of culture tends to isolate it, making it a totalized and hermetic system not definable by permeability, hybridity, or historical change.[61] In other words, anthropology treats

culture the way a formalist critic would appreciate an aesthetic object. According to this ideology, all cultures (except the most complex culture of the observer) can be conveniently packaged by analysis from the outside—especially primitive cultures perceived to be caught in a timeless, unchanging stasis.

It was just this kind of formal envelope around cultures that enabled Victorian anthropologists to employ the vaunted comparative method, what Johannes Fabian lambastes as "that omnivorous intellectual machine permitting 'equal' treatment of human culture at all times and in all places." (In Fabian's ensuing critique, "while the data fed into the machine might have been selected with positivist neutrality and detachment, its products—the evolutionary sequences—were *anything but* historically or politically neutral.")[62] The comparative method was famously used by James Frazer in one of the most influential works of modernist anthropology, *The Golden Bough* (1895–1915). In this voluminous text, Frazer attempts to explain a murderous rite in ancient Italy by exploring the primitive behaviors of cultures scattered across times and spaces. For Frazer, phenomena as diverse as English Maypole dances and Aztec human sacrifice are brought together by the fact of "the essential similarity with which, under many superficial differences, the human mind has elaborated its first crude philosophy of life."[63] Frazer's reasoning goes toward proving, in Christopher Herbert's apt formulation, that "the primitive thought-world is everywhere identical."[64]

There is a structural similarity between Frazer's comparative method—the same method used by Victorian anthropologists like Tylor and Spencer—and the aesthetics of Roger Fry and Clive Bell. For Fry and Bell, one might say, the aesthetic thought-world is everywhere identical. They postulate a formalist aesthetics that is based on a universal quality in art, a timeless vision set implicitly into the timeline of civilized progress. As Fry writes in 1906 (while director of New York's Metropolitan Museum of Art), the objects in a museum should be arranged "aesthetically," according to "the language of art," "a language which is universal, valid for all times and in all countries, but . . . a language which must be learned though it is more natural to some than to others."[65] Even while formalism is a universal visual language, the culture-spectrum is still evident in Fry's claim that some spectators are more naturally gifted than others. Similarly, in his canonical work *Art* (1914), Clive Bell argues that "significant form" is the universal, "essential quality in a work of art."[66] In this book, as does Frazer in the *Golden Bough*, Bell moves from culture to culture across wide swathes of time and space with astonishing rapidity. As he travels rhetorically through the primitive arts of many cultures, he proves the universal nature of significant form—and in the process, creates a sense of extreme dislocation:

> In primitive art you will find no accurate representation; you will find only significant form. Yet no other art moves us so profoundly. Whether

we consider Sumerian sculpture or pre-dynastic Egyptian art, or archaic Greek, or the Wei and T'ang masterpieces, . . . or whether, coming nearer home, we consider the primitive Byzantine art of the sixth century and its primitive developments amongst the Western barbarians, or, turning far afield, we consider that mysterious and majestic art that flourished in Central and South America before the coming of the white men, in every case we observe three common characteristics—absence of representation, absence of technical swagger, sublimely impressive form.[67]

In Victorian art histories, "Primitive art" (usually capitalized) referred to early-Renaissance Italian paintings by artists like Botticelli. But Bell here uses "primitive" in a broader anthropological sense, to encompass the arts of both early Western and non-Western cultures. With its anti-realist "absence of representation," primitive art is "sublimely" mysterious, "profoundly" moving; its existence "before the coming of the white men" reflects the ubiquitous modernist yearning for unmediated cultural authenticity. Though anthropologists were usually more precise in their designations of what qualified as a primitive culture, Bell is remarkably loose in his almost dizzying connections between many different cultural traditions. Like Frazer, he uses a tone of rational inquiry to propose a theory that partakes of the fantastic. "Form" is the magical substance of cultural, temporal, and aesthetic unity that can bind Greek, Chinese, Byzantine, Central American and South American styles into a single theory (figures 5.5a, b).

If Frazer was accused of "armchair anthropology" for never traveling to the countries he wrote about, then Fry and Bell might be accused of "armchair aesthetics." Their eyes survey the arts of all cultures from a single theoretical vantage point in their search for form. At this point, however, a notable difference between modernist art and anthropological theories presents itself: unlike anthropological primitivism, which distanced the Western spectator from the less developed culture under its gaze, modernist formalism broadened to include more advanced civilizations within its universal language. Thus French painters might be labeled "primitive" by art critics in 1910, but French culture would not be considered primitive by anthropologists. It is striking here that, as ethnological specimens were being transformed into collectible aesthetic objects, the forms of those objects were also being used to establish new visual styles in the high arts of painting and sculpture. In this, we might also trace a late-Victorian influence; as we saw in chapter 4, Arts and Crafts artisans made earlier arguments for decorative objects as transmitters of high art style. The anthropological interests of Fry and Bell can be seen as an internationalist version of British arguments promoting the decorative arts in the previous century.

By now it should seem less surprising that Roger Fry wrote essays in 1910 on African and Asian art, in addition to his essays on French post-impressionism.

FIGURE 5.5A, B "Early Peruvian Pot" and "Cézanne," from Clive Bell, *Art* (London, 1914). Courtesy of the Rare Book and Manuscript Library, University of Pennsylvania.

Fry uses non-Western art objects to promote a formalist style against the realist tradition. Bolstered by formalism's universal reach, the aesthetic critic became an explorer, striking out into new, unknown territory in search of beautiful art. In fact, both Fry and Bell use metaphors of the colonial voyager to describe their aesthetic projects. Bell writes in *Art* of Cézanne's post-impressionist discoveries: "Cézanne discovered methods and forms which have revealed a vista of possibilities to the end of which no man can see...Without him the artists [of today]...might have remained port-bound for ever, ill-discerning their objective, wanting chart, rudder, and compass. Cézanne is the Christopher Columbus of a new continent of form" (207). And Fry opens his essay on "Oriental Art" by describing how the aesthetic critic of today, in the face of new cultural (and imperial) discoveries, is "progressing to the conquest of new worlds, urged on by a breathless anticipation of ever new and more astonishing wonders."[68]

While these colonial metaphors suggest that Fry and Bell were exploiting foreign art for their theories, other critics perceived the widening of the artistic canon as a threat to Western cultural dominance. For example, one critic writing in 1910 mocks the new avant-garde interest in Eastern art as a bankrupt exercise in anthropology. "An enterprising young art critic with a reputation to make" could "devote a year or so to the study of tattooing as practised by the islanders of the Polynesian Archipelagos," the critic suggests sarcastically. "His scientific accuracy will compel respect and the coloured plates will do the rest. . . . As for the theory it will contain—the theory that the Polynesian and Shan tattooers are the only great and really consummate artists the world has ever seen—success will depend mainly on a bold use of artistic terms...Let him go among these words like a conqueror."[69] The critic parodies Fry and his colleagues as would-be explorers, conquerors, and colonialists, making primitive art into the new aesthetic fashion. The final irony in this parody is its modicum of truth. The mocking comparison of art critic to anthropologist has a basis in reality, as this analysis will have suggested, especially in the modernist art critic's role as interpreter and commodifier of foreign art objects and styles for an ignorant public.

Africa's Paleolithic Impressionists

While antique foreign objects like Chinese vases and Japanese fans had been valuable collectibles since the time of the aesthetes, the terrain of aesthetic culture had evidently shifted when Roger Fry devoted an essay to African cave art, as he did in *The Burlington Magazine* in 1910.[70] He was editor of the magazine at the time, which perhaps explains how he was able to include a review of "Bushman Paintings" in a magazine targeting British connoisseurs.[71] Fry's choice was not necessarily a popular one. Professor Henry Tonks, drawing master at Cambridge's Slade school of art,

wrote a letter to critic Robert Ross in May 1910 exclaiming, "I say, don't you think Fry might find something more interesting to write about than Bushmen, Bushmen!"[72] Nevertheless, given that all scientific art histories now stretched back to the prehistoric era, African primitive art was a province where connoisseurs could be expected to have expertise. And although cave paintings were not easily transported, they were still a part of the new traffic in collectible colonial objects.[73]

Fry's article is a review of Bushman cave paintings reproduced in watercolor by Helen Tongue and published in book form in 1909.[74] The book's introduction is written by none other than Henry Balfour, whose personal interest in Bushman art led him to collect specimens for the Pitt Rivers Museum during trips to South Africa in 1905, 1907, and 1910.[75] *Bushman Painting* did not simply emerge out of the blue in 1909 as a fully formed interest in African cave painting. Nineteenth-century British authors had long been fascinated with Bushman art because the images accorded with certain mythic narratives accruing to this African people during the British colonial encounter in their territory. Within the late-Victorian historiography of southern Africa (and well into the twentieth century), the Bushmen were seen as a distinctive and isolated race for being, unlike other African peoples, "yellow-skinned" and "short of stature";[76] for being primitive hunter-gatherers who preyed upon European settler flocks; for being an evolutionarily "weaker" race that was quickly disappearing under the violent incursions of "stronger" native and European races; and, significantly, for being distinguished as "a race of artists," in the words of Balfour's introduction to Tongue's book.[77] Or, as another historian put it in 1913, "the modern Bushman is singled out from other African races by his extraordinary gift for delineating and painting."[78] Romanticized as a vanishing race, the Bushmen were seen to leave behind Ozymandias-like rock paintings silently representing their dying culture.[79] They occupied the Victorian imaginary as a mythic symbol of all primitive cultures, low on the evolutionary chain, which are swept away by modern progress.

Roger Fry's essay also takes the Bushmen as representative primitive artists, though his analysis moves in an unexpected direction. He begins by discussing primitive art more generally, citing the influential theory of the German art historian Emmanuel Loewy. In a study of early Greek art, Loewy argued that primitive cultures all produced similar artworks because they shared the same primitive mental process. Like children, Loewy writes, "savages" draw conceptual images of objects as a kind of visual shorthand, built up from "spontaneous memory-pictures," and prelude to more developed styles of art. Loewy's study of the primitive psychological process of art-making strongly foreshadows later arguments for post-impressionism—for instance, he suggests that the primitive mind visualizes objects "isolated and surrounded by a void" and emphasizes outline as the "contour that consciousness first seeks."[80] This description is mirrored by Desmond McCarthy's statements in the 1910 post-impressionist catalogue,

cited above, noting that primitive art "put[s] a line round a mental conception of the object."[81] Loewy's recourse to a psychology of form allows him to theorize an authentic kind of image-making, a pure expressiveness untainted by intervening accretions of culture—the same qualities post-impressionist critics wanted to embrace.

Yet ultimately Fry and Loewy tell very different stories. Loewy's book begins with primitive Greek art and arrives at the triumphant realism of late Greek sculpture. Fry, by contrast, wants to attack realism in order to arrive at the triumphant anti-mimeticism of contemporary European artists. As it turns out, Bushmen paintings are the perfect vehicle for his argument about styles, since, surprisingly enough, despite the Bushmen's primitive status, their images capture a remarkably lifelike realism (figure 5.6). "Nothing could be more unlike

FIG. 1

FIG. 2

most difficult and complicated attitude. Or again, the man running in fig. 5. Here is the silhouette of a most complicated gesture with foreshortening of one thigh and crossing of the arm holding the bow over the torso, rendered with apparent certainty and striking verisimilitude. Most curious of all are the cases of which fig. 4 is an example, of animals trotting, in which the gesture is seen by us to be true only because our slow and imperfect

FIG. 4

FIG. 5

FIG. 3

FIG. 6

vision has been helped out by the instantaneous photograph. Fifty years ago we should have rejected such a rendering as absurd; we now know

FIGURE 5.6 Roger Fry, "Bushman Paintings," *The Burlington Magazine for Connoisseurs*, vol. 16 (1910): 336. The Pennsylvania State University Library.

primitive art than some of these scenes," Fry remarks. Animals are depicted in "extremely complicated poses," and "momentary actions are treated with photographic verisimilitude."[82] In other words, Bushman art challenged traditional assumptions about primitive artists because their cave paintings were strikingly lifelike, almost photographic. Yet this fact does not inspire Fry to argue for the Bushman's unheralded equality with Western painters. Instead, he creates a new category of "ultra-primitive," a "Palaeolithic man" from whom the Bushmen have descended, and who combines a "unique power of visual transcription" with a crude, undeveloped state of culture. The ultra-primitive peoples showing this drawing skill are "the least civilizable" and "belong to what we call the lowest of savages." Inhabiting such an early "stage of intellectual development," the Bushman-Paleolithic conceptual abilities had not yet "begun to interfere with perception, and where therefore the retinal image passed into a clear memory picture with scarcely any intervening mental process."[83] These cave drawings attain a high realism because the Bushman sensorium functions like an automatic camera lens, with no high-level thought processes to ruin the retinal data. Since the Bushman is ranked on the evolutionary continuum as "the lowest of savages," his realistic images cannot be read into the traditional story of styles, by which Western rational development led to a scientific realism.

Fry contrasts these ultra-primitives with a heroic "Neolithic man," represented by Loewy's Greek primitives. A Western ancestor to European artists, Neolithic man "was less perfectly adapted to his surroundings, but . . . his sensual defects were more than compensated for by increased intellectual power"—a power that expressed itself most clearly in anti-mimetic drawings. "With Neolithic man drawing came to express man's thought about things rather than his sensations of them . . . [;] when he tried to reproduce his sensations, his habits of thought intervened, and dictated to his hand orderly, lucid, but entirely non-naturalistic forms."[84] While the Bushman is merely a thoughtless drawing machine, the Western primitive shows mastery over his body, his thoughts deftly controlling his hand. Fry reproduces the Victorian cultural cliché elevating the Greeks for their reasoning ability; hence the conceptual arts of Neolithic man are not crude or offensive but "orderly" and "lucid." Fry follows Loewy in assuming that the Greeks had a "racial endowment," in Loewy's phrase, that elevated them above other primitive cultures and predisposed them to develop. But Loewy's story of styles is essentially a Victorian one, narrating the triumphant rise of Greek naturalistic sculpture out of primitive conceptual roots. It was the Greek "racial endowment for acutely seizing the situations of nature" that led to the "emancipation of art, viz., the discovery of nature."[85] While Fry and Loewy both value the conceptual model of primitive art for being a precursor to the Western rational eye, the two thinkers end up championing very different visual styles.

Fry concludes the essay by offering contemporary artists a stark choice: they can either reproduce the mere realism of the Bushmen, with its "ultra-primitive directness of vision," or they can embrace the more abstract "conceptual" styles modeled by the primitive Greek. He writes, "The artist of to-day has therefore to some extent a choice before him of whether he will *think* form like the early artists of European races or merely *see* it like the Bushmen."[86] Visual form or primitive abstraction—a Greek inheritance—is a more rational choice than mere mechanical realism, the "ultra-primitive" vision of the Bushmen. "Bushman Painting" was published in the spring of 1910, while Fry was busy assembling the paintings for the November show. Though he had not yet come up with the term "Post-Impressionism" to describe the French style, he was obviously already working out the terms of the debate.[87]

In "Bushman Painting," then, Fry manipulates established cultural valuations to argue for his preferred aesthetic style. His sinuous interpretation of Bushman art shows both the arbitrariness of racialized development narratives and their immutability: Bushmen are still "ultra-primitives," despite any evidence to the contrary. Still, Fry does make a radical alignment of Bushman art with French impressionism and realism—both previously coded as the height of Western civilized culture. From another perspective, Fry pays these tribal artists a back-handed compliment by bringing them into the Western stylistic debate.

Though Fry's argument about Bushman art is idiosyncratic, his use of pre-historic art to propose a modern art theory partakes of the larger trend in art histories to ground themselves in accounts of past primitive cultures. The reference now leaps out in Clive Bell's preface to *Art* (1914): "In this little book I have tried to develop a complete theory of visual art. I have put forward an hypothesis by reference to which...all aesthetic judgments can be tested, in the light of which the history of art from paleolithic days to the present becomes intelligible, [and] by adopting which we give intellectual backing to an almost universal and immemorial conviction."[88] The universality of Bell's formalism is ensured by the breadth of his timeline, which stretches from "paleolithic days to the present." In the same way that anthropologists wanted to find the most untouched versions of primitive cultures in a search for human roots, art writers wanted to find and theorize the most pure kind of visual style, a purity that was enhanced by primitive associations. The desire to trace human origins back to a single ancestor was a Victorian inheritance, embodied in the nineteenth century by the linguistic theories of Max Müller, who developed a history of human development based on a theory of descent from a single, primal language. The turn-of-the-century obsession by art writers with cave drawings and other prehistoric images can be interpreted as another version of this search, looking for an ur-artwork from which all modern art might have descended. The strange intermixture of anthro-pological primitivisms and avant-garde art theories became a British modernist

commonplace, as is evident in a telling comment from the English painter Mark Gertler, writing to Dora Carrington in September 1912: "I looked at them [other artists] talking art, Ancient art, Modern art, Impressionism, Post-Impressionism, Cubists, Spottists, Futurists, Cave-dwelling, Wyndham Lewis, Duncan Grant, Etchells, Roger Fry."[89] Now we can begin to understand why "cave-dwelling" was in fact an eminently modernist topic of conversation.

Yet Fry's post-impressionist cave-dwelling modulates the primitivism usually associated with modernist style. More than simply a desire to flee the over-refinement and self-consciousness of modern civilization, the primitivism of scientific art writers also stemmed from an older, more Victorian historicism—not really an escape to a timeless natural world scripted by Rousseau, but more a timeline authorized by the Victorian studies of anthropology, biology, and evolutionary science. As my argument suggests, this historicism was profoundly conditioned by the circumstances of the British colonial venture, which brought foreign artifacts into the sights and narratives of modern art writers. Hence Roger Fry authorizes his argument for a non-mimetic style in art by analyzing Bushman paintings, via Paleolithic man and the archaic Greeks, and cements his historicized aesthetic distinctions by asserting their basis in the biology of the human body. African cave paintings were simply one piece in a larger global assemblage of styles. Like Frazer, Fry was omnivorous in locating objects that would support his all-encompassing theory.

"Eastern Art and Western Critics"

If British art writers used colonial objects to prove their aesthetic theories, the reverse was also true: the styles of non-Western art objects were taken to both defend and attack British colonial assumptions about foreign subjects. The fraught nature of colonial art objects is nowhere more evident than in modernist art criticisms of "Oriental Art." While the Bushman native was easily primitive in British eyes, the cases of India, China, and Japan were more difficult to discern. Anthropologists would not have labeled these cultures as primitive, but many art writers did to support theories of both aesthetics and politics that were often inseparable. Roger Fry's essay "Oriental Art," also published in the spring of 1910, participated in a larger debate that had been raging since the 1890s on the value of non-imitative styles in non-European art. Evaluating Indian art was especially problematic owing to Britain's colonial involvement there; in India, unlike in Africa, the British had exerted themselves to educate native peoples in Western-style schools, including art schools. A Westernized Indian upper-middle class collected Victorian-style art objects. Some Asian artists and art critics painted and spoke in British idioms. One of the books Fry reviews in "Oriental Art" is *Medieval Singhalese Painting,* by Ananda

Kentish Coomaraswamy, "himself a Cingalese," in Fry's description.[90] By the first decade of the twentieth century, the criticism of South Asian art by both British and Asian writers had become a battleground for debating nothing less than the political subjectivities of colonized cultures. While South Asian art offered Fry the opportunity to rehearse arguments he would soon make for post-impressionism, his essay is fraught with contradictions due to the confused status of "Oriental Art" on the anthropological scale. These conflicts were a manifestation of the larger dilemma posed by colonial art, in a time when cultural relativism and tolerance were battling the rigid hierarchies established by Victorian anthropology.

In 1910, in addition to post-impressionism and Bushman painting, British spectators in London could also peruse a large and visible body of Indian, Indonesian, Chinese, and Japanese art. Chinese and Japanese paintings were displayed in the Print Room of the British Museum; a Japan-Britain exhibition occupied the green at the London neighborhood of Shepherd's Bush; and a striking Javanese Buddha was on view at the Royal Society of Arts (figure 5.7). These objects ignited controversy within the British press and professional societies. The imposing Javanese sculpture provoked a scandal at the Royal Society of Arts that led to the founding of the India Society in 1910.[91] (Though "Javanese," or Indonesian, sculpture was influenced by Indian artworks, the two traditions are obviously different; to British eyes, though, the works of both nations were apparently indistinguishable, and any Hindu or Buddhist artform might be subsumed under the amorphous term "Indian.")[92] Thus Sir George Birdwood, an authority on Indian handicraft, delivered a lecture in which he ridiculed the Javanese Buddha as "nothing more than an uninspired brazen image, vacuously squinting down its nose to its thumbs, knees, and toes. A boiled suet pudding would serve equally well as a symbol of passionate purity and serenity of soul."[93] In response to Birdwood's abuse of the Buddha, a group of British artists and critics wrote a letter of protest to the *Times* assuring "our brother craftsmen and students in India" that Indian art "will never fail to command our admiration and sympathy so long as it remains true to itself."[94] Signatories to the letter included Arts and Crafts members like Walter Crane, W. R. Lethaby, and Emery Walker, highlighting a link between the Victorian medievalist crafts movement and the twentieth-century anti-imperial movements for cultural nationalism. If the Arts and Crafts movement promoted anti-realist styles as a rebellion against the machine-made objects of British industrialism, those arguments were readily adopted by cultural nationalists who opposed British dominance around the globe.[95]

George Birdwood presents a fine example of the perversity of colonial attitudes in the aesthetic realm. While he tirelessly defended Indian handicrafts, which he saw as preserving native rural traditions against the incursions of Western industrialism, he also dogmatically refused to believe that Indians were capable of producing the fine arts of painting and sculpture.[96] Birdwood's viewpoint

FIGURE 5.7 "A Dvyâni Buddha from Bôrôbudûr, Java," Plate II, E. B. Havell, *Indian Sculpture and Painting* (London, 1908). Courtesy of the University of Pennsylvania Library.

was a commonplace of Victorian histories of art and design; while Victorian crit-
ics from Owen Jones to William Morris praised the fineness of Indian decorative
crafts, the conventional link between visual realism and Western progress—as
evidenced in the knowledge of anatomy, optics, or natural phenomena—pre-
vented European critics from acknowledging any Indian attainments in the fine
arts.[97] Indian arts had been on view to the Victorian public since the early nine-
teenth century at the India Museum, formed by the East India Company to exhibit
the busts of explorer-conquerors alongside their imperial spoils.[98] By the early
twentieth century, Indian art objects were making an uncertain transition from
ethnographic specimens to aesthetic fine art, at least for a small number of critics.
Roger Fry's essay on "Oriental Art" is a mediating text in this transition.

In "Oriental Art," Fry steps into the middle of an argument pitting cultural
nationalists against those who asserted British cultural and political dominance.
All of the books he reviews in this essay advocate the value of an indigenous art,
executed in a non-mimetic style. The three books reviewed are E. B. Havell's
Indian Sculpture and Painting (1908), Laurence Binyon's *Painting in the Far East: An
Introduction to the History of Pictorial Art in Asia, Especially China and Japan* (1908),
and Ananda Coomaraswamy's *Medieval Singhalese Painting* (1908). All three of
these authors could be the subjects of books in and of themselves; all were pow-
erful figures in anti-colonial political movements, as well as leading experts in
their chosen artistic fields. E. B. Havell served as the Principal of the Government
School of Art in Calcutta, and Keeper of Calcutta's Government Art Gallery from
1896 to 1906. While there, he campaigned for a return to older Indian styles in
art against the Western illusionistic style in which both British and colonial Indian
art students were traditionally trained. Laurence Binyon was an important art
critic and poet who curated Japanese and Chinese art for the British Museum.
And Ananda Kentish Coomaraswamy was a "Ceylonese" (now Sri Lankan) art
critic, scholar, philosopher and mystic who played a leading role in the cultural
nationalist movement in India. All of these books promote the non-mimetic style
of an Eastern tradition as a critique of Western imperialism and materialism.
Fry's summary of Binyon's philosophy might describe all of the books he reviews:
"[Binyon] points the moral, for Western minds, of Eastern art as an outcome of
Eastern life; of a life more ordered, more harmonious, a life that does not divorce
so completely as ours its ideal from its practice" (234).

Fry's ideas about this colonial art were by no means the most conservative. His
relative tolerance becomes apparent when we look, for example, at a 1910 article
on "Eastern Art and Western Critics" in the *Edinburgh Review*, which excoriates
respected authorities like Havell, Binyon, and Fry for generating a fashionable "ori-
ental boom."[99] This article lays out in the most unambiguous terms the equivalence
between an academic realist style in art—what the critic calls "form"—and the
dominant rationality of Western culture. "It would be easy to show that Western

civilisation, Western knowledge and science and thought and literature, and also Western politics and government and methods of colonising and ruling—in short, the Western influence in all its effects—has been of a distinctly intellectual and rational quality, and has been closely identified with the establishment of order, discipline, coherence—in a word, with the vindication in all things of the principle of form."[100] Colonial rule and illusionism in art are shown to stem from the same source, namely, Western rational powers of mind. "The East," on the other hand, which looms in the essay as a dark and undistinguished mass, is completely excluded from the innate rational faculty of the West. Eastern mysticism is responsible for the "grotesque fancies" of Hindu art, especially for the offensive sculptures of many-limbed gods.[101] The critic attacks a Hindu sculpture with four heads and eight arms as a "weird travesty" that perfectly maps the chaotic political state of India itself; the country is an ungovernable body that does not obey a central will since each limb "issues its own orders."[102] It comes as no surprise when the author reveals himself to have been a colonial administrator in Ceylon who can testify first-hand to the Indian character. His polemic concludes with a passionate defense of Western realism, "begun by the Greeks and continued by the European nations"—and symbolic of the durability of empire itself.[103]

Compared with this conservative tirade, Roger Fry's "Oriental Art" presents a more moderate view. Fry argues that Eastern art must soon enter the canons of High Art, following in the path inaugurated by Ruskin's Gothic, and moving through Byzantine and early Italian ("Primitive") art. Though French art goes unmentioned in the essay, we can infer that Fry's lineage of Western admiration for non-mimetic styles also authorizes the canonization of post-impressionism. Proclaiming the value of non-mimetic art from "India, Java, and Ceylon," Fry declares: "We can no longer hide behind the Elgin marbles and refuse to look; we have no longer any system of aesthetics which can rule out, *a priori,* even the most fantastic and unreal artistic forms. They must be judged in themselves and by their own standards."[104] Here he mockingly invokes the famous classical sculptures, seized from Greece at the beginning of the nineteenth century, that were triumphantly displayed at the British Museum as a symbol of the continuity between classical Greece and Victorian Britain. With their chiseled details and realistic anatomy, the Elgin marbles helped to shift taste away from the eighteenth-century idealizing "Grand Style" toward Victorian realism (figure 5.8). When Fry demands that British spectators progress from the Elgin Marbles to Javanese sculptures, his argument for a new visual style is also a plea for cultural relativism, as well as a proposal for a whole new method of aesthetic judgment.

Perhaps the most surprising moment in this essay comes when Fry dramatizes the meeting of a Western and an Eastern critic, to prove the symmetry of misunderstanding between two cultural and visual traditions. Just as Western spectators have an "underlying prejudice" preventing them from appreciating Eastern

FIGURE 5.8 Fight between a Lapith and a Centaur. Metope from the south side of the Parthenon, Elgin Marbles, 440 BCE. British Museum, London. Image © British Museum / Art Resource, N.Y.

art, so too an Eastern spectator has trouble appreciating Western illusionistic art. Fry proves this symmetry by narrating an account of a trip accompanying "Mr. Okakura, the subtle and ingenious Japanese critic, to various galleries in London."[105] While the Japanese critic is able to appreciate medieval illuminations and Anglo-Saxon drawings, naturalistic Renaissance art leaves him "altogether at a loss. Before a miniature by Simon Benink he stared with blank amazement and refused, with Oriental politeness, to express any opinion. He said that he was unfortunately unable to understand it. This of course did not mean that he failed to recognise the objects represented, but that he failed to see any artistic idea that lay behind that photographic vision."[106] The Japanese critic is still characterized by a stereotypical politeness, but the passage neatly reverses Fry's example of the mystified Westerner before Japanese art, and proposes an equivalence between the Western and Eastern eye. This cultural encounter would seem to be a signal

moment in the history of aesthetic criticism, when the eye of the Other momentarily gains the ability to practice its own rational criticism. Rather than gesture toward a monolithic geography of "the East," Fry singles out a specific critic, and later, specific Eastern painters, for particular praise. Qualified artists of the East—makers of fine arts rather than crafts—are now entitled to the same genius status as the masters of the West.

The bestowal of a name and an individual identity upon certain artists, especially Japanese artists, is an important development in the British critical treatment of Asian art. As we saw in chapter 3, Japanese art came into vogue among aesthetic artists even while it became a signifier of unreality or abstraction itself, culminating in Oscar Wilde's ironic remarks that "the whole of Japan is a pure invention. . . . [T]he Japanese people are . . . simply a mode of style, an exquisite fancy of art."[107] Though British aestheticism worked to detach Japanese style from the hands of its individual makers, it is likely that this earlier aesthetic valuation helped to prepare the way for Fry's praise of Japanese artists in 1910. Fry admires Eastern art for possessing the same valuable qualities he would later ascribe to post-impressionism. He quotes Binyon on the Japanese medieval painter Matabei: "There is a sort of primitive fire in his painting. All his qualities are native to him; there is nothing taken on from outside."[108] The Japanese medieval artist exhibits the good kind of primitivism, a version of human authenticity opposed to the negative Western qualities of mechanical imitation and godless materialism. And the review's final paragraph sounds like it comes straight from a pamphlet on post-impressionism. Once the public has grown accustomed to Eastern art, Fry claims, "then, perhaps, our artists will develope a new conscience, will throw over all the cumbrous machinery of merely curious representation, and will seek to portray only the essential elements of things. In thus purifying pictorial art, in freeing it from all that has not immediately expressive power, Western artists will be merely returning to their own long forgotten tradition."[109] Eastern art can be admitted to the Western canon because it shows a comfortable similarity to Ruskin's Gothic—hinting at the future Fry will write for French post-impressionist art.

Yet in the end, Fry's "Oriental Art" is riddled with the same confusions found in contemporary anthropological texts. In part, these confusions reflect Bloomsbury's complicated relationship to colonialism more generally.[110] Raymond Williams suggests that Bloomsbury intellectuals used their learning to critique the institutions of their own class, but also perpetuated an ideology by which "'civilised individualism'" was "a mere flag to fly over a capitalist, imperialist and militarist social order," ultimately enabling an exquisitely "privileged consumption."[111] Williams's analysis helps to explain Fry's strange fusion of tolerant cultural relativism with clichéd attitudes toward foreign peoples and cultures. Fry seems the perfect example of a Bloomsbury intellectual who is enlightened, progressive, and

willing to entertain the possibilities of "Oriental art" and "Bushman painting"—
while at the same time adhering to the racialized timelines of British anthro-
pology presuming deep inequalities between cultures, races, and geographies.
Fry's contradictory position is particularly striking in "Oriental Art," where he
juxtaposes demands for expanding the canon with the gross racial stereotyping
of Eastern peoples, especially Japanese artists. Although he escorts a Japanese art
critic around London galleries, he also ascribes the realistic techniques of medi-
eval Japanese painters to "natural instinct," versus "our scientific manner"; the
precise images of Eastern art are "less distorted by intellectual preoccupations,"
"more perceptual, less conceptual."[112] In other words, Japanese medieval artists
worked by instinct rather than by science, and experienced vision without the
distortion of any strenuous mental activity. Given the consonance of this assess-
ment with Fry's writings on the Bushmen, it would seem that his judgments
about Eastern artists are also based in an evolutionary psychology that judged
qualities of mind using biological assumptions about race.

Fry's paradoxical colonial attitude manifests itself most distinctly in his review
of Havell's book on Indian art. That Indian art should prove most problematic is
not really surprising, given the longer history of its fraught Victorian reception.
While aesthetes and fashionable ladies collected Indian textiles and shawls, the
visual styles of Indian high arts never achieved the status granted to the arts of
China and, especially, Japan. (Perhaps the lesser Victorian reception of Indian art
was a result of Britain's official empire in India, as opposed to its more informal
trade empires with the other Asian nations.) Fry does sympathetically quote one
of Havell's strident anti-colonial statements, when Havell attacks British colo-
nialists for treating Indian artists like "ignorant children" and praises an Indian
equestrian statue as far superior to all of the "commonplace statues" erected by
British officials in Indian cities (figure 5.9).[113]

Yet Fry goes on to criticize Havell for putting his claims "in a rather need-
lessly provocative manner." He then rehashes certain Western clichés about the
"grotesque" qualities of Hindu art: "We stand aghast before certain many-armed
and many-headed figures."[114] Most egregious of all, Fry concludes, is Havell's
reproduction of paintings by modern Indian artists influenced by a Western real-
ist style. "Nothing indeed could provide a stronger proof of the profound corrup-
tion which contact with European ideas has created in Oriental taste than these
well-intentioned but regrettable drawings."[115] Havell reproduces a drawing by
Abanindronath Tagore to exemplify the art of the "New India," in Havell's words,
"a new expression of former convictions," with techniques uniting "Indian and
European methods" (figure 5.10).[116] The drawing does not even seem particu-
larly illusionistic when compared to a Renaissance or Victorian tradition; yet Fry
responds not so much to the drawing itself as to its ideological signification. The
specter of hybridization between colonized and Western cultures was a "profound

FIGURE 5.9 "A colossal horse, Konarak," Plate 100A, Vincent Arthur Smith, *A History of Fine Art in India and Ceylon* (Oxford, 1911; 3rd ed. reprint, Oxford University Press, 1962). Courtesy of the University of Pennsylvania Library.

corruption," an eminently threatening impurity to the modernist aesthetic sensibility. Indian paintings executed in a Western illusionist style were seen to signify a reality of colonial mingling that both modernist aesthetics and anthropological science sought to suppress.

Ironically enough, at the same time that the formalist doctrine was being established as the norm for high art in Europe, it was also adopted as a tool for cultural nationalists in India and elsewhere to attack Western imperialism. Nationalists sought to free Indian art from the taint of academic influence, condemning illusionism and arguing for a return to non-mimetic, traditional styles. They espoused a *swadeshi* ("self-sufficiency") doctrine of Hindu separation from hybrid colonial culture, echoing British modernist calls for formal and cultural purity. Nationalist movements in India, Ireland, and Japan all invoked similar mythic associations of Western primitivism, reframed as cultural revivalist movements and symbolized by an abstracted, formal visual style.[117] One important spokesman for the pan-Asian formalist revival movement was none other than Roger Fry's "subtle and ingenious Japanese critic," Mr. Okakura. In Fry's essay Okakura does not seem like a real person so much as a rhetorical device invented to cleverly mirror the typical British spectator. But Kakuzo Okakura Tenshin (1862–1913) was indeed a real person, a disciple of the famous American Japan scholar Ernest Fenellosa (inspirer of Ezra Pound's "ideograms" in *The Cantos*.) Both men worked together to

FIGURE 5.10 Abanindronath Tagore, "Kacha and Devâjâni," Plate LXIII, E. B. Havell, *Indian Sculpture and Painting* (London, 1908). Courtesy of the University of Pennsylvania Library.

revive traditional Japanese styles in Japan, as E. B. Havell did in India.[118] Okakura wrote the influential pan-Asianist treatise *The Ideals of the East* (1903), which was hailed by Indian nationalist artists for its mission to unite Asia against Western imperialism. The introduction to the book was written by an Irish nun living in Calcutta, Sister Nivedita, who praises Okakura as a Japanese William Morris.[119] This book employs all the catchphrases of British aesthetic modernism to create an anti-imperialist argument for "Asiatic" formalism: "Imitation, whether of nature, of the old masters, ... is suicidal to the realisation of individuality"; but a formalist "idealism" in art is expressive of the "race-pride" of both India and China, "the two great poles of Asiatic civilisation."[120] This network of influences amongst British and non-British critics again demonstrates the versatility of the twinned modernist discourses of anthropology and visual style—discourses that were flexible enough to be adopted by the very nations they were used to dominate.

Many Primitives

This discussion has served to complicate our notions of British modernist primitivism by revealing its roots in Victorian intellectual traditions of science and anthropology. In fact, the primitivism advocated by Roger Fry and Clive Bell differed greatly from that of the French painting they lionized. Some British thinkers did espouse Dionysian freedoms against the restrictions of Victorian culture, embracing, like Oscar Wilde, the kind of Bacchic energy theorized in Nietzsche's *Birth of Tragedy*. And some late-Victorian critics contributed to the project of re-primitivizing ancient Greek and Roman cultures, such as Walter Pater, and even Frazer in *The Golden Bough*. But the coldly seen primitives of Fry and Bell occupy a very different tradition than the paintings of Matisse or Van Gogh. Their London seems worlds away from the modernist Paris that was to host *négrophilie* and Josephine Baker. Fry does not demand that British spectators throw off the shackles of civilization to embrace a primitive existence scripted by Nietzsche. His theory does not call for a British Gauguin to sail to Tahiti and find a native wife, nor to indulge in a sexualized "gone-native" lifestyle. Defending Gauguin, Matisse, and the other post-impressionsts in November 1910, Fry writes: "We must press on to the discovery of that difficult science, the science of expressive design...We must begin at the beginning, and learn once more the A.B.C. of abstract form. And it is just this that these French artists have set about, with that clear, logical intensity of purpose, that absence of all compromise, of all regard for side issues, which has so nobly distinguished the French genius."[121] This is French art set into the cold frame of a mirror or cinematograph. It is disinterested, mathematical, and logical, a "difficult science" produced in paint. Even while Fry repeatedly attacks impressionism in 1910 for its mechanical reproductions of nature, his support for post-impressionism is argued with the clinical detachment of a scientist, laying out the sound reasons why modern art needs a more psychological, internalized way of seeing. Fry's mode of argument seems a direct inheritance from Victorian science. Empiricism was both Britain's national method and its defining racial trait, according to both art critics and colonial administrators.

Analyzing the modernist attraction to African art, Simon Gikandi suggests that even while modernist primitivism promised an unalienated, authentic, and epiphanic experience for the Western spectator, modernism itself was quickly institutionalized in museums and at universities because it "valorized older, familiar, racial economies." Gikandi doesn't mention Victorian anthropology, but his discussion locates at the heart of modernism a founding contradiction in the movement's desire for unmediated experience set against its "almost ritualized management of difference." In particular, as Gikandi suggests near his essay's conclusion, Roger Fry's writings on African art "endowed Africans with artistic genius

but denied them the capacity to make critical judgments"—in this way cementing what was ultimately an insuperable barrier between African peoples and the modernism they ostensibly embodied.[122] In other words, modernist primitivism does not refer merely to a Western yearning for otherness, a desire to encounter or even to become the other; it also encodes a whole edifice of self-reflective judgments and racial assumptions that ironically aided in the rapid transformation of a countercultural movement into the highest canons of twentieth-century art. This chapter has gone toward exploring some of the particular mechanisms of this process of modernist canonization, with its roots in a much earlier cultural and institutional history.

If aesthetic formalism has traditionally been seen as the final flowering of a Romantic anti-mimetic tradition, traceable back to Ruskin's Gothic, this chapter has shown how the modernist theory of Fry and Bell also partook of an older, Enlightenment impulse, working to classify, separate, and distill. Their desire for "pure form" was echoed in a demand for pure categories, creating holistic structures of both artworks and cultures as rigorously ordered and separable entities. This Enlightenment inheritance also explains why both Fry and Bell were hostile to Freudianism. Where Freud postulated that the Western mind was compelled by a primitive id, and that artistic creation was motivated by sexual desire and sublimation, Fry and Bell strenuously denied this theory, arguing instead for a Kantian divide between aesthetics and bodily desire. In *Art,* Bell rejects the term "beauty" in aesthetic theory because "with the man-in-the-street 'beautiful' is more often than not synonymous with 'desirable'; . . . and I am tempted to believe that in the minds of many the sexual flavour of the word is stronger than the aesthetic."[123] Fry devotes an entire essay to "The Artist and Psycho-Analysis" (1924), arguing that an art motivated by "the phantasy-making power of the libido" is "impure" when compared to a higher art "which is pre-eminently *objective* and *dis-interested,*" and based on "purely formal relations."[124] Though Fry claims that his key terms "pure" and "impure" are used "in a strictly esthetic sense without any reference to sexual morality," I think that we need to see sexual purity as another element of this modernist theory, and not simply on a philosophical, Kantian level.[125] For if Fry were to accept that a Freudian libido occupies a part of every modernist mind, then his rationally scripted ideas of the primitive would no longer remain contained within the formal bounds (aesthetic, cultural, and historical) in which he places them.

The anthropological modernism of Fry and Bell reappears later in the twentieth century in the formalist theories of Clement Greenberg. In fact, with his austerity and obsession with purity, Greenberg's formulations owe as much to British critics as they do to French paintings, if not more so. In his iconic essay "Modernist Painting," Greenberg writes,

I identify Modernism with the intensification . . . of [a] self-critical ten-
dency that began with the philosopher Kant . . . The essence of Modern-
ism lies, as I see it, in the use of the characteristic methods of a discipline
to criticize the discipline itself—not in order to subvert it, but to entrench
it more firmly in its area of competence. Kant used logic to establish the
limits of logic, and while he withdrew much from its old jurisdiction,
logic was left in all the more secure possession of what remained to it.
The self-criticism of Modernism grows out of but is not the same thing
as the criticism of the Enlightenment. The Enlightenment criticized from
the outside, the way criticism in its more accepted sense does; Modern-
ism criticizes from the inside, through the procedures themselves of that
which is being criticized.[126]

As it is for Fry, so too for Greenberg formalism is not part of a Romantic or
Dionysian tradition, but an inheritance of Enlightenment science. The defining
trait of modernism is its "self-criticism," rehearsing the Victorian trope that char-
acterizes Western civilization by its critical, rational faculty. Greenberg makes
the story of modernist art one of professionalization, seeming to describe not
so much the development of a painting style as that of an academic practice.
Formalist art has "methods" that "entrench" "the discipline" in "its area of compe-
tence." When he figures canvases as professionals, Greenberg echoes a move we
have seen in Victorian anthropology, personifying an artwork with the qualities
of a culture at large—in this case, making a (Western) painting, like Balfour's
vases, capable of "self-criticism," "from the inside." This claim seems difficult to
sustain since paintings always need critics to interpret their visual moves, and not
everyone would agree that Greenberg's choices are indeed "self-critical." But his
writing gives the paintings their own autonomy, making it seem as though the art
theory emanates purely, without any external guidance, from the nature of the
objects themselves.

 In numerous places, Greenberg's "Modernist Painting" shows a striking con-
tinuity with the anthropological aesthetics we have been examining. He praises
"scientific method" as an analogue for modernist painting, since both activities
demand that problems be solved in the language of their disciplines; thus "a prob-
lem in physiology is solved in terms of physiology," just as an aesthetic problem
is ideally solved within the medium in which the artwork is executed.[127] For
Greenberg, as for Fry, both science and art propose an avenue to pure art forms
and pure categories of thought. Greenberg's essay even invokes the long-lived
"Paleolithic painter," who appears as proof that "Modernist art develops out of
the past without gap or break," since "the making of pictures has been governed,
since pictures first began to be made, by all the norms I have mentioned."[128]
Forty years after Fry writes on post-impressionism, the cave-dweller still lends a

stamp of scientific authority to modernist aesthetic theory. With the appearance of this figure, we can see in Greenberg's essay the faint yet still discernible presence of the culture-pyramid constructed by Victorian anthropology, which was so important to the theorization of a universal theory of art. And, flickering in the guise of the "Paleolithic painter," we might also see the ghostly presence of the colonial Other whose primitivism guaranteed the rational correctness of the Western cultural project.

In writing British criticism back into the story of visual formalist modernism, I have proposed that art writing was not merely reflective but profoundly constitutive of a dominant modernist aesthetic. The canonicity of French post-impressionists and American abstract expressionists was constructed by the writings of critics like Roger Fry, Clive Bell, and Clement Greenberg, as well as by a series of Victorian anthropological art histories. In this alternative narrative, British critics are key players in the shaping of Anglo-American aesthetics—not only for their writings, but also for the whole host of activities they engaged in as connoisseurs and taste-makers in the early twentieth century. It has gone largely unremarked that the famous turn-of-the-century American art collections of wealthy patrons like J. P. Morgan and Isabella Stewart Gardner were assembled by British connoisseurs like Roger Fry and Bernard Berenson. Fry served as the director of the Metropolitan Museum of Art in New York until 1906, when he was replaced by the British connoisseur Parsons Clarke, former head of London's South Kensington museum. And the deputy director of the Isabella Stewart Gardner Museum in Boston was Matthew Prichard, an Oxford-educated Englishman who "was instrumental in the business of evaluation, buying and shipping" art for the museum, and "was extremely well connected with a wide range of artists, dealers, and museum personnel in America and Europe."[129] The role played by British men as arbiters of taste for American collections points to a more hidden history of aesthetic taste-making at the turn of the century, one based upon an interrelated web of critical practices, both literary and extra-literary—gallery reviewing, book reviewing, theorizing general principles of aesthetics, curating for museums, collection building, anointing new artists, and staging exhibitions.

If Victorian British cultural (and imperial) power underwrote the formation of modernist art collections, it also planted the seeds for an expanding canon of modernist art. My analysis of the British encounter with art objects from India, Africa, and other non-Western cultures might be aligned with recent work reorienting the geographical focus of modernism, in both literary and art-historical studies.[130] Where scholars once spoke of an "international modernism" to refer to border-crossings between Europe, Britain, and America, new work now looks to a global modernism, widening the net of artists and traditions encompassed by the modernist phenomenon. This scholarship has also worked to broaden the temporal dimensions of modernism, seeing postcolonial writers and artists

struggling to come to terms with an aesthetic tradition that both excluded and inspired them. Though the formalism of Fry and Bell seems to be one of the more antiquated strands of modernist theory, from another perspective these British critics can be seen to herald the beginning of a new global canon of art. That canon is no longer centered upon the universalist apprehension of a shining Western aesthetic truth, however, but instead highlights the diversity of an aesthetic tradition across both geographic and temporal borders.

Conclusion
Art Writing after the Victorians

If art writing was a luminous and influential body of literature in the nineteenth century, that prominence receded in the later twentieth century. Contemporary writing about visual arts, whether in the academy or in the press, is a professionalized kind of criticism defined in opposition to qualities we would deem "literary."[1] Few courses on post-war British or American literature would include art essays in their literary canon. Professional art writing takes a more objective tone, avoids poetic effusions, and speaks within the specialized world of its educated readers. The relative importance of art writing in culture has also changed directly in proportion to the role played by the visual arts in everyday life. Although the art world today in Britain and America is infinitely more accessible to viewers than it was in the nineteenth century, the visual arts have lost their central position as a topic necessary to assure middle-class respectability. While Victorian spectators needed a knowledge of art to cement their class status, the visual arts in the twentieth century are coded as the canons of a cultural elite, existing beyond the sphere of daily life. Today art writing works less to educate ignorant eyes than to commune with a select few already possessing a knowledge of art. This development follows out of shifts in the art world we have observed in this book, as collectors and connoisseurs—especially wealthy turn-of-the century American collectors and British connoisseurs—helped to create visual art as the ultimate commodity, signifying above all its own exquisite essence. Any close look at contemporary art writing must acknowledge its intimate link to the art market and commodity culture, perhaps more so than other kinds of academic or professional criticisms.

The trajectory of this book will suggest one way that more avant-garde or oppositional Victorian art writing participated, ironically enough, in the diminishment of its own literary role. We have seen how many art writers elevated visual form above other kinds of artistic judgment as the crowning height of aesthetic sensibility. Their efforts ensured that "the image" became the model, in modernism, for formalism in all of the arts. Although Pater and Greenberg named music the most perfectly formalist art, in fact twentieth-century artists and writers showed comparatively little interest in the innovations of modern music. Instead, modernist writers avidly followed experiments in visual arts, and used metaphors from the visual arts to frame an aesthetic of literary form. The

best literary art was now figured as "Imagism" for Ezra Pound and Amy Lowell, as sculpture for Gaudier-Brzeska, as a "Golden Bowl" for Henry James, a "well-wrought urn" for Cleanth Brooks. As T. E. Hulme concluded, "Each *word* must be an image *seen,* not a counter. That dreadful feeling of cheapness when we contemplate the profusion of words in modern prose. The true ideal—the little statue in Paris."[2]

Even in modernist fictions that depended upon a profusion of words, visual form and "the image" came to serve as important shaping tools. In *The Modes of Modern Writing,* David Lodge influentially describes how modernist fiction mapped the workings of consciousness by eschewing traditional narrative structures of opening and closure, plunging us instead into bewildering "streams of experience." Turning to alternative means of aesthetic ordering, novelists adopted methods of allusion, repetition, and variation using an array of myths, symbols, images—motifs that, I would suggest, often had a visual quality, giving the elements of novelistic form a new and visible concreteness.[3] A canonical example is Virginia Woolf's *To the Lighthouse,* which makes Lily Briscoe's abstract painting into a symbol of a new kind of modernist literary style. "Beautiful and bright it [the painting] should be on the surface, feathery and evanescent, one colour melting into another like the colours on a butterfly's wing; but beneath the fabric must be clamped together with bolts of iron. It was to be a thing you could ruffle with your breath; and a thing you could not dislodge with a team of horses."[4]

As is commonly pointed out, Lily's painting symbolizes in miniature Woolf's own novel, whose three-part structure, mirroring the blasts of the lighthouse beam, presents a rigorously ordered spatial form underlying the novel's own "evanescent" narration. For Woolf, as for other modernist novelists, the image served as a new shaping force in fiction, lending structure in the midst of narrative flux.[5] If modernity was characterized for many twentieth-century authors by its tendency to chaos and crisis, in both internal states and in external events, visual forms and images appeared as authenticating shapes that might bind together an artwork or, more idealistically, unite an atomized and fragmented community. Walter Pater's visually inflected theory of recombinant forms might be seen to reappear in the modernist aesthetics of collage, or, as one critic has resonantly deemed in another context, in a "mosaic modernism."[6]

As modernism formulated a literary aesthetic around the visual arts, both art and literature in their high-art manifestations lost qualities that Victorians had deemed literary, such as straight narrative, explanatory text, didactic content, and lengthy realism. Pictures in museums shed their literary apparatus, the informative titles, accompanying snippets of poetry, and catalogue extracts.[7] In the most extreme avant-garde experiments of the twentieth century, language itself became an image—in concrete poetry or in surrealist collages, where letters figured as visual forms, part of the visible materiality of the artwork. Accompanying

the rise of certain modernist experiments, then, a strain of art writing in effect scripted language out of the art viewing experience. This is not to say that criticism stopped defining meaning in the visual arts. Quite the opposite. Yet culminating in the efforts of Roger Fry and Clive Bell, art writing stopped working to foreground its own literary artfulness, and no longer tried to compete with visual art for expression of the most transcendent authenticity. The art critic continued to gain in cultural power during the twentieth century, such that Clement Greenberg became famous in the 1950s for his ability to make or break artists with a stroke of his pen. Greenberg was one of a number of critics whose writings worked to construct the value of abstract expressionist art. Housed in temples of art, lacking any illusionist or figurative content, these paintings fulfilled a desire for a purely sensuous, spiritual experience of spectatorship through form. Some abstract works invited the religious language of critics with their titles, as in Barnett Newman's painting of 1951–2, in which the rich burgundy ground, overlaid with three red stripes, is titled *Adam* (figure 6.1). Even while the conversion narratives surrounding abstract expressionist art were generated by worshipful critics, the writing coded itself as unimportant, mere words in the face of a greater visual sublime. As Harold Rosenberg declared in 1952, abstract painting was "anything that has to do with action—psychology, philosophy, history, mythology, hero worship. Anything but art criticism."[8] Yet his words, along with those of other art critics, were crucial to the formation of the spectating experience.

One striking conclusion, then, is that abstract expressionism was the logical result of Victorian developments—a strange claim, given the shift from England to America and the remarkable stylistic differences between the paintings of the two eras. Yet the structures of discrimination established by the Victorians proved definitive for Americans—as much a pervasive social influence as that of the French avant-gardes. Though much has been made of the explosive Armory Show in 1913, when American audiences responded with the same derision to experimental French art that London did in 1910, the fact is that many major American art collections were constructed by British critics and connoisseurs, not by French painters. The Victorian British legacy of art writing, connoisseurship, and criticism still ruled the waves at the time when the capital of art innovation relocated from Paris to New York in the 1930s.[9]

When American critics anointed abstract expressionism as the summit of aesthetic modernism and the quintessence of the dogma of pure medium, their arguments were extensions of Victorian conclusions. The visual forms embraced by Victorian art professionals, socialists, and aesthetes were now harnessed by supremely authoritative art critics to usher spectators through the mystifying experience of abstract art—an experience that, as many art historians have noted, was scripted by critics to combine scientific objectivity with spiritual transcendence.

FIGURE 6.1 Barnett Newman, *Adam*. Oil on canvas, 1951–52. Tate Gallery, London. © 2009 The Barnett Newman Foundation, New York / Artists Rights Society (ARS), New York. Photo credit: Tate, London / Art Resource, N.Y.

If John Ruskin was struggling in 1843 to reconcile a fixed vision of the external object world with the myriad sights of subjectivity, those two strains manifested themselves a century later in the twin discourses of abstract expressionism, as voiced by Clement Greenberg and Harold Rosenberg. Greenberg argued for the superiority of abstraction using the cold eye of science, analogizing the flatness of abstract painting to the austere truth-making of the scientific method: "Modernist art belongs to the same historical and cultural tendency as modern science."[10] Rosenberg, meanwhile, incarnated the New York artists as the holy ministers

of the human soul: "The new movement is, with the majority of the painters, essentially a religious movement."[11] The major role played by art criticism in the cultural dominance of abstract expressionism has been described by numerous art historians.[12] In *Picture Theory,* W. J. T. Mitchell analyzes the multiple narratives deployed by art critics and professionals to construct the determinist history of abstract art. The narrative strands include a spiritual "quest-romance," "a modern epic of scientific discovery," and a "revolutionary saga" documenting the triumph of the avant-garde.[13] As Mitchell concludes, "There is no use thinking we can ignore this chatter in favor of 'the paintings themselves,' for the meaning of the paintings is precisely a function of their use in the elaborate language game that is abstract art."[14] Abstract art is perhaps the most obvious, most extreme case of a visual art whose value is constructed by the words or master-narratives of critics. Yet as this book has shown, the influential power of art writing was itself a legacy of the art and literary worlds of Victorian Britain.

While academics are now skeptical of the absolutist claims of mid-century American painters and critics, those claims have not really disappeared from the gallery world. The commodification of art fully accords with the versions of the subject told by abstract expressionism, as the bold masculine hero expresses his profound consciousness in paint. Developments in the academy, meanwhile, have made this Romantic version of the subject increasingly untenable. The 1980s saw an assault on the modes of certainty and universalism underlying the art writing of both Victorians and abstract expressionists. Religion, self, nation, empire, and the scientific truths of art: all have been thrown into question by a profound embrace of relativism, out of which this book is written.[15] The attacks on modernist formalism, aesthetic ideology, and fixed art values were a subset of this broader academic shift. Following in the wake of these developments, my study has echoed a postmodern disbelief in the possibility of absolute aesthetic values, combined with the renewed interest in history attached to the rise of cultural studies. Not coincidentally, these conditions have also led to the academic reassessment of Victorian British art more generally.

It would be reductive to claim that the humanities disciplines now uniformly espouse an idea of relativism about human values, aesthetic or otherwise. An opposing movement is evident, for example, in humanities scholars' consistent attraction to the methods and paradigms of the scientific disciplines. An emerging branch of literary scholarship seeks to make universalist claims about art by adopting scientific models, in fields ranging from psychology to evolutionary biology to cognitive science. These attempts are strikingly reminiscent of the Victorian aesthetic ideologies I have examined here, in which art writers explained shifts in wallpaper patterns using Darwinian models and proved the accuracy of Turner's artworks via the truths of botany or geology. If modernity has been characterized by a series of destabilizing and relativist intellectual movements,

a persistent counter-movement can be found in the various sciences of art, all-encompassing in their reach and utopian in their confident claims. The new pseudosciences of literature react against the uncertainties of value entailed by "the more bleakly relativistic and antihumanist strands of poststructuralism," as one recent essay puts it.[16] Yet to assert the powerful relativism of aesthetic values is not to empty them of all meaningful content. The vibrant archive of texts and images assembled in this book is intended to convey a liveliness of presence rather than a nihilism of absence. Contingent and socially dependent histories of value still speak to the deeply held beliefs of a culture, old or new. The contemporary debates raging around these issues suggest that the Victorian moment is by no means over. Indeed, the eminently Victorian methodology of interpreting the past to speak to the present seems more appropriate than ever.

NOTES

Introduction

1. *The Works of John Ruskin,* Library Edition, ed. E. T. Cook and Alexander Wedderburn, 39 vols. (London: George Allen, 1903–12), 5:333. All quotations from Ruskin's works indicate this edition, and will be noted parenthetically by volume followed by page number.

2. Studies of aesthetics usually adhere to a small canon of German philosophers ranging from Kant to Adorno. The dominance of the German philosophical tradition has led to a devaluation of other national contributions to aesthetics; Terry Eagleton explains that his *Ideology of the Aesthetic* (Oxford: Blackwell, 1990) omits British authors because "much in the Anglophone tradition is in fact derivative of German philosophy," and he prefers to go straight to "the horse's mouth" (11). The absence of Victorian British authors from the canon of aesthetic writings is most evident in anthologies of aesthetics, including: Albert Hofstadter and Richard Kuhns, eds., *Philosophies of Art and Beauty* (Chicago: University of Chicago Press, [1964], 1976); David Cooper, ed., *Aesthetics: The Classic Readings* (Oxford: Blackwell, 1996); and Alex Neill and Aaron Ridley, eds., *The Philosophy of Art: Readings Ancient and Modern* (New York: McGraw Hill, 1995). Exceptions include Charles Harrison and Paul Wood, eds., *Art in Theory, 1815–1900: An Anthology of Changing Ideas* (Oxford: Blackwell, 1998)—which devotes itself explicitly to nineteenth-century European writings—and Elizabeth Holt's three volume collection, *The Triumph of Art for the Public* (Garden City, N.Y.: Anchor Press, 1979).

3. Recent titles include George Levine, ed., *Aesthetics and Ideology* (New Brunswick, N.J.: Rutgers University Press, 1994); Emory Elliot, Louis Freitas Caton, and Jeffrey Rhyne, eds., *Aesthetics in a Multicultural Age* (Oxford: Oxford University Press, 2002); Pamela R. Matthews and David McWhirter, eds., *Aesthetic Subjects* (Minneapolis: University of Minnesota Press, 2003); and James Soderholm, ed., *Beauty and the Critic: Aesthetics in an Age of Cultural Studies* (Tuscaloosa: University of Alabama Press, 1997). Art historians address the topic in the collection edited by Michael Ann Holly and Keith Moxey, *Art History, Aesthetics, Visual Studies* (Williamstown, Mass.: Sterling and Francine Clark Art Institute, 2002).

4. Pamela R. Matthews and David McWhirter, "Introduction: Exile's Return? Aesthetics Now," in Matthews and McWhirter, *Aesthetic Subjects*, xviii.

5. In *Art for Art's Sake and Literary Life* (Lincoln: University of Nebraska Press, 1996), Gene H. Bell-Villada opens his study with Kant, writing that the *Critique of Judgment* "eventually came to be viewed as *the* sourcebook for Art for Art's Sake" (20). Yet it is worth noting the major differences between Enlightenment philosophy and modernist formalism. Kant's analysis assumes that the beautiful and the good will overlap, since humans are inherently moral creatures embedded in a harmonious universe;

hence independent human judgments about beauty will naturally agree. Kant's ide-
alistic theory lacks the nihilism and atomism underpinning the "art for art's sake"
movements of the later nineteenth century, which were predicated upon the notion
of a radically dislocated and alienated individual.

6. The most influential art writer promoting abstract expressionism was Clement
 Greenberg, a figure who appears throughout this book. Greenberg praises abstract
 painting for its emphasis on the flatness of the canvas, which achieves an ideal purity:
 "Purity in art consists in the acceptance, willing acceptance, of the limitations of the
 medium of the specific art . . . The purely plastic or abstract qualities of the work of
 art are the only ones that count." "Towards a Newer Laocoön," *Partisan Review* 7, no. 4
 (July–August 1940): 305.

7. A scathing account of this familiar art historical narrative is given by Janet Wolff in
 the introduction to *AngloModern: Painting and Modernity in Britain and the United States*
 (Ithaca, N.Y.: Cornell University Press, 2003). Wolff suggests that in the 1990s, "it
 seemed that the story of art had been hurriedly rewritten" as many art museums
 and galleries hosted shows displaying realist and figurative art—"the stuff modernism
 overthrew," in the words of art critic Robert Hughes (1–2). These events signal for
 Wolff a challenge to the "story produced and reinforced by critics, academics, cura-
 tors, and museum directors" that traces a narrow lineage from modernist French
 experimental art to the New York School at mid-century. A result of this dominant
 narrative has been "the sidelining of other artists, movements, and styles" (3). Wolff
 seeks to bring more figurative English and American paintings back into the story of
 modernism. She does not mention Victorian art, but her account opens a space for a
 new consideration of works previously dismissed as "sentimental" or "kitsch." Other
 revisionist accounts of art-historical modernism with a focus on British art include
 Charles Harrison, *English Art and Modernism, 1900–1939*, 2nd ed. (New Haven,
 Conn.: Yale University Press, 1994); David Peters Corbett, *The Modernity of English
 Art, 1914–30* (Manchester: Manchester University Press, 1997); David Peters Corbett
 and Lara Perry, eds., *English Art, 1860–1914: Modern Artists and Identity* (Manchester:
 Manchester University Press, 2000); and Lisa Tickner, *Modern Life and Modern Subjects:
 British Art in the Early Twentieth Century* (New Haven, Conn.: Yale University Press,
 2000).

8. Perhaps the most famous modernist attack on Victorianism is Lytton Strachey's *Emi-
 nent Victorians* (New York: Penguin, [1918], 1986). Narrating the biographies of four
 figures beloved of Victorians—Cardinal Manning, Florence Nightingale, Thomas
 Arnold, and General Gordon—Strachey deflates the values of religion, philanthropy,
 education, and statesmanship that were pillars of the Victorian moral world. Virginia
 Woolf was also influential in shaping modernist stereotypes about the Victorians;
 many of her writings create, at least on a superficial level, a vision of Victorians as
 naïve, optimistic, and unfailingly enthusiastic. A more nuanced reading of Woolf's
 works, however, would see her engaging with Victorianism as a profoundly symbolic
 terrain, in books ranging from *To the Lighthouse* to *A Room of One's Own*.

9. *BLAST: Review of the Great English Vortex* 1 (London: J. Lane, 1914), 9.

10. In a typical statement, art historian E. D. H. Johnson expresses frustration with what
 he sees as the bankrupt sentimentality tarnishing nineteenth-century British genre
 paintings. These artists, he suggests, "too often falsified truth of observation by making
 it serve a moral message designed to widen the appeal and heighten the significance

of [their] subjects." *Paintings of the British Social Scene from Hogarth to Sickert* (London: Weidenfeld & Nicolson, 1988), 129. For a more complex reading of sentimentality in Victorian paintings, however, see Judith Stoddart, "Pleasures Incarnate: Aesthetic Sentiment in the Nineteenth-Century Work of Art," in Matthews and McWhirter, *Aesthetic Subjects,* 70−98. The apparent complicity between Victorian bourgeois values and artworks was also exemplified for later art critics by the crisp legibility of its paintings, a supersharp realism that became fraught with twentieth-century political overtones. Thus Clement Greenberg attacked visual realism: "[I]n a period in which illusions of every kind are being destroyed the illusionist methods of art must also be renounced . . . Let painting confine itself to the disposition pure and simple of color and line, and not intrigue us by associations with things we can experience more authentically elsewhere." "Abstract Art," *The Nation* 152, no. 16 (April 15, 1944): 451. In the twentieth century, visual realism became linked to the totalitarian politics of the Soviet Union, leading to some of the more extreme attacks on the "illusions" associated with this style.

11. "Letter 79: Life Guards of New Life," *Fors Clavigera* 7 (July 1877), in *Works of John Ruskin,* 29:160.

12. Henry Ladd, *The Victorian Morality of Art: An Analysis of Ruskin's Aesthetic* (New York: Long & Smith, 1932).

13. Numerous revisionist art-historical works have recently been published to mark the centennials of the deaths of late-Victorian artists: Edward Burne-Jones, Frederic Leighton, Dante Gabriel Rossetti, and James McNeill Whistler have all been the subjects of recent exhibition catalogues. Andrew Wilton analyzes the influence of late-Victorian painters on the international European Symbolist movement in *The Age of Rossetti, Burne-Jones, and Watts: Symbolism in Britain, 1860–1910* (London: Flammarion, with the Tate Gallery, 1997). Elizabeth Prettejohn argues for the modernity of British aestheticism in *Art for Art's Sake: Aestheticism in Victorian Painting* (New Haven, Conn.: Yale University Press, 2007).

14. David Peters Corbett, *The World in Paint: Modern Art and Visuality in England, 1848–1914* (University Park: Pennsylvania State University Press, 2004), 10.

15. In *Dante Gabriel Rossetti and the Game that Must Be Lost* (New Haven, Conn.: Yale University Press, 2000), Jerome McGann argues that Rossetti's poetry anticipates Imagist and even postmodern styles. Jessica Feldman, in *Victorian Modernism: Pragmatism and the Varieties of Aesthetic Experience* (Cambridge: Cambridge University Press, 2002), links the two centuries by analyzing Ruskin, D. G. Rossetti, Augusta Evans, and William James. For Feldman, the connecting motif across these writers is a "sentimental sublimity" (41) or "domestic sublime" (73–78)—a very different emphasis than the one I make here, on various modes of formalism and detachment in British cultural history.

16. The foundational distinctions between "Victorian" and "modernist" are palpable in the *OED* definitions of both terms. While Victorian connotes "prudish, strict; old-fashioned, out-dated," "modernist" draws upon all the positive senses of "modern": in art, "characterized by a departure from or a repudiation of accepted or traditional styles and values"; in a person, "up to date in behaviour, outlook, opinions, etc.; embracing innovation and new ideas; liberal-minded."

17. Amanda Anderson, *The Powers of Distance: Cosmopolitanism and the Cultivation of Detachment* (Princeton, N.J.: Princeton University Press, 2001).

18. Matthew Arnold, "The Function of Criticism at the Present Time," in *Matthew Arnold*, ed. Miriam Allott and Robert H. Super (New York: Oxford University Press, 1986), 325.

19. In *Cultivating Victorians: Liberal Culture and the Aesthetic* (Philadelphia: University of Pennsylvania Press, 2003), David Wayne Thomas attempts to recuperate the libratory potential of both Victorian liberalism and modern aesthetics. Linda Dowling argues that a liberal strain recurs in British philosophies of art, beginning with Shaftesbury and extending through Ruskin, Pater, and Wilde. See Dowling, *The Vulgarity of Art: Victorians and Aesthetic Democracy* (Charlottesville: University of Virginia Press, 1996).

20. Thomas William Heyck, *The Transformation of Intellectual Life in Victorian England* (New York: St. Martin's Press, 1982).

21. "The Two Cultures" is the title of C. P. Snow's famous lecture, first published in 1959, diagnosing an increasing divide between the intellectual worlds of the sciences and the humanities. C. P. Snow, *The Two Cultures; and A Second Look* (Cambridge: Cambridge University Press, 1965). Snow argues that the twentieth-century divide has its roots in an anti-technology stance of nineteenth-century intellectuals like Ruskin and Morris, who took Luddite positions as a reaction against the ugly effects of the industrial revolution. Snow's conclusions parallel those of M. H. Abrams in *The Mirror and the Lamp: Romantic Theory and the Critical Tradition* (Oxford: Oxford University Press, 1953). Abrams argues that Romantic aesthetic theories, which favored an organicist, genius artist over a mechanistic, imitative artist, initiated the divide between the arts and sciences that became entrenched in the nineteenth century. Yet, as I show throughout this book, different aesthetic theories across the nineteenth century embraced the kind of objectivity associated with a scientific eye. My analysis suggests that the art-science divide was less the work of aesthetic theorists than the work of scientists, who wanted to distance themselves from increasingly powerful theories of subjectivity and relativism arising in the realms of art and philosophy.

22. Walter Pater, *The Renaissance: Studies in Art and Poetry; The 1893 Text,* ed. Donald L. Hill (Berkeley and Los Angeles: University of California Press, 1980), 186.

23. Terry Eagleton provides an important Marxist critique of German aesthetic theorists from the Enlightenment to the twentieth century in *The Ideology of the Aesthetic* (Oxford: Blackwell, 1990). Other Marxist critiques of aesthetics include Pierre Bourdieu, *Distinction: A Social Critique of the Judgment of Taste,* trans. Richard Nice (Cambridge, Mass.: Harvard University Press, 1984); Martha Woodmansee, *The Author, Art and the Market: Rereading the History of Aesthetics* (New York: Columbia University Press, 1994); Tony Bennett, "Really Useless 'Knowledge': A Political Critique of Aesthetics," *Literature and History* 13, no. 1 (Spring 1987): 38–57; and Ian Hunter, "Aesthetics and Cultural Studies," in *Cultural Studies,* ed. Lawrence Grossberg, Cary Nelson, and Paula Treichler (New York: Routledge, 1992), 347–72. A defense of aesthetic ideology appears in Peter Bürger, "The Problem of Aesthetic Value," in *Literary Theory Today,* ed. Peter Collier and Helga Geyer-Ryan (Ithaca, N.Y.: Cornell University Press, 1990), 23–25.

24. Works in the canon of formalist aesthetic philosophy include: Immanuel Kant, *Critique of Judgment,* trans. Werner S. Pluhar (Indianapolis: Hackett Publishing, [1790], 1987); Clive Bell, *Art* (London: John Murray, 1914); Roger Fry, *Vision and Design* (New York: New American Library, [1920], 1974); and Heinrich Wölfflin, *Principles of Art History,* trans. M. D. Hottinger (New York: Dover, 1932). My discussion of formalism

deliberately refers to both judgments and styles, reflecting the way in which the formalist aesthetic pertains to both art production (in art that highlights form) and art consumption (in critics promoting formalist values). This overlap has also been noted by Geoffrey Galt Harpham, who observes that the aesthetic "ambivalently refers both to particular kinds of objects and to the attitude appropriate to judging them" (124). See Harpham, "Aesthetics and the Fundamentals of Modernity," in *Aesthetics and Ideology*, ed. George Levine (New Brunswick, N.J.: Rutgers University Press, 1994), 124–49. Martin Jay also analyzes the confusion in "Drifting into Dangerous Waters: The Separation of Aesthetic Experience from the Work of Art," in Matthews and McWhirter, *Aesthetic Subjects*, 3–27.

25. Roger Fry's *Cézanne: A Study of His Development* (New York: Macmillan, 1927) made an important contribution to this art-historical narrative. See also Beverly H. Twitchell, *Cézanne and Formalism in Bloomsbury* (Ann Arbor, Mich.: UMI Press, 1987).

26. Pierre Bourdieu, *The Rules of Art: Genesis and Structure of the Literary Field*, trans. Susan Emanuel (Stanford, Ca.: Stanford University Press, 1995), 137.

27. See, for instance, Christopher Green, *Art in France, 1900–1940* (New Haven, Conn.: Yale University Press, 2000).

28. The phrase first came to link art and radical politics after the European revolutions of 1848.

29. The bibliography of scholarship on the Victorian realist novel is too long to enumerate here. A starting point is George Levine, *The Realistic Imagination: English Fiction from Frankenstein to Lady Chatterly* (Chicago: University of Chicago Press, 1981).

30. Richard Rorty, "Tale of Two Disciplines," in *Beauty and the Critic: Aesthetics in an Age of Cultural Studies*, ed. James Soderholm (Tuscaloosa: University of Alabama Press, 1997), 213.

31. Martin Jay, "Drifting into Dangerous Waters," 13.

32. John Ruskin, *Modern Painters*, vol. 1 (1843), in *Works of John Ruskin*, 3:246.

33. Art writing is a subset of the Victorian fascination with word-image interactions more generally. Much contemporary criticism has focused on the interlinked painting and poetry of the Pre-Raphaelites, especially that of Dante Gabriel Rossetti; an important example is J. B. Bullen, *The Pre-Raphaelite Body: Fear and Desire in Painting, Poetry, and Criticism* (Oxford: Clarendon Press, 1998). Also relevant are studies of Victorian illustrated novels, such as Julia Thomas, *Pictorial Victorians: The Inscription of Values in Word and Image* (Athens: Ohio University Press, 2004) and the essay collection edited by Richard Maxwell, *The Victorian Illustrated Book* (Charlottesville: University of Virginia Press, 2002). Current scholarship is also now focusing on the narrative or literary qualities of genre paintings. See in particular Kate Flint, "Criticism, Language, and Narrative," chapter 8 of her book *The Victorians and the Visual Imagination* (Cambridge: Cambridge University Press, 2000); and Pamela M. Fletcher, *Narrating Modernity: The British Problem Picture, 1895–1914* (Aldershot, Hants, UK: Ashgate, 2003). A key earlier work on Victorian word-image relations is Martin Meisel's *Realizations: Narrative, Pictorial, and Theatrical Arts in Nineteenth-Century England* (Princeton, N.J.: Princeton University Press, 1983).

34. See William T. Whitley, *Art in England, 1800–1820* (Cambridge: Cambridge University Press, 1928).

35. Joshua Reynolds, "Discourse Seven" (1776), *Discourses on Art* (New York: Collier Books, [1792], 1961), 125–26.

36. Brandon Taylor, *Art for the Nation: Exhibitions and the London Public, 1747–2000* (New Brunswick, N.J.: Rutgers University Press, 1999), 20–21. For a sociological analysis of the Royal Academy see Gordon Fyfe, *Art, Power and Modernity: English Art Institutions, 1750–1950* (London: Leicester University Press, 2000). Also relevant is Giles Waterfield, *Palaces of Art:Art Galleries in Britain, 1790–1990* (London: Dulwich Picture Gallery and the National Gallery of Scotland, 1991).

37. Many of Reynolds' terms and premises are similar to those of Kant, despite the conspicuous differences in their aesthetic preferences. Kant argues for a disinterested judgment based on an artwork's formal qualities, while Reynolds elevates history painting and old master artworks as the pinnacle of tasteful judgment.Yet both thinkers analyze taste as a function of reason, around which a community of like-minded gentlemen might gather, a select group beyond mere "common gazers," as Reynolds disdains them. "Discourse Seven," 110. Similarly, Kant regrets that his phrase *sensus communis* "enjoys the unfortunate honor of being called common sense," since the word "common" in many languages is a synonym for "*vulgar*—i.e., something found everywhere, the possession of which involves no merit or superiority whatever." Instead, Kant redirects his *sensus communis* toward an idea of a "shared" sense by which enlightened individuals can escape "mistaking subjective and private conditions for objective ones." *Critique of Judgment,* 160.

38. This argument is made by John Barrell in *The Political Theory of Painting from Reynolds to Hazlitt: 'The Body Politic'* (New Haven, Conn.: Yale University Press, 1995).

39. Andrew Hemingway, *Landscape Imagery and Urban Culture in Early Nineteenth-Century Britain* (Cambridge: Cambridge University Press, 1992), 49.

40. See Richard Altick, *The Shows of London* (Cambridge, Mass.: Harvard University Press, 1978); William H. Galperin, *The Return of the Visible in British Romanticism* (Baltimore: Johns Hopkins University Press, 1993); and Gillen D'Arcy Wood, *The Shock of the Real: Romanticism and Visual Culture, 1760–1860* (New York: Palgrave, 2001). Wood's book supplies a useful bibliography on the subject.

41. Ackermann opened his shop in London in 1797. In 1810 he renovated the establishment to include a library and a tea room, and in 1811 he illuminated the place with gas. Ann Bermingham, "Urbanity and the Spectacle of Art," in *Romantic Metropolis: The Urban Scene of British Culture, 1780–1840*, ed. James Chandler and Kevin Gilmartin (Cambridge: Cambridge University Press), 153.

42. William Hazlitt, "The Catalogue Raisonné of the British Institution," in *The Complete Works of William Hazlitt,* vol. 18. Quoted in Stephen Bann, "A Language of the Body? The Art Criticism of William Hazlitt," in *Le corps dans tous ses états,* ed. Marie-Claire Rouyer (Bordeaux, France: Presses Universitaires de Bourdeaux, 1995), 28.

43. Raymond Williams analyzes this dynamic in "The Romantic Artist," chapter two of *Culture and Society, 1780–1950* (New York: Columbia University Press, [1958], 1983). He observes that Wordsworth and Coleridge embraced the stirring ideal of "the People" while also denouncing the wayward desires of "the Public" (34).

44. Whitley, *Art in England,* 262.

45. Brandon Taylor gathers these statistics from yearly reports of the National Gallery to Parliament, 1826–54. Taylor explores the early history of the National Gallery by analyzing the parliamentary debates about State sponsorship for art institutions in the 1830s. See Brandon Taylor, *Art for the Nation: Exhibitions and the London Public, 1747–2000* (New Brunswick, N.J.: Rutgers University Press, 1999), 37.

46. John Eagles, "The Fine Arts and Public Taste in 1853," *Blackwood's* 74 (1853): 92.
47. Adele M. Holcomb, "Anna Jameson: The First Professional English Art Historian," *Art History* 6, no. 2 (June 1983): 181.
48. These developments are briefly summarized in John Charles Olmstead's introduction to his anthology, *Victorian Painting: Essays and Reviews. Volume One: 1832–1848* (New York: Garland Publishing, 1980): xiii. A storehouse of useful information on Victorian art criticism has been compiled by Helene E. Roberts. Her publications include "British Art Periodicals of the Eighteenth and Nineteenth Centuries," *Victorian Periodicals Newsletter* 9 (July 1970): 2–10; Roberts, "Art Reviewing in the Early Nineteenth-Century Art Periodicals," *Victorian Periodicals Newsletter,* no. 19 (March 1973), 9–20; and Roberts, "Exhibition and Review: The Periodical Press and the Victorian Art Exhibition System," in *The Victorian Periodical Press: Samplings and Soundings,* ed. Joanne Shattock and Michael Wolff (Toronto: University of Toronto Press, 1982), 79–107. Other sources include George Landow, "There Began to Be a Great Talking about the Fine Arts," in *The Mind and Art of Victorian England,* ed. Josef L. Altholtz (Minneapolis: Minnesota University Press, 1976); Kate Flint, "The Rôle of the Art Critic," in *The Victorians and the Visual Imagination* (Cambridge: Cambridge University Press, 2000), 167–96; and Claire Wildsmith, "'Candid and Earnest': The Rise of the Art Critic in the Early Nineteenth Century," in *Ruskin's Artists: Studies in the Victorian Visual Economy,* ed. Robert Hewison (Aldershot: Ashgate, 2000), 15–30. These critical works cover a large span of years in their histories; aside from Charles Olmstead, none of them single out c. 1840 as a unique moment in art criticism. More analytical approaches to Victorian art criticism can be found in Kate Flint, "Moral Judgement and the Language of English Art Criticism," *Oxford Art Journal* 6 (1983): 59–66; and Elizabeth Prettejohn, "Aesthetic Value and the Professionalization of Victorian Art Criticism 1837–78," *Journal of Victorian Culture* 2 (1997): 71–94.
49. Landow, "Great Talking," 130.
50. *Monthly Chronicle* 4 (1839): 502. Quoted in Roberts, "Exhibition and Review," 85.
51. *The Art-Journal* 13 (1851): 301. Quoted in Landow, "Great Talking," 190.
52. For the rise of Victorian periodical culture see Joanne Shattuck and Michael Wolff, eds. *The Victorian Periodical Press: Samplings and Soundings* (Leicester: Leicester University Press, 1982); Richard D. Altick, *The English Common Reader: A Social History of the Mass Reading Public, 1800–1900,* 2nd ed. (Chicago: University of Chicago Press, [1957], 1998); J. Don Vann and Rosemary T. VanArsdel, eds., *Victorian Periodicals and Victorian Society* (Toronto: University of Toronto Press, 1994); and Leslie Brake, "Writing, Cultural Production, and the Periodical Press in the Nineteenth Century," in *Writing and Victorianism,* ed. J. B. Bullen (London: Longman, 1997): 54–72.
53. In the introduction to *Culture and Society, 1780–1950,* Raymond Williams explains his decision to focus on English texts: "The industrial revolution, which eventually swept or impinged on most of the world, began in England. The fundamentally new social and cultural relationships and issues which were part of that historically decisive transition were therefore first felt, in their intense and unprecedented immediacy, within this culture" (x).
54. On the history of the British government's patronage of the arts see Janet Minihan, *The Nationalization of Culture: The Development of State Subsidies to the Arts in Great Britain* (New York: New York University Press, 1977); and Nicholas Pearson, *The State and the Visual Arts: A Discussion of State Intervention in the Visual Arts in Britain, 1760–1981*

(Milton Keynes: Open University Press, 1982). Victorian writers were often galled, in particular, by the paltriness of the government's support of the arts as compared to the magnificences supplied by the French government. This distinction also reflected broader stereotypes dividing the two nations: that France, inheriting a fashionable legacy of courtly aristocracy, was the cultural and artistic center of Europe, while Britain, birthplace of the industrial revolution, was Europe's manufacturing capital and imperial power, a "nation of shopkeepers." Yet the differences between the two national traditions seem to have been exaggerated, especially since Britain's economic power, as one would expect, did result in a national expansion of patronage, arts production, and art criticism—all the pressures of class mobility that made "culture" a preeminent category in the country. Sharon Marcus observes that both English and French authors in the nineteenth century wrote obsessively about their national differences, to the extent that "the many oppositions" begin to seem like "attempts to create variety in the face of interchangeability" (678). Marcus goes on to use Freud's term, "the narcissism of minor differences," to describe Anglo-French contrasts. Sharon Marcus, "Same Difference? Transnationalism, Comparative Literature, and Victorian Studies," *Victorian Studies* 45, no. 4 (Summer 2003): 677–86.

55. Henry James, "The Picture Season in London, 1877," in *The Painter's Eye: Notes and Essays on the Pictorial Arts by Henry James,* ed. John L. Sweeney (Cambridge, Mass.: Harvard University Press, 1956), 136–37.

56. Wilde, "The Critic as Artist," in *The Complete Works of Oscar Wilde,* (New York: Harper & Row, 1966), 1028.

57. So claims the anonymous author of "Eastern Art and Western Critics," *Edinburgh Review* 212 (October 1910): 450. I analyze this essay further in chapter 5.

58. A major critical tradition analyzes essays by Ruskin and Pater for their philosophical ideas and high literary prose. Emphasizing close readings and a trajectory of individual influences, this scholarship also emphasizes art writing's debt to Romanticism, seeing the turn to aesthetic culture as an offshoot of the nineteenth-century rebellion against the degradations of industry and commerce. Works include Solomon Fishman, *The Interpretation of Art: Essays on the Art Criticism of John Ruskin, Walter Pater, Clive Bell, Roger Fry and Herbert Read* (Berkeley and Los Angeles: University of California Press, 1963); Richard Stein, *The Ritual of Interpretation: The Fine Arts as Literature in Ruskin, Rossetti, and Pater* (Cambridge, Mass.: Harvard University Press, 1975); Graham Hough, *The Last Romantics* (London: Methuen, 1961); and, more recently, Kenneth Daly, *The Rescue of Romanticism: Walter Pater and John Ruskin* (Athens: Ohio University Press, 2001).

59. The disciplinary formation of art history was dominated by critics and historians writing in Germany. A collection addressing historical developments in different Western countries is Elizabeth Mansfield, ed., *Art History and its Institutions: Foundations of a Discipline* (London: Routledge, 2002).

60. Jonah Siegel, *Desire and Excess: The Nineteenth-Century Culture of Art* (Princeton, N.J.: Princeton University Press, 2000), xxvi. Siegel takes this notion, in turn, from James Buzard, who uses it to describe the nineteenth-century experience of foreign cultures on the Grand Tour. Siegel's excellent book focuses specifically on the role of institutions in the development of a broad English art culture, encompassing many kinds of arts, beginning in the eighteenth century.

61. W. J. T. Mitchell, *Iconology: Image, Text, Ideology* (Chicago: University of Chicago Press, 1986), 112.

62. Pierre Bourdieu, "The Historical Genesis of a Pure Aesthetic," *The Field of Cultural Production: Essays on Art and Literature,* ed. and intro Randal Johnson (New York: Columbia University Press, 1993), 260.

63. Jameson's *Penny Magazine* series is discussed by Adele M. Holcomb, "Anna Jameson," cited above; and by Judith Johnston, "Invading the House of Titian: The Colonisation of Italian Art. Anna Jameson, John Ruskin, and the *Penny Magazine,*" *Victorian Periodicals Review* 27, no. 2 (Summer 1994): 127–43.

64. "Andrea Mantegna," *Penny Magazine* 12 (1843): 436. Reprinted in *Memoirs of the Early Italian Painters* (New York: Houghton Mifflin, [1845], 1888), 126–27.

65. Many studies of Victorian visual culture in the 1990s were influenced by Michel Foucault's powerful history of incarceration, *Discipline and Punish: The Birth of the Prison,* trans. Alan Sheridan (London: Allen Lee, [1975], 1977). These studies focused on the rise of photography and its role in surveillance, especially as it was used by British scientists to police criminals, "deviants," and racial others. See the essays collected in Carol T. Christ and John O. Jordan, eds., *Victorian Literature and the Victorian Visual Imagination* (Berkeley and Los Angeles: University of California Press, 1995). Other studies of Victorian visual culture include Altick, *Shows of London*; Deborah Cherry, *Beyond the Frame: Feminism and Visual Culture, Britain, 1850–1900* (London: Routledge, 2000); Jennifer Green-Lewis, *Framing the Victorians: Photography and the Culture of Realism* (Ithaca, N.Y.: Cornell University Press, 1996); Kate Flint, *The Victorians and the Visual Imagination*; and Lindsay Smith, *Victorian Photography, Painting and Poetry: The Enigma of Visibility in Ruskin, Morris and the Pre-Raphaelites* (Cambridge: Cambridge University Press, 1995).

66. Jean-Louis Comolli, "Machines of the Visible," in *The Cinematic Apparatus,* ed. Teresa de Lauretis and Stephen Heath (London: Macmillan, 1980), 122–23. Quoted in Kate Flint, *The Victorians and the Visual Imagination*, 3.

67. W. J. T. Mitchell, "Showing Seeing: A Critique of Visual Culture," in *The Visual Culture Reader,* ed. Nicholas Mirzoeff, 2nd ed. (London: Routledge, 2002), 94, 92–93.

68. Wedgwood appears as a defining character in histories of the "birth of consumer society"; see Neil McKendrick, John Brewer, and J.H. Plumb, eds., *The Birth of a Consumer Society: The Commercialization of Eighteenth-Century England* (Bloomington: Indiana University Press, 1982). Roger Fry writes that Wedgwood's china plates set "a standard of mechanical perfection which to this day prevents the trade from accepting any work in which the natural beauties of the material are not carefully obliterated by mechanical means." Fry echoes Victorians like Ruskin and, especially, William Morris, who advocated for a return to handicraft. Roger Fry, "Wedgwood China" (1905), in *A Roger Fry Reader,* ed. Christopher Reed (Chicago: University of Chicago Press, 1996), 192. Joseph Bizup describes the meteoric rise of machine-made ornament in early-Victorian England in *Manufacturing Culture: Vindications of Early Victorian Industry* (Charlottesville: University of Virginia Press, 2003).

69. These developments are famously analyzed by Walter Benjamin in "The Work of Art in the Age of Mechanical Reproduction," *Illuminations,* ed. Hannah Arendt, trans. Harry Zohn (New York: Schocken Books, 1968), 217–51. Benjamin sees the rise of mass visual culture as a triumph for socialist values, and attacks "art for art's sake" as a precursor to Fascism; but he also seems nostalgic for the aura or "cult-value" attaching to older kinds of media.

70. Some of my choices originate from the book's roots as a dissertation examining a somewhat antiquated and male-dominated Victorian canon of nonfiction prose. Important scholarship is now being published on female art critics; see, for example, Meaghan Clarke, *Critical Voices: Women and Art Criticism in Britain 1880–1905* (Aldershot, U.K.: Ashgate, 2005).

71. Ian Hunter, "Aesthetics and Cultural Studies," in *Cultural Studies,* ed. Lawrence Grossberg, Cary Nelson, and Paula Treichler (New York: Routledge, 1992), 347–72.

72. John Frow, *Cultural Studies and Cultural Value* (Oxford: Oxford University Press, 1995), 145.

73. See Edward Morris, *French Art in Nineteenth-Century Britain* (New Haven, Conn.: Yale University Press, 2005); and J. B. Bullen, *Continental Crosscurrents: British Criticism and European Art 1810–1910* (Oxford: Oxford University Press, 2005).

Chapter 1

1. John Ruskin, *The Works of John Ruskin,* Library Edition, eds. E. T. Cook and Alexander Wedderburn, 39 vols. (London: George Allen, 1903–12), 10:189. All future citations in the text will refer parenthetically to this edition by volume and page number.

2. *The Letters of D. H. Lawrence,* ed. James T. Boulton, vol. 1 (Cambridge: Cambridge University Press, [1901–13], 1979), 81. Quoted in *Ruskin and Modernism*, ed. Giovanni Cianci and Peter Nicholls (New York: Palgrave, 2001), xii.

3. Henry Ladd, *The Victorian Morality of Art: An Analysis of Ruskin's Esthetic* (New York: Ray Long & Richard Smith, 1932), 1.

4. As the editors of the recent essay collection *Ruskin and Modernism* conclude, Ruskin's ideas in the twentieth century "lost their intuitive and problematic aspect . . . and were now presented as either established dogma or in a reductively simple form." Cianci and Nicholls, *Ruskin and Modernism*, xii.

5. For Ruskin's environmentalism, see Michael Wheeler, *Ruskin and Environment: The Storm-Cloud of the Nineteenth Century* (Manchester: Manchester University Press, 1995). For his gender politics see Sharon Aronofsky Weltman, *Ruskin's Mythic Queen: Gender Subversion in Victorian Culture* (Athens: Ohio University Press, 1998) and the collection edited by Dinah Birch and Francis O'Gorman, *Ruskin and Gender* (New York: Palgrave, 2002). On Ruskin's utopian political economy see Willie Henderson, *John Ruskin's Political Economy* (London: Routledge, 2000).

6. Amanda Anderson, *The Powers of Distance: Cosmopolitanism and the Cultivation of Detachment* (Princeton, N.J.: Princeton University Press, 2001), 20.

7. The most recent analysis of Ruskin's Evangelical nature aesthetics is C. Stephen Finley, *Nature's Covenant: Figures of Landscape in Ruskin* (University Park: Pennsylvania State University Press, 1992).

8. George P. Landow argues that the volumes of *Modern Painters* "possess important unity"; the "major order" informing Ruskin's works "is that of a growing, adapting organism . . . Like a growing plant, *Modern Painters* develops in relation to certain easily discernible axes." Landow, *The Aesthetic and Critical Theories of John Ruskin* (Princeton, N.J.: Princeton University Press, 1971), 23. Other organicist readings of *Modern Painters* can be found in Paul Sawyer, *Ruskin's Poetic Argument: The Design of the Major Works* (Ithaca, N.Y.: Cornell University Press, 1985); Sheila Emerson, *Ruskin: The Genesis of*

Invention (Cambridge: Cambridge University Press, 1993); and Robert Hewison, *John Ruskin: The Argument of the Eye* (London: Thames & Hudson, 1976).

9. The canonical discussion of Ruskin's influence by Wordsworth is Elizabeth Helsinger's magisterial *Ruskin and the Art of the Beholder* (Cambridge, Mass.: Harvard University Press, 1982).

10. I also include the 1844 second preface to the volume in my analysis, since it responds to some of the criticisms leveled at Ruskin by his earliest reviewers.

11. The review is reprinted in an invaluable collection of primary sources on Victorian painting edited by John Charles Olmstead, *Victorian Painting: Essays and Reviews. Volume One: 1832–1848* (New York: Garland Publishing, 1980), 464. This chapter will cite essays and reviews reprinted in the Olmstead volume by giving the original reference first, followed by the page number in *Victorian Painting*.

12. For a similarly diverse analysis of Ruskin's contexts, see the exhibition catalogue edited by Susan P. Casteras, *John Ruskin and the Victorian Eye* (New York: Harry N. Abrams and the Phoenix Art Museum, 1993). Other contextual readings of Ruskin and Victorian visual culture can be found in Robert Hewison, ed., *Ruskin's Artists: Studies in the Victorian Visual Economy* (Aldershot, U.K.: Ashgate, 2000).

13. Recent criticism on Ruskin's links to twentieth-century intellectual history can be found in Cianci and Nicholls, eds., *Ruskin and Modernism*, cited above, and Toni Cerutti, ed., *Ruskin and the Twentieth Century: The Modernity of Ruskinism* (Vercelli: Edizioni Mercurio, 2000). Other studies are now focusing on Ruskin's late works as an avenue to his modernism; these include Dinah Birch, ed., *Ruskin and the Dawn of the Modern* (Oxford: Oxford University Press, 1999) and Judith Stoddart, *Ruskin's Culture Wars: Fors Clavigera and the Crisis of Victorian Liberalism* (Charlottesville: University Press of Virginia, 1998).

14. Turner's career is described in Sam Smiles, *J. M. W. Turner* (London: Tate Gallery, 2000).

15. W. M. Thackeray, "A Second Lecture on the Fine Arts, by Michael Angelo Titmarsh, Esq," *Fraser's Magazine* 19 (June 1839): 743–50. Reprinted in *Victorian Painting*, 296.

16. The notorious review was John Eagles, "British Institution for Promoting the Fine Arts in the United Kingdom, Etc.—1836," *Blackwood's* (October 1836): 543–56. Reprinted in *Victorian Painting*, 133–48. Eagles writes of Turner's 1836 *Juliet and Her Nurse*, "Poor Juliet had been steeped in treacle to make her look sweet, and we feel apprehensive lest the mealy architecture should stick to her petticoat, and flour it" (143).

17. See Helsinger, *Ruskin and the Art of the Beholder*.

18. W. M. Thackeray, "An Exhibition Gossip. By Michael Angelo Titmarsh. In a Letter to Monsieur Guillaume, Peintre," *Ainsworth's Magazine* 1 (June 1842): 319–22. Reprinted in *Victorian Painting*, 369.

19. Rachel Toulmin Meoli, "The Rhetoric of the Picturesque: The Language of Landscape Description in Eighteenth-Century England," in *Language and Civilization: A Concerted Profusion of Essays and Studies in Honour of Otto Hietsch*, ed. Claudia Blank (Frankfurt-on-Main: Peter Lang, 1992), 738.

20. Andrew Hemingway, *Landscape Imagery and Urban Culture in Early Nineteenth-Century Britain* (Cambridge: Cambridge University Press, 1992), 22.

21. Richard Sha, *The Visual and Verbal Sketch in British Romanticism* (Philadelphia: University of Pennsylvania Press, 1998), 63.

22. See Frances Ferguson, "In Search of the Natural Sublime: The Face on the Forest Floor," *Solitude and the Sublime: Romanticism and the Aesthetics of Individuation* (New York: Routledge, 1992), chapter six.

23. William Combe, *The Tour of Doctor Syntax, in Search of the Picturesque* (London: W. Tegg, [1809], 1872), 3.

24. Jane Austen, *Sense and Sensibility* (Mineola, N.Y.: Dover, 1996), 64.

25. These annuals are listed in Helene E. Roberts, "British Art Periodicals of the Eighteenth and Nineteenth Centuries," *Victorian Periodicals Newsletter* 9 (July 1970): 2–10, plus an unpaginated checklist of periodicals.

26. See Timothy J. Standring, "Watercolor Landscape Sketching During the Popular Picturesque Era in Britain," in *Glorious Nature: British Landscape Painting, 1750–1850*, ed. Katharine Baetjer (New York: Hudson Hills Press, 1993), 73–84.

27. *Athenaeum* (February 1844): 105–7, 132–33. Reprinted in *Victorian Painting*, 463.

28. James Buzard, *The Beaten Track: European Tourism, Literature, and the Ways to Culture, 1800–1918* (Oxford: Clarendon Press, 1993), 66.

29. Fabius Pictor, [pseud.], *The Hand-book of Taste: Or, How to Observe Works of Art, especially Cartoons, Pictures, and Statues* (London: Longman, Brown, Green, & Longmans, 1843). This handbook is addressed to the British public viewing the 1843 cartoon competition, sponsored by the Queen, to create history frescoes suitable to decorate the new Houses of Parliament.

30. As James Buzard, Ian Ousby, and other historians of tourism have observed, this mobility (and the whole accompanying "hand-book" genre) owe their existence in large part to the new train tracks being laid across England and Europe in the early 1840s. See Ian Ousby, *The Englishman's England: Taste, Travel, and the Rise of Tourism* (Cambridge: Cambridge University Press, 1990).

31. For discussions of these developments in British landscape painting around 1800 see Charlotte Klonk, *Science and the Perception of Nature: British Landscape Art in the Late Eighteenth and Early Nineteenth Centuries* (New Haven, Conn.: Yale University Press, 1996); E. H. Gombrich, *Art and Illusion: A Study in the Psychology of Pictorial Representation*, 2nd ed. (New York: Pantheon Books, 1961), and Peter Galassi, *Before Photography* (New York: Museum of Modern Art, 1981).

32. Quoted in E. H. Gombrich, *Art and Illusion*, 33.

33. *Hand-book of Taste*, 37, 39.

34. Jules David Law, *The Rhetoric of Empiricism: Language and Perception from Locke to I. A. Richards* (Ithaca, N.Y.: Cornell University Press, 1993), 2, 7.

35. The tremendous influence of Herschel's book on Victorian science is evident in the letter Charles Darwin wrote to Herschel in 1859 to accompany a copy of his newly published *Origin of Species*: "I cannot resist the temptation of shewing in this feeble manner my respect, & the deep obligation, that I owe to your Introduction to Natural Philosophy. Scarcely anything in my life made so deep an impression on me: it made me wish to try to add my mite to the accumulated stores of natural knowledge." Quoted in Larry J. Schaaf, *Out of the Shadows: Herschel, Talbot, & the Invention of Photography* (New Haven, Conn.: Yale University Press, 1992), 16.

36. J. F. W. Herschel, *A Preliminary Discourse on the Study of Natural Philosophy* (Philadelphia: Carey and Lea, [1830], 1831), 60.

37. Hewison, *John Ruskin*, 21.

38. Cook and Wedderburn detail at length Ruskin's precocious scientific interests in their introduction to his juvenilia. His first publications were two articles in Loudon's *Magazine of Natural History* (1836).

39. Lorraine Daston and Peter Galison, "The Image of Objectivity," *Representations* 40 (1992): 85.

40. Ibid.

41. Michel Foucault, *The Order of Things: An Archaeology of the Human Sciences* (New York: Vintage Books, [1970], 1994), 132–33.

42. For a classic discussion of Locke's metaphorics of mind-as-screen (as well as a critique of contemporary philosophy which makes epistemology a matter of "seeing"), see Richard Rorty, *Philosophy and the Mirror of Nature* (Princeton, N.J.: Princeton University Press, 1979).

43. John Locke, *An Essay Concerning Human Understanding,* ed. A. C. Fraser, vol. 1 (Oxford: Clarendon Press, 1894), 212.

44. A. C. Fraser sums up this point in his critical introduction to Locke's *Essay*: both "external sensible objects" and "our own minds" "are presupposed to exist, and to become gradually clothed with qualities, through an experience of the simple ideas in which they make themselves known in sense" (lxxxii).

45. Here I propose a different argument than Gary Wihl, who analyzes the appearance of Locke in *Modern Painters I* to conclude that Ruskin's aesthetic is "profoundly anti-mimetic." Gary Wihl, *Ruskin and the Rhetoric of Infallibility* (New Haven, Conn.: Yale University Press, 1985), 6.

46. M. H. Abrams, *The Mirror and the Lamp: Romantic Theory and the Critical Tradition* (Oxford: Oxford University Press, 1953), 11.

47. Gombrich, *Art and Illusion*, 14.

48. On the Bridgewater Treatises see Charles Coulston Gillispie, *Genesis and Geology: A Study in the Relations of Scientific Thought, Natural Theology, and Social Opinion in Great Britain, 1790–1850* (New York: Harper & Row, 1959); and John Robson, "The Fiat and Finger of God: The Bridgewater Treatises," in *Victorian Faith in Crisis: Essays on Continuity and Change in Nineteenth-Century Religious Belief*, eds. Bernard Lightman and Richard J. Helmstadter (London: Macmillan, 1990), 71–125.

49. See Jonathan R. Topham, "Beyond the 'Common Context': The Production and Reading of the Bridgewater Treatises," *Isis* 89, no. 2 (June 1998): 233–62.

50. Many eighteenth-century thinkers maintained a contradictory allegiance to both empiricism and divinity. As Ernst Cassirer sums up the problem, philosophers moved in "an obvious vicious circle" when they inferred "the absolute unity and immutability of God from the empirical homogeneity which nature seems to exhibit," while at the same time using "the unity and immutability of God as an argument for perfect homogeneity in the order of nature." Cassirer asks, "Do we not offend against the most elementary laws of logic . . . by supporting all certainty of our judgments and conclusions on a metaphysical assumption which is more problematical than empirical certainty itself?" This accusation could just as well be leveled against Ruskin's *Modern Painters I*. Ernst Cassirer, *The Philosophy of the Enlightenment* (Boston: Beacon Press, 1955), 58.

51. "Words being intended for signs of my *Ideas,* to make them known to others, not by any natural signification, but by voluntary imposition, 'tis plain cheat and abuse, when

I make them stand sometimes for one thing, and sometimes for another." Locke, *An Essay Concerning Human Understanding,* III.x.5, vol. 2, 125.

52. Ibid., III.xi.25, vol. 2, 163.

53. See Foucault, *The Order of Things,* chapter 8, "Language Become Object"; and Linda Dowling, *Language and Decadence in the Victorian Fin de Siècle* (Princeton, N.J.: Princeton University Press, 1986).

54. Herschel, *Preliminary Discourse,* 11.

55. Ibid.

56. Mary Warner Marien, *Photography and Its Critics: A Cultural History, 1839–1900* (Cambridge: Cambridge University Press, 1997), 3.

57. William Henry Fox Talbot, *The Pencil of Nature,* intro. Beaumont Newhall (New York: Da Capo Press, [1844–46], 1969), n. p. For a history of Talbot's contribution to photographic history see Gail Buckland, *Fox Talbot and the Invention of Photography* (London: Scolar Press, 1980).

58. The seminal essay outlining early photography's relation to traditional art forms, especially to painting and drawing, is Peter Galassi's *Before Photography* (New York: Museum of Modern Art, 1981). Galassi seeks to revise the master-narrative that places photography within a deterministic march from the camera obscura onward to film: "The object here is to show that photography was not a bastard left by science on the doorstep of art, but a legitimate child of the Western pictorial tradition" (12).

59. The modern sense of photography as a soulless machine appeared in Victorian writing by the later 1850s,, but at its moment of discovery in the early 1840s, most commentators expressed a sense of wonder at its "fixing of shadows." Henry Fox Talbot writes that photography is a "*marvellous*" phenomenon, in which "a shadow, the proverbial emblem of all that is fleeting and momentary, may be fettered by the spells of our *natural magic.*" Talbot, "Some Account of the Art of Photogenic Drawing" (London: R. & J. E. Taylor, 1839), 6. Photography lost its sense of the "marvelous" as it became attached to the early rise of mass culture in England. By the late 1850s Lady Elizabeth Eastlake would write that photography catered to "the craving . . . for cheap, prompt, and correct facts in the public at large. Photography is the purveyor of such knowledge to the world. . . . [W]hat she does best is beneath the doing of the real artist." "Photography," *Quarterly Review* 101 (1857): 444.

60. *Art-Union* 1, no. 15 (April 1840): 60.

61. Anonymous, *The Hand-book of Heliography, or, The Art of Writing or Drawing by the Effect of Sun-Light with the Art of Diorama Painting, as Practiced by M. Daguerre* (London: Robert Tyas, 1840), 44. A helpful bibliography of early photographic literature can be found in Helmut Gernsheim, *Incunabula of British Photographic Literature* (London: Scolar Press, 1984).

62. Ruskin was a great fan of the daguerreotype in the 1840s and quickly became adept at using the new technology to capture views of Venice in 1845. But, unsurprisingly, his views shifted with photography's reputation, and in later lectures he disdained photographs for their impersonal mechanical detail. Ruskin's attitudes toward photography are described by Cook and Wedderburn in a long footnote to *Modern Painters I* in Ruskin's *Works,* 3:210. See also Michael Harvey, "Ruskin and Photography," *Oxford Art Journal* 7 (1984): 25–33.

63. Wihl, *Ruskin and the Rhetoric of Infallibility*, 8. Wihl argues that Ruskin's *Modern Painters* offers an intelligent and lucid re-reading of Locke—although some of his resolutions of Ruskin's intellectual paradoxes seem more final than Ruskin's writing would allow.

64. The relationship between Victorian photography and the realist novel is analyzed in Nancy Armstrong, *Fiction in the Age of Photography: The Legacy of British Realism* (Cambridge, Mass.: Harvard University Press, 1999) and Jennifer Green-Lewis, *Framing the Victorians: Photography and the Culture of Realism* (Ithaca, N.Y.: Cornell University Press, 1996).

65. M. H. Abrams discusses the history of the two terms in relation to poetics in *The Mirror and the Lamp*. Abrams attributes their origin to Kant, Schlegel, and German thought in the 1790s, but finds that "From their earliest uses in criticism, the terms 'subjective' and 'objective' were both multiple and variable" (241). A loose generalization (with many exceptions) would find "objective" describing the external object-world, while "subjective" describes the realm of the individual mind. See *The Mirror and the Lamp*, 235–44.

66. J. Ch. August Franz, *The Eye: A Treatise on the Art of Preserving this Organ in a Healthy Condition, and of Improving the Sight* (London: J. Churchill, 1839), 17. Franz defines "objective" sight as "an optical process dependent upon the external world, together with the visual apparatus," while "subjective vision" is "a mental act, dependent upon the mind, together with the optic nerve in its whole extent" (17). The distinction also appears in James Mill's 1829 *Analysis of the Phenomena of the Human Mind*, ed. J. S. Mill, 2 vols. (London: Longmans, Green, Reader, & Dyer, [1829], 1878): "The contrasted terms 'Object' and 'Subject' are the least exceptionable for expressing the fundamental antithesis of consciousness and of [physical] existence. Matter and Mind, External and Internal, are the popular synonyms" (5).

67. Foucault, *The Order of Things*, 138.

68. Hewison, *John Ruskin*, 22.

69. Landow, *Aesthetic and Critical Theories of John Ruskin*, 101.

70. Landow suggests that Ruskin modified his views in the later 1840s, accepting the role of associationism in aesthetics in *The Seven Lamps of Architecture*. But Helsinger argues in *Ruskin and the Art of the Beholder* that Ruskin was more profoundly influenced by associationism, and observes in a footnote that "Alison's influence is more pervasive on the Ruskin of *Modern Painters I* and even *II* than Landow implies" (325, n 52).

71. As Helene Roberts has observed, the associative method was the primary mode of art criticism before 1850. See her "Trains of Fascinating and Endless Imagery: Associationist Art Criticism before 1850," *Victorian Periodicals Newsletter* 10, no. 3 (September 1977): 91–105.

72. In "The Sublime Rivalry of Word and Image: Turner and Ruskin Revisited," Alexandra K. Wettlaufer suggests that Ruskin uses language to compete with Turner's images, giving an experiential and active account of Turner's *Snow Storm—Steam-Boat off a Harbour's Mouth* that deliberately goes beyond mere "imagistic mimesis" (162). *Victorian Literature and Culture* 28, no. 1 (2000): 149–69.

73. This is the classic distinction between word and image Lessing makes in his *Laocoön* (1766)—although in a critique of Lessing, W. J. T. Mitchell points out that the viewing

of paintings is always time-bound and sequential as our eyes move across the image; so the distinction is not really a rigorous one. See Mitchell, *Iconology: Image, Text, Ideology* (Chicago: University of Chicago Press, 1986), 95–115.

74. M. H. Abrams influentially contrasted the two theories in *The Mirror and the Lamp* to argue that the metaphorics of aesthetic theory shifted from eighteenth-century mirrors and a mimetic idea of art to nineteenth-century lamps and a new expressivist ideal. While this trajectory is a compelling one, the shift from one model to the other in the nineteenth century is perhaps not as complete as Abrams's analysis would imply, given the duality apparent in *Modern Painters*. Abrams also underlines what he sees as the growing divide between poetry and science (taking as exemplary Keats's lines in *Lamia* that Newton's optics have "unweav'd the rainbow"); yet throughout the nineteenth century, as my chapters here will explore, aesthetic theorists invoked science to support their claims about art.

75. See R. Cairns Craig, "The Continuity of the Associationist Aesthetic: From Archibald Alison to T. S. Eliot (and beyond)," *Dalhousie Review* 60 (1980): 20–37. In her survey of Victorian poetry criticism, Isobel Armstrong notes that critics until the 1860s are "surprisingly free both from the vocabulary and concepts of Coleridge and of German criticism." Isobel Armstrong, *Victorian Scrutinies: Reviews of Poetry, 1830–1870* (London: The Athlone Press, 1972), 14.

76. Many readers learned of Alison's ideas from a famous review article by Francis Jeffrey, the influential Romantic critic, whose glowing account of Alison's theory first appeared in the *Edinburgh Review* in 1811. Jeffrey's article was expanded into the entry on "Beauty" for *Encyclopedia Britannica*'s 1824 supplement, and was reprinted again in 1842. (In fact, the essay was reprinted as the *Encyclopedia*'s definitive statement on "Beauty" until 1875). These facts are given by Craig, "The Continuity of the Associationist Aesthetic," 20–21, and Roberts, "Trains of Fascinating and Endless Imagery," 95.

77. For a discussion of associationism in the eighteenth century see Martin Kallich, *The Association of Ideas and Critical Theory in Eighteenth-Century England* (The Hague, Netherlands: Mouton, 1970).

78. The early nerve experimentalist Charles Bell wrote in 1811 that "sensation is more in the brain than in the external organ of sense," and that "the operations of the mind are confined not by the limited nature of things created, but by the limited number of our organs of sense." Charles Bell, "Idea of a New Anatomy of the Brain," privately printed, 1811. Reprinted in *Visual Perception: The Nineteenth Century*, ed. William N. Dember (New York: John Wiley & Sons, 1964), 22.

79. Johannes Müller, "Of the Senses," from *Elements of Physiology*, trans. W. Baly (London: Taylor & Walton, vol. 1 [1838]; vol. 2 [1842]). The first German edition of *Handbüch der Physiologie des Menschen für Vorlesungen* was published between 1834 and 1840.

80. Mill, *Analysis of the Phenomena of the Human Mind*, 94–95.

81. Sir Charles Morgan, "Of Certainty in Taste," *Athenaeum* (November 2, 1834): 804–7. Reprinted in *Victorian Painting*, 91.

82. Ibid. The audacity of Morgan's claims are somewhat mitigated at the end of the essay, when he theorizes the existence of a "middle man" who calibrates his opinions according to those of others and thus enables "principles of taste" to be established. "Good taste...stands upon the same foundation as orthodoxy in religion: it exists only by the suffrage of the majority" (95).

83. Quoted in Craig, "Associationist Aesthetic," 24.

84. Hewison, *John Ruskin*, 57.

85. J. S. Mill was one of the transitional figures in the history of Victorian psychology. In his panoramic *History of Experimental Psychology*, Edwin G. Boring writes that Mill was among the thinkers who contributed to the mid-nineteenth century meeting of philosophy and biology, as "philosophical psychology" evolved into "scientific psychology." Boring describes how nineteenth-century associationism, as codified by the Mills, was made by Alexander Bain into the "the system that was to become the substructure for the new physiological psychology." Edwin G. Boring, *A History of Experimental Psychology*, 2nd ed. (New York: Appleton-Century-Crofts, 1957), 219.

86. John Stuart Mill, "Bain's Psychology" (1859), in *Collected Works of John Stuart Mill*, ed. J. M. Robson, vol. 11 (Toronto: University of Toronto Press, 1978), 363–64.

87. These articles include Arthur H. Hallam, "On Some of the Characteristics of Modern Poetry," *Englishman's Magazine*, vol. 1 (August 1831), 616–28; and William J. Fox, "Tennyson, *Poems, Chiefly Lyrical* (1830)," *Westminster Review* 14 (January 1831): 210–24. Both are reprinted in Armstrong, *Victorian Scrutinies*, 71–83 and 84–101. Mill published two essays on Tennyson: "The Two Kinds of Poetry" (1833) and "What is Poetry?" (1833), both appearing in the *Monthly Repository*, which was edited by Mill's friend, W. J. Fox. These were republished as a single essay in Mill's *Dissertations and Discussions*, "Thoughts on Poetry and its Varieties", omitting many key passages. The two original essays are reprinted in *Mill's Essays on Literature and Society*, ed. J. B. Schneewind (New York: Collier Books, 1965), 102–30.

88. "Nervous systems vary from the finest degree of susceptibility down to the toughness of a coil of hempen cable. *Poeta nascitur* [Poets are born] in a frame the most favourable to acute perception and intense enjoyment of the objects of sense." W. J. Fox, "Tennyson, *Poems, Chiefly Lyrical* (1830)," quoted in Armstrong, *Victorian Scrutinies*, 72.

89. Mill, "The Two Kinds of Poetry," 118, 119.

90. Mill, "What is Poetry?" (1833), 112, 115.

91. John Eagles, "Modern Painters," *Blackwood's Magazine* 54 (October 1843): 485–503. Reprinted in *John Ruskin: The Critical Heritage*, ed. J. L. Bradley (New York: Routledge, 1984), 35–36.

92. Critics generally agree that Ruskin tempered his early negative opinion of color in writings after 1850. In the final volume of *Modern Painters* Ruskin describes color as "the purifying or sanctifying element of material beauty," and "the type of Love" (7:417). For an analysis of Ruskin's later, more accepting discourse of color, see Stephen Bann, "The Colour in the Text: Ruskin's Basket of Strawberries," in *The Ruskin Polygon: Essays on the Imagination of John Ruskin*, ed. John Dixon Hunt and Faith M. Holland (Manchester: Manchester University Press, 1982), 122–36.

93. Thackeray, "A Second Lecture on the Fine Arts." Reprinted in *Victorian Painting*, 296.

94. W. M. Thackeray, "A Pictorial Rhapsody by Michael Angelo Titmarsh," *Fraser's Magazine* 21 (June 1840), 720–32. Reprinted in *Victorian Painting*, 325.

95. Anna Jameson, "The Exhibition of the Royal Academy: English Art and Artists," *Monthly Chronicle* (June 1838), 348–55. Reprinted in *Victorian Painting*, 231.

96. "Royal Academy," *Athenaeum* (May 12, 1838): 346–47. Reprinted in *Victorian Painting*, 216.

97. John Eagles, "Exhibitions—Royal Academy," *Blackwood's Edinburgh Magazine* 52 (July 1842): 23–34. Reprinted in *Victorian Painting*, 396.

98. Eagles, "Modern Painters." Reprinted in *Ruskin: The Critical Heritage,* 52.

99. John Charles Olmstead, "Introduction," *Victorian Painting,* xxi.

100. "Painting and the Fine Arts," *Athenaeum* (July 14, 1838), 482–84. Reprinted in *Victorian Painting,* 247.

101. John Gage, *Color in Turner: Poetry and Truth* (New York: Frederick A. Praeger, 1969), 11.

102. Johann Wolfgang von Goethe, *Theory of Colours,* trans. Charles Locke Eastlake (London: John Murray, [1810], 1840), xxiv. The quarrel is analyzed in Frederick Burwick, *The Damnation of Newton: Goethe's Color Theory and Romantic Perception* (Berlin: De Gruyter, 1986).

103. Goethe, *Theory of Colours,* 306, 310.

104. Ibid., 350.

105. In *Techniques of the Observer: On Vision and Modernity in the Nineteenth Century* (Cambridge, Mass.: MIT Press, 1992), Jonathan Crary takes these images as evidence of Turner's participation in an early-nineteenth century "experimentation and innovation in the articulation of new languages, effects, and forms made possible by the relative abstraction and autonomy of physiological perception" (143). This reading fits well with Crary's desire to locate the origins of a postmodern sensibility in the early nineteenth century, but it seems somewhat anachronistic, given that our post-humanist notions of relativism, "perceptual autonomy" and "abstract optical experience" would have been alien concepts to aesthetic thinkers of the time (141). Crary's postmodernist reading seems more applicable to the German vision scientists he analyzes than to painters like Turner.

106. Another influential color theorist of the 1830s and 1840s was the dyer and pigment scientist George Field. Like Goethe and Turner, Field was also a promoter of eccentric color symbolisms. His 1835 classic *Chromatography; or a Treatise on Colours and Pigments, and of their Powers in Painting* argued that the three primary colors were a manifestation of a universal pattern of triads in nature, of which the Holy Trinity was the supreme example. See John Gage, *George Field and His Circle: From Romanticism to the Pre-Raphaelite Brotherhood,* Exhibition Catalogue (Cambridge, UK: Fitzwilliam Museum, 1989).

107. Gage, *Color in Turner,* 59.

108. There is no evidence that Ruskin read Goethe's *Theory of Colours,* although Turner obviously did. Ruskin makes hostile remarks toward Goethe in an 1875 footnote to *Modern Painters V,* accusing him of being "an evil influence in European literature" (5:330). But in another (typically contradictory) passage, Ruskin says that "Goethe has formed, directly or indirectly, the thoughts of all strong and wise men since his time" (5:331). As my analysis suggests, there are clear reasons why Ruskin would find both admirable and despicable qualities in Goethe's writings.

109. T. S. Eliot, "Tradition and the Individual Talent," first published in *The Egoist* (1919). Reprinted in *The Norton Anthology of English Literature,* 6th ed., vol. 2 (New York: W. W. Norton, 1993), 2174, 2175.

110. Lea Baechler, A. Walton Litz, and James Longenbach, eds., *Ezra Pound's Poetry and Prose: Contributions to Periodicals,* vol. 1 (New York: Garland, 1991), 63.

111. T. E. Hulme, *Speculations: Essays on Humanism and the Philosophy of Art,* ed. Herbert Read (London: Routledge & Kegan Paul, 1958), 137.

Chapter 2

1. The rise of professionalism is usually traced back to the eighteenth century, when, as Penelope Corfield has observed, the word "profession" came to refer not merely to any occupation but to a certain kind of employment differentiated from unskilled industrial or commercial trades (19). The professional career demanded long training and specialist knowledge, and members were often distinguished by the use of jargon terms and special costumes (21). In the eighteenth century, the first and most recognizable professions were the great trio of doctors, lawyers, and clergymen. Only in the nineteenth century, in 1861, did the census list artists, authors, and musicians as members of a "Professional class" (168). The professionalization of the art critic is a subset of the Victorian professionalization of journalism more generally, with the resulting specialization of various kinds of journalistic writing. While the professional art critic became a more recognizable figure in the 1860s—as I discuss in chapter 3—the early moment of the Great Exhibition proves a signal event in the move toward professionalization in all areas of the art world and its attendant bureaucracies. See Penelope J. Corfield, *Power and the Professions in Britain, 1700–1850* (New York: Routledge, 1995). Also relevant is W. J. Reader, *Professional Men: The Rise of the Professional Classes in Nineteenth-Century England* (London: Weidenfeld, 1966). For developments in Victorian journalism see the work of Laurel Brake, including Brake, Aled Jones, and Lionel Madden, eds. *Investigating Victorian Journalism* (New York: St. Martin's Press, 1990).

2. There is a large body of descriptive secondary literature on the Great Exhibition. Many general accounts were published on the occasion of the Exhibition's centenary; particularly useful are C. R. Fay, *Palace of Industry, 1851* (Cambridge: Cambridge University Press, 1951) and Yvonne Ffrench, *The Great Exhibition: 1851* (London: Harvill Press, 1950). Other helpful sources include Patrick Beaver, *The Crystal Palace, 1851–1936: A Portrait of Victorian Enterprise* (London: Hugh Evelyn, 1970); Tobin Andrews Sparling, *The Great Exhibition: A Question of Taste* (Exhibition Catalogue. New Haven, Conn.: Yale Center for British Art, 1982), Eric De Mare, *London 1851: The Year of the Great Exhibition* (London: The Folio Society, 1972), and, more recently, Jeffrey A. Auerbach, *The Great Exhibition of 1851: A Nation on Display* (New Haven, Conn.: Yale University Press, 1999). Thomas Richards applies a Marxist lens to the Exhibition in the first chapter of his book *The Commodity Culture of Victorian England: Advertising and Spectacle, 1851–1914* (Stanford, Ca.: Stanford University Press, 1990). The cultural history of the Exhibition is explored in two essay collections, *The Great Exhibition of 1851,* ed. Louise Purbrick (Manchester: Manchester University Press, 2001) and James Buzard, Joseph Childers, and Eileen Gilloooly, eds., *Victorian Prism: Refractions of the Crystal Palace* (Charlottesville: University of Virginia Press, 2007). George Stocking sees the Exhibition as the birthplace of modern anthropology in *Victorian Anthropology* (New York: Free Press, 1987). Some of the most analytical discussions of the Crystal Palace contextualize it with other nineteenth-century exhibitions and world's fairs; these include John Allwood, *The Great Exhibitions* (London: Studio Vista, 1977) and Paul Greenalgh, *Ephemeral Vistas: The 'Expositions Universelles,' Great Exhibitions and World's Fairs, 1851–1939* (Manchester: Manchester University Press, 1988). Benedict Burton analyzes exhibition ideology in *The Anthropology of World's Fairs: San Francisco's*

Panama Pacific International Exposition of 1915 (London: Scolar Press, 1983). I cite the primary sources I consulted as they appear below; the best starting point is the *Official Descriptive and Illustrated Catalogue of the Great Exhibition of 1851*, 3 vols. (London: Spicer Brothers, 1851).

3. Larry Lutchmansingh has gathered some of the impressive statistics: over 10,000 objects were displayed by almost 14,000 exhibitors, with over ten miles of display frontage. The building itself used 3300 cast iron columns, 34 miles of guttering tube, 2224 girders, 1128 gallery supports, 205 miles of sash bar, 33 million cubic feet of wood flooring, and measured 1851 feet by 450 feet. Larry Lutchmansingh, "Commodity Exhibitionism at the London Great Exhibition of 1851," *Annals of Scholarship* 7, no. 2 (1990): 203–16.

4. Tony Bennett sees the Exhibition as a nineteenth-century innovation on the display of state power. Using Foucault's *Discipline and Punish: The Birth of the Prison*, Bennett defines "the exhibitionary complex" as a regimen of surveillance and discipline that governed the viewers of nineteenth-century exhibitions. See Bennett, "The Exhibitionary Complex," *New Formations* 4 (Spring 1988): 73–102. Richards also makes the comparison with earlier state spectacles, writing, "In the nineteenth century, most of the rituals that fixed a king firmly at the center of a long-standing hierarchical order had disappeared...But the need for legitimating the new bourgeois order remained...[thus the spectacle was transformed] into a new kind of political theater." Richards, *Commodity Culture*, 54–55.

5. Kenneth Clark, *The Gothic Revival: An Essay in the History of Taste* (London: Penguin, [1928], 1964).

6. Rather than focusing on actual spectators, whether amateur or expert, I am looking instead at authors who harnessed contrasting rhetorics of populism versus expertise. I am thus not imagining how audiences actually saw exhibits so much as analyzing how authors positioned themselves using different forms of cultural power.

7. *Official Guide*, 23. This chapter will provide brief biographical notes on a series of would-be art experts to show how they were involved in the professionalizing world of mid-Victorian art institutions. Sir Henry Cole (1808–82) began his career as a bureaucrat; he was personally responsible for the modernization of the national record office and the postal service. In 1847 he founded an organization for the production of "art-manufactures." Cole was the most energetic member of the Exhibition's executive committee and is usually credited with its financial success. His vigorous campaigning for art education led to the diversion of some Exhibition profits into the founding of a museum of design, the South Kensington Museum, today known as the Victoria & Albert (V & A) Museum. As director of the South Kensington, Cole became one of the most influential art experts in Britain in the later nineteenth century.

8. Henry Cole delineates acceptable objects for the Fine Arts Class in *The Official Descriptive and Illustrated Catalogue*: "Those departments of art which are, in a degree, connected with material processes, which relate to working in metals, wood, or marble, and those mechanical processes which are applicable to the arts, but which...still preserve their mechanical character, as printing in colour, come properly within this Class. Paintings, as works of art, are excluded; but, as exhibiting any improvements in colours, they become admissible" (819).

9. Quoted in the *Official Descriptive and Illustrated Catalogue*, 4.

10. The theoretical soundness of the Exhibition's classification system did not translate into a neat division of all of the objects on display, since some items defied easy categorization. For instance, the "Fine Arts Court" contained, among other things, a German domestic scene of stuffed frogs and the Crown Princess's carved wooden cradle. A wig-maker famously protested the categorization of his product not as the "fine art" he esteemed it, but among "vegetable and animal substances chiefly used in manufacture, as implements, or as ornaments." Asa Briggs, *Victorian Things* (Harmondsworth: Penguin, 1988), 56.

11. The classic account is given by George Stocking in *Victorian Anthropology*.

12. Tony Bennett, "The Exhibitionary Complex," 95.

13. See Maxine Berg, *Luxury and Pleasure in Eighteenth-Century Britain* (Oxford: Oxford University Press, 2005), chap. 2, "Goods from the East," 46–84.

14. C. A. Bayly, *Imperial Meridian: The British Empire and the World, 1780–1830* (London: Longman, 1989), 18.

15. Henry Weekes (1807–77), a sculptor, was a member of the Royal Academy of Arts, and elected professor of sculpture in 1873.

16. Henry Weekes, *The Prize Treatise on the Fine Arts Section of the Great Exhibition of 1851*, [Awarded by the Society of Arts] (London: Vizetelly, 1852), 9.

17. In his memoirs, Cole relates how his idea for "art-manufactures" led directly to his administrative role in the Exhibition. In 1845, the Society of Arts (led by Prince Albert) held a competition for the best design of a tea service fit for ordinary domestic use. Cole studied Greek earthenware in the British Museum for inspiration and personally supervised the casting of his design. The tea set sold in the thousands. See Cole, *Fifty Years of Public Work of Sir Henry Cole, K. C. B., Accounted for in his Deeds, Speeches and Writings* (London: G. Bell, 1884). See also Sparling, *The Great Exhibition*, 9.

18. Mrs. Merrifield, "The Harmony of Colours as Exemplified in the Exhibition," in *The Arts Journal Illustrated Catalogue: The Industry of All Nations, 1851* (1851; reprint, London: David & Charles, 1970). Mary Philadelphia Merrifield (1804/5–89) was a scholar, expert in paint pigments, and a prolific translator of Italian art treatises. In 1844 she published a translation of Cennini's newly rediscovered fifteenth-century treatise on painting, "with introductory preface and copious notes." In 1849 she followed up with a collection of translated Italian art treatises from the twelfth to eighteenth centuries. Published on the cusp of a revival in fresco-mural painting in Europe and America, these two books were extremely influential—and are still in print in the twenty-first century.

19. Berg, *Luxury and Pleasure in Eighteenth-Century Britain*, 14.

20. Joseph Bizup, *Manufacturing Culture: Vindications of Early Victorian Industry* (Charlottesville: University of Virginia Press, 2003). In chapter four, "'Appropriate Beauty': The Work of Ornament in the Age of Mechanical Reproduction" (115–46), Bizup contrasts the pro-industry rhetoric of Cole's *Journal of Design* with that of the *Art-Union*, founded in 1839. While the *Journal of Design* sought to place ornamental arts (and the industrial techniques that produced them) on the same level as fine arts, the *Art-Union* insisted upon the superior aesthetic qualities of the fine arts, whose improvements were expected to trickle down to the lesser, and more blatantly commercial, arts of manufacture. See also James A. Schmiechen, "Reconsidering the Factory, Art-Labor,

and the Schools of Design in Nineteenth-Century Britain," *Design Issues* 6, no. 2 (Spring 1990): 58–69.

21. The 1835 Select Committee on Arts and Manufactures concluded that Britain should fund art schools largely for economic reasons. "To us as a peculiarly manufacturing nation, the connection between art and manufactures is most important;—and for this merely economical reason (were there no higher motive) it equally imports us to encourage art in its loftier attributes" (*Arts and Manufactures Select Committee Report*, British Sessional Papers, 1836). Quoted in Paul A. C. Sproll, "Matters of Taste and Matters of Commerce: British Government Intervention in Art Education in 1835," *Studies in Art Education* 35, no. 2 (Winter 1994): 110.

22. Asa Briggs, *1851* (London: The Historical Association, 1951), 20.

23. Richards, *Commodity Culture*, 17.

24. Andrew Park, Song, "The Glorious Exhibition," *The Poetical Works of Andrew Park* (London: David Bogue, 1854), 260.

25. Quoted in De Mare, *London 1851*, 36.

26. Jonathan Crary, *Techniques of the Observer: On Vision and Modernity in the Nineteenth Century* (Cambridge, Mass.: MIT Press, 1992).

27. *Little Henry's Holiday at the Great Exhibition* (London: Houlston and Stoneman, 1851), 47.

28. Mrs. Merrifield, "The Harmony of Colours," 1.

29. Michel Foucault, *The Order of Things: An Archaeology of the Human Sciences* (New York: Vintage, 1973).

30. Crary, *Techniques of the Observer*, 79.

31. Isobel Armstrong suggests that the rise of mass-produced glass inaugurated "the first era of a scopic culture," spanning approximately 1830 to 1890, which was "generated from just two components, the glass panel and the lens." See her "Technology and Text: Glass Consciousness and Nineteenth-Century Culture," in *Culture, Landscape, and the Environment: The Linacre Lectures 1997*, ed. Kate Flint and Howard Morphy (Oxford: Oxford University Press, 2000), 151.

32. *Punch* 20 (1851): 63.

33. Charles Dickens famously wrote of his overwhelming experience of the Crystal Palace, "I have a natural horror of sights, and the fusion of so many sights in one has not decreased it. I am not sure that I have seen anything but the fountain and perhaps the Amazon" (Letter to Mrs. Richard Watson, July 11, 1851, quoted in Fay, *Palace of Industry*, 73).

34. *Little Henry's Holiday at the Great Exhibition*, 74.

35. For discussions of nude controversies in Victorian painting, see Lynda Nead, *The Female Nude: Art, Obscenity, and Sexuality* (London: Routledge, 1992); and Alison Smith, *The Victorian Nude: Sexuality, Morality and Art* (Manchester: Manchester University Press, 1996).

36. Quoted in *Object Lessons from the Exhibition of the Industry of All Nations*, with the title "More Curious Facts from the Great Exhibition" (London [?]: n.p., 1851).

37. Anonymous, *Friendly Observations…to the Sculptors and Artists of Great Britain…on Some of Their Work in the Great Exhibition of the Productions of Art and Industry of all Nations*. [By a Lover of Painting and Sculpture] (London: John Farquhar Shaw, 1851), 13.

38. Ibid., 22.

39. *Punch* 20 (1851): 224.

40. Sir Charles Wentworth Dilke (1810–69) chaired the Society of Arts for many years, and worked zealously as a member of the Great Exhibition's executive committee to bring the project to fruition. Afterward he traveled to America, France, and Russia as a royal commissioner to their exhibitions.

41. Charles Wentworth Dilke, *Gallery of Arts: From the Great Exhibition of All Nations, 1851* (London: Read & Co., 1851), 110.

42. The attackers of nudity were so persuasive that, when the Crystal Palace reopened at Sydenham in 1854 as a permanent site of Victorian attraction, all of the nude sculptures on display had been covered in appropriate places with fig leaves. See Patrick Beaver, *The Crystal Palace*.

43. Robert Ackrill, *The Yorkshire Visitor's Guide to the Great Exhibition, and also to the Principal Sights of London* (Leeds: Joseph Buckton, 1851), 23.

44. *The Crystal Palace and its Contents; an Illustrated Cyclopaedia of the Great Exhibition of the Industry of All Nations* (London: W. M. Clark, 1851), 98.

45. *The Art Journal,* quoted approvingly in *The Crystal Palace and its Contents,* 119.

46. Weekes, *Prize Treatise on the Fine Arts,* 38.

47. *Crystal Palace and its Contents,* 173.

48. Ruskin writes, "It is true, greatly and deeply true, that the architecture of the North is rude and wild; —but it is not true, that, for this reason, we are to condemn it, or despise. Far otherwise: I believe it is in this very character that it deserves our profoundest reverence." "Nature of Gothic," *Works of John Ruskin,* 12:245.

49. *Crystal Palace and its Contents,* 205.

50. Richard Jenkyns, *The Victorians and Ancient Greece* (Cambridge, Mass.: Harvard University Press, 1980), 138, 137.

51. Jenkyns, *Victorians and Ancient Greece,* 146.

52. Jenkyns points out that whiteness was classed in England because those with tan skin were usually members of working or rural classes whose occupations forced them under the sun.

53. William Whewell, "The General Bearing of the Great Exhibition on the Progress of Art and Science," *Lectures on the Results of the Great Exhibition of 1851*, Ser. 1 (London: David Bogue, 1852), 1–35. Whewell (1794–1866) was a famous scholar and master of Trinity College, Cambridge. He contributed to the fields of mathematics, architectural history, geology, theology, and philosophy. He also inaugurated Prince Albert's prestigious lecture series on the lessons of the Exhibition. His essay is important in the history of anthropology for its vision of the Crystal Palace as a "magical glass" in which "the infancy of nations, their youth, their middle age, and their maturity, all appear, in their simultaneous aspect, like the most distant objects revealed at the same moment by a flash of lightning in a dusky night" (13).

54. Whewell, "General Bearing of the Great Exhibition," 15.

55. *The Crystal Palace and its Contents,* 305.

56. *Official Descriptive and Illustrated Catalogue,* 1598.

57. Little Henry's Papa (of *Little Henry's Holiday at the Great Exhibition*) asks him, "How would you like your mamma to be taken away, and to be chained, and thus held up for sale?" (78). The poet Samuel Warren wrote of the sculpture, "Look ye yourselves upon

her loveliness! / Ponder her thrilling tale of grief!— / She is not mute, O marble eloquent! / She pleads! She pleads!" (quoted in Beaver, *The Crystal Palace*, 61).

58. The history of the British antislavery movement can be found in Howard Temperly, *British Antislavery, 1833–1870* (Columbia: University of South Carolina Press, 1972).

59. *Punch* 20 (1851): 236. Another Exhibition source contrasting Powers's sculpture with American slaves is an anonymous antislavery propaganda play, a two-act comic farce titled *Chaff, or, The Yankee and Nigger at the Exhibition* (1853). The play depicts the grotesque shenanigans of different visitors to the Exhibition all staying in the same boarding house, among them "Gumbo Jumbo," an escaped American slave. Despite much gross stereotyping, the author is well-informed about the slavery debate and puts surprisingly moving words into the dialect-heavy speech of the ex-slave. These include an attack on the hypocrisy of Power's statue and a vision of a utopian slave-free future: "[D]e world shall yet see coloured Shakespeares and black Miltons" (65). The play is held by the National Arts Library, London.

60. Powers' *The Greek Slave* has a long bibliography in American criticism and art history, receiving a whole chapter in Jean Fagan Yellin's book, *Women and Sisters: The Antislavery Feminists in American Culture* (New Haven, Conn.: Yale University Press, 1989). Powers completed the sculpture in 1843, and before it even arrived in Britain it had acquired a huge volume of responses in the American press. Many with abolitionist leanings compared the sculpted slave to American slaves. According to Yellin, *The Greek Slave* was the most popular American sculpture of the nineteenth century, as well as, significantly, "the first female nude to win the acceptance of American audiences" (102).

61. Charles Wentworth Dilke, *Reminiscences of the Crystal Palace, with a Full Description of the Principal Objects Exhibited* (London: Routledge, 1852), 125.

62. James Ward, *The World in its Workshops: A Practical Examination of British and Foreign Processes of Manufacture, with a Critical Comparison of the Fabrics, Machinery, and Works of Art Contained in the Great Exhibition.* (London: William S. Orr, [1851]), 148, 149.

63. *Crystal Palace and its Contents*, 305.

64. For an American perspective on the Exhibition, see Horace Greeley, *Glances at Europe: In a Series of Letters from Great Britain, France, Italy, Switzerland, &c. during the Summer of 1851* (New York: Dewitt & Davenport, 1851). Greeley bristles at the sneering attacks of the British press against the American entries in the Exhibition. He points out that Britain has in fact engineered its own domination of the arts-manufactures pyramid through its colonial economic policy. Britain has encouraged America to "grow Food and Cotton and send them hither in exchange for Wares and Fabrics, especially those of the finer and costlier varieties...Well: here are American samples of all the staples you say our Country *ought* to produce and be content with... yet these you run over with a glance of cool contempt, and say we have nothing in the Exhibition!" (91).

65. This sonnet first appeared in the periodical edited by Charles Dickens, *Household Words* 2:31 (October 26, 1850): 99. It was reprinted, along with Barrett Browning's other antislavery poems, in her 1850 *Poems*.

66. "Mr. Pugin's Mediaeval Court," *Journal of the Great Exhibition of 1851* 1:14 (May 24, 1851): 277.

67. Mrs. Merrifield, "The Harmony of Colours as Exemplified in the Exhibition," 8.

68. *Crystal Palace and its Contents*, 215.

69. See Walter Arnstein, *Protestant Versus Catholic in Mid-Victorian England* (Columbia: University of Missouri Press, 1982).

70. Quoted in Auerbach, *The Great Exhibition of 1851*, 171.

71. Quoted in Fay, *Palace of Industry*, 37.

72. Quoted in Beaver, *The Crystal Palace*, 59.

73. Ralph N. Wornum (1812–77) wrote art criticism for the *Art Journal* in the 1840s. In 1847 he wrote the official catalogue to the collection in the National Gallery, and in 1854 he was installed as keeper and secretary to the trustees of the Gallery, reforming the position from its previously clerical nature into one of active arts administration.

74. Ralph Wornum, "The Exhibition as a Lesson in Taste," Prize Essay in *The Arts Journal Illustrated Catalogue: The Industry of All Nations, 1851* (1851; reprint, London: David & Charles, 1970), 2, 5.

75. C. A. Bayly traces similarities between the British governance of Catholic Ireland and other colonial territories like Jamaica in *Imperial Meridian*, 86–95.

76. Wornum, "The Exhibition as a Lesson in Taste," 2.

77. Weekes, *Prize Treatise on the Fine Arts Section*, 15.

78. Mrs. Merrifield, "The Harmony of Colours as Exemplified in the Exhibition," 8.

79. *Punch* 20 (1851): 37.

80. Bayly, *Imperial Meridian*, 152.

81. See Dennis T. Lanaghan, *A Dream of the Past: Pre-Raphaelite and Aesthetic Movement Paintings, Watercolours, and Drawings from the Lanigan Collection* (Toronto: University of Toronto Art Centre, 2000), 10.

82. Michaela Giebelhausen writes, "Although religious painting constituted a minute field of artistic production, the periodical press invested it with a disproportionate amount of symbolic capital." "Academic Orthodoxy versus Pre-Raphaelite Heresy: Debating Religious Painting at the Royal Academy, 1840–50," in *Art and the Academy in the Nineteenth Century*, ed. Colin Trodd and Rafael Cardoso Denis (New Brunswick, N.J.: Rutgers University Press, 2000), 168.

83. Anna Jameson, *Sacred and Legendary Art*, 5th ed. (London: Longmans, Green, 1866), 7–8.

84. Stephen Bann, *The Clothing of Clio: A Study of the Representation of History in Nineteenth-Century Britain and France* (Cambridge: Cambridge University Press, 1984). See also Christina Crosby, "Reading the Gothic Revival: 'History' and Hints on Household Taste," in *Rewriting the Victorians: Theory, History, and the Politics of Gender*, ed. Linda M. Shires (New York: Routledge, 1992), 101–15.

85. The Victorian love affair with Raphael also had nationalist overtones because Britain had acquired, in the seventeenth century, a series of Raphael's cartoons for the Sistine Chapel tapestries, and displayed them at Hampton Court Palace. This aesthetic possession signaled one of the ways that Britain was claiming the patrimony of Renaissance Italy. The earlier European culture combined an artistic and economic power that Britain wanted to inherit, if only symbolically. In 1865 Queen Victoria decided that the Raphael cartoons should be loaned for display to the Victoria and Albert museum, where they can still be seen today. Her decision cements a link of the Raphael cartoons to the Great Exhibition, since the V & A was founded as the "South Kensington Museum" in 1852 to permanently display some of the designed wares from the 1851 event.

86. Ralph Wornum, "Modern Moves in Art: The Young England School," *The Art-Journal* 12 (September 1, 1850): 269–71.

87. *Punch* 19 (May 18, 1850): 198.

88. Charles Dickens, "Old Lamps for New Ones," *Household Words* 12 (June 15, 1850): 12–14. J. B. Bullen gives an excellent account of the controversy surrounding Millais's painting in *The Pre-Raphaelite Body: Fear and Desire in Painting, Poetry, and Criticism* (Oxford: Clarendon Press, 1998). See especially the first chapter, "The Ugliness of Early Pre-Raphaelitism," in which he interprets much of the negative press received by the Pre-Raphaelites in 1850 as a function of their perceived allegiance to the Catholic church.

89. Ibid., 13.

90. "The Royal Academy. May Exhibition," *Tait's Edinburgh Magazine* 17 (June 1850): 355–60. The offensive "red hair" on the Virgin Mary, singled out by this Scottish critic, might allude to the influx of Irish-Catholic immigrants into Scotland in the wake of the potato famine, which served to fan the flames of anti-Catholic sectarianism in the 1840s and 1850s.

91. Ibid., 356.

92. F. G. Stephens, "The Purpose and Tendency of Early Italian Art," *The Germ* (1850): 59.

93. Ibid., 60.

94. Ibid., 58.

95. John Ruskin, "Pre-Raphaelitism" (1851), in *Works of John Ruskin,* 12:357.

96. For more on the idiosyncrasies and contradictions of Ruskin's visual theories, see chapter 1.

97. Ruskin, "Pre-Raphaelitism," 12:359, 12:357.

98. A. W. Pugin, *An Apology for the Revival of Christian Architecture in England* (London: John Weale, 1843), 4.

99. W. H. Leeds, "Architectural Revival and Puginism," *Fraser's Magazine* (1843): 605. Quoted in Nicola Humble, "The Poetry of Architecture: Browning and Historical Revivalism," *Victorian Literature and Culture* 25, no. 2 (1997): 226.

100. Quoted in Benjamin Ferrey, *Recollections of A. W. N. Pugin and His Father Augustus Pugin* (London: Scolar Press, [1861], 1978), 107.

101. *Works of John Ruskin,* 10:114. Ruskin sees the glass-and-iron architecture of the Crystal Palace as a symbol of the mechanical production he despises. The title of his tract is *The Opening of the Crystal Palace Considered in Some of its Relations to the Prospects of Art* (London: Smith, Elder & Co., 1854). For an extended analysis of Ruskin's reaction to the Crystal Palace design, see Gary Wihl, "'Neither a Palace Nor of Crystal': Ruskin and the Architecture of the Great Exhibition," *Architectura* 13, no. 2 (1983): 187–202.

102. Owen Jones (1809–74), architect and ornament designer, was appointed superintendent of the works of the Great Exhibition in 1851, and helped to direct the arrangement and decoration of the building. In 1852 he was made joint director of the decoration of the Crystal Palace at Sydenham. He became famous as an interior decorator with expertise in Egyptian, Greek, Roman, and Spanish-Arabic styles, as elucidated in his well-known book *The Grammar of Ornament* (1856).

103. Owen Jones, "Colour in the Decorative Arts," in *Lectures on the Results of the Great Exhibition of 1851 . . . 2nd Series* (London: David Bogue, 1853), 266.

104. Sir Matthew Digby Wyatt (1820–77), architect and art writer, was employed by the Society of Arts in 1849 to report on the French Exhibition; his excellent report secured him the post of secretary to the executive committee of the Great Exhibition. Afterward, when the Crystal Palace was relocated to Sydenham, he superintended

the arrangements of the fine arts departments into different time periods and nationalities. In 1869 he was selected to hold the first Slade professorship of fine arts at Cambridge.

105. Digby Wyatt, "Form in the Decorative Arts," in *Lectures on the Results of the Great Exhibition of 1851*, 237.

106. Henry Cole, "On the International Results of the Exhibition of 1851," in *Lectures on the Results of the Great Exhibition of 1851*, 420. Of course, Cole's claim that Britain is exempt from "the follies of nationality" must seem somewhat absurd given the patriotic fervor surrounding the Exhibition. Indeed, his main point is that Britain's cosmopolitanism makes it superior to other nations.

107. For the history of the South Kensington Museum and Cole's active role in its founding see Anthony Burton, *Vision and Accident: The Story of the Victoria and Albert Museum* (London: V & A Publications, 1999).

108. I would argue, though, that the aesthetes did inherit from Cole and the Exhibition's other experts a sense of distinction adhering to the formal valuation of art. Even though the aims of the two groups differed tremendously, both still wanted to set themselves apart from average spectators using similar interpretative approaches.

109. Matei Calinescu, *Five Faces of Modernity,* 2nd ed. (Durham, N.C.: Duke University Press, 1987), 229.

Chapter 3

1. See Gordon J. Fyfe, "Art Exhibitions and Power during the Nineteenth Century," in *Power, Action and Belief*, ed. John Law (London: Routledge & Kegan Paul, 1986), 20–45; and Sidney C. Hutchinson, *The History of the Royal Academy, 1768–1986*, 2nd ed. (London: Royce, 1986).

2. Accounts of a Victorian avant-garde have been narrated almost exclusively by art historians. These include David Peters Corbett, *The World in Paint: Modern Art and Visuality in England, 1848–1914* (University Park: Pennsylvania State University Press, 2004); Elizabeth Prettejohn, *Art for Art's Sake: Aestheticism in Victorian Painting* (New Haven, Conn.: Yale University Press, 2007); and Dianne Sachko MacLeod, "The Dialectics of Modernism and English Art," *The British Journal of Aesthetics* 35, no. 1 (1995): 1–14. In *The British Avant-Garde: The Theory and Politics of Tradition* (New York: Harvester Wheatsheaf, 1991), Josephine Guy argues that writers like Pater, Morris, and Wilde belonged to a British avant-garde defined by their appropriation of tradition "to authorise non-conventional practices" (14). Guy approaches the subject as an intellectual history of individual writers, rather than considering specific cultural contexts or group formations of their moment.

3. Unlike other Victorian writers, Pater regularly appears in writings and collections on modernism. For a recent example see Heather K. Love, "Forced Exile: Walter Pater's Queer Modernism," in *Bad Modernisms*, ed. Douglas Mao and Rebecca L. Walkowitz (Durham, N.C.: Duke University Press, 2006). In *Walter Pater: Lover of Strange Souls* (New York: Knopf, 1995), Denis Donoghue sees Pater's influence in modernist writers who include Yeats, Woolf, Eliot, and Ashbury. For Pater and postmodernism see Jonathan Loesberg, *Aestheticism and Deconstruction: Pater, Derrida, and De Man* (Princeton, N.J.: Princeton University Press, 1991).

4. Greenberg's footnote reads, "The ideas about music which Pater expresses in *The School of Giorgione* reflect this transition from the musical to the abstract better than any single work of art." "Towards a Newer Laocoön," *Partisan Review* 7, no. 4 (July–August 1940): 305.

5. Most scholarship on "The School of Giorgione" focuses on the essay's advocacy of formalism through the figure of music. See, for instance, Patricia Herzog, "The Condition to Which All Art Aspires: Reflections on Pater on Music," *British Journal of Aesthetics* 36, no. 2 (April 1996): 122–34.

6. Peter Bürger, *Theory of the Avant-Garde,* trans. Michael Shaw (Minneapolis: University of Minnesota, 1984).

7. Kenneth Clark, Introduction, *The Renaissance* (New York: Fontana/Collina, 1961), x.

8. "Subjective criticism" is also the name given to a version of reader-response literary theory in the twentieth century. See David Bleich, *Subjective Criticism: Reading, Response, and Values in the Teaching of Literature* (Baltimore: Johns Hopkins University Press, 1978). Ian Small describes the mid-century professionalization of criticism—and Pater's reaction against this development—in *Conditions for Criticism: Authority, Knowledge, and Literature in the Late Nineteenth Century* (Oxford: Clarendon Press, 1991).

9. Philip G. Hamerton, "Art Criticism," *Cornhill Magazine* 8 (1863): 334–43. Elizabeth Prettejohn further contextualizes art criticism in the 1860s in her article, "Aesthetic Value and the Professionalization of Victorian Art Criticism 1837–78," *Journal of Victorian Culture* 2 (1997): 71–94.

10. Kate Flint, *The Victorians and the Visual Imagination* (Cambridge: Cambridge University Press, 2000), 196.

11. For a more in-depth exploration of *Modern Painters V* see Rachel Teukolsky, "Modernist Ruskin, Victorian Baudelaire: Revisioning Nineteenth-Century Aesthetics." *PMLA* 122, no. 3 (May 2007): 711–27.

12. As Nicholas Shrimpton summarizes, Ruskin in the 1870s "expressed views fiercely hostile to Aestheticism," yet "could also speak and act in ways which seem unexpectedly Aesthetic" (150). Nicholas Shrimpton, "Ruskin and the Aesthetes," in *Ruskin and the Dawn of the Modern,* ed. Dinah Birch (Oxford: Oxford University Press, 1999), 131–51.

13. Charles Swinburne, *William Blake: A Critical Essay* (1868). Quoted in Jerome McGann and Charles L. Sligh, eds. *Algernon Charles Swinburne: Major Poems and Selected Prose* (New Haven, Conn.: Yale University Press, 2004), 380–81.

14. Charles Swinburne, "Notes on Designs of the Old Masters at Florence," in *The Complete Works of Algernon Charles Swinburne,* eds. Edmund Gosse and Thomas James Wise, vol. 15 (London: William Heinemann, 1926), 160.

15. Swinburne, "Notes on Some Pictures of 1868," *Complete Works,* 15:198.

16. Sidney Colvin, "English Painters and Painting in 1867," *The Fortnightly Review* n.s. 2 (July–December 1867): 464.

17. W. M. Rossetti, "Royal Academy Exhibition," *The Chronicle* (May 25, 1867): 210.

18. See Catherine Carter Goebel, "The Brush and the Baton: Influences on Whistler's Choice of Musical Terms for his Titles," *The Whistler Review* 1 (1999): 27–36.

19. [Walter Pater], "The Earthly Paradise," *Westminster Review* 90 (October 1868): 300–21. The review is reprinted in *William Morris: The Critical Heritage,* ed. Peter Faulkner (London: Routledge & Kegan Paul, 1973), 92.

20. Kirsten MacLeod studies aesthetic fiction in *Fictions of British Decadence: High Art, Popular Writing, and the Fin de Siècle* (New York: Palgrave Macmillan, 2006). As MacLeod's study would suggest, most aesthetic fiction was produced in the 1890s, while aesthetic poetry and painting were already circulating in the 1860s.

21. Walter Pater, "Winckelmann," in *The Renaissance: Studies in Art and Poetry*, ed. Donald L. Hill (Berkeley and Los Angeles: University of California Press, 1980), 146. All future quotations from the text will refer parenthetically to this edition.

22. See William Shuter, "History as Palingenesis in Pater and Hegel," *PMLA* 86, no. 3 (May 1971): 411–21.

23. Mrs. Pattison, *Westminster Review* n. s. 43 (April 1873): 639–41. Quoted in *Walter Pater: The Critical Heritage*, ed. R. M. Seiler (London: Routledge & Kegan Paul, 1980), 71.

24. March 17, 1873, in *The Letters of Walter Pater*, ed. L. Evans (Oxford: Clarendon Press, 1970), 12–14.

25. Linda Dowling, *The Vulgarization of Art: The Victorians and Aesthetic Democracy* (Charlottesville: University of Virginia Press, 1996), 77.

26. W. J. Courthope, "Modern Culture," *Quarterly Review* 137 (October 1874): 409.

27. Sidney Colvin, "English Painters and Painting in 1867," *The Fortnightly Review* n.s. 2 (July–December 1867): 464.

28. Oscar Wilde, "The Grosvenor Gallery," *Dublin University Magazine,* 90 (July 1877): 118–26.

29. Walter Pater, "The School of Giorgione," in *The Renaissance,* 102.

30. Billie Inman, Elizabeth Prettejohn, and J. B. Bullen all suggest in passing that "School of Giorgione" responds to the Grosvenor Gallery controversy, but none of these scholars makes the comparison in any detail. See Billie Andrew Inman, *Walter Pater and His Reading, 1874–1877* (New York: Garland, 1990), 380–81; Elizabeth Prettejohn, "Walter Pater and Aesthetic Painting" in *After the Pre-Raphaelites: Art and Aestheticism in Victorian England*, ed. Elizabeth Prettejohn (New Brunswick, N.J.: Rutgers University Press, 1999), 39; and J. B. Bullen, *The Pre-Raphaelite Body: Fear and Desire in Painting, Poetry, and Criticism* (Oxford: Clarendon Press, 1998), 203 n.

31. Walter Hamilton, *The Aesthetic Movement in England*, 3rd ed. (1882; reprint, New York: Garland, 1986), 23.

32. For history and analysis of the Grosvenor Gallery, see Christopher Newall, *The Grosvenor Gallery Exhibitions: Change and Continuity in the Victorian Art World* (Cambridge: Cambridge University Press, 1995); Colleen Denney, *At the Temple of Art: The Grosvenor Gallery, 1877–1890* (London: Associated University Presses, 2000); Susan P. Casteras and Colleen Denney, eds. *The Grosvenor Gallery: A Palace of Art in Victorian England* (New Haven, Conn.: Yale University Press, 1996); and Barrie Bullen, "The Palace of Art: Sir Coutts Lindsay and the Grosvenor Gallery," *Apollo* 102 (November 1975): 352–57.

33. *Complete Works of Oscar Wilde* (New York: Harper & Row, 1989), 18.

34. Wilde's review, signed with his name and "Magdalen College, Oxford," was published in *Dublin University Magazine* 90 (July 1877): 118–26.

35. Shearer West, "Tom Taylor, William Powell Frith, and the British School of Art," *Victorian Studies* 33, no. 2 (Winter 1990): 307–26.

36. Kate Flint analyzes modes of narrative in Victorian painting in *The Victorians and the Visual Imagination* (Cambridge: Cambridge University Press, 2000), chap. 8, "Criticism, Language, and Narrative."

37. Henry James, "The Picture Season in London, 1877," in *The Painter's Eye: Notes and Essays on the Pictorial Arts by Henry James*, ed. John L. Sweeney (Cambridge, Mass.: Harvard University Press, 1956), 148. James's attitude toward British aestheticism was highly conflicted, as Jonathan Freedman analyzes it in *Professions of Taste: Henry James, British Aestheticism and Commodity Culture*. (Stanford, Ca.: Stanford University Press, 1990). James often took more avant-garde views, mocking the taste of the typical bourgeois viewer, but he also criticized aesthetic paintings for their elitist and unrealistic styles. Similarly, his fiction adopted a formalist shapeliness associated with aestheticism, even while his plots tended to vilify aesthetes as immoral opportunists.

38. Quoted in E. R. and J. Pennell, *The Life of James McNeill Whistler* (Philadelphia, Pa.: J. B. Lippincott and Heinenmann, 1909), 81–82.

39. On the growth of Victorian art audiences, see Brandon Taylor, *Art for the Nation: Exhibitions and the London Public, 1747–2001* (New Brunswick, N.J.: Rutgers University Press, 1999), especially chap. 3, "Instructing the Whole Nation . . ."

40. "The Grosvenor Gallery," *Daily News* (July 21, 1877): 4.

41. James, "The Picture Season in London, 1877," 145.

42. Kate Flint also discusses the critical reaction to Burne-Jones at the Grosvenor Gallery. She focuses on the psychologist James Sully's response to Burne-Jones's 1878 painting *The Mirror of Venus,* and analyzes the contributions of late-Victorian psychology to the notion of aesthetic spectatorship. See "Edward Burne-Jones's *The Mirror of Venus:* Surface and Subjectivity in the Art Criticism of the 1870s," in Prettejohn, *After the Pre-Raphaelites*, 152–64.

43. James, "The Picture Season in London, 1877," 144.

44. H. Heathcote Statham, "The Grosvenor Gallery," *Macmillan's Magazine* 36 (May 1877): 113.

45. "Letter 79: Life Guards of New Life," *Fors Clavigera* 7 (July 1877), in *The Works of John Ruskin,* ed. E. T. Cook and Alexander Wedderburn, 39 vols. (London: George Allen, 1903–12), 29:160.

46. Hamilton, *Aesthetic Movement in England*, 18.

47. *The Grasshopper* was a three-act play adapted by John Hollingshead from a French comedy, *La Cigale,* a parody of Impressionist painters. The London play replaced the Impressionist hero with a modern artist more recognizable to British audiences. It premiered at the Gaiety Theatre in December 1877. See Theodore Reff, "Degas and the Literature of his Time—II," *Burlington Magazine* 112, no. 811 (October 1970): 674–88; "Appendix I: *La Cigale* in England," 687–88.

48. "Whistler versus Ruskin," *Illustrated London News* 73 (November 30, 1878): 518.

49. "Whistler: A Fantasia in Criticism," *London* (August 18, 1877): 63.

50. The trial transcripts have been assembled from contemporary newspaper accounts by Linda Merrill in *A Pot of Paint: Aesthetics on Trial in* Whistler v. Ruskin (Washington, D.C.: Smithsonian Institute Press, 1992), 178.

51. Tom Taylor, "The Grosvenor Gallery," *The Times* (May 2, 1878): 7.

52. Merrill, *Aesthetics on Trial,* 184; "Whistler versus Ruskin," *Illustrated London News* 73 (November 30, 1878): 518.

53. "A Symphony in Bronze," *Examiner* (November 30, 1878): 1516.

54. Henry James, "On Whistler and Ruskin (1878)," in *The Painter's Eye,* 173.

55. "Whistler v. Ruskin," *Saturday Review* (November 30, 1878): 687.

56. James McNeill Whistler, *Whistler vs. Ruskin: Art & Art Critics*. Reprinted in *Whistler on Art: Selected Letters and Writings, 1849–1903*, ed. Nigel Thorp (Manchester: Fyfield Books, 1994), 57.

57. Ibid.

58. Hamilton, *Aesthetic Movement in England*, 17.

59. See Stuart Culver, "*Whistler v. Ruskin*: The Courts, the Public, and Modern Art," in *The Administration of Aesthetics: Censorship, Political Criticism, and the Public Sphere*, ed. Richard Burt (Minneapolis: University of Minnesota Press, 1994), 153; and Dowling, *Vulgarization of Art*, 37–47.

60. For analysis of Leighton's unusual position as both aesthete and academician see Tim Barringer and Elizabeth Prettejohn, eds., *Frederic Leighton: Antiquity, Renaissance, Modernity* (New Haven, Conn.: Paul Mellon Centre for Studies in British Art, 1999).

61. See Alastair Grieve, "Rossetti and the Scandal of Art for Art's Sake in the Early 1860's," in *After the Pre-Raphaelites*, ed. Prettejohn, 17–35; and Paul Spencer-Longhurst, *The Blue Bower: Rossetti in the 1860's* (London: Scala & The Barber Institute of Fine Arts, 2000).

62. Elizabeth Prettejohn, "Beautiful Women with Floral Adjuncts: Rossetti's New Style," in *Dante Gabriel Rossetti*, ed. Julian Treuherz, Elizabeth Prettejohn, and Edwin Becker (New York: Thames & Hudson, 2003), 69.

63. See, for example, F. G. Stephens, "Pictures by Rossetti," *Athenaeum* 2494 (August 14, 1875): 219–21. An extensive bibliography of reviews of Rossetti and other Pre-Raphaelite artists can be found in Thomas J. Tobin, *Pre-Raphaelitism in the Nineteenth-Century Press: A Bibliography* (Victoria, B.C.: University of Victoria Press, 2002).

64. Megilp, "The Grosvenor Gallery and the Royal Academy," *Vanity Fair* 17 (May 5, 1877): 281.

65. Statham, "The Grosvenor Gallery," 118.

66. Denney, *At the Temple of Art*, 72.

67. Hamilton, *Aesthetic Movement in England*, 23.

68. Harry Quilter, "The New Renaissance; or, The Gospel of Intensity," *Macmillan's Magazine* 42 (September 1880), 393, 400.

69. Merrill, *Aesthetics on Trial*, 159.

70. Matthew Arnold, *Culture and Anarchy* (London: Smith, Elder, & Co., 1869), 45. Of course, it was only a matter of time before Arnold himself was accused of belonging to the school of "culture" he was promoting.

71. Pater's specific target is J. A. Crowe and G. B. Cavalcasselle's *A History of Painting in North Italy*, 2 vols. (London: John Murray, 1871).

72. In "'Schooling Leonardo': Collaboration, Desire, and the Challenge of Attribution in Pater," Jonah Siegel argues that Pater celebrates schools in a way that modern art history does not. Siegel points out that Pater reverses the valuations of doctrinaire art history, for which the "school" is a negative concept, an idea of lesser achievement. Siegel's important analysis focuses largely on "Leonardo da Vinci," but his argument also applies to "The School of Giorgione." In *Walter Pater: Transparencies of Desire*, eds. Laurel Brake, Lesley Higgins, and Carolyn Williams (Greensboro, N.C.: ELT Press, 2002), 133–50.

73. Pater also wrote an essay on "Dante Gabriel Rossetti" in 1883, upon the occasion of the poet's death. His depiction of Rossetti here is perhaps less explicitly subversive

and "Giorgionesque" than it was in 1877. Pater works to emphasize the spiritual qual-
ity of Rossetti's sensuous works in both painting and poetry, protesting against the
"false contrast" created by "schoolmen" between "spirit and matter." His new emphasis
on "aesthetic worship" accords with the religious meditations in the *Greek Studies* and
in *Marius*, discussed later in this chapter. Pater's depiction of Rossetti as spiritualizing
the body still has a subversive edge, however. Walter Pater, *Appreciations, with an Essay
on Style* (Evanston, Ill.: Northwestern University Press, 1987), 212.

74. The *Fête Champêtre* is now usually attributed to Titian; for the purposes of this chapter,
however, I refer to it as a work of Giorgione.

75. Rossetti's sonnet was first published in *The Germ* (1850), and again, extensively
revised, in *Poems* (1870):

> For *A Venetian Pastoral* by Giorgione (In the Louvre)
>
> WATER, for anguish of the solstice:—nay,
> But dip the vessel slowly,—nay, but lean
> And hark how at its verge the wave sighs in
> Reluctant. Hush! Beyond all the depth away
> The heat lies silent at the brink of day:
> Now the hand trails upon the viol-string
> That sobs, and the brown faces cease to sing,
> Sad with the whole of pleasure. Whither stray
> Her eyes now, from whose mouth the slim pipes creep
> And leave it pouting, while the shadowed grass
> Is cool against her naked side? Let be:—
> Say nothing now unto her lest she weep,
> Nor name this ever. Be it as it was,—
> Life touching lips with Immortality.

76. On the link between Manet and Giorgione see Michael Fried, "Manet's Sources:
Aspects of his Art, 1859–1865," *Artforum* 7 (March 1969): 40–46.

77. Agnes Atkinson, "The Grosvenor Gallery," *Portfolio* 8 (1877): 98.

78. Quilter, "The New Renaissance," 392.

79. Linda Dowling, *Hellenism and Homosexuality in Victorian Oxford* (Ithaca, N.Y.: Cornell
University Press, 1994), 112.

80. George Du Maurier, "Modern Aesthetics," *Punch* (February 10, 1877): 242.

81. 'Z,' "Modern Cyrenaicism," *Examiner* (April 12, 1873): 381–82. Reprinted in Seiler,
Walter Pater: The Critical Heritage, 76.

82. W. H. Mallock, *The New Republic; or, Culture, Faith, and Philosophy in an English Country
House* (London: Chatto & Windus, [1877], 1906), 28.

83. A reviewer of Burne-Jones's figures accuses them of having "a satiated, worn-out look,
the very reverse of healthy." Megilp, "The Grosvenor Gallery," 281. The extensive bib-
liography on the sexual politics of aestheticism includes Dowling, *Hellenism and Homo-
sexuality*; Richard Dellamora, *Masculine Desire: The Sexual Politics of Victorian Aestheticism*
(Chapel Hill: University of North Carolina Press, 1990); Dennis Denisoff, *Aestheticism
and Sexual Parody, 1840–1940* (Cambridge: Cambridge University Press, 2001); and
Thaïs E. Morgan, "Victorian Effeminacies," in *Victorian Sexual Dissidence*, ed. Richard
Dellamora (Chicago: University of Chicago Press, 1999), 109–26.

84. Walter Pater, "*Love's Labour's Lost*," in *Appreciations*, 164–65.

85. A lavishly illustrated introduction to the world of aesthetic commodities is Charlotte Gere, *House Beautiful: Oscar Wilde and the Aesthetic Interior* (Aldershot, U.K.: Lund Humphries, 2000). Reginia Gagnier presents an important study of aesthetic commodity culture in the 1890s in *Idylls of the Marketplace: Oscar Wilde and the Victorian Public* (Stanford, Ca.: Stanford University Press, 1986).

86. T. Hall Caine, *Recollections of Dante Gabriel Rossetti* (London: Elliot Stock, 1882), 47–48. For more on Rossetti's china collection and British "chinamania," see Elizabeth H. Chang, "'Eyes of the Proper Almond-Shape': Blue-and-White China in the British Imaginary, 1823–1883," *Nineteenth Century Studies* 19 (2005): 17–34.

87. George Du Maurier, "The Six-Mark Tea-Pot," *Punch* 79 (1880): 194.

88. Justin McCarthy, "The Pre-Raphaelites in England," *Galaxy* 21 (1876): 725–32. Quoted in Bullen, *The Pre-Raphaelite Body*, 192.

89. Leonore Davidoff, *The Best Circles* (London: Croom Helm, 1973), 59. As Davidoff notes, a few "rich entrepreneurs" and "talented entertainers" had always been found in Society circles; but these were "the remarkable and remarked few" (59).

90. Colleen Denney, "The Grosvenor Gallery as Palace of Art: An Exhibition Model," in *The Grosvenor Gallery,* ed. Casteras and Denney, 25.

91. See Linda Merrill, *The Peacock Room: A Cultural Biography* (New Haven, Conn.: Yale University Press, 1998).

92. James, "The Picture Season in London, 1877," 139.

93. *Mrs. J. Comyn-Carr's Reminiscences*, ed. E. Adam (1925), 27. Quoted in Davidoff, *The Best Circles,* 64.

94. *Daily Telegraph* (November 27, 1878): 5.

95. Merrill, *Aesthetics on Trial*, 177.

96. Ibid., 168.

97. Dianne Sachko MacLeod, *Art and the Victorian Middle Class: Money and the Making of Cultural Identity* (Cambridge: Cambridge University Press, 1996), especially 124–26.

98. For Harry Quilter, a chief transgression of the Aesthetic movement is that "the incomprehensibility of art-criticism [is seen] to be a guarantee of its profundity." Quilter, "The New Renaissance," 400.

99. Individual workshops and firms are described in Victor Arwas, *Art Nouveau: From Mackintosh to Liberty: The Birth of a Style* (London: Andreas Papadakis, 2000). Arwas devotes different chapters to Glasgow, Dundee, London, and Birmingham as sites of aesthetic production.

100. The history of the store is narrated by Alison Adburgham in *Liberty's: A Biography of a Shop* (London: George Allen & Unwin, 1975).

101. Japanese art first became popular in Britain when it appeared in the Japanese section of the International Exhibition of 1862, finally appearing on British shores in the wake of a new commercial treaty signed in 1858. Some of the objects on display made their way into the "Oriental Warehouse" attached to Farmer & Rogers's Great Shawl and Cloak Emporium, managed by Arthur Liberty. Liberty later opened his own shop, thus beginning his ascendance as an arbiter of aesthetic fashion. See Toshio Watanabe, *High Victorian Japonisme* (Bern: Lang, 1991).

102. James Eli Adams, *Dandies and Desert Saints: Styles of Victorian Manhood* (Ithaca, N.Y.: Cornell University Press, 1995), 206–7. Adams is less interested in the collective

nature of these organizations than in the fact of their secrecy, which, he argues, ties Pater to a bourgeois ideal of ascetic masculinity.

103. See Leon Chai, *Aestheticism: The Religion of Art in Post-Romantic Literature* (New York: Columbia University Press, 1990). James Eli Adams argues that the priest is an important masculine model for aestheticism. See *Dandies and Desert Saints,* especially 202–3.

104. Walter Pater, *Greek Studies: A Series of Essays* (London: Macmillan, 1910), 11. All future citations will refer parenthetically in the text to this edition.

105. Pater's simultaneous investment in both synchronic and diachronic Western history is powerfully analyzed by Carolyn Williams in *Transfigured World: Walter Pater's Aesthetic Historicism* (Ithaca, N.Y.: Cornell University Press, 1989). While many of my observations accord with Williams's, we both ultimately work toward different ends. Williams argues (to crudely reduce her elegant discussion) that Pater's "aesthetic historicism" is founded upon his dialectical notion of history: artworks are always differentiated by the culture that creates them, but from a relativist, comparative perspective they can also be united across time into a single, Western aesthetic continuum. Williams's goal is to read "both aestheticism and historicism" as "strategies of epistemological self-consciousness and representation" (3)—in other words, to place Pater in a philosophical trajectory toward modernism. Yet the close focus upon Pater's writings, to the exclusion of contextualization, means that the emphasis lands much more upon historicism than upon history itself—that is to say, the synchronic aspects of history in Pater's writings are quickly taken as a bridge to the diachronic trajectories he weaves across his essays. As Williams notes, her study is "concerned throughout...with Pater's practices of generalization" (7). This emphasis can be seen in her conclusion about the myth studies, where Pater's "extreme form of literary comparativism" ultimately reveals "so many connections and overlappings that every version of every story seems to be part of a vast totality, a deep and stable structure that reiteratively expresses itself throughout history" (257). In my analysis, by contrast, Pater's subversive play with history allows him to comment obliquely upon the specific conditions of his own day, though in highly idealized and aestheticized terms. Hence I use the term "political" to describe some of Pater's historicist leaps, while Williams gestures toward more universalist frameworks, such as the Freudian unconscious, as extensions of Paterian thought. This is all by way of distinguishing my analysis from hers; Williams's book still stands as the definitive study of Pater's philosophy.

106. Linda Dowling concludes that Pater's "ethical" stage of myth exhibits "qualities other people would call 'aesthetic'" (218). "Walter Pater and Archaeology: The Reconciliation with Earth," *Victorian Studies* 31, no. 2 (Winter 1988): 209–31. Dowling reads Pater's essay on Demeter and Persephone for its engagement with the new Victorian social sciences of archaeology and comparative mythology. Pater's "ethical phase" of myth addresses in particular the sculptures of Demeter and Persephone unearthed in 1857 and displayed at the British Museum. Shawn Malley also contributes an important analysis of Pater's dialogue with modern archaeology, especially Pater's response to Charles Newton's *A History of Discoveries at Halicarnassus, Cnidus, and Branchidae* (1862–63). See Shawn Malley, "Disturbing Hellenism: Walter Pater, Charles Newton, and the Myth of Demeter and Persephone," in *Walter Pater: Transparencies of Desire,* ed. Brake, Higgins, and Williams, 90–106.

107. Though "The Bacchanals of Euripides" was most likely written in 1878, it was not published until 1889 in *Macmillan's Magazine*. The publishing history of all of myth studies is provided by Charles Shadwell in his introduction to the 1894 edition of *Greek Studies*.

108. An important reading of "The Bacchanals of Euripides" is Yopie Prins's "Greek Maenads, Victorian Spinsters," in Dellamora, *Victorian Sexual Dissidence*, 43–81. Prins argues that Pater's Bacchic women influenced a generation of late-Victorian female scholars, as seen in their recurring explorations and reanimations of the figure of the maenad.

109. Pater remakes Bunyan's Christian notion of the "House Beautiful" into a secular yet spiritual repository for arts and artists across the ages. As Carolyn Williams describes it, the House Beautiful is "his spatial representation of all aesthetic history gathered together in one place" (*Transfigured World*, 248). Pater uses the phrase in his essay "Romanticism," first published in *Macmillan's Magazine* in 1876.

110. Mallock, *New Republic*, 261.

111. Ibid., 266.

112. Ibid., 267.

113. Walter Pater, *Marius the Epicurean: His Sensations and Ideas*, 2 vols. (London: Macmillan, 1910), 1:147. Future citations in the text will refer parenthetically to this edition.

114. As Mrs. Humphrey Ward wrote in one of the novel's earliest reviews, "No one can fail to catch the autobiographical note of *Marius*." "*Marius the Epicurean*," *Macmillan's Magazine* 52 (June 1885): 132–39. Numerous critics have written on *Marius* as autobiography; for a wide-ranging example see Gerald Monsman, *Walter Pater's Art of Autobiography* (New Haven: Yale University Press, 1980). Victorian responses to the novel are summarized in Franklin E. Court, "The Critical Reception of Pater's *Marius*," *ELT* 27 (1984): 124–39.

115. Matthew Potolsky narrates how this interpretation of *Marius* became interwoven with a biographical story of Pater's own chastening in the wake of the *Renaissance* scandal. Thomas Wright's influential 1907 biography first popularized the account of Pater's own life as a conversion narrative, in which his early aestheticist excesses were cured by a healthy turn to Christianity. An influential version of this account appears in U. C. Knoepflmacher's *Religious Humanism and the Victorian Novel: George Eliot, Walter Pater, and Samuel Butler* (Princeton, N.J.: Princeton University Press, 1965). For Potolsky, numerous critics find proof of Pater's change of heart in the literary death of Flavian, in which Pater seems to kill off his novel's most hedonistic character as a sign of an awakened moral sense. Yet, as Potolsky convincingly argues, Flavian's seductive teachings are influential enough to outlast the death of their pagan advocate; thus "Pater's portrait of Flavian can be read as a defense of aestheticism rather than an account of its dangers, as a questioning of didactic intentions rather than a belated reassertion of them" (719–20). Matthew Potolsky, "Fear of Falling: Walter Pater's *Marius the Epicurean* as a Dangerous Influence," *ELH* 65, no. 3 (Fall 1998): 701–29.

116. Pater's most well-known generic invention is the "imaginary portrait," of which *Marius* is a key example. The imaginary portrait combines fiction, philosophical prose, biography, autobiography, and—not least important for this analysis—the visual arts. See Martine Lambert-Charbonnier, "Poetics of *Ekphrasis* in Pater's 'Imaginary Portraits,'" in *Walter Pater: Transparencies of Desire*, ed. Brake, Higgins, and Williams, 202–12; and

Elisa Bizzotto, "The Imaginary Portrait: Pater's Contribution to a Literary Genre," in *Walter Pater: Transparencies of Desire,* ed. Brake, Higgins, and Williams, 213–23.

117. A recent reading of Pater and Romanticism is Stefano Evangelista, "'Outward Nature and the Moods of Men': Romantic Mythology in Pater's Essays on Dionysus and Demeter," in *Walter Pater: Transparencies of Desire*, ed. Brake, Higgins, and Williams, 107–18. Evangelista focuses in particular on Pater's debt to Shelley.

118. Linda Dowling notes this link in a discussion of Pater's "Demeter and Persephone": "Matthew Arnold's 'Culture'...begins for Pater as culture, the turning over of the earth." Dowling, "Walter Pater and Archaeology," 220.

119. Pater's urban sensibility also figures in "The Child in the House," when Florian remembers his childhood play-space in the attic as a "wonderland of childish treasures" made more wonderful for its juxtaposition against the gritty rooftops of a "great city," with "its beds of rolling cloud and smoke, touched with storm or sunshine." Views of the surrounding city establish Florian's lifelong preference for "*urbanity*," for the "modes of life" of the "pale people of towns." *Miscellaneous Studies: A Series of Essays* (London: Macmillan, 1910), 175–76. *Marius* recapitulates Pater's delight in juxtaposing country and city pleasures, though his allegiance ultimately seems an urban one, as he prefers the sociability, cosmopolitanism—and, perhaps, white skins—of city folk.

120. Jonah Siegel incisively argues that Pater's obsession with images of death and rebirth are crucial to his historicist notion of artistic creativity, aligning him with a longer nineteenth-century tradition of artistic anxiety about plenitude and originality. See Siegel, *Desire and Excess: The Nineteenth-Century Culture of Art* (Princeton, N.J.: Princeton University Press, 2000), chap. 8.

121. David J. DeLaura writes that Marius's final conversion is "too passive and too deliberately inconclusive" to conclude that Pater was himself embracing Christianity. Pater's later meditation on religion in *Plato and Platonism* (1893) is "even more remote from historic Christianity in any authentic or recognizable form." DeLaura makes these points in the course of arguing for Newman's influence on Pater, though, as Maureen Moran points out, the idea that Pater was espousing the ideals of any one previous critic contradicts Pater's own relativist creed. See David J. DeLaura, *Hebrew and Hellene in Victorian England: Newman, Arnold, and Pater* (Austin: University of Texas Press, 1969), 337; and Maureen Moran, "Pater's 'Great Change': *Marius the Epicurean* as Historical Conversion Romance," in *Walter Pater: Transparencies of Desire,* ed. Brake, Higgins, and Williams, 170–88.

122. Walter Pater, *Plato and Platonism* (London: Macmillan, [1893], 1910), 8.

123. Walter Pater, "The Beginnings of Greek Sculpture," in *Greek Studies* (London: Macmillan, 1910), 252–53.

124. For Pater's contributions to Victorian liberalism see Dowling, *The Vulgarization of Art*. For Pater's links to Romanticism see Kenneth Daly, *The Rescue of Romanticism: John Ruskin and Walter Pater* (Athens: Ohio University Press, 2001).

125. This definition of poetry was first framed by John Stuart Mill's 1833 essay "What is Poetry?" Of course, Romantic literature itself consisted of more than lyric poetry; but it is this tradition to which critics refer when they align Pater with a Romantic past.

126. Rossetti's pets included, at various times, an armadillo, a kangaroo, a marmot, a raccoon, wombats, and peacocks. See Jan Marsh, *Dante Gabriel Rossetti: Painter and Poet* (London: Weidenfeld & Nicolson, 1999).

127. Roland Barthes, *Critical Essays,* trans. Richard Howard (Evanston, Ill.: Northwestern University Press, 1972), 67.

128. Charles Baudelaire, *My Heart Laid Bare,* trans. Norman Cameron (London: Weidenfeld & Nicolson, 1950), 188–89. Quoted by Matei Calinescu, *Five Faces of Modernity* (Durham, N.C.: Duke University Press, 1987), 110–11.

129. The irony of this lineage is captured in the vehemence of Bloomsbury's rejections of its own Victorian roots—as when Virginia Woolf makes her famous declaration that "on or about December 1910, human nature changed."

130. Martin Puchner, *Poetry of the Revolution: Marx, Manifestos, and the Avant-Gardes* (Princeton, N.J.: Princeton University Press, 2006), 70.

131. Clement Greenberg's political affiliations were complex and changed over his lifetime. Historians have generally discerned a shift in his writings from doctrinaire Marxism to a more individualist, pro-American, Cold-War-era formalism. See Nancy Jachec, "Modernism, Enlightenment Values, and Clement Greenberg," *Oxford Art Journal* 21, no. 2 (1998): 121–32; and Stephen C. Foster, "Clement Greenberg: Formalism in the '40s and '50s," *Art Journal* 35, no. 1 (Fall 1975): 20–24.

132. Pater, "Demeter and Persephone," in *Greek Studies,* 119.

133. Most scholarship has linked Pater and Joyce through the modernist notion of epiphany. See, for example, John McGowan, "From Pater to Wilde to Joyce: Modernist Epiphany and the Soulful Self," *Texas Studies in Literature and Language* 32, no. 3 (Fall 1990): 417–45.

134. In *Literary Impressionism and Modernist Aesthetics* (Cambridge: Cambridge University Press, 2001), Jesse Matz includes Pater in a lineage of modernist impressionism, focusing in particular on the homoerotics of Paterian style. My discussion here describes a "mythical method" of modernist literary form that differs from T.S. Eliot's resonant account of Joyce's *Ulysses.* For Eliot, Joyce's myths famously provide "a way of controlling, of ordering, of giving a shape and a significance to the immense panorama of futility and anarchy which is contemporary history" ("*Ulysses,* Order and Myth," *The Dial* 75 (November 1923): 480–83). Eliot's myths (at least in theory) serve to harness and control an anarchic present, while those of Joyce or Pater provide structure at the same time that they enable multiplicity or myriad-mindedness across different characters.

Chapter 4

1. See, for example, Jeffrey L. Spear, *Dreams of an English Eden: Ruskin and His Tradition in Social Criticism* (New York: Columbia University Press, 1984). Also relevant is Patrick Brantlinger, "A Postindustrial Prelude to Postcolonialism: John Ruskin, William Morris, and Gandhism," *Critical Inquiry* 22, no. 3 (Spring 1996): 466–485.

2. Reginia Gagnier also ties Paterian aestheticism to Morrisian idealism in *The Insatiability of Human Wants: Economics and Aesthetics in Market Society* (Chicago: University of Chicago Press, 2000). Gagnier connects modes of aesthetic production and consumption using Victorian economic theory.

3. Nikolaus Pevsner, *Pioneers of Modern Design: From William Morris to Walter Gropius* (New York: Museum of Modern Art, 1949). The book was first published in 1936 under the title *Pioneers of the Modern Movement* (London: Faber & Faber). It was recently republished in an expanded version by Yale University Press in 2005.

4. Jerome McGann, *Black Riders: The Visible Language of Modernism* (Princeton, N.J.: Princeton University Press, 1993), 69. Perry Anderson notes that many radical nine-teenth-century artists lost their political edge in posthumous critical receptions. He includes two fin-de-siècle socialist theorists, William Morris and Oscar Wilde, in a group for whom "a purely aesthetic reconstruction took place." Anderson, *Arguments Within English Marxism* (London: NLB & Verso Editions, 1980), 173.

5. E. P. Thompson, *William Morris: Romantic to Revolutionary* (New York: Monthly Review Press, 1955).

6. Gertrude Himmelfarb, *Poverty and Compassion: The Moral Imagination of the Late Victori-ans* (New York: Alfred A. Knopf, 1991), 71.

7. Ibid., 73. To give just a brief summary of the numerous threads of late-Victorian socialism: Max Hyndman was Marx's translator in England, but his dogmatic stance alienated followers and splinter-groups quickly formed. Intellectual-elite Fabians like George Bernard Shaw and Sidney Webb favored a strong centralized government, as opposed to communistic anarchists like Prince Kropotkin, who opposed any form of central government. Socialism was popular in both bourgeois parlor-rooms and working-class trade union halls. There were Christian and Jewish socialist groups; there were also "foreign clubs" that brought in radicalism from France, Germany, and Russia. Somewhere in the middle was the Social Democratic Federation, the official organized branch of socialism, which William Morris helped to form in 1884. By 1890 Morris had seceded from the group, disaffected by its anarchist bent, and formed his own socialist group at Hammersmith. Useful sources on British social-ism include: Stanley Pierson, *Marxism and the Origins of British Socialism* (Ithaca, N.Y.: Cornell University Press, 1973); Ian Britain, *Fabianism and Culture: A Study in British Socialism and the Arts, c. 1884–1918* (Cambridge: Cambridge University Press, 1982); and Gregory Claeys, *Citizens and Saints: Politics and Anti-Politics in Early British Social-ism* (Cambridge: Cambridge University Press, 1989). Ruth Kinna analyzes William Morris's political theory against the background of British socialist history in *William Morris: The Art of Socialism* (Cardiff: University of Wales Press, 2000).

8. Among political theorists, William Morris has been a locus of controversy—described by some as a utopian dreamer, and by others as an espouser of real "scientific" Marx-ism. The canonical reading of Morris as a Marxist is Paul Meier's two-volume *Wil-liam Morris: The Marxist Dreamer,* trans. Frank Gubb (New Jersey: Humanities Press, 1978). E. P. Thompson presents Morris as more of a Romantic in the famous 1977 postscript to the second edition of *William Morris: Romantic to Revolutionary*, suggest-ing that Morris's lack of a scientific basis for his socialism was in fact positive since "science cannot tell us what to desire or how to desire" (452). Thompson's defense of Morris amounts to a critique of post-war leftist thought, to which Perry Anderson responds in a chapter titled "Utopias," in *Arguments within English Marxism*. Anderson suggests that a solution might be found in a synthesis between Morris's romantic utopianism and a more systematic, scientific approach to politics—comparable to a synthesis Anderson finds in Marx's own thought, in the "dialectical complementarity of Utilitarianism and Romanticism" (169).

9. "The Lesser Arts," in *Political Writings of William Morris,* ed. A. L. Morton (New York: International Publishers, 1973), 37.

10. Ibid., 46.

11. William Morris, *News from Nowhere*, ed. James Redmond (London: Routledge & Kegan Paul, 1970), 5. All future quotations will refer parenthetically to this edition.

12. Numerous groups claimed Morris as a mentor. In 1882 Arthur Mackmurdo and Selwyn Image founded the Century Guild, which produced furniture and decorative housewares as well as its own little magazine, *The Hobby Horse* (1884, 1886–92). The Art Workers' Guild formed in 1884 as a forum for debate regarding the political future of the decorative arts. A faction of its members moved to gain wider recognition by organizing an exhibition society, and in 1888 the first "Arts and Crafts Exhibition Society" displayed its works at the New Gallery in London. For the history of the Arts and Crafts workshops, see Peter Stansky, *Redesigning the World: William Morris, the 1880's, and the Arts and Crafts* (Princeton, N.J.: Princeton University Press, 1985); and Lionel Lambourne, *Utopian Craftsmen: The Arts and Crafts Movement from the Cotswolds to Chicago* (Salt Lake City: Peregrine Smith, 1980).

13. The Arts and Crafts movement published a collection of essays, edited by Morris, each addressed to a different type of decorative art. Topics ranged from bookmaking to weaving to wallpaper patterning. See *Arts and Crafts Essays*, ed. William Morris (1893; reprint, New York: Garland Publishing, 1977).

14. In fact, Wilde's early lectures are saturated with Morris's notions of a democratic art. See Kevin Henrion Francis O'Brien, "An Edition of Oscar Wilde's American Lectures" (Ph.D. diss., University of Notre Dame, 1973). O'Brien scrupulously annotates Wilde's numerous borrowings from Ruskin, Pater, and, especially, Morris.

15. Wilde first delivered this lecture in Philadelphia in 1882. Reprinted in O'Brien, "Wilde's American Lectures," 169–70.

16. Among the tremendous bibliography of works addressing the relationships between Darwinian science and nineteenth-century political theory, a lucid summary is provided by Peter J. Bowler, *Biology and Social Thought, 1850–1914* (Berkeley: University of California Office for History of Science and Technology, 1993).

17. Darwin, *On the Origin of Species*, 61, 60.

18. Ibid., 490.

19. Charles Darwin, *The Descent of Man and Selection in Relation to Sex* (London: John Murray, [1871; rev. 1874], 1913), 608.

20. Ibid., 630.

21. Darwin de-emphasizes the more animalistic and violent behavior of humans, directing attention toward the odd rituals of "savage" Fujians rather than the violent proclivities of English gentlemen.

22. Darwin, *Descent of Man*, 662.

23. Robert M. Young, *Darwin's Metaphor: Nature's Place in Victorian Culture* (Cambridge: Cambridge University Press, 1985), 87.

24. Ibid., 93.

25. Gillian Beer, *Darwin's Plots: Evolutionary Narrative in Darwin, George Eliot, and Nineteenth-Century Fiction*, 2nd ed. (Cambridge: Cambridge University Press, 2000), 28.

26. Lynn Barber, *The Heyday of Natural History: 1820–1870* (Garden City, N.Y.: Doubleday, 1980), 13–14.

27. Lynn L. Merrill, *The Romance of Victorian Natural History* (New York: Oxford University Press, 1989), 11.

28. Isobel Armstrong, "The Microscope: Mediations of the Sub-Visible World," in *Transactions and Encounters: Science and Culture in the Nineteenth Century*, eds. Roger Luckhurst and Josephine Mcdonagh (Manchester: Manchester University Press, 2002), 32.

29. J. G. Wood, *Common Objects of the Microscope* (London: Routledge, 1861), iv. See also Philip Gosse, *Evenings at the Microscope* (London: Society for Promoting Christian Knowledge, 1859).

30. Philip Henry Gosse, *A Year at the Shore* (London: Alexander Strachan, 1865), 324–25.

31. Owen Jones, *The Grammar of Ornament* (London: Quaritch, [1856], 1910), 5.

32. Ibid., 5. Jones's language of natural theology is also matched by that of J. G. Wood. Bernard Lightman finds that Wood's subtle discourse of natural theology left it "to the reader to infer the movement from nature to God" (17). Bernard Lightman, "The Story of Nature: Victorian Popularizers and Scientific Narrative," *Victorian Review* 25 (2000): 1–29.

33. Heather Atchison argues that Grant Allen's greatest influence was not Darwin so much as Herbert Spencer. From Allen's perspective, Darwin was a scientist and observer of biodiversity, while Spencer was a philosopher who traced evolution's cosmic significance "from nebula to man, from star to soul, from atom to society," in Allen's words. Allen, "Spencer and Darwin," *Fortnightly Review* 61/67 (February 1897): 256. See Atchison, "Grant Allen, Spencer and Darwin," in *Grant Allen: Literature and Cultural Politics at the* Fin de Siècle, ed. William Greenslade and Terence Rodgers (Aldershot, U.K.: Ashgate, 2005), 55–64.

34. Grant Allen, "Dissecting a Daisy," *Cornhill Magazine* 37 (1878): 62. My discussion here parallels that of Jonathan Smith in "Grant Allen, Physiological Aesthetics, and the Dissemination of Darwin's Botany," in *Science Serialized: Representations of the Sciences in Nineteenth-Century Periodicals*, eds. Geoffrey Cantor and Sally Shuttleworth (Cambridge, Mass.: The MIT Press, 2004), 285–305. Smith argues that Allen's aesthetic theories, based in Darwinian biology, were meant to serve as a direct rebuke to Ruskin's theories. My ensuing analysis, however, finds that the two writers shared much in common, despite Ruskin's hostility to Darwin and to modern science.

35. Grant Allen, *The Colour-Sense: Its Origins and Development* (Boston: Houghton, Osgood, & Co, 1879), 38.

36. See Peter Morton, "Grant Allen's Publications: A Checklist," in *Grant Allen*, ed. Greenslade and Rodgers, 185–227.

37. Grant Allen, "A Mountain Tulip," *Longman's Magazine* 1:4 (Feb. 1883): 410, 411, 420.

38. Ibid., 411.

39. Jonathan Smith explores Allen's attacks on Ruskin in "Grant Allen, Physiological Aesthetics, and the Dissemination of Darwin's Botany," cited above, as well as in his book, *Charles Darwin and Victorian Visual Culture* (Cambridge: Cambridge University Press, 2006), 160–65. This excellent book analyzes Darwin's influence upon popular visual items like natural history guides and physiognomical treatises.

40. Lightman suggests that Allen's narratives of nature were "infused . . . with a cosmic dimension which represented a secularized version of similar themes in natural theology." Lightman, "The Story of Nature," 17.

41. Grant Allen, "The Origin of Fruits," *Cornhill Magazine* 38 (1878): 175. Jonathan Smith considers the same passage in his essay "Grant Allen, Physiological Aesthetics," cited above, in order to show Allen's opposition to Ruskin. Smith does not observe the

passage's similarity to Darwin's famous conclusion, nor does he note the political resonances.

42. See Chris Nottingham, "Grant Allen and the New Politics," in *Grant Allen,* ed. Greenslade and Rodgers, 95–110.

43. Grant Allen, "XVI.—Post-prandial Philosophy. The Political Pupa," *Westminster Gazette* 2 (July 24, 1893): 1–2. Reprinted in Allen, *Post-Prandial Philosophy* (London: Chatto and Windus, 1894), 130–32.

44. Important studies include Dinah Birch, "Ruskin and the Science of *Proserpina,*" in *New Approaches to Ruskin: Thirteen Essays*, ed. Robert Hewison (London: Routledge & Kegan Paul, 1981), 142–56; Frederick Kirchhoff, "A Science against Sciences: Ruskin's Floral Mythology," in *Nature and the Victorian Imagination*, ed. U. C. Knoepflmacher and G. B. Tennyson (Berkeley and Los Angeles: University of California Press, 1977), 246–58; and Jonathan Smith, *Charles Darwin and Victorian Visual Culture,* 165–78. These readings do not address the political resonances of Ruskin's odd botany.

45. See Beverly Seaton, "Considering the Lilies: Ruskin's *Proserpina* and Other Victorian Flower Books," *Victorian Studies* 28, no. 2 (Winter 1985): 255–82.

46. Dinah Birch, "Introduction," in John Ruskin, *Fors Clavigera: Letters to the Workmen and Labourers of Great Britain*, ed. Dinah Birch (Edinburgh: Edinburgh University Press, 2000), xxxv. Birch notes that *Fors Clavigera* "became, in part . . . [the] house journal" of the Guild of St. George (xxxv). Other useful sources on the Guild include Catherine W. Morley, *John Ruskin Late Work 1870–1890; The Museum and Guild of St. George: An Educational Experiment* (New York: Garland, 1984) and Edith Hope Scott, *Ruskin's Guild of St. George* (London: Methuen, 1931).

47. Ruskin describes his plans for a "grammar" of natural history to illustrate collections housed at the Museum of St. George in *Deucalion* (1875–83), his treatise on geology and mineralogy. *Deucalion* is usually grouped with *Proserpina* and *Love's Meinie* (1873–81), a book of ornithology, as Ruskin's late contributions to natural history. For more on Ruskin's grammars see Catherine Morley, *John Ruskin,* 82–145. In *Proserpina,* Ruskin mentions that the Guild's own homemade coins are decorated with an image of a daisy because the flower is "the symbol of the splendour or light of heaven, which is dearest where humblest" (25:491). The Guild of St. George, as well as the museum, still exist today.

48. For a useful summary of Darwin's reception see Martin Fichman, "Biology and Politics: Defining the Boundaries," in *Victorian Science in Context,* ed. Bernard Lightman (Chicago: University of Chicago Press, 1997), 94–118.

49. Lewis F. Day, "The Nature of Art," in *Every-Day Art: Short Essays on the Arts Not Fine* (1882; reprint, New York: Garland, 1977), 50.

50. Walter Crane, "On the Structure and Evolution of Decorative Pattern," in *The Claims of Decorative Art* (London: Lawrence and Bullen, 1892), 46.

51. Ibid., 40.

52. Ibid., 42.

53. Walter Crane, "The Racial Influence in Design," in *The Bases of Design* (London: George Bell, 1898), 43.

54. Crane, *Bases of Design,* 212.

55. Ibid., 339.

56. Crane, "Preface," *The Claims of Decorative Art,* v–vi.

57. Fichman, "Biology and Politics," 97.

58. Diane Paul, "'In the Interests of Civilization': Marxist Views of Race and Culture in the Nineteenth Century," *Journal of the History of Ideas* 42, no. 1 (January–March 1981): 117.

59. William Morris, "How We Live and How We Might Live," *Political Writings of William Morris*, 148. This lecture was first delivered to the Hammersmith Branch of the Social Democratic Foundation at Kelmscott House in 1884; it was printed in *Commonweal* in 1887.

60. Ibid., 149.

61. Diane Paul discusses nineteenth-century eugenic theories among progressive thinkers in "Eugenics and the Left," *Journal of the History of Ideas* 45, no. 4 (October–December 1984): 567–90. Paul doesn't mention William Morris, but her analysis of the Fabians seems relevant here.

62. William Morris, "Making the Best of It," *The Collected Works of William Morris,* ed. May Morris, vol. 22 (London: Longmans Green and Co., 1914), 87.

63. Ibid., 88.

64. Ibid.

65. Ibid., 109.

66. Ibid., 111, 110.

67. William Morris, "Some Hints on Pattern-Designing," *Collected Works of William Morris,* 22:180.

68. Ibid., 178.

69. Ibid., 177.

70. Morris, "Making the Best of It," 110.

71. Ibid., 111.

72. Ibid., 100.

73. For a discussion of Morris & Co. see Thompson, *William Morris: Romantic to Revolutionary,* 90–109.

74. Morris, "The Lesser Arts," *Political Writings of William Morris,* 33.

75. Ibid., 45–46.

76. Patrick Brantlinger argues that *News from Nowhere* is an "anti-novel" or "a deliberate work of non-art" for its critique of a novelistic literary tradition that "is based on bourgeois individualism" (41). Though Brantlinger does not explicitly mention the decorative arts, one implication is that Morris's novel argues for the rise of decorative art as a more significant art form than any mere literary production. Patrick Brantlinger, "'News from Nowhere': Morris's Socialist Anti-Novel," *Victorian Studies* 19, no. 1 (September 1975): 35–49.

77. See, for example, David Weir, *Decadence and the Making of Modernism* (Amherst: University of Massachusetts Press, 1995); or the special journal issue of *Modernism/Modernity* devoted to "British Decadence and Modernism," 16, no. 3 (September 2008).

78. For a subtle exploration of the meanings and history of decadence see the introduction to *Perennial Decay: On the Aesthetics and Politics of Decadence,* ed. Liz Constable, Denis Denisoff, and Matthew Potolsky (Philadelphia: University of Pennsylvania Press, 1999).

79. Christine Ferguson, "Decadence as Scientific Fulfillment," *PMLA* 117, no. 3 (2002): 470. Ferguson goes on to argue that literary representations of decadence often conclude with the deaths of their protagonists "because the collapse of the self fulfills a

certain project of knowing" (470). Her analysis focuses in particular on Wilkie Collins' *Heart and Science: A Story of the Present Time* (1882) and Arthur Machen's *The Great God Pan* (1894).

80. Paul Barolsky identifies Holmes's decadent qualities in "The Case of the Domesticated Aesthete," *Virginia Quarterly Review* 60, no. 3 (Summer 1984): 438–52.

81. Arthur Conan Doyle, *A Study in Scarlet* (Oxford: Oxford University Press, [1887], 1999), 40.

82. See Caroline Reitz, *Detecting the Nation: Fictions of Detection and the Imperial Venture* (Columbus: Ohio State University Press, 2004).

83. Matei Calinescu explores some of the accusations made against decadence, particularly in France, in "The Idea of Decadence," *Five Faces of Modernity* (Durham, N.C.: Duke University Press, 1987), 151–221.

84. Paul Bourget, *Essais de psychologie contemporaine* (Paris: Lemerre, 1893), 24. Quoted in Calinescu, *Five Faces of Modernity*, 170.

85. See G. A. Cevasco, *The Breviary of Decadence: J.-K. Huysmans's* À Rebours *and English Literature* (New York: AMS Press, 2002).

86. Joris-Karl Huysmans, *À Rebours,* trans. John Howard (New York: Albert & Charles Boni, 1924), 48. All future quotations will refer parenthetically to this edition. This 1922 English translation omits some of the particularly scandalous pieces in Huysmans's original text, but offers an excellent version of the passages that interest me.

87. Morris, "Making the Best of It," 90.

88. Whitney Davis, "Decadence and the Organic Metaphor," *Representations* 89 (Winter 2005): 131–49. Davis differentiates between Darwin's research and Des Esseintes' collections: while Darwin showed how even the most grotesque orchid had evolved for the purpose of cross-fertilization, Des Esseintes' collections seem more devoted to proving the ingenuity of human artificial selection. For Davis, Huysmans's syphilitic orchids are symbols of Des Esseintes' own degenerate, non-reproductive sexuality (136).

89. All of Des Esseintes' sexual escapades are narrated in retrospect or flashback, provided as explanations for his retreat into lonely bachelorhood. Many of these involve ambiguous gender alignments—as when he falls for a masculine-acting female circus performer, but then loses interest once he perceives her essential womanhood.

90. Lorraine Janzen Kooistra argues that this illustration's blatant sexual imagery creates a kind of anti-Eden, serving to undermine the chivalric codes of Beardsley's medieval source material. See Kooistra, "Beardsley's Reading of Malory's *Morte D'Arthur*: Images of a Decadent World," *Mosaic* 23, no. 1 (Winter 1990): 71–72.

91. Beardsley's Darwinian imagery is perhaps most marked in his grotesque drawings of fetuses. These worm-like creatures seem to have been adapted directly from Darwin's study of embryos. For illustrations see Linda Gertner Zatlin, *Beardsley, Japonisme, and the Perversions of the Victorian Ideal* (Cambridge: Cambridge University Press, 1997), especially chapter 4, "The Grotesque" (171–217).

92. For more on Wilde and socialism see Ruth Livesey, "Morris, Carpenter, Wilde, and the Political Aesthetics of Labor," *Victorian Literature and Culture* 32, no. 2 (2004): 601–16; Aaron Noland, "Oscar Wilde and Victorian Socialism," in *Oscar Wilde: The Man, His Writings, and His World,* ed. Robert N. Keane (New York: AMS Press, 2003), 101–11; and two useful, older essays: J. D. Thomas, "'The Soul of Man under Socialism': An Essay in Context," *Rice University Studies* 51, no. 1 (1965): 83–95; and Masolino

D'Amico, "Oscar Wilde Between 'Socialism' and Aestheticism," *English Miscellany* 18 (1967): 111–139.

93. Jeff Nunokawa argues that the postmodern Wilde emerged from current theories of queer sexuality. This strain of Wilde criticism finds an "alliance . . . between perversity and postmodernism, sexual dissidence and the denial of depth," and presumes that "the concept of essence is the prop of a heterosexual normativity whose propagations rely on the claim that nature is on its side." See Jeff Nunokawa, *Tame Passions of Wilde: The Styles of Manageable Desire* (Princeton, N.J.: Princeton University Press, 2003), 92. Nunokawa footnotes Eve Kosofsky Sedgwick's rebuttal of these types of readings (in, for example, Chris Craft and Jonathan Dollimore): "Each of these readings traces and affirms the gay possibility in Wilde's writing by identifying it—feature by feature, as if from a Most Wanted poster—with the perfect fulfillment of a modernist or post-modern project of meaning-destabilization and identity-destabilization." Sedgwick's comments are found in *Tendencies* (Durham, N.C.: Duke University Press, 1993), 55.

94. *The Complete Works of Oscar Wilde* (New York: Harper & Row, 1966), 970. All future quotations from Wilde will refer parenthetically to this source, unless otherwise noted.

95. Terry Eagleton suggests that Wilde's organicist Individual is a paradoxical blend of Nietzschean and more Romantic impulses: "Wilde's problem here is that he values the non-identical, but is committed to a notion of individualism which depends on self-identity. The Schillerian and Arnoldian language of self-perfecting he inherits posits the very unified self which his more Nietzschean doctrines seek to undermine. On the one hand, he calls for a multiplication of personalities; on the other hand, he values the individual who is 'perfectly and absolutely himself,' and imagines true personality as a simple, flower-like growth." Terry Eagleton, "Oscar and George," in *Heathcliff and the Great Hunger: Studies in Irish Culture* (London: Verso, 1995), 337. Eagleton argues that the conflict emerges from Wilde's Irishness, which provides "the self-ironizing consciousness of the colonial mimic man, for whom truth can only mean the wry knowledge of one's own fictionality" (337).

96. Oscar Wilde, "Poetical Socialists," *Pall Mall Gazette,* February 15, 1889. Reprinted in *Reviews by Oscar Wilde* (London: Methuen & Co., 1908), 426.

97. In *Oscar Wilde's Oxford Notebooks*, Philip E. Smith II and Michael S. Helfand argue that Wilde's "Soul of Man" contains an underlying Darwinian strain consonant with other cultural theorists of the time, especially those writing about "Celtic Art" such as Matthew Arnold and Grant Allen. Smith and Helfand include Wilde in the group of "radical Darwinists" who used Darwin's theories near the end of the century to promote cooperation and socialist politics. Philip E. Smith II and Michael S. Helfand, *Oscar Wilde's Oxford Notebooks* (New York: Oxford University Press, 1989).

98. Walter Pater, "Leonardo da Vinci," in *The Renaissance: Studies in Art and Poetry; The 1893 Text,* ed. Donald L. Hill (Berkeley and Los Angeles: University of California Press, 1980), 99.

99. The novel here implies a sinful association with the decorative arts, since chapter eleven elaborates on Dorian's objects while insinuating that at the same time he has been busy ruining the virtue of young men. Wilde's depiction invokes a long tradition linking homosexuality with the collection of luxurious objects, stretching back

to eighteenth-century parodies of *cognoscenti* caressing beloved artworks instead of women.

100. Wilde continues the passage, "It [my novel] reacts against the crude brutality of plain realism. It is poisonous if you like, but you cannot deny that it is also perfect, and perfection is what we artists aim at." *The Complete Letters of Oscar Wilde* (New York: Henry Holt, 2000), 436. Wilde's letter responds to the *Daily Chronicle*'s attack: "It is a tale spawned from the leprous literature of the French *Décadents*—a poisonous book, the atmosphere of which is heavy with the mephitic odours of moral and spiritual putrefaction" (Quoted in *Letters*, 435).

101. Eve Sedgwick analyzes this moment in the text—with its juxtaposition of the opium and the luxurious container—as exemplifying the "commodity-based orientalism of *Dorian Gray*," suggesting that the novel "populariz[es] a consumerism that already derived an economic model from the traffic in drugs" (227). See Sedgwick, *Epistemology of the Closet* (Berkeley and Los Angeles: University of California Press, 1990), 173.

102. Stella Tillyard traces the influence of the Arts and Crafts movement on the Bloomsbury Omega Workshops, where avant-garde artists created home décor, in *The Impact of Modernism 1900–1920* (London: Routledge, 1988). Cleanth Brooks suggests that a poem is not a self-conscious statement of the poet but an organism possessing its own aesthetic unity in his essay "The Poem as Organism: Modern Critical Procedure," *English Institute Annual, 1940* (New York: Columbia University Press, 1941), 32–41.

Chapter 5

1. S. K. Tillyard, *The Impact of Modernism 1900–1920* (London: Routledge, 1988). For more details on Bloomsbury's relations to the decorative arts see Isabelle Anscombe, *Omega and After: Bloomsbury and the Decorative Arts* (London: Thames & Hudson, 1981) and Christopher Reed, *Bloomsbury Rooms: Modernism, Subculture, and Domesticity* (New Haven, Conn.: Yale University Press, 2004).

2. The standard history of British modernist art is Charles Harrison, *English Art and Modernism, 1900–1939*, 2nd ed. (New Haven, Conn.: Yale University Press, 1994). Other studies include David Peters Corbett, *The Modernity of English Art, 1914–30* (Manchester: Manchester University Press, 1997); Lisa Tickner, *Modern Life and Modern Subjects: British Art in the Early Twentieth Century* (New Haven, Conn.: Yale University Press, 2000); and Janet Wolff, *AngloModern: Painting and Modernity in Britain and the United States* (Ithaca, N.Y.: Cornell University Press, 2003).

3. Virginia Woolf, "Mr. Bennett and Mrs. Brown," in *Collected Essays*, vol. 1 (London: Hogarth Press, [1924], 1966), 319–37.

4. Detailed accounts of the London post-impressionist shows are given in: Peter Stansky, *On or About December 1910: Early Bloomsbury and Its Intimate World* (Cambridge, Mass.: Harvard University Press, 1996) and Ian Dunlop, *The Shock of the New: Seven Historic Exhibitions of Modern Art* (New York: American Heritage Press, 1972). An important sourcebook on the British reception of post-impressionism is the collection of reviews and essays assembled by J. B. Bullen in *Post-Impressionists in England* (London: Routledge, 1988).

5. A basic summary of the philosophies of Fry and Bell, and their impact on Bloomsbury more generally, is given in Heinz Astor, *The Bloomsbury Group: Its Philosophy, Aesthetics, and Literary Achievement* (Heidelberg: Carl Winter, 1986). A classic and still useful study is J. K. Johnstone's *The Bloomsbury Group* (New York: Noonday Press, 1954). Many literary studies of Fry use his philosophy as an avenue into the novels of Virginia Woolf. These include Ann Banfield, *The Phantom Table: Woolf, Fry, Russell, and the Epistemology of Modernism* (Cambridge: Cambridge University Press, 2000); and Sue Roe, "The Impact of Post-Impressionism," in *The Cambridge Companion to Virginia Woolf* (Cambridge: Cambridge University Press, 2000), 164–90. Virginia Woolf wrote a peculiar biography of Fry, the final book she completed before her death: *Roger Fry: A Biography,* ed. Diane F. Gillespie (Oxford: Blackwell, [1940], 1995). The standard scholarly biography of Roger Fry is Frances Spalding, *Roger Fry: Art and Life* (Berkeley and Los Angeles: University of California Press, 1980).

6. Kenneth Clark, introduction, Roger Fry, *Last Lectures* (Cambridge: Cambridge University Press, 1939), ix.

7. The traditional story of Fry's heroic role in ushering formalist criticism into the twentieth century is told in Jacqueline V. Falkenheim, *Roger Fry and the Beginnings of Formalist Art Criticism* (Ann Arbor, Mich.: UMI Research Press, 1973).

8. Elizabeth Prettejohn, "Out of the Nineteenth Century: Roger Fry's Early Art Criticism," in *Art Made Modern: Roger Fry's Vision of Art*, ed. Christopher Green (London: Merrell Holberton & The Courtauld Gallery, 1999), 43. Intellectual histories of art writing that include Roger Fry are: Graham Hough, *The Last Romantics* (London: Duckworth, 1949); Solomon Fishman, *The Interpretation of Art: Essays on the Art Criticism of John Ruskin, Walter Pater, Clive Bell, Roger Fry, and Herbert Read* (Berkeley and Los Angeles: University of California Press, 1963); and Falkenheim, *Roger Fry*.

9. Francis Frascina and Charles Harrison, eds., *Modern Art and Modernism: A Critical Anthology* (London: Harper & Row, 1982). The selections appear with no introduction or context; a footnote identifies their original place of publication.

10. I use the term "primitive" throughout this chapter with implicit quotation marks, since the term is no longer used in academic disciplines as a neutral description of a non-Western culture.

11. Sources on modernist primitivism in art include: Robert Goldwater, *Primitivism in Modern Art,* enlarged ed. (Cambridge, Mass.: Harvard University Press, 1986); Colin Rhodes, *Primitivism and Modern Art* (New York: Thames & Hudson, 1994); Susan Hiller, ed., *The Myth of Primitivism: Perspectives on Art* (London: Routledge, 1991); and Lynda Jessup, ed., *Antimodernism and Artistic Experience: Policing the Boundaries of Modernity* (Toronto: University of Toronto Press, 2001).

12. William Rubin, "Modernist Primitivism: An Introduction," in *'Primitivism' in 20th Century Art: Affinity of the Tribal and the Modern,* vol. 1 (New York: Museum of Modern Art, 1984), 24, 28.

13. Some of the important critical responses include: Hal Foster, "The 'Primitive' Unconscious of Modern Art, or White Skin Black Masks," in *Recodings: Art, Spectacle, Cultural Politics* (Port Townsend, Wash.: Bay Press, 1985); Patrick Manning, "Primitive Art and Modern Times," *Radical History Review* 33 (1985): 165–81; and Thomas McEvilley, "Doctor, Lawyer, Indian Chief," *Art Forum* 23 (November 1984): 54–61.

14. James Clifford, "Histories of the Tribal and the Modern," in *The Predicament of Culture: Twentieth-Century Ethnography, Literature, and Art* (Cambridge, Mass.: Harvard University Press, 1988), 196–97.

15. *The Roger Fry Reader*, edited by Christopher Reed, organizes Fry's texts exclusively around his writings on European art. Anthologizing almost sixty essays, *The Reader* omits all of Fry's writings on non-Western art (Chicago: University of Chicago Press, 1996). One well-known exception is Marianna Torgovnick's *Gone Primitive: Savage Intellects, Modern Lives* (Chicago: University of Chicago Press, 1990). Analyzing Fry's essays on "Bushman Painting" and "Negro Sculpture," Torgovnick concludes that they "contain a virtual encyclopedia of colonialist stereotypes about the African" (94). She does not note any similarities between these essays and Fry's constructions of post-impressionism—indeed, from reading her account, one would not know that "Bushman Painting" appeared in the same year that Fry organized the Grafton Gallery exhibition. Marjorie Perloff refutes Torgovnick's premises in an essay titled "Tolerance and Taboo: Modernist Primitivisms and Postmodern Pieties," writing: "In her attack on . . . the 'primitivism' of Conrad and Lawrence, Freud and Roger Fry, Malinowski and Mead, Torgovnick's root assumption is that a good writer (or ethnographer) is equivalent to a good person, and, concomitantly, that a 'good' book is one that is a repository of the 'right' cultural values" (352). If the goal were simply to locate racist ideology, then most of the modernist canon would be indicted. I am attempting instead to see how British colonial encounters with non-Western cultures—and the Victorian intellectual history shaping these encounters—influenced the theorization of a modernist formalist aesthetic. Perloff's essay appears in *Prehistories of the Future: The Primitivist Project and the Culture of Modernism*, eds. Elazar Barkan and Ronald Bush (Stanford, Ca.: Stanford University Press, 1995), 339–54. The other important exception to the critical lacuna surrounding Fry's primitivism is Christopher Green, "Expanding the Canon: Roger Fry's Evaluations of the 'Civilized' and the 'Savage,'" in Green, ed., *Art Made Modern: Roger Fry's Vision of Art*, 119–32. Green's essay moves in the opposite direction to Torgovnick's, working to recuperate Fry as a multicultural hero for embracing non-Western cultures, especially in his writings on African and child art.

16. Paintings by the French and European artists who were labeled "Post-Impressionist" in 1910 had appeared in England previously, in smaller shows outside of London. But the November 1910 show was the first to foreground this art in an exclusive London gallery, with promotion by some of the most influential art critics of the day.

17. Holbrook Jackson, "Pop Goes the Past," *T.P.'s Weekly*, December 16, 1910. Reprinted in Bullen, *Post-Impressionists in England*, 144–46.

18. Quoted in Stansky, *On or About December 1910*, 214.

19. *The Spectator* (November 12, 1910): 798. Quoted in Bullen, "Introduction," *Post-Impressionists in England*, 15.

20. Bullen, "Introduction," *Post-Impressionists in England*, 14.

21. Robert Ross, "The Post-Impressionists at the Grafton: The Twilight of the Idols," *Morning Post* (November 7, 1910). Reprinted in Bullen, *Post-Impressionists in England*, 100–4.

22. T. B. Hyslop, "Post-Illusionism and the Art of the Insane," *Nineteenth Century* (February 1911). Reprinted in Bullen, *Post-Impressionists in England*, 211.

23. "Post-Impressionist Problems," *Punch* 139 (November 23, 1910): 368.

24. "The International Society of Plasterer Painters," *Punch* 139 (November 30, 1910): 386.

25. "Editorial Article," *The Burlington Magazine for Connoisseurs* 1 (March–May 1903): 3–5.

26. Ibid., 4.

27. Ibid., 5.

28. See Ernest Samuels, *Bernard Berenson: The Making of a Connoisseur* (Cambridge, Mass.: Harvard University Press, 1979).

29. Christopher Green, "Into the Twentieth Century: Roger Fry's Project Seen from 2000," in *Art Made Modern*, ed. Green, 18.

30. Elizabeth Prettejohn, "Out of the Nineteenth Century: Roger Fry's Early Art Criticism," in *Art Made Modern*, ed. Green, 32. Prettejohn gathers her statistics from Donald Laing's important bibliography, *Roger Fry: An Annotated Bibliography of the Published Writings* (New York: Garland Publishing, 1979).

31. Prettejohn, "Out of the Nineteenth Century," 33.

32. Malcolm Baker and Brenda Richardson, eds., *A Grand Design: The Art of the Victoria and Albert Museum* (New York: Harry Abrams and the Baltimore Museum of Art, 1997), 43–44.

33. Charles Ricketts, "Post-Impressionism at the Grafton Gallery," *Pages on Art*, (1913; written in 1911). Reprinted in Bullen, *Post-Impressionism in England*, 201–8.

34. T. B. Hyslop, "Post-Illusionism and the Art of the Insane." Reprinted in Bullen, *Post-Impressionists in England*, 213.

35. Julius Meier-Graefe, *Modern Art*, vol. 2 (1908). Reprinted in Bullen, *Post-Impressionists in England*, 57.

36. Spalding, *Roger Fry: Art and Life*, 141.

37. Woolf, *Roger Fry: A Biography*, 121–22.

38. Desmond McCarthy, "The Post-Impressionists," introduction to the exhibition catalogue, 1910. Reprinted in Bullen, *Post-Impressionists in England*, 98.

39. Roger Fry, "The Grafton Gallery—I," *Nation* (November 19, 1910). Reprinted in Bullen, *Post-Impressionists in England*, 121.

40. Important scholarship on Victorian anthropology and racial theory includes: George W. Stocking, Jr., *Victorian Anthropology* (New York: The Free Press, 1987); Gillian Beer, "Speaking for the Others: Relativism and Authority in Victorian Anthropological Literature," in *Sir James Frazer and the Literary Imagination: Essays in Affinity and Influence*, ed. Robert Fraser (New York: St. Martin's Press, 1990), 38–60; and Christopher Herbert, *Culture and Anomie: Ethnographic Imagination in the Nineteenth Century* (Chicago: University of Chicago Press, 1991).

41. See Adam Kuper, *The Invention of Primitive Society: Transformations of an Illusion* (New York: Routledge, 1988).

42. Annie E. Coombes, *Reinventing Africa: Museums, Material Culture and Popular Imagination in Late Victorian and Edwardian England* (New Haven, Conn.: Yale University Press, 1994), 203.

43. On Gauguin at the Exposition Universelle see Nancy Perloff, "Gauguin's French Baggage: Decadence and Colonialism in Tahiti," in Barkan and Bush, eds., *Prehistories of the Future*, 226–69. On T. S. Eliot at the St. Louis World's Fair see Ronald Bush, "The

Presence of the Past: Ethnographic Thinking / Literary Politics," in Bush and Barkan, eds., *Prehistories of the Future,* 23–41.

44. This development can be contextualized within the history of museums more generally. If the eighteenth-century cabinet of curiosities was distinctive for its heterogeneous mixture of artworks, natural wonders, and other oddities, the nineteenth-century museum saw objects more intensely classified, with different groups acquiring particular bodies of expertise. Artworks were now seen only in art museums, and were increasingly displayed by school within each room; natural history museums divided flora and fauna by geography; and anthropology museums, as I discuss here, classed objects by their forms or shapes. See especially James Clifford, "On Collecting Art and Culture," *The Predicament of Culture: Twentieth-Century Ethnography, Literature, and Art* (Cambridge, Mass.: Harvard University Press, 1988), 215–51. Yet the kind of vaunted experience one was supposed to have in a museum was ultimately dictated by the art museum, especially as artworks became the most valuable and status-driven commodities available.

45. Coombes mentions Pitt Rivers at various points in *Reinventing Africa,* especially 118–19. See also David K. van Keuren, "Museums and Ideology: Augustus Pitt Rivers, Anthropological Museums, and Social Change in Later Victorian Britain," *Victorian Studies* 28 (Autumn 1984): 171–89.

46. A. Pitt Rivers, "Typological Museums, as Exemplified by the Pitt Rivers Museum at Oxford, and his Provincial Museum at Farnham, Dorset," *Journal of the Society of Arts* 40 (December 18, 1891): 116.

47. A. Pitt Rivers, *The Evolution of Culture and Other Essays*, intro. Henry Balfour (Oxford: The Clarendon Press, 1906).

48. Alfred C. Haddon, *Evolution in Art: As Illustrated by the Life-Histories of Designs* (London: Walter Scott, 1895), 1.

49. Henry Balfour, *The Evolution of Decorative Art: An Essay Upon its Origin and Development as Illustrated by the Art of Modern Races of Mankind* (London: Rivington, Percival & Co., 1893), vi.

50. Henry Balfour, "Notes on the Arrangement of the Pitt-Rivers Museum," in *Museums Association: Report of Proceedings*, ed. James Paton (London: Dulau and Co., 1897), 53.

51. The idea that prehistoric human cultures could be reconstructed using evidence from existing primitive cultures was in print as early as 1834. (For various citations see Glyn Daniel, *A Hundred Years of Archaeology* (London: Duckworth, 1950), 41–49). The two great popularizers of the idea before 1890 were J. Lubbock's *Prehistoric Times as Illustrated by Ancient Remains and the Manners and Customs of Modern Savages* (London: Williams and Norgate, 1865) and E. B. Tylor's *Primitive Culture* (London: J. Murray, 1871), a foundational text in the discipline of anthropology.

52. Balfour, *Evolution of Decorative Art*, 1, 13.

53. The argument is made by Johannes Fabian, *Time and the Other: How Anthropology Makes its Object* (New York: Columbia University Press, 1983).

54. Critics like Pater and Wilde are key exceptions to this investment in visual realism, and the debates they were involved in represent an alternative tradition that makes its impact on modernist theory—as my previous chapters argue.

55. See Daston and Galison, "The Image of Objectivity," discussed in chapter 1.

56. Balfour, *Evolution of Decorative Art,* 44.

57. Roger Fry, "An Essay in Aesthetics," first published in *New Quarterly* (London, 1909). Reprinted in Fry, *Vision and Design* (New York: Dover, [1920], 1998), 13.

58. Ibid., 14–15.

59. Ibid., 14.

60. Clifford, "On Collecting Art and Culture," 232.

61. See Fabian's *Time and the Other*, Clifford, *Predicament of Culture*, and, especially, the blistering first chapter of Christopher Herbert's *Culture and Anomie.*

62. Fabian, *Time and the Other*, 17.

63. *The Golden Bough* was published in twelve volumes over a twenty year period. I quote from a reprint of Frazer's own abridged version, first published in 1922 (Ware: Wordsworth Editions, 1993), 2.

64. Christopher Herbert, "Frazer, Einstein, and Free Play," in *Prehistories of the Future,* ed. Barkan and Bush, 148.

65. Roger Fry, "Ideals of a Picture Gallery," *Bulletin of the Metropolitan Museum of Art* (March 1906): 58–60. Reprinted in Reed, *A Roger Fry Reader*, 263.

66. Clive Bell, *Art* (London: Ballantyne Press, 1914), 7.

67. Ibid., 23.

68. Roger Fry, "Oriental Art," *Quarterly Review* 212 (January 1910): 225.

69. "Eastern Art and Western Critics," *Edinburgh Review* 212 (October 1910): 475.

70. Roger Fry, "Bushman Paintings," *The Burlington Magazine for Connoisseurs* 16, no. 84 (March 1910): 334–38. Citations in the text will refer to the 1910 essay. That Fry valued the essay is evident in his decision to reprint it in his canonical collection *Vision and Design* (1920), under the title "The Art of the Bushmen."

71. I use the term "Bushman" here following the early twentieth century designation, while fully acknowledging the problematic nature of the term. As Edwin N. Wilmsen poses the question, "Why are there peoples in the twentieth century who could conceivably be labeled 'Bushmen'?" Edwin N. Wilmsen, *Land Filled With Flies: A Political Economy of the Kalahari* (Chicago: Chicago University Press, 1989), 1.

72. Margery Ross, ed. *Robert Ross: Friends of Friends* (London: Cape, 1952), 181. Quoted in Spalding, *Roger Fry*, 129.

73. Christopher Heywood argues that Roger Fry and D. H. Lawrence were greatly influenced by their encounter with African art. While Heywood's recuperative project is valuable, he makes Fry a visionary, pro-African hero without observing some of Fry's more equivocal attitudes toward different African cultures. (Fry's biographer Frances Spalding follows the same heroicizing line). Christopher Heywood, "African Art and the Work of Roger Fry and D. H. Lawrence," *Sheffield Papers on Literature and Society* 1 (1976): 102–13.

74. Helen Tongue, *Bushman Paintings*, preface Henry Balfour (Oxford: Clarendon Press, 1909). Tongue's watercolors were first exhibited at the Anthropological Institute in 1908. The book was also reviewed in *The Athenaeum* 4277 (October 1909): 467 (a periodical that Fry occasionally wrote articles for, also aimed at the "connoisseur" set), as well as in various anthropological journals, such as *Man* 9 (1909): 169–71.

75. Coombes, *Reinventing Africa*, 145. Bushman art receives only passing mention in Coombes's book, which focuses more on the influence of Benin art on British anthropology. Helen Tongue's book, *Bushman Paintings,* also includes an anthropological essay, "Notes on the Bushmen," written by Dorothea Bleek, who, along with her father, Wilhelm Bleek, was one of the foremost authorities on Bushman culture.

76. Harry H. Johnston, *A History of the Colonization of Africa by Alien Races* (Cambridge: Cambridge University Press, 1913), 6.

77. These quotes are taken from Balfour's preface to Tongue, *Bushman Paintings,* 4.

78. Johnston, *History of the Colonization of Africa,* 8.

79. One of the most popular Victorian depictions of Bushman art appeared in Olive Schreiner's 1883 novel *The Story of an African Farm*. Early in the book, the odd philosophical child Waldo observes a Bushman painting and feels that the painted stones "are speaking of the old things, of the time when the strange fishes and animals lived that are turned into stone now; and the time when the little Bushmen lived here, so small and so ugly." Waldo's Bushmen seem truly mythic when one considers that the stone paintings could have been no more than a few hundred years old, and were probably much more recent than this. Yet Waldo presumes that they belong to a time when prehistoric animals were fossilized. Olive Schreiner, *The Story of an African Farm* (Harmondsworth: Penguin Books, [1883], 1971), 49–50. In his influential history of Southern Africa, George Stow also wants to find evidence of cave paintings that are centuries old, but his own description of the process of Bushman art-making implies a much more recent history. According to his Bushman sources, "the productions of an artist were always respected as long as any recollection of him was preserved in his tribe . . . But when his memory was forgotten, some aspirant after artistic fame appropriated the limited rock surface of the shelter . . . for his own performances, and unceremoniously painted over the efforts of those who had preceded him" (*The Native Races of South Africa* (London: S. Sonnenschein, 1905), 26–27).

80. Emmanuel Loewy, *The Rendering of Nature in Early Greek Art,* trans. J. Fothergill (London: Duckworth, 1907), 13, 13, 14.

81. McCarthy, "The Post-Impressionists," in Bullen, ed., *Post-Impressionists in England,* 98.

82. Fry, "Bushman Painting," 335, 335.

83. Ibid., 337, 337.

84. Ibid.

85. Loewy, *Rendering of Nature,* 98, 98, 74.

86. Fry, "Bushman Painting," 338.

87. The history of the term "Post-Impressionism" seems somewhat accidental. In the summer of 1910, while Roger Fry, Desmond McCarthy and Clive Bell were assembling pictures for the exhibition, they consulted with a journalist on how to publicize the event. After suggesting many unacceptable labels, Fry finally tossed out "Post-Impressionism," which became the famous catchphrase still in use today (Dunlop, *Shock of the New,* 137).

88. Bell, *Art,* v.

89. Mark Gertler, *Selected Letters,* 47. Quoted in Spalding, *Roger Fry,* 154.

90. Roger Fry, "Oriental Art," *Quarterly Review* 212, no. 422 (January 1910): 237.

91. The incidents leading up to the founding of the India Society are described in Partha Mitter, *Much Maligned Monsters: A History of European Reactions to Indian Art* (Oxford: Clarendon Press, 1977), chap. 6; and Partha Mitter, *Art and Nationalism in Colonial India, 1850–1922: Occidental Orientations* (Cambridge: Cambridge University Press, 1994), chap. 8 and 9. They also receive brief mention in Baker and Richardson, eds., *A Grand Design,* 227. An excellent art-history textbook analyzes the reception history of Indian and Indonesian art in Britain in the early twentieth century; see Catherine

King, ed., *Views of Difference: Different Views of Art* (New Haven, Conn.: Yale University Press, 1999).

92. See Jan Fontein, *The Sculpture of Indonesia* (Washington, D.C.: National Gallery of Art, 1990).

93. Vincent A. Smith, *A History of Fine Art in India and Ceylon* (1911), 2–4.

94. *The Times,* February 28, 1910. The full list of signatories to the letter were: Frederick Brown, Walter Crane, George Frampton, Laurence Housman, E. Lanteri, W. R. Lethaby, Halsey Ricardo, T. W. Rolleston, W. Rothenstein, G. W. Russell, W. R. Stephens, Charles Waldstein, and Emery Walker. Quoted in Mitter, *Much Maligned Monsters,* 270.

95. William Morris expressed an enthusiasm for indigenous Indian art and also opposed British colonialism. The trajectory from nineteenth-century crafts movements to twentieth-century colonial independence movements suggests a context for Gandhi's well-known influence by John Ruskin. See Patrick Brantlinger, "A Postindustrial Prelude to Postcolonialism: John Ruskin, William Morris, and Gandhism," *Critical Inquiry* 22, no. 3 (Spring 1996): 466–85.

96. Sir George Birdwood had been a key arbiter of London's taste in Indian art for almost forty years. He served as curator of the India Office Museum and referee for the Indian section of the South Kensington Museum (which in 1902 became the Victoria and Albert Museum). His book *The Industrial Arts of India* (1880) served as an official handbook to the Indian art collection at the V & A.

97. See John M. Mackenzie, *Orientalism: History, Theory, and the Arts* (Manchester: Manchester University Press, 1995), especially chap. 5, "Orientalism in Design," 105–37.

98. Partha Mitter narrates the history of the India Museum in "The Imperial Collections: Indian Art," in *A Grand Design,* ed. Baker and Richardson, 222–29.

99. "Eastern Art and Western Critics," *Edinburgh Review* 212 (October 1910): 454.

100. Ibid., 455.

101. British critical repugnance for Hindu art stretches back to at least the eighteenth century, when many-limbed Hindu gods were stereotyped by the British as "monsters." See Mitter, *Much Maligned Monsters,* 2.

102. "Eastern Art and Western Critics," 461–62, 463.

103. Ibid., 476.

104. Fry, "Oriental Art," 226.

105. Ibid., 227, 227.

106. Ibid., 227.

107. Oscar Wilde, "The Decay of Lying" [1891], in *The Soul of Man Under Socialism & Selected Critical Prose,* ed. Linda Dowling, 163–92 (New York: Penguin, 2001), 187.

108. Fry, "Oriental Art," 228.

109. Ibid., 239.

110. The contradictory relation of the Bloomsbury social circle to British colonial practice can also be seen in two incidents in 1910. First, in the so-called "*Dreadnought* Hoax," a group of Bloomsbury members, including the painter Duncan Grant, Virginia Woolf, and her brother Adrian Stephen, dressed up as Ethiopian ambassadors, with darkened skin and elaborate costumes, and convinced the crew of the H.M.S. *Dreadnought* to give them a tour. The practical joke was revealed in the press, and Stephen was required to answer questions before Parliament. Peter Stansky relates the

story in *On or About December 1910* (17–46) and concludes that the conspirators got off lightly because of their high social standing. Another episode of primitive costuming is related in Francis Spalding's biography of Roger Fry: "Fry, Vanessa and Clive Bell, Virginia and Adrian Stephen and James Strachey appeared as Gauguinesque savages at a fancy dress ball at Crosby Hall, their limbs browned and draped in little else than the Manchester African cloth" (*Roger Fry,* 141). In both cases, especially in the *Dreadnought* hoax, Bloomsbury members donned African clothes to express anti-establishment, anti-colonial attitudes. But also, in both cases, "Africa" is nothing more than an excuse for fancy dress-up, making global politics into a joke for members of a privileged class.

111. Raymond Williams, "The Significance of 'Bloomsbury' as a Social and Cultural Group," in *Keynes and the Bloomsbury Group,* ed. Derek Crabtree and A. P. Thirlwall (London: MacMillan Press, 1980), 58, 63. This contradictory position leads Williams to conclude that, ultimately, the "liberalisation and modernisation" of the Bloomsbury group was a form of adaptation that allowed them to maintain power, rather than enabling them to truly change the class system they dominated (59).

112. Fry, "Oriental Art," 230, 229.

113. Ibid., 236.

114. Ibid., 237, 236.

115. Ibid., 237.

116. Havell, *Indian Sculpture and Painting,* 256–57.

117. These movements are described and analyzed by Mitter, *Art and Nationalism in Colonial India.*

118. As Partha Mitter points out, although Japan was not colonized by the West, its culture still underwent a comparable process of westernization to that of India; and it, too, had revivalists in the late nineteenth and early twentieth centuries who argued for the recovery of a disappearing native visual style (*Art and Nationalism,* 262).

119. Kakuzo Okakura, *The Ideals of the East, with Special Reference to the Art of Japan* (London: John Murray, [1903], 1905), xi. A "prefatory note" reads: "Mr. Murray wishes to point out that this book is written in English by a native of Japan." Okakura completed the book while he was residing in Calcutta, in the house of the Tagores, a leading family in the Indian cultural nationalist movement. The Indian poet and nationalist Rabindranath Tagore won the Nobel Prize for literature in 1913, in part owing to the support of W. B. Yeats in the West. Rabindranath's brother was the painter Abanindranath Tagore, mentioned above, a disciple of E. B. Havell, a leading anti-realist artist, and a *swadeshi* nationalist.

120. Ibid., 228, 19.

121. Roger Fry, "The Grafton Gallery – I," *Nation* (November 19, 1910): 331. Reprinted in Bullen, *Post-Impressionists in England,* 122.

122. Simon Gikandi, "Africa and the Epiphany of Modernism," in *Geomodernisms: Race, Modernism, Modernity,* ed. Laura Doyle and Laura Winkiel (Bloomington: Indiana University Press, 2005), 33, 33, 48. Gikandi's essay focuses on the writings of German ethnographer and explorer Leo Frobenius. He mentions Roger Fry briefly in the essay's final section.

123. Bell, *Art,* 15.

124. Roger Fry, "The Artist and Psycho-Analysis," in Reed, *A Roger Fry Reader,* 364, 356.

125. Ibid., 358.

126. Clement Greenberg, "Modernist Painting," in *Modern Art and Modernism,* ed. Frascina and Harrison, 5.

127. Ibid., 8.

128. Ibid., 9.

129. J. B. Bullen describes Prichard this way in connection to Prichard's interest in Byzantine art and his influence on the Bloomsbury Group: "Byzantinism and Modernism 1900–1914," *The Burlington Magazine* 141, no. 1160 (November 1999): 668. Interestingly enough, another influential tastemaker in America was Ananda Kentish Coomaraswamy, the Sri Lankan philosopher and Indian art expert reviewed by Roger Fry. Son of a famous Sri Lankan statesman and an English mother, Coomaraswamy became known as a key interpreter of Asian art for Western audiences. After lecturing on Indian art in London, he moved to America in 1917 to become the curator of Indian art at the Boston Museum of Fine Arts. He also advised on the collection of Persian art at the Freer gallery in Washington, D.C. Coomaraswamy seems to occupy a hybrid space between colonial subject and modernist critic. His authority in America ultimately seems to have emerged from his mastery of the British codes of criticism traced in this chapter, as seen in his numerous published works on Indian and Asian art. See Roger Lipsey, *Signature and Significance: A Study of the Life and Writings of Ananda K. Coomaraswamy,* 2 vols. (Ann Arbor, Mich.: University Microfilms, 1974).

130. For literary studies of modernism's global turn, see Doyle and Winkiel, eds., *Geomodernisms: Race, Modernism, Modernity*; Douglas Mao and Rebecca L. Walkowitz, eds., *Bad Modernisms* (Durham, N.C.: Duke University Press, 2006); Simon Gikandi, *Writing in Limbo: Modernism and Caribbean Literature* (Ithaca, N.Y.: Cornell University Press, (1992); Patricia Chu, *Race, Nationalism, and the State in British and American Modernism* (Cambridge: Cambridge University Press, 2006); and Howard J. Booth and Nigel Rigby, eds., *Modernism and Empire: Writing and British Coloniality, 1890–1940* (Manchester: Manchester University Press, 2000). In art history, see Lucy Bowditch, "Global Modernism," *Afterimage* 35, no. 2 (September–October 2007); John Onians, ed., *Atlas of World Art* (London: Laurence King Publishing, 2004); Rasheed Araeen, Sean Cubitt, and Ziauddin Sardar, eds., *The Third Text Reader on Art, Culture and Theory* (London: Continuum, 2002); and *Cubism in Asia: Unbounded Dialogues* (Tokyo: The National Museum of Modern Art, 2000).

Conclusion

1. There are a small number of exceptions to this generalization, as when well-known novelists publish essays on art. See, for example, John Updike, *Still Looking: Essays on American Art* (New York: Knopf, 2005).

2. T. E. Hulme, "Notes on Language and Style," in Michael Roberts, ed., *T. E. Hulme* (London: Faber and Faber, 1938), 274.

3. David Lodge, *The Modes of Modern Writing: Metaphor, Metonymy, and the Typology of Modern Literature* (London: Longman, 1977), 45–46.

4. Virginia Woolf, *To the Lighthouse,* part 3, chap. 5.

5. An important recent analysis of Woolf's visual aesthetics is Jane Goldman, *The Feminist Aesthetics of Virginia Woolf: Modernism, Post-Impressionism, and the Politics of the Visual* (Cambridge: Cambridge University Press, 1998).

6. David Kadlec, *Mosaic Modernism: Anarchism, Pragmatism, Culture* (Baltimore: Johns Hopkins University Press, 2000).

7. An early expression of these values can be found in an 1893 essay by aesthete George Moore, in which he savages the literary qualities of Victorian art. The essay's title, appropriately enough, is "The Failure of the Nineteenth Century": "For the last hundred years painters seem to have lived in libraries rather than in studios. All literatures and all the sciences have been pressed into the service of painting, and an Academy catalogue is in itself a liberal education. In it you can read choice extracts from the Bible, from Shakespeare, from Goethe, from Dante . . . For the last hundred years the painter seems to have neglected nothing except to learn how to paint." George Moore, "The Failure of the Nineteenth Century," in *Modern Painting* (London: W. Scott, 1898), 52.

8. Rosenberg goes on to describe the mythic quality of the abstract artist's biography: "Some formulate their myth verbally and connect individual works with its episodes. With others, usually deeper, the painting itself is the exclusive formulation." Harold Rosenberg, "The American Action Painters," in *Art Theory and Criticism,* ed. Sally Everett (Jefferson, N.C.: McFarland, 1991), 58, 60.

9. The classic cultural study of this shift is Serge Guilbaut, *How New York Stole the Idea of Modern Art: Abstract Expressionism, Freedom, and the Cold War,* trans. Arthur Goldhammer (Chicago: University of Chicago Press, 1983).

10. Clement Greenberg, "Modernist Painting," in *Modern Art and Modernism: A Critical Anthology,* eds. Francis Frascina and Charles Harrison (London: Harper & Row, 1982), 9.

11. Rosenberg, "The American Action Painters," in *Art Theory and Criticism,* ed. Everett, 60.

12. See, for example, Michael Leja, *Reframing Abstract Expressionism: Subjectivity and Painting in the 1940s* (New Haven, Conn.: Yale University Press, 1993).

13. Mitchell derives these narratives by analyzing the famous cover of the catalogue to the 1936 exhibition *Cubism and Abstract Art* at the Museum of Modern Art. Constructed by the museum's director, Alfred H. Barr, Jr., the cover depicts a complex chart of art movements, a dizzying assembly of "isms" connected by swooping arrows. The chart begins with numerous items that include "Fauvism," "Negro Sculpture," and "Near Eastern Art," but all of the terms eventually funnel into two lone categories: "Geometrical Abstract Art" and "Non-Geometrical Abstract Art." W. J. T. Mitchell, "*Ut Pictura Theoria*: Abstract Painting and Language," in *Picture Theory: Essays on Verbal and Visual Representation* (Chicago: University of Chicago Press, 1994), 232–33.

14. Ibid., 235.

15. Of all the art writers considered in this book, only Walter Pater seems to have anticipated the extreme relativism of some contemporary post-structuralist theories. Jonathan Loesberg makes this argument in *Aestheticism and Deconstruction: Pater, Derrida, and De Man* (Princeton, N.J.: Princeton University Press, 1991).

16. Alan Richardson and Frances F. Steen, "Literature and the Cognitive Revolution: An Introduction," *Poetics Today* 23, no. 1 (Spring 2002): 2. The essay introduces a special issue of the journal devoted to literature and cognitive science.

INDEX

Note: Page numbers in *italics* indicate illustrations.

Ireland as viewed by British, 89, 265n73,
266n90
Isabella Stewart Gardner Museum
(Boston), 232

Jackson, Holbrook, 196
James, Henry
Burne-Jones viewed by, 115
formalism and, 270n37
The Golden Bowl, 235
"The Picture Season in London, 1877"
14, 112, 114, 133, 270n37
on the Royal Academy, 112, 114
Whistler viewed by, 115, 118
Jameson, Anna
essays in the *Penny Magazine* by, 18,
249n63
first professional British art historian, 17
Memoirs of the Early Italian Painters, 17, 19
Sacred and Legendary Art, 92
Turner viewed by, 57
Jane Eyre (Brontë), 10
Japanese art, 135, 220, 222, 223–25, 226,
227–28, 273n101
Javanese (Indonesian) art, 220, 221, 223
Jeffrey, Francis, 256n76
Jenkyns, Richard, 81
Johnson, E. D. H., 242–43n10
Jones, Owen
Crystal Palace and, 266n102
Grammar of Ornament, 159, 161, 162,
266n102
Indian art viewed by, 222
Joyce, James, 148, 277nn133–34

Kant, Immanuel
"autonomy of art" idea, 8–9
compared with Reynolds, 246n37
Critique of Judgment, 4, 9, 241–42n5,
246n37
and disinterest, 89, 210, 230, 231
theories of, 47, 51, 52, 241–42n5
Keats, John, 256n74
"Kelmscott Chaucer," 182, 183
Kelmscott Manor, 153, 154
Kinna, Ruth, 278n7
Kiss, August, *Amazon* sculpture, 75, 76

kitsch, 98–100, 101
Knight, Richard Payne, 31

"Lacock Abbey in Wiltshire" (Talbot), 43
Ladd, Henry, *The Victorian Morality of Art*,
5, 25–26
Lamarckism, 167, 171–72, 189
Lamb, Charles, 35
Landow, George, 49, 250n8, 255n70
landscape painting
in 1830s, 30–34, 33
Ruskin's views on, 26, 27, 35–36,
38–41, 48, 60–61
of Turner, 28–30
landscape photography, 43–45
Laocoön (Lessing), 16–17, 255–56n73
Law, Jules David, 35
Lawrence, D. H., 25, 290n73
Leighton, Frederick, 119, 130, 243n13
Leonardo da Vinci, 144
Lessing, Gotthold Ephraim, *Laocoön*,
16–17, 255–56n73
Lessing, Julius, 64
Lethaby, W. R., 220
Lewis, Wyndham, 210
Leyland, Francis R., 133
Liberty, Arthur, 135, 273n101
Light and Colour (Goethe's Theory)
(Turner), 59
Lightman, Bernard, 163, 280n32, 280n40
Lindsay, Blanche, 111–12, 133
Lindsay, Coutts, 111–12, 115, 119,
120, 126
Linnaeus, Carl, 35
"literate eye" (defined), 3
Locke, John
An Essay Concerning Human Understanding,
39–40, 42, 253n44, 253–54n51
Ruskin influenced by, 27, 39–40, 42,
45, 57
Lodge, David, 235
Loewy, Emmanuel, 192, 215–17
Loftie, W. J., 130
Lorenzo and Isabella (Millais), 93, 93
Lowell, Amy, 235
Lowie, Robert, 194
Lyell, Charles, 48